Constable in Love

Constable in Love

*Love, Landscape, Money and the
Making of a Great Painter*

MARTIN GAYFORD

FIG TREE
an imprint of
PENGUIN BOOKS

FIG TREE

Published by the Penguin Group
Penguin Books Ltd, 80 Strand, London WC2R ORL, England
Penguin Group (USA) Inc., 375 Hudson Street, New York, New York 10014, USA
Penguin Group (Canada), 90 Eglinton Avenue East, Suite 700, Toronto, Ontario, Canada M4P 2Y3
(a division of Pearson Penguin Canada Inc.)
Penguin Ireland, 25 St Stephen's Green, Dublin 2, Ireland (a division of Penguin Books Ltd)
Penguin Group (Australia), 250 Camberwell Road, Camberwell, Victoria 3124, Australia
(a division of Pearson Australia Group Pty Ltd)
Penguin Books India Pvt Ltd, 11 Community Centre, Panchsheel Park, New Delhi – 110 017, India
Penguin Group (NZ), 67 Apollo Drive, Rosedale, North Shore 0632, New Zealand
(a division of Pearson New Zealand Ltd)
Penguin Books (South Africa) (Pty) Ltd, 24 Sturdee Avenue,
Rosebank, Johannesburg 2196, South Africa

Penguin Books Ltd, Registered Offices: 80 Strand, London WC2R ORL, England

www.penguin.com

First published 2009
1

ISBN: 978–1–905–49024–0

www.greenpenguin.co.uk

Mixed Sources
Product group from well-managed
forests and other controlled sources
www.fsc.org Cert no. SA-COC-1592
© 1996 Forest Stewardship Council
FSC

Penguin Books is committed to a sustainable future
for our business, our readers and our planet.
The book in your hands is made from paper
certified by the Forest Stewardship Council.

To Cecily and Tom

Contents

List of Illustrations ix

CONSTABLE IN LOVE 1
Married Life 321

Afterword and Note on Sources 335
Selected Bibliography 341
Acknowledgements 349
Index 351

List of Illustrations

All works are by John Constable unless otherwise stated.

p. 6 Ramsay Richard Reinagle: *John Constable* (1799), oil on canvas – National Portrait Gallery, London

p. 8 *Maria Bicknell* (*c.* 1809), pencil on paper – Tate

p. 12 *Barges on the Stour: Gleams of Light on the Meadows* or *Scene on the River Stour, Suffolk*, engraved by David Lucas after Constable, mezzotint, published 1832

p. 14 Claude Lorraine: *Landscape with Hagar and the Angel* (1646), oil on canvas mounted on wood – National Gallery, London

p. 15 *An Overshot Water-wheel*, from *Intact Sketch-book used in Suffolk and Essex from July till October 1814*, pencil on paper – Victoria and Albert Museum, London

p. 17 *Frontispiece: Paternal Home and Grounds of the Artist*, engraved by David Lucas after Constable, mezzotint, published 1832

p. 19 *Golding Constable* (1815?), oil on canvas – Tate

p. 22 *East Bergholt Common with the Windmill*, from *Intact Sketch-book used in Suffolk and Essex from July till October 1814*, pencil on paper – Victoria and Albert Museum, London

p. 25 Robert Horwood, Map of London, Westminster and Southwark (1799), detail of sheet C3

p. 27 Samuel Freeman and Matthew Dubourg, after Denis Brownell Murphy: *Charles Bicknell*, stipple engraving, published 1814 – National Portrait Gallery, London

p. 29 Augustus Pugin and Thomas Rowlandson: *The Admiralty: Board Room*, hand-coloured aquatint, from *The Microcosm of London*, published by Rudolph Ackermann 1808–10

p. 32 David Wilkie: *Benjamin Robert Haydon* (1815), black and white chalk – National Portrait Gallery, London

p. 43 John Hoppner: *Sir George Beaumont* (1803), oil on canvas – National Gallery, London

p. 45 Sir Thomas Lawrence: *Joseph Farington RA* (1796), oil on canvas – Bridgeman Art Library

p. 58 *Stoke-by-Nayland Church and Village*, from *Intact Sketch-book used in Suffolk and Essex from July till October 1814*, pencil on paper – Victoria and Albert Museum, London

p. 64 *East Bergholt Church* (1811), watercolour – National Museums of Liverpool

p. 80 *Ann Constable (c. 1800–05)*, oil on canvas – Tate

p. 87 Augustus Pugin and Thomas Rowlandson: *The Royal Academy: Life Room*, hand-coloured aquatint, from *The Microcosm of London*, published by Rudolph Ackermann 1808–10

p. 89 *Study of Female Nude Lying on her Back* (1811), black and white chalk – whereabouts unknown

p. 90 *Summer Evening – A Homestead, Cattle Reposing*, engraved by David Lucas after Constable, mezzotint, published 1831

p. 102 *A Seated Woman from behind, Holding a Child*, from *Intact Sketch-book used in Suffolk and Essex from July till October 1814*, pencil – Victoria and Albert Museum, London

p. 121 *Mary Constable* (1812), pencil – The Samuel Courtauld Trust, The Courtauld Gallery, London

p. 122 Augustus Pugin and Thomas Rowlandson: *The Royal Academy: The Great Room*, hand-coloured aquatint, from *The Microcosm of London*, published by Rudolph Ackermann 1808–10

p. 123 J. M. W. Turner: *Snow Storm: Hannibal and his Army Crossing the Alps*, engraved by J. Cousen, published 1859–61 – Tate

p. 131 *David Pike Watts* (1812), oil on canvas – Private Collection

p. 150 *Brantham Mill*, from *Intact Sketch-book used in Suffolk and Essex from July till October 1814*, pencil – Victoria and Albert Museum, London

p. 152 *Spring: East Bergholt Common, Hail Squalls – Noon*, engraved by David Lucas after Constable, mezzotint, published 1830

p. 176 *Head of a Lock on the Stour. Rolling Clouds* (based on *Landscape: Boys Fishing*, 1813), engraved by David Lucas after Constable, mezzotint, published 1831

p. 180 J. M. W. Turner, *A Frosty Morning. Sunrise*, engraved by R. Brandard, published 1859–61 – Tate

p. 182 Augustus Pugin and Thomas Rowlandson: *The British Institution*, hand-coloured aquatint, from *The Microcosm of London*, published by Rudolph Ackermann 1808–10

p. 194 Charles Robert Leslie: *Joseph Mallord William Turner* (1816), pencil – National Portrait Gallery, London

p. 199 *Willie Lott's Cottage Seen over the Stour by Moonlight*, from *Intact Sketch-book used in Suffolk and Essex in 1813*, pencil – Victoria and Albert Museum, London

p. 199 *Study of Cows*, from *Intact Sketch-book used in Suffolk and Essex in 1813*, pencil – Victoria and Albert Museum, London

p. 200 *Dedham Vale from Langham*, from *Intact Sketch-book used in Suffolk and Essex in 1813*, pencil – Victoria and Albert Museum, London

p. 211 Augustus Pugin and Thomas Rowlandson: *Covent Garden Theatre*, hand-coloured aquatint, from *The Microcosm of London*, published by Rudolph Ackermann 1808–110

p. 219 *A Summerland, Rainy Day – Ploughmen. Noon*, engraved by David Lucas after Constable, mezzotint, published 1831

p. 230 *The Village Feast, East Bergholt*, from *Intact Sketch-book used in Suffolk and Essex from July till October 1814*, pencil on paper – Victoria and Albert Museum, London

p. 231 *Warwick House*, coloured engraving, 1811

p. 237 *The Temple of Concord, Green Park*, hand-coloured aquatint, 1814

p. 244 *Rhubarb Leaves*, from *Intact Sketch-book used in Suffolk and Essex from July till October 1814*, pencil – Victoria and Albert Museum, London

p. 248 *Boat-building near Flatford Mill* (1815), oil on canvas – Victoria and Albert Museum, London

p. 251 *James Gubbins in Church Street, East Bergholt by Moonlight*, from *Intact Sketch-book used in Suffolk and Essex from July till October 1814*, pencil – Victoria and Albert Museum, London

p. 253 *A Cart with Two Horses* (1815), oil on paper – Victoria and Albert Museum, London

p. 263 *Golding Constable's Garden* (1814 or '15), pencil – Victoria and Albert Museum, London

p. 272 J. M. W. Turner, *Dido Building Carthage*, engraved by E. Goodall, published 1859–61 – Tate

p. 281 *A Hay Cart*, from *Intact Sketch-book used in Suffolk*

and Essex from July till October 1814, pencil – Victoria
and Albert Museum, London

p. 285 A Cottage in a Cornfield (Woodman's Cottage),
engraved by David Lucas after Constable, mezzotint,
published by Lucas '2nd Series', 1846

p. 288 A Woman Writing at a Table, Watched by a Girl from
Intact Sketchbook used in Suffolk and Essex in 1813,
pencil – Victoria and Albert Museum, London

p. 306 Maria Bicknell (1816), oil on canvas – Tate

p. 308 Golding Constable's House East Bergholt, Two Studies
on One Sheet (1814), pencil – Victoria and Albert
Museum, London

p. 315 Flatford Mill, engraved by David Lucas after
Constable, mezzotint, published by Lucas '2nd
Series', 1846

p. 320 Augustus Pugin and Thomas Rowlandson:
St Martin's in the Fields, hand-coloured aquatint,
from The Microcosm of London, published by Rudolph
Ackermann 1808–10

p. 328 Maria Constable and Four of her Children, medium and
whereabouts unknown, 1822?

p. 332 The Nore, Hadleigh Castle – Morning after a Stormy
Night, engraved by David Lucas after Constable,
mezzotint, published 1832

Endpapers: Flatford Mill from the Lock (1811), sketch, oil on
canvas, David Thomson Collection

'My Dear Sir,' Maria Bicknell began, 'His only objection would be on the score of that necessary article Cash.' But her father's reservation, though merely financial, was fundamental.

> What can we do? To live without it is impossible. It would be involving ourselves in misery instead of felicity. Could we but find this golden treasure we might yet be happy, you say it is not impossible.
>
> I wish I had it, but wishes are vain – we must be wise, and leave off a correspondence that is not calculated to make us think less of each other, we have many painful trials required of us in this life, and we must learn to bear them with resignation.

They could still, she added – like innumerable young women through the ages – be friends.

She was writing to her suitor, a little-known painter named John Constable, on 4 November 1811, while staying at the house of her half-sister, Mrs Sarah Skey, outside Bewdley in Worcestershire.

The house, a mansion named Spring Grove, had been built by Mrs Skey's father-in-law. It had a porch with Ionic pilasters and, within, a handsome curving staircase surmounted by a domed octagon. Outside there was a conservatory where oranges and lemons grew in profusion and

from which rare specimens were sent to the botanic gardens at Kew. Beyond were 270 acres of grounds, landscaped in the style of Capability Brown, with a lake, adroitly placed clumps of trees and serpentine paths.

Altogether, Spring Grove was striking evidence of the wealth and comfort that a good marriage could bring: Mrs Skey lived in this delightful place because it had belonged to her late husband. The evidence was visible all around: Mrs Skey had married very well indeed.

Maria's letter concerned the opposite state of affairs: the difficulty of marrying without money. John Constable had been courting her for two years and she had fallen in love with him, with the only result that her parents had sent her to stay here in Worcestershire, safely out of his way.

Recently, a letter had arrived from Constable, whom she had not seen for months and never corresponded with at all. This was a clear invitation to resume their relationship and, indeed, to move it decisively forward. To exchange letters with a man was, as everyone knew, implicitly to accept him as a lover. It was a step on the path to the altar. Maria's dilemma was clear. Her heart urged her to write back, and keep on writing; but prudence and her sense of duty to her parents – who were firmly against this attachment – argued that she should not.

It was often noted during the Georgian era that the British were unusual in their approach to love and marriage. The unexpected thing about them, noted by numerous foreign visitors, was that they so often married for love. In his fable 'Rasselas', written in 1759, Dr Johnson described the normal procedure: 'A youth or maiden meeting by chance, or brought together by artifice, exchange dances, reciprocate civilities, go home and dream of one another.' Finding them-

selves uneasy when apart, Johnson observed, they concluded that they should be happy together.

The process the great lexicographer outlined was of course what is usually termed falling in love, and it sounds commonplace enough. But it wasn't at all usual in the rest of Europe for love to be combined with marriage. Outsiders thought it peculiar that the two should go together in this way. The German novelist Sophie von La Roche noted in 1784 as a feature of the country – along with the rain and the roast beef – that 'so many love matches are made in England'.

The Duc de la Rochefoucauld, a French aristocrat staying in England, was surprised to discover that English husbands and wives were always to be seen together, and seemed to enjoy each other's company. In London it was as unusual to come across a married couple apart as it was to meet them together in Paris. An Englishman, he concluded, 'would rather have the love of the woman he loves than that of his parents'.

Across the Channel, where Roman Law ruled, the choice of spouse was ultimately a matter for the fathers of the bride and groom. In Britain, legally at any rate, it was a matter for the man and woman involved, so long as they were over twenty-one. The marriage service began by checking that this union was the choice of the couple involved: 'Will you take this woman to be your wife? Will you take this man to be your husband?' Dr Johnson pronounced that 'a father had no right to control the inclinations of his daughter in marriage'. Or, to be precise, that he had an entitlement only to influence. 'The parent's moral right can arise only from his kindness, and his civil right only from his money.'

Here was the nub of the case of Maria Bicknell. Her

father had not told her that she could not marry John Constable. He had merely said that he thought it was a bad idea himself, because that suitor had no money. He, Charles Bicknell, could not or would not provide enough for Maria and Constable to live a comfortable life.

Maria did not think it likely that her father would change his mind. So there was no more to be done. 'I had better not write to you any more, at least *till I can coin*, we should both of us be bad subjects for poverty, should we not? Even Painting would go badly, it could not survive in domestic worry.'

Constable's courtship had begun two years before, but its progress had been slow. Indeed, latterly, all the movement in the affair had been backwards. We do not know exactly where or how John Constable and Maria Bicknell first met, but we do know when. Many years later, he remarked that he had first set eyes on her in 1800 – when he was twenty-four and she was only twelve. Nine years later, however, it was a different matter. She was then twenty-one and he was thirty-three.

There is no mystery about how they met. They were both members, at least intermittently, of the same community: East Bergholt, a large village on the brow of a low hill above the river Stour in Suffolk. According to the 1800 census 970 people lived there, but John Constable and Maria Bicknell were part of the much smaller group – a few dozen at most – of wealthy and prominent inhabitants.

Neither of them was a permanent resident. By 1800, Constable had already departed for London, where he was attempting to become a professional painter. He regularly returned, however – especially in the late summer and autumn – to stay with his family. Maria was an occasional visitor to

East Bergholt, where her grandfather the Revd Dr Durand Rhudde DD was the rector of the parish (together with two adjoining villages, Brantham and Little Wenham).

She came to stay with her grandparents – partly, perhaps, because her health was fragile and the clear air of Suffolk was expected to do her good. She was there in 1800, and again a few years later. In 1806, when Maria was eighteen, she received a letter from Mrs Everard, a single woman living in the village – one of several whose social lives centred around Dr Rhudde and his entourage of curates.

In the letter, Mrs Everard recalled to Maria the 'pedestrian rambles' they had taken together around East Bergholt and addressed her letter, jokingly, to 'Miss Bicknell, favor'd by Dr Rhudde'. The last point – that Maria was a favourite of her grandfather's – later had a surprisingly crucial effect on her romance with Constable.

The young John Constable was a remarkably, almost ostentatiously handsome young man. His looks, his personality and his intriguing, even romantic, situation in life combined to make him an object of great interest to young women in the neighbourhood. He seems to have appealed particularly to girls from clerical families – perhaps because they came from bookish backgrounds and were inclined to take an interest in the arts.

In 1799 Ann Taylor, the daughter of a dissenting minister who took up residence in East Bergholt, thought him as 'finished a model of what is reckoned manly beauty' as she had ever come upon. She described how one morning she and her four sisters walked over to Bergholt to inspect John's work, and a portrait of him just finished by a friend, Ramsey Richard Reinagle.

'We found,' Ann Taylor recalled, 'his mother, Mrs

Constable, a shrewd-looking, sensible woman, at home. There we were, five girls, all "come to see Mr. John Constable's paintings", and as we were about to be shown up to his studio, she turned and said dryly, "Well, young ladies, would you like to go up all together to my son, or one at a time?" I was simpleton enough to pause for a moment, in doubt, but we happily decided upon going *en masse*.'

That portrait by Reinagle reveals that at twenty-three Constable had chestnut hair, fine eyes, a manly nose and fashionably bushy side-whiskers.

'There were too,' Ann Taylor went on, 'rumours afloat which conferred on him something of the character of a hero in distress, for it was understood that his father greatly objected to his prosecution of painting as a profession and wished to confine him to the drudgery of his own business –

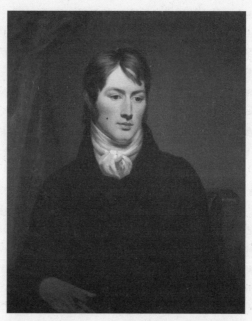

John Constable by Ramsey Richard Reinagle

that of a miller. To us that seemed unspeakably barbarous, though in Essex and Suffolk a miller was commonly a man of considerable property, and lived as Mr Constable did, in genteel style.'

A decade later, Constable was still good-looking, still struggling to make his way as a painter, and his father, Mr Golding Constable, still took the view that John was wasting his time in doing so. In 1816 he observed that it was seven years since he had declared his love to Maria, so we know that event took place in 1809 and also that it happened in East Bergholt where that year Constable stayed from late August until after Christmas. So it was during those four months that their courtship reached an intense phase, and did so, the evidence suggests, against a background of rustic landscape.

In East Bergholt there was the usual round of social interchange – as there also was in Steventon, the Hampshire village where Jane Austen was living at the time. There were routs, dances, tea parties, dinners, card-playing parties and soirées, at any of which Maria Bicknell and he might have encountered one another. Constable, however, was temperamentally averse to parties of most kinds. It was regarded as extraordinary for him to appear at a dance or a game of cards – although his younger brother, Abram, and youngest sister, Mary, were extremely fond of such occasions.

Rather than any social event, it was the walks he and Maria took together that Constable remembered. From the back of his father's house he looked out over 'the sweet fields' where they had been so happy. This was a stretch of gently undulating agricultural land, mostly owned and farmed by Mr Golding Constable, but to the south adjoining the small wood surrounding the rectory. It was therefore

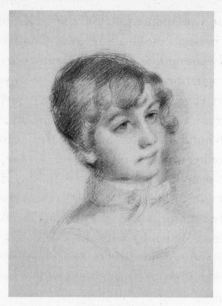

Maria Bicknell

an ideal terrain for the two young people to meet and talk freely.

Maria was unostentatiously pretty, with a wide, oval face, large grey eyes and brown hair something between curly and wavy, one lock of which tended to flop down charmingly over her forehead. Her gaze was mild, steady and intelligent. Much later, he enumerated among her virtues her 'fine mind'.

During those happy hours of strolling and talking they no doubt established that they had interests in common. Both were keen readers, especially of poetry; both were serious-minded and intelligent; and both had a taste for art. Maria was an amateur painter and at some point, probably that autumn, she tried her hand at a depiction of the mill at Flatford owned by the Constable family.

From what you might call the chemical point of view they were a perfect combination. John Constable's appearance of manly strength and dashing looks concealed a mass of nervous agitation: he was depressive, hypersensitive, frequently on edge, neurotic – in short, much what you might expect in a painter of great originality. He needed Maria's steadying calm and rationality; she in turn valued his talent and intelligence.

Under the watching eyes of the rest of the village, Maria and one or more of her sisters – probably Louisa, who was only a year her junior, rather than Catharine, who was still a child – came to take tea with the Constables. The Revd Henry Kebell, one of the curates, was offended that he was not asked too and had to be soothed by Mrs Constable.

By Christmas, as far as Constable at least was concerned, the matter was settled. He would have said, as James Boswell had in 1775 of the woman he chose to be his wife, 'I only know or fancy that there are qualities and compositions of qualities (to talk in musical metaphor) which in the course of our lives appear to me in her, that please me more than what I have perceived in any other woman, and which I cannot separate from her identity.'

Maria too had formed a deep attachment. It was only afterwards that the difficulties began.

In Georgian England there was considerable social mobility. It was possible to ascend quite rapidly through energy, good fortune and enterprise as Golding, Constable's father, had – and just as easy to slip down again.

John Constable was living on an allowance of £100 a year, provided rather against his better judgement by his father, plus any small fees that he might earn from painting (and these to date had been meagre and infrequent). This

was sufficient to maintain him in a moderately comfortable bachelor existence in lodgings in London – especially as he often spent several months of the year at home in Suffolk. It was not enough to maintain a wife, though, let alone a family, in a genteel manner. For that £400 or £500 would be required.

From Maria's point of view both marriage and spinsterhood involved hazards. To become the wife of a husband with insufficient income risked poverty for oneself and one's children, and the prospect of an indigent widowhood, not all that unlikely if the husband were a dozen years older. The early demise of the wife, however, was even more probable, since – in the absence of contraception – many middle-class women were worn out by constant pregnancy and childbirth.

On the other hand, the prospects for an unmarried middle-class woman were also bleak. Maria came from an era of greater female education which was widely, if not universally, agreed to be a great improvement to society. It was, indeed, exactly what made the marriage of intellectual equals a possibility. Dr Johnson observed that 'All our ladies read now, which is a great extension.' As a result, he believed, they were more virtuous and faithful to their husbands, 'because their understandings were better cultivated'.

Unfortunately, there was little work available for them to do with these educated minds and the possibilities that did exist were not attractive. A middle-class spinster could become the companion to a wealthy married woman. This, the authoress and feminist pioneer Mary Wollstonecraft, who had tried it, described as life with 'intolerably tyrannical' strangers. 'It is impossible to enumerate the many hours of anguish such a person must spend. She is alone, shut out from equality and confidence.' The main alternative career

open to educated Georgian women was teaching in a girls' school, characterized by Wollstonecraft as being 'only a kind of upper servant, who has more work than the menial ones'.

With a little money, a woman could live alone. The writer William Hayley, biographer of Maria's favourite poet, William Cowper, summed up such an existence. A woman who had received a 'polite education' and spent her 'sprightly years' in the house of an opulent father is then reduced to 'contracted lodgings' where, in the company of a female servant, she ekes out an existence on the 'interest of two or three thousand pounds, reluctantly and perhaps irregularly paid to her by an avaricious or extravagant brother'. Not surprisingly, despite all the pitfalls, Georgian women were on the whole keen to get married.

This was what you might call the Jane Austen situation: a finely balanced tussle of heart and head, economic realities and romantic possibilities, duty and desire. Six months older than John Constable, Austen had yet to publish anything. It would be two years before *Sense and Sensibility*, the first of her novels to appear, came out in October 1811. By then, she had already begun *Mansfield Park*, the book which, with its contrast of worldly London attitudes and simpler rural life, its richly inhabited Regency landscapes, its delicate and patient heroine, offers the closest fictional parallel to the story of Maria Bicknell and John Constable.

It was obvious even from the letter in which she told him that they must be just friends that Maria loved John Constable. Love was the emotional force that drew them together. There was, however, an unusual complicating factor in the situation: art. Everything was made more difficult by Constable's determination to be a painter.

John Constable was unconventional in mind and character. That is, and always was, part of the psychological equipment required to become a great artist. After his death, his friend and biographer Charles Robert Leslie analysed Constable thus: 'With great appearance of docility, he was an uncontrollable man. He said of himself, "If I were bound with chains I should break them, and with a single hair round me I should feel uncomfortable."'

He showed this stubbornness early on in his choice of career. By his own account, Constable had mused about painting long before he had actually begun to do it. This wish to become an artist was connected with the emotions he felt for a particular place: his own village, and most of all the landscape around the banks of the river Stour. This river, which forms the border between Suffolk and Essex, winds between low hills for the last few miles of its course before reaching its estuary. That area, the parishes of East Bergholt, Dedham, Stratford St Mary, Langham and Nayland, is what eventually became known as 'Constable country'.

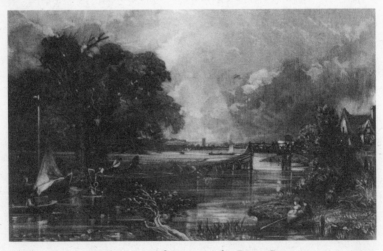

Engraving of *Scene on the River Stour*

Constable himself lived long enough to hear those words said. While travelling through the Stour valley in a stagecoach, he remarked to a fellow passenger that the scenery looked beautiful. 'Yes, sir,' his companion replied. 'This is *Constable*'s country.' The artist then admitted who he was, in case the man should go on to spoil it. But long before then he knew he painted his 'own places' best. By that he meant most of all a small area around the watermill at Flatford that was his father's property.

These lowland riverside scenes, Constable wrote, 'made me a painter (& I am grateful) that is I had often thought of pictures of them before I ever touched a pencil' (by pencil, he and his contemporaries meant what is now called a brush). For an artist to be inspired so powerfully from the beginning by a single spot is so unusual as to be almost unique. The closest analogy in the history of art is the obsession, almost a century later, of Paul Cézanne with the landscape of Mont Sainte-Victoire, in sight of which he had grown up.

It is not clear how Constable even came to know of painting as an activity. He did not see a great and inspiring work of art until he was nineteen years old, in 1795. He was then introduced to a wealthy connoisseur and amateur artist, Sir George Beaumont, whose mother happened to know Constable's mother. Sir George owned several paintings by Claude, one of which, small enough to be portable, he generally brought with him when he travelled. It depicted the biblical story of Hagar and the Angel but the figures of Hagar, an Egyptian expecting a child by Abraham, and the angel were tucked away in the bottom left-hand corner.

The true subject of the painting was late evening in a river valley. The sinking sun still illuminated the distant hillsides with golden light, the shadows were a soft blue. A river

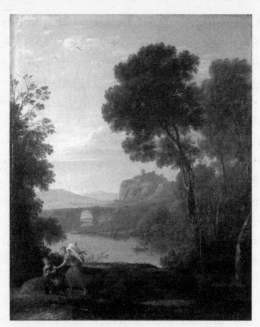

Landscape with Hagar and the Angel
by Claude Lorraine

wound away into the distance. Small clouds, tinted the palest delicate yellow, floated above in a mild, milky and delectable sky. To one side was a group of trees, casting refreshing shade on the grass in the foreground. It was a picture of a place not unlike the Stour valley, but in which the everyday landscape was transfigured and classicized.

The sight of it came to the young John Constable with the force of revelation: a sudden flood of understanding of what a great painting could be. He never forgot the experience. But at that stage he was already an aspiring painter, which was why his mother had sought the meeting with Sir George in the first place.

Certainly, there was no precedent in the Constable family. His father, Golding, was a successful corn merchant, miller

and coal transporter. He had inherited the watermill at Flatford from an uncle, Abram Constable, and steadily built up the business. Eventually he ran another mill at Dedham and bought a windmill on East Bergholt Heath, a fleet of river-going barges which he built in his own dry-dock at Flatford, and a merchant brig, *The Telegraph*, that plied its trade between Mistley, the port at the mouth of the Stour, and London.

All of this amounted to a neatly integrated enterprise. The grain was ground in Constable mills and transported in Constable boats to London, where it was sold. On their return journey, the barges carried commodities such as coal from Tyneside upriver to Bergholt, Dedham, Nayland and Sudbury. At times, Golding had overcome financial difficulties as his son Abram, John's younger brother, later recalled. But he had won through. From his father, John Constable might have inherited fortitude and patience –

A Water-wheel

15

both of which he required in his career as a painter – but definitely no artistic genes.

Neither did these seem to derive from his mother's side of the family. Ann Constable's father, William Watts, was a successful cooper living in Upper Thames Street, London. The Watts, like the Constables, were upwardly mobile. One of Ann's brothers, David Pike Watts, became through a freak of fortune remarkably rich. The others were for the most part solidly respectable middle-class people. Their offspring were inclined to become officers in the army and the navy.

The only member of the family with a love of nature even remotely comparable with John's was his older brother, who was named Golding like their father. There was something odd about this younger Golding: he had fits and he suffered from what his mother fretfully described as 'apathy'. His intelligence was not affected so gravely that he could not read and write, but his few surviving letters are jerky in style and lack the easy, urbane flow of correspondence by other members of the family. He was not suited, his family concluded, for responsible tasks. It was only in his letters to him that Constable used local dialect, in which for example 'Bergholt' turned into 'Bargell'.

The Constables, who were a close and loving family, looked after Golding and worried about him (somewhat as they did over John's equally eccentric determination to be a painter). Eventually they arranged for him to have a job as a woodsman in charge of a woodland owned by a local aristocrat, the Earl of Dysart.

Golding, born in 1774, was two years older than John. He, the older male sibling, was his obvious playmate on the banks of the Stour, beside the family mill. The two of them did in fact have one thing in common: a deep feeling for the

natural world. In Golding's case this came out in the more conventional fashion – for a Georgian country gentleman – of hunting. Golding's one notable ability was that he was a remarkable shot, and the sole way in which he could aid his brother in his art was by providing models in the form of dead game.

In 1808 Constable wanted a woodpecker for a picture – now lost – and Golding accordingly provided it. On 9 December 1807, the youngest of the Constable family, Mary, wrote a letter to John, or, as she addressed him, 'My dearest Johnny'. 'This morning,' it began, 'Golding took the *fatal* aim at the beautiful woodspite [the local name of the bird], which my mother sends you, and under its wing it will convey these few lines from me.'

The Constable family home was named, with a touch of self-satisfaction, 'East Bergholt House'. It was a visible sign

Engraving of *East Bergholt House and Garden*

of Golding Constable's achievements in life. He had bought the land on which it was constructed in 1772 and had a house erected on it – presumably according to his own ideas.

Like Golding Constable himself, his dwelling was solid, substantial and very English. It was three storeys high, built of red brick. The main door had a pediment above it, and over that a Venetian window. At the front there was a curving drive, leading in from the village street on which John once sketched some of the Constable family's dogs lazing in the sun. To one side of the main building was the counting house – Golding's office and a laundry. There were stables to the back, and a handsome barn a little further away across Golding Constable's fields.

The entire arrangement was imposing and caught people's eyes. A passing writer named Frederick Shoberl, who compiled the Suffolk volume of *The Beauties of England and Wales* (1812), noted that 'Old Hall', the manor house and seat of the squire, Mr Peter Godfrey, together with 'the residences of the rector, the Reverend D Rhudde, Mrs Roberts, and Golding Constable, Esq' gave East Bergholt 'an appearance far superior to most villages'.

This passage in the book caused John Constable such pride that he was still quoting it decades later, long after the Constables ceased to live in the place. East Bergholt House was the architectural expression of Golding Constable's position in the village, which was almost that of leading citizen. In 1785, when John was nine, John Crosier of Maldon jotted down that in East Bergholt 'A Mr Golding Constable, a man of fortune and a miller has a very elegant house in the street and lives in the style of a country squire.'

Golding was a local figure of note. He was director of the workhouse at Tattingstone (which he conveniently happened to supply with corn), he was one of the com-

Golding Constable, 1815?

missioners of the River Stour Navigation board – the river
had been canalized in the early eighteenth century, and the
locks and towpaths required constant supervision. In 1787 he
bought the ecclesiastical equivalent of East Bergholt House –
a family pew in the parish church. This was in the north side
of the middle aisle, near that of his neighbour Mrs Roberts.

When Golding Constable's brig *The Telegraph* was
launched on 19 August 1797, the local newspaper, the *Ipswich
Journal*, devoted a lengthy piece to the event: '. . . an immense
concourse of people were assembled, who testified their
approbation by repeated acclamations, with good wishes
for her success, and the long life and property of her
worthy owner. An handsome entertainment was provided at
the Crown Inn, where many loyal, constitutional toasts,
appropriate to the occasion, were drunk.'

Golding Constable's rise was recent and rapid enough to attract the jealousy of another proud, self-made man: the rector, Maria's grandfather, Durand Rhudde. But Golding Constable's wealth was dependent on the continuance of his business; for the most part it didn't consist of property or land. His financial position had large implications for his son John, both as an aspiring artist and a would-be married man.

In the first place, the Constables were a little too well off for their son to consider art as a profession. In England, painters had only recently risen from the ranks of artisans. Now a few, pre-eminently Joshua Reynolds, had achieved the rank and income of gentlemen. Still it was far from being an obvious career for the son of a prosperous man such as Golding Constable.

If his father had been less wealthy, there would have been less objection to Constable becoming a painter. In fact, his antecedents were not unlike those of Thomas Gainsborough (1727–88), an earlier master of the East Anglian landscape.

The Gainsboroughs came from Sudbury, a dozen miles up the Stour at the end of the journey for Golding Constable's barges, and they, too, were upwardly mobile. Thomas's uncle was a successful businessman. But crucially his father, John Gainsborough, failed in trade, went bankrupt and ended up as the Sudbury postmaster. So when young Thomas showed precocious talent as a painter, there was no question as to what he should do. He was sent to London at the age of thirteen to learn his art.

Constable, in contrast, was brought up as a gentleman. He was sent away to school at Fordstreet in Essex, then Lavenham in Suffolk, where the boys were beaten by a brutal usher – to Constable's lasting anger. His family, kind and humane, took him away and sent him instead to the grammar school at Dedham, a pleasant walk away down

across the Stour. This was a good school, with several notable alumni, presided over by the Revd Dr Thomas Grimwood.

There Constable was happy and, according to his friend and biographer C. R. Leslie, who was no doubt relying on Constable's own recollections, a favourite. 'Dr Grimwood had penetration enough to discover that he was a boy of genius, although he was not remarkable for proficiency in his studies, the only thing he excelled in being penmanship. He acquired however, some knowledge of Latin, and subsequently took private lessons in French, in which he made less progress.' (Maria was the one who eventually mastered that language.)

By that stage, at sixteen or seventeen, Constable was already set on becoming an artist. 'During his French lessons a long pause would frequently occur, which his master would be the first to break, saying, "Go on, I am not asleep: Oh! Now I see you are in your painting-room."' This studio – known to his mother, Ann Constable, as his 'shop' – was a little two-storey structure in the village street near the entrance to East Bergholt House.

Another aspect of their son's enthusiasm that made Golding and Ann Constable uneasy was his growing friendship with the only other person in East Bergholt who was keen on painting: the local plumber and glazier, John Dunthorne. Constable often sketched with Dunthorne, either in the plumber's cottage or out in the fields. Golding Constable made a joke – and a muddled-reference worthy of Mrs Malaprop – when he saw them coming home: 'Here comes Don Quixote with his Man Friday.'

This expressed Golding's feelings about the whole matter. The idea of becoming a painter was folly, and Dunthorne an unsuitably rude and mechanical ally. The relationship with

the plumber indeed suggested exactly where this might all be leading: down the social ladder. His parents' original plan for John was for him to go into the church – a conventional path for an educated young man from a family with money. The career choices for a gentleman without independent means were few. When, in Jane Austen's *Mansfield Park*, Mary Crawford expresses surprise that Edmund Bertram was intending to become a clergyman, he replied, 'Why should it surprise you? You must suppose me designed for some profession, and might perceive I am neither a lawyer, nor a soldier, nor a sailor.'

When it became clear that John had no appetite for the 'necessary studies' required of a man of the cloth, he went instead into the family business for a while. At one point he was responsible for supervising the post mill on East Bergholt Common – the one visible from the rear of the Constables'

East Bergholt Common with the Windmill

house. This task he performed, according to Leslie, 'carefully and well' and he was known for a while around the village as 'the handsome miller'. He was, his biographer related, 'remarkable among the young men of the village for personal strength, and being tall and well formed, with good features, a fresh complexion and fine dark eyes, his white hat and coat were not unbecoming to him'.

He continued to help his father for several years, while pressing to be allowed to become a painter. Eventually, when it became clear that the youngest of the Constable sons – Abram, seven years John's junior – was much more cut out for the trades of milling grain and transporting coal, John was reluctantly allowed to begin his artistic training at the Royal Academy Schools in London. This was not, however, until early 1799, when he was almost twenty-four. His father thought then that he was 'pursuing a shadow', and nothing had happened to change that view a decade later.

Constable's financial and social background had a crucial effect on his attitude to art – it gave him a sense of independence. He painted because he wanted to, not because he had to, and as far as possible, he painted what he wished. In this he resembled later artists such as Cézanne or Van Gogh – eccentric middle-class mavericks both of them, like Constable. He worked for money on occasion, but always grudgingly. His real aim was 'reputation' – a fame like that of Claude or Ruisdael – rather than profit or immediate popularity. This was one of the attitudes that made Constable a distinctively modern artist.

There were, however, severe limitations to his independence. Golding Constable could afford to keep two sons in idleness – Golding junior and John – plus two daughters who remained at home (only the middle one, Martha, was married). What he could not do was support a son with little

or no income, plus a wife and an unknown number of children.

Quixotic and uncontrollable in the matter of marriage as he had been over his choice of career, John ignored these practicalities.

The courtship had gone well during the autumn of 1809, so, when he returned to London in the New Year of 1810, he decided to take the next step. This was to pay a visit to Maria's family.

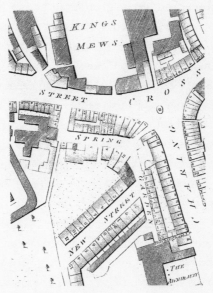

Spring Gardens and vicinity, 1799

The Bicknells lived at the very hub of London. Their home, 3 Spring Gardens Terrace, was just off Charing Cross where, according to Dr Johnson, 'the full tide of human existence' could be encountered. The statue of Charles I that stood at the junction of Cockspur Street, the Strand and Charing Cross was eventually named the geographical centre

of the capital. Already, however, it marked the vortex: the spot where government London met commercial London, the smart West End met the poverty-stricken slums of St Martin's and St Giles, respectable citizens jostled with the street-walkers of the Haymarket, and still, on rare occasions, criminals were exposed in the pillory. The preoccupations of the Bicknells were, as you might expect from their address, metropolitan.

To say that Maria Bicknell came from a legal family would be understating the case. Her paternal grandfather, great-grandfather and great-great-grandfather had all been lawyers; so too were her father, three of her uncles and two of her cousins. The professional history of her entire family revolved around the Inns of Court in London.

Maria's father, Charles Bicknell, was an especially lawyerly kind of lawyer – dry and businesslike. He had been born in Fetter Lane, close by Lincoln's Inn and the Temple, in 1751. In 1774, a lodger of his, a young Virginian named John Laurens who was soon afterwards to become a hero and martyr of the American War of Independence, found Charles Bicknell, not that old himself at the time, astonishingly boring.

He was, Laurens complained to his father, 'the merest machine in the world, the most barren in conversation and the least likely to improve of any man I was ever connected with'. It is fair to add that John Laurens eventually became quite fond of Charles Bicknell and continued to exchange friendly messages with the lawyer until he was killed at the Battle of Brandywine in 1777.

Mr Bicknell's correspondence, in so far as it survives, tends to be matter of fact, if not mechanical. Here is a sample, sent to his son-in-law:

Dear Sir,

If you will send me the Letter of Attorney I will get it registered at the Bank, where it must lie for two compleat days, before I can act upon it, so that the transfer cannot be made out before the next week.

Yours &c

Cha. Bicknell

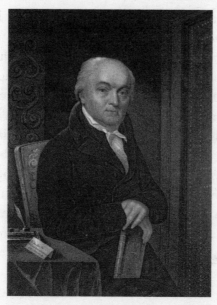

Engraving of *Charles Bicknell* by D. Murphy

At the beginning of 1810, when John Constable went to pay him a visit, Charles Bicknell had already been the man of business to the Prince of Wales for almost twenty years.

An etching after a portrait by D. Murphy gives a good idea of the man Constable encountered when he knocked on the door of 3 Spring Gardens Terrace. In appearance he was small and neat, with a large head. His hair was silver, swept back from a domed, balding forehead, but his eyebrows – the

strongest feature in his face – remained dark. Those eyes and brows showed a distinct similarity to Maria's.

Whether or not he was 'the merest machine', Charles Bicknell was of use to the libertine, spendthrift, gluttonous, art-and-architecture loving eldest son of George III – and many other clients. In the prince's correspondence and other historical documents of the time, at intervals the figure of Charles Bicknell flits past.

He tries with some success to calm an angry creditor of the prince's and attempts – in vain – to bribe a hostile newspaper editor into supporting him. Bicknell has a hand in suppressing a report about the Princess of Wales's unruly private life; he advises mercy rather than the pillory for one of the numerous writers who libelled his royal client.

It was claimed that Bicknell himself joined a group – dubbed the Loyal Association – dedicated to 'publishing caricatures by public subscription of Her Majesty and her supporters'. That is, attacking the Princess of Wales, Caroline of Brunswick, estranged wife and hated enemy of his master. Bicknell was the treasurer of this slightly sinister purveyor of propaganda. He was often appointed treasurer of charities and clubs; he was that kind of man.

Evidently, Charles Bicknell was a faithful member of the prince's entourage. It was not, however, Mr Bicknell's only position in life. His house on Spring Gardens Terrace was strategically placed. A hundred yards in one direction was the prince's London palace, Carlton House; a similar distance the opposite way was the Admiralty, to which Charles Bicknell had long been solicitor.

In this capacity, in early 1810 he was dealing with the case of a young Cornish seaman, Robert Jeffery, who had been marooned on a waterless and barren Caribbean island by the captain of his ship as a punishment for drinking

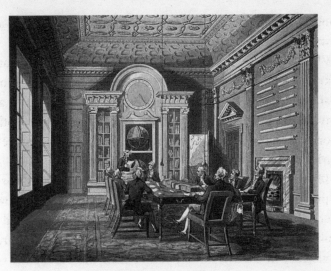

The Admiralty: Board Room

some beer without permission. Fortunately for Jeffery – and unfortunately for the captain, Warwick Lake – he had been rescued by an American ship. Now the whole affair had come to light. Lake's court martial was held between 5th and 10th February and resulted in him being dismissed from the service. Charles Bicknell had given a strictly cautious opinion that Lake's conduct in condemning a teenager to a lingering death for drinking a glass of beer was illegal 'however infamous that of the man had been'.

In addition to acting for the Admiralty, Charles Bicknell was Commissioner of Bankrupts, and Deputy Bailiff of the City and Liberty of Westminster and he practised privately, in partnership with a man named Anthony Spedding. Altogether, his experience of life – he had just turned fifty-eight at the time that John Constable came to call – had given him a wide knowledge of debt, marital break-up and human misfortune of every kind, together with a shrewd professional skill in handling difficult situations. He was

about to be confronted by one of those himself in the form of an unwanted suitor for his daughter's hand.

Although, legally, the decision about whom – if anyone – to marry was entirely up to the person concerned once over twenty-one, in practice the position was far more complicated. Everybody agreed that it was fitting, indeed a positive duty, for a child to obtain the parents' consent, particularly in pious middle-class families such as Maria's (and Constable's). The upper classes still often disposed of their offspring with only dynastic and financial considerations in mind, and the bride and groom were barely consulted in the matter.

When a daughter selected a prospective spouse herself, as Maria Bicknell showed signs of doing, the parents' responsibility was twofold. Love, as Dr William Buchan advised in his *Domestic Medicine*, 'is perhaps the strongest of all the passions'. Nonetheless, there was no strong emotion with which people were so ready to tamper. 'The first thing which parents ought to consult in disposing of their children in marriage, is certainly their inclinations. Were due regard always paid to these, there would be fewer unhappy couples.'

On the other hand, there were aspects that the participants, gripped by passion, might easily overlook. In *Mansfield Park*, Jane Austen's clever but cynical character Mary Crawford put the case: 'There is not one in a hundred of either sex who is not taken in when they marry. Look where I will, I see that it is so. When I consider that it is, of all transactions, the one in which people expect the most from others and are least honest with themselves.'

The most important practical consideration was, obviously, what Maria concisely described as 'that necessary article *cash*'. Without it, the most passionate match might

founder, ending up as the caricaturist James Gillray described in *Les Plaisirs de Mariage*, 'a smoky house, a failing trade/Six squalling brats and a scolding jade'.

Benjamin Robert Haydon, a painter and erstwhile friend of Constable's, wrote a similar but more detailed description of an unsuccessful artist's household. 'What an unfortunate thing it is,' Haydon mused in his journal in October 1809, while Constable and Maria were courting in the Suffolk fields,

to see an old artist about forty walking about with a large sketch book under his arm, ugly, conceited and imbecile, a large nose covered with pimples, a dirty cravat, an old hat and never-cleaned boots, a rusty black coat and a torn silk waistcoat, living too, in a miserable filthy house at the top of Tottenham Court Road, in a street that has never been paved, a foot deep in mud, with pigs, ducks, and fowls spluttering up dirty stinking cabbage and putrid ashes and a wife too and eight ragged children ... paddling about among his plaister heads, and dusty canvases, one bedaubing himself with paint and another fighting with his dirty nosed brother.

Haydon, though ten years younger, was a sort of *alter ego* of Constable's – opposite, yet in some ways similar. Both were utterly dedicated to their art and each pursued lasting fame, despite innumerable setbacks. The difference was that Constable eventually succeeded, whereas in the eyes of his contemporaries and posterity poor Haydon did not.

By 1809 Haydon and Constable were no longer on speaking terms, their friendship having foundered because of Haydon's egotism and arrogance. But Constable remained fascinated by the frequent dramas of his career, and – perhaps – Haydon continued to brood over Constable's activities. It is conceivable he had caught wind of the latter's romance,

Benjamin Robert Haydon by David Wilkie

and that this was a comment on the likely outcome (Constable was indeed living off Tottenham Court Road at the time, on Percy Street). Certainly, this was a grim and plausible prediction of the prospects for a married painter with no money.

It was Charles Bicknell's clear duty to think about the dangers to his daughter of such a life. But first there was no sign of his opposition. Constable's visit to the Bicknells was a success, as he wrote to his mother, who was gratified by the news. By March he had confided in her his newfound ambition: to marry Maria Bicknell.

Ann Constable, alone of all the four parents involved, supported this match. Nonetheless, she was anxious about what she heard. Constable's mother was also his most steadfast ally in his equally bold plan to become a painter, but she was aware of, and often fretted about, his tendency to despondency, inertia and depression. Often she urged him on to greater efforts. 'Your last letter,' she wrote this time,

'in most parts pleased me because written with more energy than usual. You must exert yourself if you feel a desire to be independent.' And she added a cautious qualification, 'You must also be wary how you engage in uniting yourself with a housemate' – or any other 'yokes', that is children.

For a while, Charles Bicknell seemed positively to encourage the relationship between John Constable and his daughter. When passing the painter's lodgings in Soho, as Constable later bitterly recalled, he would knock on the door, Maria on his arm. Perhaps Maria Bicknell's parents did not take her preference for this handsome miller-turned-artist very seriously at first. Possibly, Charles Bicknell, experienced in human affairs of all kinds, suspected that in time it would fade away of its own accord as so many love affairs do. He must have been well aware from the beginning of the perils of marriage on insufficient money.

John Constable did not just want to be a painter, he wanted to be a particular kind of painter: a landscape artist. And he was not merely set on being a specialist in depicting the countryside, he wanted to do so in a particular, unconventional way. Thereby, he made things even more difficult for himself than they would have been anyway.

Painting was at best a precarious way of earning a living – as compared, for example, with the church or the law. It was possible to make a good living from art and even earn fame, though few actually did so. Those who succeeded – Sir Joshua Reynolds, first President of the Royal Academy, for example, who had died eighteen years before and whose *Discourses on Art* Constable read and revered – generally did so through painting portraits.

This was a trade about which English artists constantly complained. Thomas Lawrence, in many ways Reynolds's

successor, and Constable's senior by seven years, called it 'this dry mill-horse business'. His implication was that portraiture was slavery as boring and unremitting as that of a horse walking in harness and blinkers to power a mill. In any case Constable did not have the emollient manner necessary for a society portraitist, comparable to that required by a society dentist or doctor; he was too private and prickly a man. Nor did he have a suitable style. Society portraiture required the sitter to appear grand and/or glamorous, whatever their actual appearance. Truth was Constable's watchword as a painter, but in portraiture the facts often had to be improved.

Landscape was a more risky path in art. The Welshman Richard Wilson (1713–82) was the first great British painter of the countryside. He had won lasting fame, but financially his life had ended in failure. There were living painters who did well out of landscape painting. Turner, only one year Constable's senior, was already a full member of the Royal Academy and a rich man. Constable, however, was set on a variety of landscape painting that focused on the real, sometimes humble, facts of the rural scene – and this had turned out to be both difficult to do and hard to sell.

He announced his ambition in a letter to his friend John Dunthorne, the East Bergholt plumber and glazier, in May 1802, almost eight years before his interview with Maria's parents. That year Constable had paid a visit to the Royal Academy exhibition in London, which always opened at the beginning of May and he was unimpressed with what he saw. 'There is little or nothing in the exhibition worth looking up to – there is room enough for a natural *painture*.' That phrase, despite its characteristically bad spelling of the French word, contained the compressed essence of everything Constable wanted to achieve.

He went on to explain a little more of what he meant

to Dunthorne. 'The great vice of the present day is *bravura*, an attempt at something beyond the truth. In endeavouring to do something better than well they do what in reality is good for nothing. *Fashion* always had, & will have its day – but *Truth* (in all things) only will last.'

In 1802, making pictures of landscape already had a long history. In Europe it had begun in classical Greece and Rome, and been revived in the fifteenth century at the time of the Italian Renaissance and the beginning of naturalistic painting in Burgundy by Jan van Eyck. At that stage, beautiful depictions of fields, clouds, mountains and seas by artists such as Van Eyck and Giovanni Bellini were included in the backgrounds of pictures that were ostensibly of something else: the lives of saints or the sufferings of Christ. In the sixteenth century landscape developed into an independent form of art; in the seventeenth it flourished with great brilliance. This was the time of Claude and Nicolas Poussin, who were both based in Rome, and Dutch artists including Jacob van Ruisdael. Constable looked back to those three above all – Poussin, Claude, Ruisdael – as great predecessors: masters of what he called 'natural *painture*', and of what that meant: truth.

There were two sorts of artist, Constable argued: one 'intent only on the study of departed excellence, or what others have accomplished, becomes an imitator of their works'; the other 'seeks perfection at its PRIMITIVE SOURCE, NATURE'.

It was crucial, Constable thought right from the beginning, to go out and sketch in the landscape itself. When towards the end of his life he lectured on landscape, he made that one of the morals of the life of the painter Claude, born in the Duchy of Lorraine in 1600 and who only later travelled to Italy.

'It was at Rome,' Constable believed, 'that Claude became a real student of nature. He came there a confirmed mannered painter, but he soon found it necessary to "become a little child", and he devoted himself to study with an ardour and a patience perhaps never before equalled. He lived in the fields all day, and drew at the Academy at night.'

Constable could have been describing his own youth. He actually used the same phrase, living 'in the fields', of his sketching campaigns in East Bergholt. And he applied himself to the second part of the Claude programme. Each night, when he was in London, he would draw in the life room of the Royal Academy. He was assiduous in copying the works of the masters because he did not believe that a painter should reinvent the art of painting from first principles. 'A *self-taught artist*,' he said with typical sharpness, 'is a very ignorant person.'

What Constable was attempting – the task set him by his instincts, temperament and talents – was quite similar to what Cézanne spoke of trying to do a century later: 'to recreate Poussin after nature'. He wanted to redo Claude, but make the picture true to real experience. That is, his aim was to make paintings with the formal power and force of those masters, but filled with the details of the scene he actually saw around him: the tumbled East Anglian skies, the willows, the sun on the Stour.

This was an immensely difficult, almost impossible, project. Not surprisingly, in the eight years since he had written that letter to Dunthorne, Constable had made little apparent progress. Indeed, he had been diverted. At the prompting of his parents, and so as to earn at least some money from his art, he had done a number of portraits. The results, if he had sympathy with the sitter, which was particularly likely if she were a pretty girl, had an appealing

freshness and honesty. However, they added little either to his reputation or his income.

Four years before, in 1806, his wealthy uncle David Pike Watts had funded a journey to the Lake District. This had produced a large number of pictures, and most of his exhibited landscapes in the following few years. But it was not, as he later came to realize, a place that meant enough to him. Constable believed landscape painting ought to be not only true to the visible facts but also flooded with feeling. About the works of another painter called Lee, now completely forgotten, he once gave this verdict: 'They pretend to nothing but the imitation of nature, but that is of the coldest and meanest kind. All is utterly heartless.'

His own heart was most moved by the sight of his native landscape, to which he had just begun to return. He renewed his outdoor sketching around East Bergholt in 1808, and more and more intensively from 1809 when he declared his love for Maria. In fact, his love for her, his feelings for the place and his art seemed connected in a deep and complicated fashion.

Constable's determination to marry Maria coincided with a renewed focusing and intensification of his work. The years that followed were the ones in which he began to reach maturity as a painter, and first depicted many of the subjects that eventually brought him fame (almost all of which were around East Bergholt). It is probable that his renewed energy had its source in his love for Maria. But, on the other hand, his long sojourns in Suffolk were from now on periods that they spent apart. And, as Maria eventually came to realize, landscape and painting were her only true rivals for his attention.

When Constable presented himself at Maria's parents' house early in 1810, however, almost all the achievements

for which he eventually became world-famous lay in the future. If he had died of the chest infection he caught that spring, his name would barely be remembered. Charles Bicknell saw before him a man approaching middle age who had as yet won little professional reputation – and that in a walk of life which was a dubious proposition at best. In worldly terms, Constable seemed a failure.

Unfortunately, Charles Bicknell had little understanding of his prospective son-in-law's art. 'Speaking to a lawyer about pictures,' Constable concluded, perhaps with his experience of Bicknell in mind, 'is something like talking to a butcher about humanity.'

To be fair, however, he was not well disposed himself to Charles Bicknell's professional interests as solicitor to the Admiralty. A sailing ship, Constable thought, was in reality 'a huge & hideous floating mass', and the Royal Navy, 'a hateful tyranny, with starvation into the bargain'. Presumably he kept these views to himself.

Constable believed in natural painting, and was not alone in his faith in nature. His contemporaries, or some of them, searched for nature in all manner of things. Natural government, natural manners, natural education, and – a quest that had touched Maria's family closely – a natural partner in marriage.

Hidden beneath the dusty legal surface of the Bicknells' lives, there was a secret – which was now no longer very secret since the whole affair had been described in racy terms in a book published six years before, in 1804, by the poetess Anna Seward. The affair concerned one of Charles Bicknell's older brothers, John Bicknell, Maria's uncle. Though trained and qualified at the Inner Temple, he had spent much of his time writing controversial and scandalous

publications and in dissipation. Not surprisingly, he was far more to the taste of the dashing young American John Laurens, who cultivated his company 'as much as possible'.

As a law student, John Bicknell had been a close friend of two young men who were also studying for the Bar: Thomas Day and Richard Lovell Edgeworth. Both were gentlemen of means – Edgeworth from family estates in Ireland – and both were enthusiastic admirers of the French philosopher Jean-Jacques Rousseau.

Rousseau was the greatest thinker of the age. One day in the summer of 1749, resting under a tree on the road to Vincennes – he was like Constable a lover of rural solitude and hater of cities – Rousseau had experienced a revelation. The essence of what came to him was this: man is naturally good, and it is only unnatural human institutions that make him bad. Education therefore should allow the natural character to emerge unhindered by formal instruction.

Nature was the governing ideal of the age. She appeared as a goddess in front of the ruins of the Bastille in 1793, at a festival celebrating the abolition of the French monarchy, water sprouting from her breasts. To many who disagreed profoundly with the political aims of the Revolution, the 'PRIMITIVE SOURCE, NATURE' also seemed to be the fountain-head of truth and virtue. It appeared so to John Constable, who in that year was just beginning to paint the beauties of East Bergholt. The problem was that nature is an elusive deity to worship. What after all is truly natural?

Rousseau's ideas burst like a revelation on the minds of the three young Britons – Bicknell, Day and Edgeworth – with varying results. It inspired Bicknell and Day to write 'The Dying Negro', a poem of protest, the first in the English language, against the unnatural institution of slavery. Edgeworth brought up his son Dick according to Rousseau's

treatise *Emile, ou l'education* with a less happy outcome. Young Dick Edgeworth turned out very badly. He was parodied in due course by Jane Austen as the 'very troublesome, hopeless' and 'thick-headed' Dick Musgrave in *Persuasion.*

Edgeworth's friend Thomas Day also conducted an unsuccessful experiment – in romance and marriage. Day was an earnest, intellectual and not especially attractive young man: large, pock-marked, slab-faced and heavy. However, he concluded that it was not his own lack of charm but defects in female education that prevented him from finding a suitable mate, and he decided on a startling plan. He would himself have to bring one up on Rousseau's principles: a *natural* bride. The philosopher had declared that 'the woman is made especially to please the man!', that in women learning was 'unpleasing and unnecessary'.

Aged twenty-one and in control of his fortune, Day travelled to Shrewsbury accompanied by John Bicknell. They went to the Foundling Hospital and from the orphaned female inmates they selected a girl – an auburn-haired twelve-year-old of appealing appearance – on whom to conduct the experiment.

Because she had been found by the banks of the river Severn, Day gave her the river's Latin name, Sabrina. Then Day and Bicknell returned to London, where they went to the main Foundling Hospital in Coram Fields and Day chose another prospective bride. This one, an eleven-year-old, he dubbed Lucretia, after a famously virtuous Roman wife.

Shortly afterwards Day took the girls off to France, where for a while he was delighted with his pupils' progress. Sabrina wrote a touching letter to Edgeworth, confiding that 'I love Mr Day best in the world, Mr Bicknell next, and you next.'

But by and by, Day found life with two female orphans

more difficult than he had expected. They misbehaved, they quarrelled, they contracted smallpox and he had to look after them, they screamed, they refused to have anything to do with their French nurse as she could not speak English. Then they recovered, went swimming in the Rhone and nearly drowned – fortunately Day, an excellent swimmer, was able to rescue them.

At length, in the spring of 1770, Day and his charges returned to London. He had concluded in the interim that Lucretia was insuperably stupid, so he apprenticed her to a milliner and in due course she married a linen draper. In Sabrina's case, however, he persisted with the experiment. For a while he placed her in the care of Bicknell's mother, Maria's grandmother. Then he took a twelve-month lease on a mansion in the Lichfield area.

At that time, in the area around Birmingham there was a circle of scientists and thinkers known as the Lunar Men. They were called that because their society held its meetings on nights lit by the full moon, so that the members were able to find their way back to their homes safely in the dark.

There, Day embarked on a programme intended to test and harden the mettle of thirteen-year-old Sabrina. In Rousseau's book, the young Emile is accustomed to the sound of gunfire by his tutor; the boy is delighted by the flash and bang. But when Day suddenly discharged a blank pistol at Sabrina's petticoats, she screamed and jumped. Her response was equally disappointing when he tried to teach her indifference to pain by dropping hot sealing wax on her arm.

Eventually he was forced to conclude that she simply didn't prefer – as Rousseau's theory held she should – heroism and self-denial to vanity and idle luxury. So Day

consigned Sabrina, who was blossoming into a beauty, to a boarding school in Sutton Coldfield.

Years went by and John Bicknell, rather than being a stern moralist such as his friend Thomas Day, had become a rake, as Anna Seward discovered to her surprise: 'But, Lord what a pale, maidenish-looking animal for a voluptuary – so reserved as were his manners! – and his countenance! – a very tablet, upon which the ten commandments seemed written.'

John Bicknell had neglected his legal career and dabbled in writing. 'He lived in London, partly engaged by pleasure, and partly pursuing his profession of the law,' Richard Lovell Edgeworth recalled. 'But he had some of the too usual faults of a man of genius; he detested the drudgery of business. He is said to have kept briefs an unconscionable time in his pocket, or on his table, unnoticed. Attorneys complained, but still he consoled himself with wit, literature, and pleasure, till health as well as attorneys began to fail.'

It was only at this point, apparently, that John Bicknell's thoughts turned to marriage and he remembered Sabrina. He found her living quietly, but a popular figure among the intellectuals of the West Midlands, and offered his hand. They were married on 16 April 1784 at the splendid baroque church of St Philip's in Birmingham, designed by Thomas Archer. She was twenty-six, he was thirty-seven.

The marriage was a happy one – producing Maria's cousins Henry Edgeworth Bicknell and John Laurens Bicknell – but it did not last long. John Bicknell died in 1787, still not much over forty. It was then discovered that he had left his widow and sons without anything to live on. A collection was quickly raised amongst John Bicknell's colleagues at the Bar. Eventually, his widow – now Mrs Sabrina Bicknell – was offered a post as housekeeper at a

school for boys run by Dr Charles Burney, son of the famous musicologist, in Greenwich.

Thus Sabrina, after being lifted from the obscurity of the Foundling Hospital, ended up in the second of the two purgatories for indigent ladies described by Mary Wollstonecraft: companionship to a wealthy woman or a job in education. It was a dramatic reminder of what might await Maria if she married on no money, and one still fresh in the minds of the Bicknells.

Apart from visits to his affluent uncle David Pike Watts, who lived on Portland Place, in London Constable's circle was restricted to the world of painting. He had some friends among younger artists, including a Yorkshireman named John Jackson and David Wilkie, a very successful Scottish

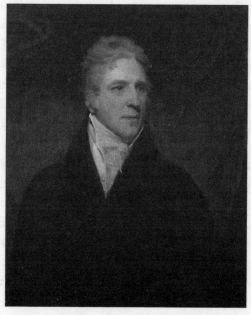

Sir George Beaumont by John Hoppner

specialist in low-life scenes a decade his junior. But at this stage in his life, relationships with older figures – mentors, or as he put it 'monitors' – were more important to him.

Two of these had been his supporters since the time of his early efforts to paint in East Bergholt; in fact, without their help he would not have got as far as he had. One was Sir George Beaumont, the owner of the Claude, the first sight of which Constable considered 'an important epoch in his life'. Sir George, who split his time between country seats in Essex and Leicestershire and a grand house on Grosvenor Square, continued to offer his assistance, guidance and access to his marvellous collection.

According to anecdotes later passed around by artists, Sir George's advice was not always welcome. Beaumont, allegedly believed, for example, that every good landscape should include a brown tree. 'Do you not find it very difficult to determine where to place your brown tree?' 'Not at all,' Constable is supposed to have replied, 'for I never put such a thing into a picture in my life.' Greatly though Beaumont hoped to see a truly 'accomplished landscape painter' arise in Britain, he never properly appreciated the talent of Constable (or, for that matter, Turner). Nonetheless, Constable always remained grateful to Sir George.

He owed a similar debt to Revd Dr John Fisher, to whom he was introduced in 1798. Both Beaumont and Fisher were amateur artists, and both spent time in the valley of the Stour where Fisher at that time was the – mainly absentee – vicar of Langham. Fisher and his wife took a kindly interest in this promising young man from East Bergholt. The following year, Fisher gave him a letter of introduction to an old friend of his, the landscape painter Joseph Farington, who became the third of Constable's 'monitors'. It was through Farington's intervention that in 1799, at the advanced age of

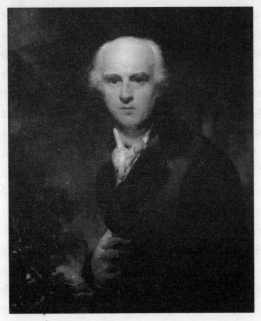

Joseph Farington RA by Sir Thomas Lawrence

twenty-three Constable had been admitted as a student in the Royal Academy Schools.

Farington was a kindly and fussy man who has had the odd fate of being remembered far better for his diary than for his pictures, which were boring and dry. His diary displayed those unappealing traits too, but compensated by preserving a huge mass of detail about his daily life: whom he met, what they said, what he ate, where he dined, who sat next to whom around the table (Farington always added a diagram of the table setting) and the misbehaviour of his digestive system which caused him a lot of trouble.

In 1810 Joseph Farington was sixty-three and had been a widower for ten years. His life revolved around painting and the Royal Academy, of which he was a moving spirit. As treasurer he had much improved its finances; he incessantly

discussed Royal Academy business, attended many meetings and fretted over the affairs of the organization. He continued to take an interest in the progress of John Constable, whom he had early predicted would become a 'distinct feature' in landscape painting. A decade later, Constable remained no more than promising, but Farington continued to see him frequently and attempted to guide his so far less than brilliant career.

On Sunday 8 April 1810, Constable and Joseph Farington dined with John Fisher, who had by then become the Bishop of Salisbury, in his house on Seymour Street. Also present were the bishop's wife, daughters, brother and the Revd Dr Nott, tutor to Princess Charlotte, whose education the bishop was supervising, as well as a number of maiden ladies. Farington, as was his habit, drew a diagram of the seating at the table:

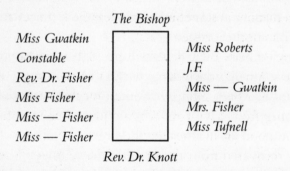

The Bishop

Miss Gwatkin
Constable
Rev. Dr. Fisher
Miss Fisher
Miss — Fisher
Miss — Fisher

Miss Roberts
J.F.
Miss — Gwatkin
Mrs. Fisher
Miss Tufnell

Rev. Dr. Knott

The political situation was tense that evening, owing to the impending arrest of Sir Francis Burdett, leader of the radical party in Parliament. The streets were full of troops, as riots or worse revolutionary insurrection seemed to threaten. After they had discussed the agitated state of affairs in town because of the Burdett affair, the conversation

around the dinner table turned to the mental condition of the king.

One of the guests, a Miss Roberts, was a member of the court at Windsor. She related how recently the king had begun to expound to the Dean of St George's Chapel on 'the excellence of *British Constitution*'. But after he had spoken for a while, 'he became affected by his feelings & during many minutes could only utter what he chose to express by uttering single words'. George III, as everybody around the table knew, was prone to fits of excitability leading into madness. On one occasion, in 1788, he had been deranged for such a long period that the Prince of Wales was on the point of being declared regent when, unexpectedly, the monarch recovered.

The talk around the bishop's table then turned to illness. Constable related how his friend the landscape painter William Redmore Bigg suffered from a worrying affliction of the stomach or bowels, which every night affected him 'in such a manner as sometimes to appear fatal' (fortunately Bigg lived for another sixteen years).

Miss Roberts then described the distressing condition of Princess Amelia, the youngest child of the king. The poor princess had been ailing for some time, and especially since returning from a visit to Weymouth, where she had gone for the good of her health, the previous autumn. She had never recovered from the strain of the journey. 'She is now so weak,' explained Miss Roberts, 'as to be unable to be taken from her bed but to have it occasionally made again. It is a matter of conjecture only what her complaint is. It is an inflammatory disorder & internal. She is frequently bled and blistered etc to counteract the inflammation. Her patience, resignation & piety are exemplary.'

★

Increasingly, the affairs of Princess Amelia were taking up the time of Charles Bicknell. Since the previous winter, he had been her solicitor, taking over from a Mr Bolton, who had proved fraudulent. Amelia had implored her brother, the Prince of Wales, to appoint Bicknell to sort out the confusion in her finances. And as the princess's health deteriorated, further difficulties became pressing.

Though Miss Roberts hesitated to say so at the Bishop of Salisbury's dinner, poor Princess Amelia was suffering from tuberculosis. The princess had fallen in love with one of the royal equerries, a man named General Charles Fitzroy, much older than her. Unfortunately, this attachment was not only unsuitable in the eyes of the court, but for Amelia to marry Fitzroy was actually against the law. The Royal Marriages Act of 1772 prohibited any descendant of George II from marrying before the age of twenty-five, and allowed them to do so after that only provided there was no objection from Parliament.

The princess loved General Fitzroy passionately and piteously. She considered herself his wife in the eyes of God, and even signed herself as such. Such a marriage was unthinkable in the opinion of the court; nonetheless Amelia made a will, leaving almost everything to Fitzroy and addressing him with passionate devotion. A copy of this was deposited with Charles Bicknell.

Maria's father knew a lot about wills. One of his longest-running cases involved a will. His client was the novelist Charlotte Smith, who had been forced to marry, in 1765 when still not sixteen, Benjamin Smith, the son of a wealthy merchant and proprietor named Richard Smith. She described this action of her father as selling her as a 'legal prostitute, in my early youth'.

The marriage was spectacularly unsuccessful, her husband

Benjamin turning out to be a drunken, violent spendthrift. In an attempt to protect the interests of his daughter-in-law and her children (there were twelve of them), Richard Smith left them a fortune, £36,000, in trust in his will. Unfortunately for Charlotte, her husband was one of the executors of the trust. In seven years £16,000 disappeared. He was imprisoned for debt, a fresh board of trustees was appointed, then another; she appealed for justice to each of them with increasing desperation.

Charlotte was forced to make a living in a third way open to indigent ladies, not mentioned by Mary Wollstonecraft: authorship. She was 'chained to her desk' as the poet William Cowper put it, 'like a slave to his oars'. Poems and novels poured from her pen, and were read enthusiastically by the young Jane Austen. Maria Bicknell too owned the first volume of *Emmeline: The Orphan of the Castle*, though perhaps that was because Mrs Smith was her father's client. Maria was not a great reader of novels; her taste was more for poetry and non-fiction.

Litigation about the trust ground on and on year after year. Sometimes Charlotte Smith wondered whether Charles Bicknell was not too nice for the job. 'Mr Bicknell,' she wrote, 'is an honest, humane, conscientious & good man, & it is perhaps those very qualities that render him as an Attorney unfit for the defence of a cause where there has already been great dishonesty and prevarication & falsehood on the part of the assailants.'

At times she had doubts about his competence. In February 1802 she called on Bicknell at his house, and he showed her the will of her father-in-law, the document at the root of the whole, endless dispute, plus other deeds, 'which he has twenty times declared to me *he never saw*, & which I have been at a great expense to obtain otherwise

& have been tormented to death by the want of them'.

It was not to Charles Bicknell's disadvantage that the Smith case carried on interminably. Charlotte Smith and her ghastly husband both died in 1806, but her children wearily pursued the matter in the Court of Chancery. It still continued in 1810, still generating fees. It has been suggested as the model for the celebrated case of Jarndyce vs Jarndyce in Dickens's *Bleak House*.

A will was also central to the case of Maria and Constable's romance. Charles Bicknell did not consider Constable likely to provide a satisfactory income for the couple – that was one black mark against him. And, regardless of the circumstances of the suitor, Charles Bicknell did not feel wealthy enough himself to provide a marriage portion that would keep Maria comfortably in life.

He was not at all badly off. On the other hand, in 1810 he had two sons and three daughters. Providing settlements for all the girls, plus keeping the rest of the family, and himself and his wife, in suitable style would stretch his resources. Furthermore, there were probably certain assets that he might not have been sure he could recover – at least not at short notice. As an untitled member of the Prince of Wales's circle he was vulnerable to requests for loans.

Years later Constable described this predicament. 'As soon as he got any money the "great folks" came and *borrowed* it of him on little or no security. But they kindly ask him to "dine" with frequently, knowing he loved "a table" – these habits no doubt laid the foundation of this evil.' It was Mr Bicknell's fate, Constable thought, looking back, 'to be devoured by strangers'.

Whatever the truth of this, the important point was that Charles Bicknell didn't feel able, or didn't want, to make over a large sum to Maria. That made the will of her grand-

father, the Revd Dr Durand Rhudde, crucial to her future.

Dr Rhudde, unlike Charles Bicknell, thought of himself as a wealthy man. As well as having three parishes in Suffolk he was a Chaplain in Ordinary to the king, and served at the Chapel Royal, St James's Palace each spring. He lived ostentatiously, with a London house at Stratton Street, a smart address off Piccadilly, conveniently close to St James's. Dr Rhudde maintained a fine coach which transported him between Suffolk, London and the seaside resort of Cromer where he spent most summers. Its new patent lamps glowed through the Suffolk nights, greatly impressing Mrs Constable, as Dr Rhudde rumbled past the Constables' house.

Where Dr Rhudde had got his money was unclear. He was born in 1734, and his father was a clergyman without a fortune. At King's College, Cambridge, he had been a poor scholar. Thereafter he spent many years associated with the Hankey family, important bankers in the city of London. This close connection with wealth may have helped him to gain some of it himself.

Also, Durand Rhudde's brother, Anthony, was adroit at amassing property through marriage, including the manor of Hitchin in Hertfordshire which was eventually bequeathed to the rector. So, in one way and another, Dr Rhudde emerged in middle age a man of considerable property, with the degree of Doctor of Divinity from the University of Cambridge and a very good opinion of himself.

In 1791, still an ambitious man in his fifties, Dr Rhudde wrote a letter to the then prime minister, William Pitt. He had never met Pitt, so he set out his 'pretensions' to the favour he asked – unsuccessfully as it turned out – which was an ecclesiastical preferment such as a canonry or a deanery:

I have the honour to be one of His Majesty's Chaplains, and, exclusive of my Livings, have a considerable independent fortune, in virtue of which, am an elector in Westminster, a freeholder in the several counties of Middlesex, Suffolk, Herts., and Bucks., and have a vote besides at the Bank and India House. My influence thro' life has been uniformly devoted to the support of Government.

This letter so perfectly expresses the close connection of property, political influence and the Georgian Church of England that it was reprinted as illustrating the attitudes of that time. Dr Rhudde had risen in the world and was naturally unwilling to see his descendants decline in class and wealth. Maria was a favourite with him, and it was vital to her prospects that he should approve her choice of husband.

Unfortunately for her and John Constable his opinion on the subject of marrying a husband without funds was clear. He had expressed it in a sermon he delivered in 1790 in St Paul's Cathedral, when he outlined the fate of the widow of a poor clergyman, brought up in her father's house, 'where she had been long nurtured with fond anxiety and tenderest care'. These advantages of wealth and education endeared her to her husband. But after his death,

they unqualified her for the fate of humiliation into which she is fallen: for though she may be but too well acquainted with narrow circumstances and all the inconveniences incident to them, yet having been unaccustomed to struggle with absolute penury she has new lessons of practice to acquire; she has much to learn and still more to forget: and every generous habit, both of thinking and acting must be forever erased from her memory before she can patiently submit to the painful degradation of precarious dependence, menial employments and servile offices.

In short, Dr Rhudde had the same opinion as Jane Austen's Mary Crawford: 'A large income is the best recipe for happiness I ever heard of.'

3

There was an ominous link between the cases of Princess Amelia and Maria Bicknell, very different though their circumstances were: it is likely that Maria too suffered from consumption. This terrifying disease had been described by John Bunyan in the seventeenth century as the 'captain of all the men of death', and was yet more prevalent by 1810. In early nineteenth-century London it accounted for 25 per cent of all mortality, and even more than that amongst the poor and deprived. Perhaps – it has been argued – the omnipresent melancholy of the Romantic age was partly the result of this sinister threat.

Consumption seemed to strike especially at the young. As the poet John Keats wrote, 'youth grows spectre thin and dies'. Keats was himself a victim of the illness, which went by many names: consumption (because of how sufferers wasted away), phthisis, asthenia, bronchitis, inflammation of the lungs, hectic fever. In addition to the respiratory system, it might affect many other parts of the body – the skin, the kidneys, the spine. No one knew what caused the menace, let alone how it might be cured.

But six years before, in March 1804, a brilliant young French doctor named René Théophile Hyacinthe Laënnec had announced the first important discovery about this terrible disease. After dissecting some 200 victims, Laënnec, who was five years younger than Constable, concluded that the small grey 'tubercles' (or warty nodules) he discovered in the lungs of the dead, the masses of soft pus-like matter, the

cavities in the chest space, were all expressions of a single ailment.

It was almost eight more decades before a German scientist, Robert Koch, found the culprit: a tiny rod-shaped organism, *Mycobacterium tuberculosis*. Here was another example, though a malign one, of the workings of nature. The bacillus had evolved with human beings for thousands, perhaps millions of years. *Mycobacterium tuberculosis* was quite as much a part of that primitive source, nature as a cow or a cloud. Unfortunately, it often killed its hosts: among them – eventually – Laënnec himself.

Some of those infected died quickly – a syndrome known as galloping consumption; some lived for many years in a semi-invalid state; some recovered altogether. Both Rousseau and Goethe reported coughing blood in their youth, but lived to old age.

Though not highly infectious, tuberculosis was likely to be caught by anyone spending prolonged periods in the company of a sufferer. That was the reason why it would inexorably creep through whole families. Keats contracted the sickness, in all probability, while nursing his younger brother. The same process was occurring, it seemed likely, in the Bicknell family.

In January 1802 the novelist Charlotte Smith heard that Maria's mother was dangerously ill. They hoped for her life, but she was so delirious that there was 'more fear than hope'. This was a few months after the birth of Maria's youngest sister, Catharine. Perhaps Mrs Bicknell was suffering from the after-effects of childbirth, or tuberculosis or both. At any rate, in 1810 Mrs Bicknell had been an invalid for years. The eldest boy in the family, Durand, was also ailing.

Maria herself suffered from recurrent coughs and colds that almost always turned into lung infections and fevers.

Sometimes she was bed-bound or confined to the house at Spring Gardens Terrace for weeks. This was the reason why the Bicknells so often fled the polluted, germ-laden air of London to stay in Putney, Richmond or Bergholt. Constable never mentioned the word 'consumption' when referring to Maria, but the anxiety was always present: a menacing cloud in the sky above them.

Scientific enquiry, like nature, was an obsession of the time. It affected even art. At the end of his life Constable held to the view that painting had two aspects: one he called poetical, the other scientific. By poetical, he meant everything connected with the emotional and moral meaning of the work. By scientific, the physical truth of the picture: the extent to which it resembled nature itself. And to achieve this was an immense task, at which even the greatest of artists had only made a start.

'In reality,' he declared in a lecture, 'what are the most sublime productions of the pencil [to us, the brush] but selections of the forms of nature, and copies of a few of her evanescent effects; and this is the result, not of inspiration, but of long and patient study, under the direction of much good sense.'

Painting, he insisted, 'should be understood, not looked on with blind wonder, nor considered only as a poetic aspiration, but as a pursuit *legitimate, scientific and mechanical*'. He imagined Richard Wilson, the father of British landscape painting, walking arm in arm in the afterlife, with on one side Milton, and on the other Linnaeus, the founder of botanical classification. Botany was only one of Constable's scientific interests. He eventually developed others, equally suited to a landscape painter, such as geology and meteorology.

For a landscape painter, the equivalent of experimental data was the open-air sketch. Ever since Impressionism, this has seemed the obvious and inevitable way for an artist to paint a natural scene. Historically, however, that wasn't always the case. The great landscape painters of the seventeenth century – Rubens, Claude, Ruisdael – had made studies from nature. But many of their successors had not.

Constable quoted with particular scorn the example of the French painter François Boucher (1703–30), who had informed Joshua Reynolds that 'he never painted from the life, for nature put him out'. Boucher's landscapes – charming to lovers of rococo – reduced Constable's mind to 'a state of bewilderment from which laughter alone can relieve it'. Boucher's countryside, Constable objected, was 'inhabited by opera dancers with mops, brooms, milk pails and guitars' and his scenery 'diversified with winding streams, broken bridges, and water wheels'. Hedge stakes danced minuets, while groves of trees bowed and curtsied to each other. Many connoisseurs, even in Britain, felt that nature should follow art rather than the other way round. That was the point of a gadget called the 'Claude Glass', which tinted a view with the golden tone of an oil painting coated by old varnish.

In the late eighteenth century, the practice of making landscape studies in the open air was revived. Most artists did so, but none had yet scrutinized a single, small area in the detailed obsessive manner that Constable examined East Bergholt and environs over the next few years.

For working out of doors Constable used a sketching box. One has survived. It is 9¼ inches by 12, with a recessed panel in the lid which could contain the finished study. The other half of the box held four bristle brushes, nine glass phials of ground pigment – Constable liked his colours

freshly ground every day – a Cumberland lead pencil and a palette knife. Missing, but part of his usual kit, are pig-skin bladders, bound with twine, containing paint already mixed, which you opened by piercing them with a tack. They were the predecessors of the portable tubes invented in the mid nineteenth century.

Constable would find his subject in the countryside, then sit down, resting the box on his knees, and work on a surface – paper, canvas or board – pinned to the lid. The latter could be fixed at a convenient angle with a metal stay. Thus equipped, he was ready to apply himself to studying the primitive source, nature itself.

Stoke-by-Nayland Church and Village

This had long been his practice. That was what he and Dunthorne were doing when they returned from the fields, to be mocked by Golding Constable as Don Quixote and

Man Friday. Both he and Dunthorne, according to David Lucas, an engraver with whom Constable worked closely later in his career, were 'very methodical in their practice'. They painted 'one view only for a certain time each day. When the shadows from objects changed, their sketching was postponed until the same hour next day.'

This information, derived from Constable himself, has the ring of truth. It is of a piece with one of his fundamental insights: that in painting landscape, one is not depicting a given number of three-dimensional items – hills, trees, cows – but instead an immensely complex natural system at a specific moment.

To the end of his life he remembered a lesson he received from Benjamin West, the kindly American President of the Royal Academy. A picture of his had been rejected for exhibition in the Royal Academy, and, dejected, he showed it to West, who said, 'Don't be disheartened, young man, we shall hear of you again; you must have loved nature very much before you could have painted this.' Then, as C. R. Leslie recounted Constable's story, West took a piece of chalk and added 'touches of light between the stems and branches of the trees'.

'Always remember, sir,' West said as he did so, 'that light and shadow *never stand still.*' Constable liked to say that this was the best lesson on chiaroscuro, the drama of light and shade, that he ever had. Like all of us, Constable remembered the advice that chimed with what, deep down, he wanted and needed to hear. One of his basic feelings about landscape painting was that it was the record not only of a place, but also of a time and a mood. Describing a Poussin that he loved, for example, he began not by detailing the subject, but the season and time of day it depicted: 'a solemn, deep, still, summer's noon'. It was the same with his own work.

In the late summer of 1810, he returned, as he had the year before, to East Bergholt and spent the harvest season and autumn studying the countryside. On 27 September he painted and dated a study 10 inches by 10 of the Stour at sunset, the sky orange, pink and grey, the colours reflected in the waters, the willows dark against the fading light. Three days later, on 30 September, he chose the beginning of the day to investigate.

From an upper window of the Constable house he looked across the fields – the fields where he and Maria had walked a year before. Dawn was breaking above the rectory where she had stayed. The grey clouds above Dr Rhudde's residence were blushing deep salmon shades, a few ducks flapped across the landscape. Maria was not in East Bergholt that year, but it is hard to believe that as he painted this little picture he was not thinking of her.

At first, his courtship had gone well. The Bicknells were friendly, Maria herself obviously had strong feelings for him. But at some point between the summer of 1810 and the early part of 1811, it had begun to go wrong. The surviving sources do not allow us to pinpoint the moment when the Bicknell family's attitude changed. But change it did. And when it did, Constable slipped into a depression that badly worried his relations and friends.

On 13 November at eight o'clock on a cold clear evening a procession formed at Augusta Lodge, Windsor. It was led by the servants and grooms of the Royal Household in full liveries, and the trumpeters of the Horse Guards apparelled in blue. Then came a hearse, pulled by the king's set of eight black horses, fully caparisoned. The monarch himself could not attend, as his reason had given way under the pressure of grief caused by the last illness and death of his favourite

daughter, Princess Amelia. After the hearse was a line of coaches containing the attendants of the deceased, followed by those of the Prince of Wales and Duke of Cambridge each drawn by six horses. The entire cortège was flanked by the Staffordshire militia, every sixth man carrying a lighted flambeau.

On arrival at St George's Chapel, the servants, grooms and trumpeters filed off and the body was met by the dean, prebendaries and choir, who processed down the south aisle at the head of a fresh procession of royal dukes, nobility, government ministers, bishops and others flanked by the Horse Guards, with more flambeaux. Immediately after the choir came the Poor Knights of Windsor. And after them, walking alone, was Mr Charles Bicknell. He took his place in the seat below the choir stalls on the south side, nearest to the altar.

He had had a great deal of awkward business to transact of late. When Amelia's will had been opened after her death, there was consternation in royal circles. It turned out that she had left her jewels, valuables and all her possessions to General Fitzroy, her lover, and – in the eyes of heaven, she believed – her husband.

After this revelation, Fitzroy was summoned to Carlton House, residence of the Prince of Wales, where the prince and one of his brothers received him. They explained, in the most cordial terms, that this will must not become public so as to prevent scandal. The best solution, they explained, was for Fitzroy to sign a paper making the Prince of Wales sole executor. He did so. Then Charles Bicknell was called in from an adjoining room, where he was waiting to decide whether it was sufficient for the purpose. He said it was.

Thereafter, the wishes of the late princess were systematically thwarted. Every effort was made to prevent Fitzroy

receiving anything of much worth, such as the jewels, or marked as one of Amelia's possessions. He finally took delivery of some empty shelves, a few books and a very small quantity of plate from which the princess's cipher and coronet had been clumsily effaced. Also, the prince sent him 'an Inkstand, a clock, a Red Box, and a Mahogany Dressing-Box', the last 'empty and without any key'. In all this, General Fitzroy could see only 'a settled plan to disgust and offend'.

There was, of course, as there usually is, more than one way of looking at the affair. In the eyes of the royal family, Fitzroy had darkened Amelia's existence – perhaps even shortened it – by persisting with a relationship that was plainly impossible. Her sister Princess Mary believed she had died of a broken heart which destroyed her health by degrees.

This was perhaps exactly what the Bicknells feared would happen in the case of Maria: that an unwise love would damage her health, which was already delicate. The other point that emerges from the story of Princess Amelia, General Fitzroy and the disregarded will is how well Charles Bicknell was able to handle unpleasant situations, and how deftly he managed to evade personal blame. However badly creditors and others were treated by the prince, they were likely to emerge declaring that Charles Bicknell was the soul of urbanity.

On Christmas Day Dr Rhudde preached to a full church in East Bergholt. The rector was about to turn seventy-seven and complained of rheumatism, but Mrs Constable had scarcely seen 'him looking better, or preach with more delightful energy'. She watched Dr Rhudde keenly and

apprehensively, since although she personally got on well with him – he liked female company – there had been bad feeling between him and the Constable household.

The problem was never spelt out. It could have been anything or nothing. Golding Constable and Durand Rhudde were both formidable patriarchs, living side by side in a small community, their properties actually touching. There was endless scope for quarrelling; and Durand Rhudde was a quarrelsome man. Years later, Constable described a similar situation in a different parish, in which the local clergyman was not on speaking terms with most of his parishioners. 'What a sad thing – there is always work of this sort in villages.' There, he summed up his own experience.

Whatever the cause of the dispute between the Constables and Dr Rhudde, it had been smoothed over. But Mrs Constable remained permanently uneasy about the rector; she watched his demeanour closely for signs of enmity or friendliness. In her letters she was always pressing John to make courteous calls on the doctor while he was staying in his London house on Stratton Street.

The fact of the matter was that deep down Dr Rhudde did not much like John Constable, and Constable in turn detested Dr Rhudde. Since the elderly rector's approval was crucial to his courtship of Maria Bicknell, this was a serious problem.

In the New Year, which was bitterly cold, Mrs Constable, fretting about her son John's affairs, evolved a scheme intended to endear him to Dr Rhudde. On 18 January she wrote asking John to make a copy of a watercolour drawing of East Bergholt Church done some time before. She sent the original to London in the safe keeping of Abram, since she was extremely fond of this work herself, regarding it as

'almost sacred'. She intended to have the copy neatly framed and inscribed and to present it as a gift from John Constable to Dr Rhudde.

During February John, who, depressed and lonely, had gone down with a persistent lung infection, copied the drawing requested by his mother. This was a less poetic depiction of the subject than the painting he had exhibited at the Royal Academy the previous year under the title 'A Church Yard'. It delineated the south side of the building in a dry style that he sometimes used for executing topographical pictures to please others.

He signed it 'John Constable, feby 1811' and dispatched it to East Bergholt, where it was greeted with delight by Mrs Constable, so much so that she was loath to part with it. She had John's friend Dunthorne, the plumber and glazier, add an inscription which she hoped her son would approve: 'A South East view of East Bergholt Church, a drawing by JC & presented in testimony of respect to Durand Rhudde DD. the Rector. February 26, 1811.'

East Bergholt Church

Mrs Constable then summoned the resolution necessary to part with this treasure, took it to the rectory and gave it to Dr Rhudde, who responded graciously. He seemed uncommonly pleased, indeed delighted, with the gift. He couldn't imagine, he said, how he could possibly make an adequate return to Mrs Constable for such handsome generosity. 'It is most beautiful,' he told the nervous mother of the artist, 'I am quite proud of it.'

On reflection his response suggested a possible misunderstanding. It occurred to Mrs Constable that when Dr Rhudde read the inscription and realized that the picture was in fact a present from John, there was a disconcerting possibility that he might try to offer payment. She added a worried last line to the letter in which she recounted all this, 'You will not take any gratuity from Dr. Rhudde I know.'

That was, unfortunately, exactly what the doctor decided to offer. On 16 March, from his London house in Stratton Street, the rector sent John a letter:

Dear Sir,

I thank you most sincerely for your very elegant Present, of a View of my Church, and beg you to believe I value the picture most highly: not merely as a Specimen of Professional Merit, but as a Testimony of your Regard.

I know not what to offer to your acceptance in Return for the very flattering Compliment you have paid me, but if you will allow me, to solicit, that you will devote the Note accompanying this, to the Purchase of some little article by which you may be reminded of me, when I am no more, you will confer a still further Obligation, on Sir,

Your very faithful Friend & Servant
D. Rhudde

Mortifyingly, he included a banknote.

Constable had just received a request from Revd Henry Kebell, one of the two curates whom Dr Rhudde required to run his small ecclesiastical realm, to draw a portrait of the doctor. If Durand Rhudde was a figure who evoked anxiety and dislike among the Constables, he was a benign and venerable figure to Kebell and his descendants. He was still recalled affectionately almost a century later by one of the curate's sons, who became a Conservative politician. In his memoir this son related:

Dr Rhudde was a Tory of the Tories, and in his society my father's political principles, already founded on a warm appreciation of Mr Pitt, received their finishing touch. The Doctor's High Churchmanship took the form of intense dislike for Calvinism, and his curate imbibed the same horror of that austere creed. Except this article of faith, I think, he bequeathed him nothing except his walking stick, which now [1907] is in my possession, black with age.

Henry Kebell was a man to please both Dr Rhudde and Charles Bicknell, a lawyer turned clergyman, who kept a London *pied-à-terre* and was a keen theatregoer (he admired the great actress of the day, Mrs Siddons). He would, in fact, have been a far more acceptable suitor for Maria's hand.

The curate was leaving the parish of East Bergholt, and wanted a memento of the mentor he revered. He could not afford an oil painting but would pay anything 'within the reach of his purse' and be greatly obliged to Constable into the bargain. The offered fee, however small, would have been useful. But – either because Constable was busy, or ill, or could not bear to spend time in the company of Dr Rhudde – this portrait does not seem to have been drawn.

★

There were good reasons why Dr Rhudde was not able to apply his entire mind to the gift of a topographical study by his parishioner's son. His wife, Mary, Maria's grandmother, was sinking into dementia.

Mrs Constable received reports from the rectory, via Thomas, Dr Rhudde's coachman, and she passed this information on to her son John. It seemed that old Mrs Rhudde's mind was giving way. 'She would scarcely eat any thing for two or three days, as she said the Bicknells were below, *poisoning* every thing she should eat – but hunger prevailed and she called out or rather made signs, for a pork chop or a mince pie.'

At Windsor the king's mental condition sometimes improved, sometimes deteriorated, but it seemed unlikely he would soon, or perhaps ever, be able to supervise the government again. So on the afternoon of 6 February the Prince of Wales formally became regent. The ritual took place at the prince's residence, Carlton House, with his entire entourage, including Charles Bicknell, in attendance.

On 19 March Mrs Rhudde died. At her funeral in East Bergholt, Mrs Constable was 'exceedingly sorry' to see Mr Bicknell looking ravaged. But, she surmised, he had great cause: his own wife, an invalid, was grieving for her mother. It seemed too that the Bicknells' eldest son, Durand (named after his grandfather) would not live long. Maria, ill herself, was not at the funeral; probably she had already been sent away from the house of sickness and the unsanitary, disease-ridden midden of London. On 26 April Durand Bicknell also died, aged twenty, at 3 Spring Gardens Terrace.

Around this time, or even before, Maria was dispatched to stay with her half-sister, Sarah Skey, in Worcestershire. This was partly at least for the good of her health. On the last occasion Constable saw her, later correspondence shows,

she was in a bad enough state to make him worried about her welfare. The other advantage of sending her hundreds of miles away from London was to get her well out of Constable's way. Her family had decided it was time to put a stop to this love affair for good.

Tuesday, 11 June was Constable's thirty-fifth birthday. He was, by traditional biblical reckoning, halfway through his life. On this occasion his uncle, David Pike Watts, sent a letter. In his kindly yet irritatingly fussy way, he was worried about his nephew. Mr Watts was one of those people in whom an urge to do good results in a tendency to offer unsought advice. In this he resembled the tutor of his early years, a pious Scot of enormous industry and pedantry named Alexander Cruden, who had made it his business to go around the country and in a genial but unquenchably eloquent fashion, point out to others the errors of their ways – such, for example, as taking walks and other frivolous amusements on the Sabbath. Cruden had been locked up as a lunatic from time to time, though he always emerged protesting his sanity.

David Pike Watts's vast correspondence mainly consisted of guidance and exhortation, not always welcome to the recipients. He quite often gave his nephew hints and tips – well meant but nonetheless galling – on how to paint. The previous autumn he had sent a letter criticizing an altarpiece Constable had painted for the church of Stoke-by-Nayland under twenty-five numbered headings. It made it no better that Mr Watts was often right; the altarpiece, a commission from a pious aunt, was a job in which Constable did not have his heart.

'I am sorry to see,' wrote John's well-intentioned uncle, 'too visible Traits in your whole person, of an inward

anxiety, which irritates your nervous system and in its effects doubtless deranges the digestion & secretions, vitiates the Blood and undermines the Health.' These 'depressions of the animal system' were damaging to his energy – a point that also worried Constable's mother. Without mental and physical vigour, how could he paint well?

Delicately, Mr Watts introduced the question of the cause that underlay these symptoms. It was difficult, he acknowledged, for even the closest friend to deduce the inner thoughts of another from observing their outward appearance. No doubt there were various factors darkening his nephew's mood. But of the 'major trouble' he had no doubt. It was 'a deep Concern of the Heart and Affections'.

Mr Watts knew what he was speaking of. This prosaic and prolix man had derived his fortune – improbably – from an unhappy love affair. As a young man he had been apprenticed to a man named Benjamin Kenton, a self-made brewer and wine merchant of great wealth. The young David Pike Watts had fallen in love with his employer's daughter, and she with him, but Kenton had forbidden their marriage. Subsequently – heart-broken – she wasted away and died. Whereupon her father, distraught with guilt and grief, had made Mr Watts the main beneficiary of his will, and so Constable's uncle had become one of the richest men in London.

Sometimes, Mr Watts observed, it was God's will for human passion to be thwarted. There was no recourse except patience and resignation: in a word, religion. But despite this pious message Mr Watts included with his letter an amusing mock remedy that was circulating at the time, 'A Cure for Love'. 'Take a grain of sense,' it began, 'half a grain of Prudence, a dram of understanding, one ounce of patience, a pound of resolution, and a handful of dislike, intermix

them and fold them in the alembic of your brain for twenty four hours.' This rightly made and properly applied was 'an effectual remedy never known to fail'.

Constable, needless to say, did not try this prescription. His love, and his depression, persisted. Sir George Beaumont, the connoisseur and amateur painter, also came up with a proposed cure for his mental condition. The idea was that Constable should walk every day to Sir George's mansion in Grosvenor Square, and there look at a certain painting for as long as he liked. Carrying the mental image in his mind, he would then return to his lodgings in Frith Street and work on a copy from memory.

Evidently, Sir George's plan was to fix this image so firmly in Constable's mind that it and the effort of concentration would obliterate the rival obsession with Maria. The painting selected was one by Richard Wilson, the eighteenth-century landscape painter much admired by Constable. Sir George's treatment worked no better than David Pike Watts's.

While Constable was sinking deeper and deeper into despair, Maria was staying at Spring Grove. A contemporary guide book, *The Beauties of Britain*, described this mansion as 'a large white extensive house, situated in a park, whose wall is skirted by the road to Kidderminster, and the views both of it and from it are delightful'.

The site was close to a magnificent stretch of the Severn. North of the town of Bewdley it rushes through steep hanging woods and continues to the south past red sandstone rocks. In the centre of the town was Thomas Telford's elegant three-arched bridge and cast-iron balustrade along the banks of the river.

Spring Grove and the estate, with its landscaped grounds, was held in trust by Maria's sister Sarah for her spoiled

and sickly ten-year-old son Samuel Skey. She had married into a family made wealthy by the new industries that had sprung up in this part of the country. Her father-in-law, also named Samuel Skey, had been a man of enormous enterprise. Starting life as an apprentice grocer in Bewdley, he had by the end of his life amassed a fortune. Among other concerns, he had pioneered the manufacture of oil of vitriol (sulphuric acid) in lead chambers. His career was a striking example of how the scientific examination of nature, carried out in such different ways by René Laënnec and John Constable, could create great wealth.

The ingenious Mr Skey had also bred an excellent type of mule, snow-white specimens of which drew the Spring Grove coaches. The house and estate were rumoured to have been paid for by the profits of one stroke of business concluded before breakfast. His neighbours were also impressed by the fact that the elegant estate of Spring Grove had been, well within living memory, a sandy, rock-strewn heath. Here was striking evidence of the transformation human enterprise could work upon nature.

Old Samuel Skey had died in 1800, the same year that Sarah had married his son, another Samuel. The connection between the London-based, legal Bicknells and the Midlands industrialist Skey was not hard to find. It lay in her Aunt Sabrina, the foundling selected by Thomas Day from the orphanage at Shrewsbury. During the years after she had been abandoned by Day as a failed experiment in Rousseau-esque education, Sabrina had become quite a favourite in the scientific and intellectual community that centred around the Lunar Society.

An important member of this was James Keir, a Scottish chemist and geologist who was a good friend of Day's and also at one point the business partner of Samuel Skey in a

glass-making factory at Stourbridge. When Samuel Skey junior, at forty-one, was in search of a wife – his first having died – his choice fell on 25-year-old Miss Bicknell. The introduction must have come via her widowed aunt. Sadly, six years later this younger Samuel Skey died suddenly after a mere four days of illness, leaving Sarah with two young sons and in effective control of a sulphuric acid factory, a team of mules, a large fortune and a handsome estate.

This was where Maria had spent several months in the middle of 1811 in the calm and sensible company of her sister, walking in the grounds of Spring Grove and on the banks of the Severn, recovering her health and to some extent the equanimity of her mind.

In September, Mrs Bicknell came to stay. The following six weeks spent in the company of her invalid mother had worn down Maria's emotional resistance. She was now firmly, if sadly, convinced that there was no further point in clinging to her hopeless attachment to John Constable. It was bad for her, bad for him, and caused needless anxiety to her poor, suffering mother and kindly father. It would have to stop.

In early autumn, Constable also found himself in fresh landscapes. He had accepted an invitation from his friend John Fisher, the Bishop of Salisbury, to visit his see in Wiltshire. It was the second year running this offer had been made, evidence the bishop and Mrs Fisher were concerned, as were many of Constable's well-wishers, by the painter's physical and mental condition. They were among his most stalwart supporters. Years later Constable wrote of how he looked back on the 'great kindness shown' especially in his early days when it was of great value. 'For long I floundered on the path – and tottered on the threshold – and there

was never any young man nearer being lost than myself.'

This was an important moment in Constable's life. If East Bergholt and environs provided his first and most important subject as an artist, Salisbury was his second great theme – and this was his first sight of it. It should have been an exhilarating experience. Yet he remained too despondent to make the most of the Fishers' kind suggestions for his entertainment.

Even so, during those weeks, for the first time he had an opportunity to get to know the bishop's nephew, also named John Fisher, who was just down from Cambridge and had been ordained that summer. In the lives of the bishop and his wife this intelligent, direct, cultivated young man took the place of a son – their own son, Edward, being mentally handicapped and entrusted to the care of a country clergyman. Over the next few years, he became Constable's closest friend.

The younger John Fisher and Constable shared many tastes – for streams, walks, dogs, fishing and Latin verse (a working knowledge of Latin was one of the painter's few academic accomplishments at school in Dedham). On their walks together the friendship between these two men – one young, the other now only youngish – was cemented.

At the beginning of October, Constable and the Fishers made a journey north to stay at Stourhead with Sir Richard Colt Hoare. Constable did not like country house life. The 'reserve, restraint, coldness and form that belongs to "great houses"' did not appeal to him. Though very far from being a radical – indeed, politically he was the reverse – Constable disliked formality. His preference was for easy friendship, relaxed conversation, learning worn lightly, sharp private jokes, walks under the willows.

The landscaped garden at Stourhead, with lake, temples,

grotto, hermitage and carefully composed vistas, was a masterpiece in its way. Constable did sketch it from several vantage-points, and praised it at the time. Years later, however, he revealed his true feeling on the matter: 'A gentleman's park is my aversion. It is not beauty because it is not nature.' Although beautiful, Stourhead was the reverse of what Constable was striving for. This was nature forced to resemble art – in fact, the paintings of Claude. Much though he revered Claude, Constable wanted to create an art more like nature.

Early in October, Constable returned to London, still low in spirits, still suffering from the absence of Maria. Twice, hopeful that she might have returned or that he might at least get news of her, he went to the Bicknell house at 3 Spring Gardens Terrace. Twice he was told that there was nobody at home. Finally, he decided to write to her, a bold step because to write a letter was to acknowledge that one was a suitor.

'Dear Miss Bicknell,' he wrote in desperation. 'Am I asking for that which is impossible when I request a few lines from you?' He would be able to depart for Suffolk with far less anxiety if he could hear that she was well. To fill out the letter he gave a few details about his visit to Salisbury and Stourhead, and ended with a salutation that also read like a plea. 'Believe me, dear Miss Bicknell, to be, Yours most truly, John Constable.'

When the letter arrived at Spring Grove it must have aroused a confusion of feelings in Maria. It was – it could scarcely fail to be – a source of pleasure and excitement to hear from John Constable after so long an interval. On the other hand, as a result of a month and a half of persuasion from her mother, her mind was made up. She replied immediately, with a carefully balanced combination of formality and cordial regret which probably cost her much in thought and emotion.

'Accept my grateful thanks, dear Sir,' she began without going so far as to write his name, 'for your enquiries after me. I cannot with truth say I am Hygeia herself, but I am far better than when I last had the pleasure of seeing you.' The image of the classical goddess of health was one of the main exhibits in the Statue Gallery at Thomas Hope's house on Duchess Street. This, open by ticket on Mondays, was well known to cultivated Londoners.

Maria continued, civilly, taking a polite interest in John Constable's news about Salisbury and Stourhead, which she had heard 'named as a most beautiful spot'. Then she came to the point. Her parents had convinced her that she must give up her attachment to Constable. The unsuitable liaison worried her sick mother, and that in turn made Maria feel guilty and miserable. This relationship, which Constable's letter hinted by its mere existence might continue, must cease. Maria's tone, previously cool, became suddenly urgent.

After an absence of some months I felt particularly happy in the company of dear Mamma, who was here six weeks. You are fully aware of the constant uneasiness I have caused her, but you know not the grief I feel when I distress her, let me beg and entreat you to think of me no more but as one who will ever esteem you as a friend. I am confident it will hurt your feelings as much as it has done mine, but the sooner we accustom ourselves to what is inevitable the better, I am blessed with the kindest the most affectionate of Parents, can I willfully make them unhappy? I have too long given way to a delusion that I might have known must sooner or later have an end.

She ended in a fashion that indicated how their relations would be in future: warm, but strictly within the limits of friendship. 'Believe me, my dear Sir, with the sincerest interest in your welfare, Your obliged M. E. Bicknell.'

While waiting fretfully in London for Maria's reply, Constable fell ill. 'A gradual fever' that had dogged him for months – in fact since Maria had left for Spring Grove – suddenly flared up. Whether from a persistent virus, a psychosomatic condition or some combination of both, Constable felt very ill indeed in the few days that elapsed between sending his message and hers arriving. He had been intending to leave for East Bergholt, but instead sent a message explaining his sudden sickness. Consequently, his mother became worried. 'Your indisposition gives me much concern, but your desponding mind still more so; but make haste & come home & we will chat over all your Salisbury tour & cc.'

In the village there was much socializing because the ex-curate Revd Kebell had returned on a visit. Dr Rhudde

was continually passing the Constables' house to fetch Mrs Everard and her young companions, to some new rout or tea party. For some reason, however, none of the Constables was invited on these occasions. Was Dr Rhudde nursing some new grievance? Mrs Constable asked Revd Kebell straight out, and he replied that he thought not, though he himself had wondered at it.

Despite this nervousness about the rector, Mrs Constable was captivated in church by his funeral oration on the text *O, that men would be wise that they would consider, their latter end.* 'It was a discourse to the very heart, & in consequence of the untimely exit of poor Mr. Joseph Lott, late Sir Richard's tenant.' The unfortunate man, a relation of William Lott whose cottage featured frequently in Constable's pictures, had been thrown out of a gig on the way back from Monk's Eleigh and hit his head on a post. 'So soon do accidents happen,' Mrs Constable concluded with pious relish, 'so much in the midst of Life we are in Death. You know, I have a terror at gigs – they are by no means a vehicle for the aged – his age 75.'

Dr Rhudde had made his reputation as a preacher in London, where he had been the 'lecturer' at St Dionis Backchurch, Fenchurch Street, near the premises of his banker patron. In his younger days two of his sermons had been printed, whereas the Bishop of Salisbury, who was more a courtier than an orator, had not yet published any. A fiery address to the Laudable Order of Anti-Gallicans (opponents of that national enemy, the French) had appeared under the title 'The Love of Country Recommended and Inforced' when Durand Rhudde was only twenty-three.

But, as Edmund Bertram pointed out to Mary Crawford in *Mansfield Park*, 'We do not look in our great cities for our best morality.' A fine preacher, he argued, 'is followed and

admired' as Dr Rhudde clearly was, 'but it is not in fine preaching only that a good clergyman will be useful in his parish and his neighbourhood, where the parish and the neighbourhood are of a size capable of knowing his private character, and observing his general conduct'.

East Bergholt was of that size, and Dr Rhudde's conduct and character were closely observed. It can't be said, however, that he set the example of morality and high principles that Edmund Bertram had in mind.

To communicate with each other Maria Bicknell and John Constable relied on the efficient national postal service. In 1784, the British government had signed an agreement with John Palmer, a theatre owner from Bath who had pioneered a new system of sending mail by stagecoach. He was given the title of Surveyor and Comptroller General of the Post Office. By the end of the next year, the black and maroon mail coaches with wheels in 'Post Office' red were running between most of the major cities in Britain.

The design of coaches and the quality of roads steadily improved, bringing unprecedented speeds which eventually approached ten miles per hour. The carriages were drawn by teams of four horses and had room for four passengers inside and more, at cheaper rates but exposed to the elements, on top. In East Bergholt, the postman's name was Beaumont – just like Sir George's. He would blow his horn as a sign that he was ready to collect the mail.

Payment was made not by the sender, but by the person who received the letter, and it was much more for longer distances – eight pence over sixty miles, as opposed to two pence within London. As a result, people travelling to London from East Bergholt, including Dr Rhudde and the squire, Peter Godfrey, often took the Constables' post with

them. Even if they could not deliver it in person, they could post it for a quarter of the price. A few important people, such as the Bishop of Salisbury, had the right to send mail free in envelopes bearing their frank. Occasionally, the bishop would let Constable send his letters free under an episcopal stamp.

When the postman brought Maria's answer, John could only bear to read it once, so discouraging were the contents. But he clung to the most positive interpretation her words allowed. And with unconscious guile, he began his reply by telling her what would pain her most: the decline of his health. 'Your letter found me recovering from the most severe indisposition I have ever experienced. I cannot say I have been quite well since I had last the happiness of seeing you.'

Then he went on to accept, and simultaneously refuse to accept, her decision. Her selflessness only made him love her more.

Much indeed must I congratulate myself on having loved you, when I see you exerting those high principles of duty on the behalf of your excellent parents – and with these sentiments it is impossible for me to think for a moment of relinquishing every hope of our future union, however unfavourable any prospects may be at present.

Her readiness to give him up out of duty made him reluctant to give her up. The formality of his ending blended into a sigh, 'Believe me to be (dear Miss Bicknell) always most affectionately yours John Constable.'

Two days later, on 31 October, somewhat recovered, Constable walked over to Spring Gardens Terrace and found

both Mr and Mrs Bicknell at home. He was received with surprising kindness and courtesy. Charles Bicknell gave his permission for John to continue to write to Maria, which seemed to indicate that he did not object to his suit for her hand. However, he was a man well used to delicate negotiations and was perhaps depending on Maria's firmness of mind, reinforced by lengthy discussion with her mother, to conclude this business without an unpleasant confrontation. When Constable asked to see Maria, he prevaricated. Had she been on the premises, of course he would have no objection, but sadly she was not. So for him to see her was unfortunately impossible. Charles Bicknell told Constable that he would write to Maria about this attachment, and then communicate with him when he had her answer.

Constable was elated. That afternoon he wrote to Maria,

Ann Constable

telling her the good news. He also sent a letter to his mother, his great – in fact more or less his only – ally in his wooing of Maria. Mrs Constable in turn was cheered, but not quite sure what to make of this development. She was sent into confusion.

> Now my dear Son – what can this mean! And what may be augured from this! I pray it may be favourable for you & all – they are too good and too honourable to trifle with you, or your feelings – therefore I am inclined to hope for the best, and that all will end well, and to the mutual comfort of all. Perhaps I am too buoyant – what ought I to think or do – indeed I am in a great straight. My maternal anxiety is almost overpowering to me.

As John had not turned up to a musical party that evening, Uncle D. P. Watts concluded, with his usual talent for getting the wrong end of the stick, that the interview with Charles Bicknell had gone badly. He sent a message intended to stiffen his nephew's resolve: 'Well, it may mortify you but it cannot *unman* you. Though you are miserable yet you are a *man*. If you weakly sink that heroic character, you would have been a feeble Prop to a Woman who puts herself in your Protection. Arise! revive! bravely surmount even Shipwreck and Ruin!'

In Spring Grove Maria was wavering. Her heart had been touched to read of Constable's illness, her hopes had been raised, but only a little, since she was the more practical and realistic of the two, at the report of his meeting with Charles Bicknell. She was not very optimistic, but no longer able to disguise how she felt.

I dare not suffer myself to think on your last letter. I am very impatient as you may imagine to hear from Papa on a subject so fraught with interest to us both – but was unwilling to delay writing to you as you would be ignorant of the cause of such seeming inattention. I hope you will not find that your kind partiality to me made you view what passed in Spring Gardens too favourably, you know my sentiments, I shall be guided by my Father in every respect.

Should he acquiesce in my wishes I shall be happier than I can express, if not, I shall have the consolation of reflecting that I am doing my duty, a charm that will stifle every regret and in the end give the greatest satisfaction to my mind. I cannot write any more 'till the wished but fearfully dreaded letter arrives.

She signed off – 'with the most ardent wishes for your health' – and her first name appeared in place of an initial: 'believe me, dear Sir, your obliged friend, Maria E. Bicknell'.

Of course, the letter from Charles Bicknell had said, reasonably and logically, exactly what it might have been expected to say. Were John Constable a richer man, there would be no reason why they could not wed. But he wasn't, so there was little more to be said. Maria broke the news to John. It was then that she sent her sad letter, wryly commenting that their relationship was doomed, 'without that necessary article *cash*'.

This was unanswerably true, and there the matter rested, except that John did not give up his hard-won right to correspond. He took comfort in the tone of Maria's letter, rather than the contents. Her heart, he deduced, was his – even if circumstances forced them apart.

★

82

Constable's life was disrupted in other ways during November 1811. It was not only his relationship with Maria that was in a state of nerve-racking suspension. He was searching again for somewhere to live. Having left his rooms in Frith Street, which his mother thought poky and expensive, he had temporarily moved in with John Jackson and his wife in Newman Street. The Jacksons had what John craved – domestic happiness – even though they lived in humble lodgings in Soho.

On 4 November, the very day that Maria wrote with her father's verdict on their hopes of happiness, the election for associates of the Royal Academy was held at Somerset House. For years, Constable had hesitated to try at all. Then in 1810 he had had a small success at the Royal Academy exhibition. One of his pictures – the mill pond at Flatford – attracted favourable mention in the press, the first time a painting by Constable had been singled out for praise. Then, an even more exciting first, he sold the picture for thirty guineas to the Earl of Dysart.

Admittedly the price was a small one – that year Benjamin West, President of the Royal Academy, had been offered 1,000 guineas for a picture entitled *Christ and the Little Child* – and the Earl of Dysart was almost a friend, an old patron from Suffolk. Even so Constable had been 'overjoyed' at this small success, Farington noted in his diary. On the older man's advice, he decided to stand for election as an Associate. But when the vote came, however, he had no support among the Academicians. It had been just the same this time, a year later.

Founded four decades before in 1768, the Academy was made up of forty self-selected artists and architects, plus twenty more associates who were elected by the full members. King George III presided over this turbulent artistic

association of artists, rather as he did as a constitutional monarch over the Houses of Parliament (although since he had lost his reason, this duty had passed to the Prince Regent). And internal dissention within the Academy was almost as fierce.

The institution had begun in disagreement, with senior figures such as William Hogarth stoutly opposing its foundation. There had been an insurrection against the revered first president, Sir Joshua Reynolds, in 1790. As a result Reynolds had resigned in a fury and had to be calmed by George III. A few years later one of the Academicians, an arrogant Irish painter named James Barry, had been expelled in a plot orchestrated by, among others, Constable's friend Joseph Farington. Dissention continued, most recently over John Soane's lectures on architecture, in which he took the opportunity to make cutting criticisms of a fellow architect.

Unfortunately, the Academicians were unanimous on one point. They did not want to elect John Constable, although the reason was not clear. There was some feeling that painting of the figure was more elevated than mere landscape, but that had not prevented Turner from being elected an associate at twenty-five (he had almost been chosen the year before, but it was discovered that the rules prevented it as he was too young).

To his contemporary's eyes, Constable's paintings probably looked quiet, a little raw and too pedantically true to the appearance of a particular place. J. H. Fuseli, the professor of painting at the RA, mentioned in his lectures 'as the last branch of uninteresting subjects, that kind of landscape that is entirely occupied with the tame delineation of a given spot; an enumeration of hill and dale, clumps of trees, shrubs, water, meadows, cottages and houses, what is commonly called views'. The great landscape painters such

as Rubens and Claude, he went on, spurned 'this kind of mapwork'. The description fitted Constable's paintings of East Bergholt all too closely.

Whatever the reason, despite the encouragement of West and Farington, and his own dogged devotion to the institution, Constable had no support. But it was crucial for him to be elected if he was going to make any professional progress as a painter, although belonging to the RA was not enough to ensure success. Several senior Academicians, including Constable's friends Stothard and Bigg, eked out a living from cleaning pictures and book illustration.

With everything in his professional and private life as discouraging as it could be, Constable left London to stay in Suffolk, where his mother was dismayed at his thinness and paleness. And yet he was not as low as he had been. The renewed contact with Maria buoyed him up, and he was keen to tell his mother of the happiness Maria's letters had given him; they were the greatest treasure he possessed.

On the subject of John and his hopeless love, Mrs Constable had a sharp exchange of letters with her pious brother David Pike Watts. Mr Watts continued to take the view that the relationship with Maria was hopeless and that John should force himself to forget it. He went so far as to tell his sister that her own approval of it was tainted by social and financial ambition.

She sent back a tart answer. 'I love the writer & I in general approve all his sentiments – but when he tells me I am worldly in my wishes & views for my Son, I can but reply, that whilst we are on this Earth, our plans & ideas must be worldly.'

David Pike Watts's own daughter, Mary – his only surviving child – had married earlier in the year into immense

wealth. Her husband was Jesse Russell, son, as Constable put it to Farington, of an 'eminent soap-boiler'. Mr Russell senior was somewhat eccentric: Constable heard that he personally broke up every piece of sugar used in his house, showing obsessive attention to detail. But he was rumoured to be worth half a million pounds, even more than David Pike Watts himself.

The young couple had been bought Ilam Hall, a country house in a beautifully picturesque part of Derbyshire (visited and approved some years before by Constable himself). Their happiness and prosperity seemed assured.

After his return to London in early December, Constable resumed his evening visits to the Life Room at the Royal Academy. This institution occupied part of Somerset House, to the right as one passed through the entrance from the Strand. The lobby was filled with casts of ancient sculptures. And sitting just inside the room one might well encounter Sam Strowger, one of the porters and also the incarnation of the artistic ideal in his other role as principal male nude model in the Life Room. Upstairs there was a room filled with more antique casts, which young artists copied before they were allowed to progress to the living figure.

The 'Winter Academy of Living Models' ran from 29 September to 9 April each year, from six o'clock to eight in the evening, every day except Sunday. Constable had been a frequent attender ever since he had enrolled at the Academy Schools over a decade before, though why he was so diligent was not clear. Such assiduous study of the nude was not strictly necessary for a landscape painter; perhaps he liked the company of fellow artists that he found there.

This habit of evening life-drawing made his mother anxious, especially in cold weather. 'Pray be careful of your-

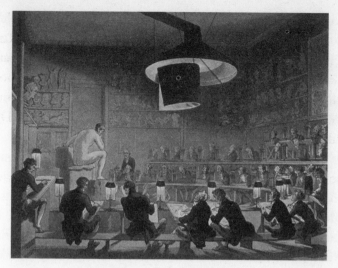

The Royal Academy: Life Room

self. I form an idea that the warmth of the Academy room, smoke from lamps or many candles, & then coming into the air & streets of London are most inimical to tender chests & lungs – therefore do not be too adventurous – not sit up *too late.*'

On Tuesday, 10 December Constable drew and dated a drawing of a naked young woman posing in a relaxed position. On this sheet of paper he scribbled some information so rapidly that some words were hard to read: 'Mr West's (?) discovery/ A Paris (?) girl/ successful model/ Owen visitor.' That is, William Owen was the Academician in charge of the session, a job that included giving the model her pose, and the girl herself had been recruited by the president, Benjamin West.

There was excitement among artists when a really good model appeared. The previous autumn, for example, several had been enormously struck by the heroically muscular physique of a black man, whom Benjamin Robert Haydon

had almost killed by accident while trying to cast his entire body in plaster of Paris (which started to suffocate him as it set). Finding female models was a more difficult and delicate task.

Female models were unlikely to be virtuous as no respectable woman would willingly show herself naked in front of a roomful of men (though occasionally, out of desperation, one was driven to do so and might pose, pathetically, with her face covered to disguise her identity).

The men, such as Sam Strowger, were treated differently from the women. They were paid less – five shillings a week, plus a shilling per sitting. The women were rewarded with twice as much, but remained anonymous in the RA accounts. The men on the other hand were named, respected as fine physical specimens, and might be regarded as models of virtue as well as anatomy. Haydon went to visit Strowger and his family at home, 'which was a perfect model of neatness'. 'I don't know,' Haydon reflected, 'when I spent a more innocent evening.'

Constable himself, years later, had the same task of supervising the Life Room and setting the pose. Typically, he had a model take the role of Eve, surrounded by greenery – a nude in a landscape (though, it being winter, the Garden of Eden was 'taken for Christmas all holly and mistletoe'). It was difficult to heat the room: 'poor Eve shivered sadly and became like a "goose" all over. I got her warm and told her not to be such a goose as to tell her "Aunt" who was very loathe to let her come to the Academy.' That 'Aunt' was the madam for whom 'Eve' worked when she was not doing duty as a model.

Landscape painter though he was, Constable had an eye for female beauty. His best portraits were often of pretty girls, among them Maria Bicknell. But he never drew a

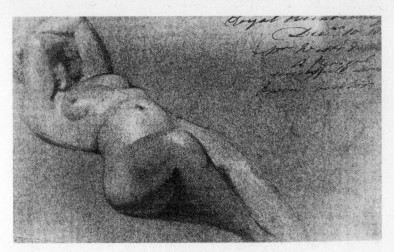

Study of Female Nude

nude with more delicate sensuality than this girl from Paris lying on her back, one leg bent at the knee, the other straight, both arms raised, her hands cradled behind her head.

Constable returned to work in London with renewed vigour, despite the troublesome cough he couldn't shake off. He began to plan his contributions to the Academy exhibition the following May, of which there were to be four. Reassured by his renewed contact with Maria, refreshed by his visit to East Bergholt, he felt equal to an intense 'winter campaign' of painting.

His mother urged him on in letter after letter. 'Pray be diligent and paint with energy – remembering the prize you have in view.' The prize, of course, was Maria. Constable had written to her in November, telling her of his new lodgings in Charlotte Street and his work in progress – a view of Flatford Lock, and a view over the Stour on a summer's evening from old Mrs Robert's garden (a study which had

Engraving of *Summer Evening*

been 'quite a pet' of his). On his return from Suffolk, two days after he drew the French model, he wrote again telling her of his hopes and renewed determination to succeed, for both their sakes.

> I am endeavouring to settle myself as much as possible to my profession, as I am convinced that nothing so much as employment will keep the mind from preying upon itself – especially an employment which takes up the attention so much as painting does, as it is our duty to make every manly exertion. I trust that I may expect the greatest good to be the result of this advancement in the art I love, and more deserving of you.

After an interval, he received Maria's answer. It took the form – however gently, indeed lovingly delivered – of a blow, destroying his hopes.

Dear Sir,

You grieve and surprise me by continuing so sanguine on a subject altogether hopeless. I cannot endure that you should harbour an idea that must terminate in disappointment. I never can consent to act in opposition to the wishes of my Father, how then can I continue a correspondence wholly disapproved by him? He tells me too that I am consulting your happiness, as well as my own, by putting an end to it. Then let me beg and intreat that you will cease to think of me, forget that you have ever known me, and I will willingly resign even all pretensions to your regard, or even acquaintance to facilitate the tranquillity and peace of mind which is so essential to your advancing success in a pro-fession, which will ever in itself be a source of continued delight. You must be certain that you cannot write without increasing feelings that must be entirely suppressed. You will therefore I am sure see the impropriety of sending me any more letters.

I congratulate you on your change of residence, it is, I think, a very desirable situation. Fare well, dear Sir, and ever believe me,

Your sincere and constant well-wisher,

M. E. Bicknell

This looked like a verdict from which there was no appeal. In response, John acted as his uncle had advised, in a manly and decisive manner, but with the opposite purpose. Instead of exerting his will to suppress his feelings, shortly after receiving this crushing letter he climbed on a stagecoach and set off for Worcestershire.

The mixture of delight and consternation that Maria experi-enced when Constable arrived at Spring Grove can easily

be imagined. She had expected to see him, if ever again at all, only in the sad role of an ex-lover obliged to become a friend and well-wisher. Instead, here he was, knocking at the door. A decision, indeed a series of decisions, had to be made there and then. The first of which was whether to let him in.

An influential role in this choice and all that followed was played – it can fairly be deduced – by Maria's older half-sister, Mrs Skey, née Sarah Laurens Bicknell. Obviously, in the first place it fell to Mrs Skey as hostess, the owner of Spring Grove, to invite him in or turn him away. She chose the first. After his return to London, Constable wrote asking Maria to 'make my most respectful compliments to Mrs. Skey, with my thanks for her very great politeness'. By that impulse of kindness, Mrs Skey changed the trajectory of two people's lives and perhaps – though she could scarcely have anticipated that – the history of art. If he had been turned away from that door and been permanently deprived of Maria, it is hard to know what would have become of Constable, but it seems possible that his development as an artist would have been paralysed by misery.

Earlier in the autumn, Maria had been under the influence of her parents: six weeks in the company of her ailing and anxious mother, followed by mild but completely discouraging letters from her father. Now, however, her sole companion and hence adviser was Mrs Skey. It is clear from the warmth of Constable's subsequent references to her that he liked Mrs Skey. She was, as far as he was concerned, the nicest of the Bicknells and the most like Maria. His mother, responding to his descriptions, declared Mrs Skey 'is a charming and a good woman, & her Sister must be happy to be with her, as no doubt they are Congenial Minds'.

No doubt, the reverse was also true: he made a good

impression on her. When Constable presented his handsome, artistic and romantically lovelorn self at her door, he acquired an ally in Mrs Skey.

If Constable's appearance and manner had not been enough to win Mrs Skey over, his kindness to her boys would have done the trick. Of her two sons, the older, Samuel, was sickly and, in the opinion of John and Maria, spoiled and tiresome. The five-year-old Arthur, on the other hand, immediately took to Constable. The two of them played so entertainingly with the boy's set of bricks that months afterwards, according to Maria, young Arthur mentioned Constable whenever the bricks were brought out.

Mrs Sarah Skey was the product of an earlier and, the evidence suggests, more liberal-minded Bicknell family. After all, she was given her middle name 'Laurens' after John Laurens, fallen hero of the American War (and, as it happens, one of the earliest supporters of the rights of African-Americans). Maria's mother was the daughter of Dr Rhudde and sister of the snobbish Mrs Farnham, and hence susceptible to their prejudices and pressure; Mrs Skey, on the other hand, was the daughter of Charles Bicknell's long-dead first wife, Mary Firebrace.

A poem by the late John Bicknell addressed to Miss Firebrace had been published in the *Gentleman's Magazine* in September 1808. It was submitted by someone under the pseudonym of 'Philo-Genius', who contributed a short introduction and in doing so paid a rather public compliment to Mrs Skey's mother and herself. 'The enclosed lines,' wrote Philo-Genius to the editor '... were written by the late John Bicknell, Esq, the Barrister, to a young lady who very soon afterwards became the wife of his brother, Charles, the present solicitor to the Admiralty. The

lady died many years since; and has left a daughter still living, who inherits all the virtues and accomplishments of her mother.'

'Philo-Genius' was in all probability one of John Bicknell's sons: Henry Edgeworth or John Laurens Bicknell. The moment was apposite because Henry Bicknell himself had married in August 1808 – what better occasion to revive these slight, but charming, verses by his long-dead father on the subject of marriage?

The poem was not just a plea for cash.

> I wish you no superfluous wealth
> The bane of happiness and health
> I need not wish you Beauty – Youth
> Good-nature – Virtue – Sense – or Truth.

Instead John Bicknell hoped for Miss Firebrace's rapid marriage to his brother Charles:

> I wish (and I shall now speak true
> Tho' poet born and lawyer too
> If not I pray my tongue might blister)
> In short I wish you soon were my sister.'

Sarah Laurens Bicknell, now Mrs Skey, the daughter of this match, was – events suggested – equally well disposed to John Constable becoming her brother-in-law.

Those days at Spring Grove rivalled the autumn months of 1809 when his love for Maria had first been pledged as Constable's happiest memories. He and Maria walked the winding paths of the park together, so that afterwards Constable – always inclined to place the people he knew in a

landscape – was able to trace Maria's solitary strolls there in his imagination.

She could not withstand John's actual physical presence: his words, the sight of him grown haggard and anxious. She melted, she forgave his imprudent action in appearing univited at Spring Grove. From now on, however many obstacles arose, no matter how difficult things became, there was no question of their giving each other up.

The weather during John's stay at Spring Grove was intermittently wet, so exploration of the park was only sometimes possible. The spacious rooms of the house were almost as good a location for an intense discussion. Maria had been continuing her efforts at drawing by making a copy of a painting by Joshua Reynolds depicting Robin Goodfellow (or Puck). John naturally took an interest in her progress. For a short interval, they lived on almost domestic terms.

He returned to London on Sunday, 22 December, three days before Christmas. It was a bright clear frosty day, which if it had occurred a day or two before would have allowed Constable and Maria to investigate the wooded banks of the Severn near Bewdley; with the ground frozen hard, it would not have been impossibly muddy underfoot.

When he arrived at Worcester, it turned out Constable had two or three hours to wait before the mail coach set off for London. He spent them visiting the cathedral and town. To pass the time, he drew the medieval structure from the opposite bank of the river, its pinnacles mirrored in the water, flanked by leafless trees, a clear sky above except for a small light cloud floating over the roofs to the right. On that little piece of paper he set down a microcosm from which a mighty painting could have grown.

Blissful as it had been, that short sojourn at Spring Grove

was shadowed by a sense that this impossible love was an affliction to Maria. He expressed his feeling of mingled emotional light and darkness to her on his return:

> I may now say that some of the happiest hours of my life were passed at Spring Grove – mixed as they were with moments of unutterable sadness. Nor could it be otherwise when I reflected that you who might, & who deserved to have been entirely happy, I had taken pains to render not so – and had implanted in your excellent mind a source of sorrow to your worthy parents.

It might be questioned how sincere John was in his concern for Mr and Mrs Bicknell. But obviously, their feelings were of great, if not, fortunately as it turned out, absolutely paramount importance to Maria. His praise of Maria's sister Sarah, on the other hand, was entirely heartfelt. She was an ideal companion, and a new friend for him. 'I congratulate you on being with Mrs. Skey – it was in the highest degree gratifying to me to see you enjoying that calm, which her domestic circle and more especially her friendship and society seemed so much calculated to impart.'

He was keen that she should not brood, but he added a note of desperation – almost of threat. Life without at least the hope of seeing Maria was unthinkable, like dying. Providence must bring them back together, 'for I shall think that I am leaving this world when I think for a moment to the contrary'.

To prevent a slide back into depression, Constable decided to invite his youngest sister, Mary, to share his new lodgings in Charlotte Street. Now thirty and still unmarried, Mary was the fondest of his female siblings, the only one who wrote at the top of her letters, not 'Dear John' but

'Dearest Johnny'. On Christmas Eve, the painter Thomas Stothard – kindly, elderly and deaf – called on Constable. He approved this plan of summoning Mary to Charlotte Street. By being too much on his own, he told Constable, the younger man was led to 'think *impertinently*'. Constable would have spent a solitary Christmas in London, but the Bishop of Salisbury thoughtfully invited him to dine with him and his family in Seymour Street.

On the last day of December, Constable's father sent him a rare letter. The old man was worried by his son's nerviness, the fretful ambition that drove him on but seemed to prevent him from making a workmanlike job of his painting. 'I fear your too great anxiety to excell may have carried you too far above yourself; & that you make too serious a matter of the business & thereby render yourself less capable; it has impaired your health & spirits. Think less & finish as you go (perhaps that may do).'

Industrious and sober himself, Golding was attempting to imagine how John might establish himself more solidly as an artist. More steadiness seemed to be required. 'Once you have fixed on a subject, finish it in the best manner you are able, & not through despair put it aside & so fill your room with lumber.' John's brilliantly rapid brushwork obviously did not impress his father.

As for the notion of getting married, that was plainly out of the question without more income. Viewed as a business proposition, Constable's enterprise was obviously unsound. The figures didn't add up; he wasn't making enough to support himself. Add a wife, and perhaps numerous children, and what would John's situation be? 'If my opinion was requested,' Golding Constable concluded, firmly but not unkindly, 'it would not be to give up your female acquaintance

97

in toto but by all means to defer all thoughts of a connection until some removals have taken place, & your expectations more certainly known.' Golding meant John might eventually inherit enough from himself and from David Pike Watts to marry on. But what, if anything, he would be left was not yet decided.

His letter brought some more immediate good news. At John's earnest request, Mrs Constable and Mary had decided that the latter would indeed come to live with him for a while.

A week later came a wonderful surprise. Maria, with her sister Sarah Skey and her boys, was in London. They had come to stay in Spring Gardens Terrace. Maria, however, had resolved not to let John know. She felt that if she did it would place more strain on them and waste more of John's time, which should be devoted to art rather than frantic efforts to be with her.

As it happened, John did indeed find out that the Spring Grove party had arrived in town, and promptly. Who can have let him know? Obviously, it wasn't Maria, and under the circumstances it seems unlikely to have been either Mr or Mrs Bicknell, although Mrs Skey was a possible informant. At any rate, Constable immediately came to call at 3 Spring Gardens Terrace and as luck would have it found Maria out.

This was too much for her to bear. Breaking her self-imposed vow of silence, she wrote to him the next day:

How unfortunate and vexed I was yesterday in not seeing you, but shall I tell you, I was even more sorry to hear you had called – I have exerted all the powers of my mind to think of you as of any other friend, with what success you are

but too well acquainted. I will own I did not mean to tell you I was in Town. I felt so perfectly assured of your sentiments that I thought it was more for our peace of mind to think that a length of distance divided us than to be continually planning walks which can very rarely be accomplished.

She concluded the letter stoically: 'Time alone can cure our griefs, hope may still support us.'

But now John knew that Maria was near by it was unbearable for him not to take any chance of seeing her. As a result he embarked on what his mother disapprovingly described as a programme of 'continual molestation'. He spent a lot of time, which would have been more wisely spent in his painting room in Charlotte Street, shivering in St James's Park, hoping he might have the luck to bump into Maria and her sisters as they strolled beneath the trees and, quite naturally, join them for a time.

For anyone living in Spring Garden Terrace, this was the obvious destination in fine weather, a substitute for the garden that, despite the name of the street, her father's house did not have. St James's Park was still – though not for much longer – an early eighteenth-century pleasure ground, dominated by a long, straight canal and rows of trees. In this terrain, a familiar figure could easily be made out from far away.

Constable's mood had greatly improved despite the rigours of spending hours in the open, fretfully looking out for a sighting of Maria appearing from the end of New Street, which led from her door to the park.

On 10 January he paid a visit to Joseph Farington and told him about his private affairs. Constable's mind, Farington noted, had been 'made easy' by assurances he had received. Those were, of course, Maria's avowals of affection for him

– nothing else would have thus quietened his anxiety. But the logistics of actually seeing Maria remained awkward. He could not constantly call on the Bicknell household, especially given the possibility that Charles Bicknell might forbid their correspondence and bar further meetings. After a month of this tension, Maria felt it was best for her to return to the sanctuary of Worcestershire. The current situation, she quite rightly felt, was very bad for both of them.

On Thursday, 20 February she wrote to explain her reasons for returning. It was clear from the way that she began that Constable was in danger of getting into an emotional state once more, presumably about the prospect of her return to Spring Grove.

> How can you thus distress me and needlessly torment your-self. It was not without a severe struggle over my feelings that I resolved upon [leaving] Town, every hour shows me the necessity of it, my health, my peace, would be gradually undermined, will not these considerations have weight with you. At Spring Grove I shall remain quiet for some months. I shall hear from you, I shall think of you, and you know I am even *to look at you*.

It seems he had given her a self-portrait so she could see his face while they were apart.

> Think my dear Sir of the number of wasted hours spent in the Park, think what an unsettled being I am rendered. I should not love you if you did not feel my absence, but feel it as a Man, rejoice that I shall be acquiring health and that you will be getting on with a profession upon which so much depends.

Like Maria, John's mother urged him to get on with his painting – on which every other hope hung. 'Now my dear John, with these cheering and animating hopes, do paint with energy and spirit – do not be *supine* – *but* work that you may obtain, when you know to what good account you can turn your gains.

'You are both I have no doubt so confident in the purity & constancy of your attachment,' Mrs Constable advised, 'that you can part, with the blest hope, and confidence of meeting again, & never forgetting each other; – you will show the sincerity of your affection by your prudence – and I do hope and trust it is allotted for me before I go hence & am no more seen, to add another amiable and good daughter, to those I am already blessed with.'

Nonetheless, on the Tuesday before their departure – 25 February – Constable spent hours loitering vainly on the wide sandy walks of St James's as the weather turned from bad to terrible. A young meteorologist named Thomas Forster, observing the weather of London from the nearby village of Clapton, described that day as 'mostly cloudy, rainy and tempestuous, with hail in the evening'. Maria, understandably, did not venture out. But before she departed from London, he and she spent an evening together at the theatre.

Drama was a family interest of the Bicknells'. Fourteen years before, in 1798, Mr Bicknell had happened to be in Maidstone, along with many legal notables, for state trials of four men accused of treasonable correspondence with the revolutionary French government. At the local playhouse a struggling young actor and playwright named Thomas Dibdin was allowed to present a benefit on his own behalf on 12 July, and staged a farce of his own composition, *The Jew and the Doctor*.

Afterwards, Dibdin was approached by Charles Bicknell,

'a man I had never seen or spoken to, but who proved a very material friend on this, to me, memorable occasion'.

On returning to London, despite having the misfortune to be robbed by highwaymen on the way – he was prone to such mishaps – Bicknell recommended both author and play to Thomas Harris, the manager of the Theatre Royal, Covent Garden. Following this lucky break, Dibdin became one of the best-known playwrights of the day, and Charles Bicknell's disinterested good deed earned him a footnote in theatrical histories of the period.

The Bicknells had a regular arrangement for picking up tickets at Covent Garden. But how was John and Maria's evening at the theatre arranged? It seems improbable that Charles Bicknell – stage-struck though he was – would have

A Seated Woman from behind,
Holding a Child

thus thrown together a couple he would have preferred to separate. Once more, perhaps, one can discern the hand of Mrs Skey – the good angel of John and Maria's romance. Nothing prevented her, a wealthy widowed woman, from going out to see a play, accompanied by her sister. Under those circumstances it would have been entirely respectable for another friend, Mr Constable, to join them.

Constable had the triumph of handing Mrs Skey into her carriage (an account of this event was relayed to East Bergholt, where it caused delight to Mrs Constable). He also had an opportunity to pick up little Arthur Skey in his arms and carry him across a muddy street, a small kindness to his mother and a slightly sad pleasure to Constable whose fondness for children, as Leslie recalled, 'exceeded that of any man I ever knew'. As his letters to Maria were to reveal, he longed for some of his own.

For several weeks after Maria and her sister left, Constable did nothing but work on his four pictures for that year's exhibition – an unprecedented number, reflecting increased ambition and energy.

It was part of his yearly routine to complete his Royal Academy paintings in the late winter and early spring. The ideas for them would come the season before, while he was walking and painting in Suffolk. The bigger paintings on which his public reputation depended were sometimes begun in East Bergholt, but generally completed in his London painting room, far from the fields and hedgerows.

The studies that he did in the open air, marvellous though they were, were not intended as finished works of art. They were tied up in bundles and stored in his painting room and few except his intimate friends ever saw them. Their purpose was exactly what the word 'study' implies: learning. They were observations of the natural world which slowly increased the painter's knowledge and understanding. 'The study of Nature in her most minute details is indispensable,' he believed, 'and can never be made in vain.' But this was only the beginning of the process, not the end.

Visual information from the studies would eventually be included in a proper picture for public exhibition. But these finished paintings should not be 'mere copies of the productions of Nature, which can never be more than servile imitations'. On the contrary, the final result should be carefully pondered, composed and completed indoors.

Constable believed that landscape began in precise observation, but it was also an emotional and spiritual affair. Landscape was in fact about everything. After all, he declared in a lecture at Hampstead in 1836, at the end of his life, 'man is the sole intellectual inhabitant of one vast natural landscape. His nature is congenial with the elements of the planet itself, and he cannot but sympathize with its features, its various aspects, and its phenomena in all aspects.'

The Poussin landscape depicting a 'solemn, deep, still, summer's noon' that so impressed him gave a measure of how profound a landscape painting could be. To Constable it was 'the most affecting picture' he had ever stood before. 'It surely cannot be saying too much,' he went on, 'when I assert that his landscape is full of religious and moral feeling, & shows how much of His own nature God has implanted in the mind of man.' With its deep, still morning light, 'umbrageous' trees and clouds 'with the most enchanting effects possible', the landscape suggested to Constable feelings of divinity and goodness. In fact, trees, clouds and light *were* how Constable experienced the good and the divine.

That spring, the artists of London were fascinated by the increasingly wild behaviour of Benjamin Robert Haydon. Haydon now disdained the Royal Academy, having been infuriated by its failure to elect him an associate member. Now he pinned all his hopes on a prize awarded for a 'historical painting' by the British Institution, an organization for encouraging the arts run by gentleman connoisseurs.

The headstrong and abrasive Haydon wrangled for most of 1810 and 1811 with Sir George Beaumont about a picture of a scene from *Macbeth* commissioned by the latter then rejected because the figures were 'dwarvish'. Sir George offered Haydon 100 guineas for his trouble, which the

painter turned down, 'not in a courteous manner'. Haydon was now confident that his *Macbeth* would win the first prize from the British Institution, and the 300 guineas that went with it.

However, he was not courting those gentleman connoisseurs as he should. Sir George Beaumont was a leading figure in the British Institution, and the auguries were not good. Sir George's friend Lord Mulgrave, a senior colleague of Mr Bicknell's at the Admiralty, owned Haydon's first important picture, *The Assassination of L Dentatus*. This painting, much praised initially by Sir George and his friends, was now, as Constable reported to Farington, 'in its *case* placed in His Lordship's stable'.

Haydon also feuded with Richard Payne Knight, another important member of the British Institution. Payne Knight, known as 'Priapus' Knight because of his scholarly work on the phallus in classical art, opposed the purchase by the government of the marble sculptures removed from the Parthenon at Athens by Lord Elgin. Haydon admired these with wild enthusiasm, and therefore ridiculed and attacked Payne Knight in the pages of the radical journal *The Examiner*.

Constable, who followed Haydon's career closely, though they were no longer on speaking terms, told Farington that Haydon was 'very much elated with his prospects & speaks of the Royal Academy very slightly, saying they had now missed the opportunity when they might have elected him, it might now be for them to send a deputation for him to be of the society'.

Haydon had shot up into the firmament of the London art world like a rocket, then almost immediately fallen back to earth; it was the opposite of Constable's slow, indeed almost indiscernible, progress. Both of them, however, faced

the same problem: if a painter followed his own ideas, rather than executing a commission for a portrait or country house view, who was going to buy his work? It was, in essence, the difficulty of the innovative artist in the modern world. Van Gogh and Cézanne would encounter it too.

Constable, for all his nervous tendency to depression, was far more stable than Haydon, whose behaviour verged on the unhinged. But this time of year when he was completing his pictures for the Academy exhibition was always a difficult one for Constable. He had the awkward kind of temperament – not unusual among creative people – that is tormented without a challenging project and tortured in a different way by struggling with one.

'Occupation is my sheet anchor,' he reflected, 'my mind would soon devour me without it.' On the other hand, the struggle to get his major paintings right caused him anguish, sleepless nights and suffering. The previous year, in poor health and in mental agony over Maria, he actually prayed in front of his main painting for the Royal Academy, a view of the Stour valley in early morning.

With relations with Maria re-established and sister Mary Constable on hand for company, he was now much steadier. But in February and March London, where he painted so many of his greatest works, was a hostile environment for Constable. It was the opposite of what he loved and craved: instead of umbrageous trees and sunlit fields, a huge warren of brick walls and crowded streets, veiled in coal smoke and smog.

Soon after he had moved to the metropolis, Constable wrote to his friend Dunthorne that in London during the cold months he sometimes saw the sun, but it appeared as did 'a pearl through burnt glass'.

Constable loved light. Lack of it – one guesses – drove him into a black mood as it does many who, like him, are subject to depression and mood swings. The thing he most valued about the paintings of Claude was their 'placid brightness'.

Despite the new gaslights that had recently appeared on Pall Mall, there was still little light in Regency London during the dark months of the year. As a result of Britain's success as an industrial and trading nation, its capital had become the largest, richest and grimiest place on earth. Already this behemoth of brick and stone was home to a million inhabitants, and everyone who could afford it cooked and warmed themselves with a coal fire.

Louis Simond, a well-to-do American of French descent, travelled in Britain in 1810–11 and kept a journal of his experiences. On winter days in London, he noted,

the smoke of fossil coals forms an atmosphere, perceivable for many miles, like a great round cloud attached to the earth. In the town itself, when the weather is cloudy and foggy, which is frequently the case in winter, this smoke increases the general dingy hue, and terminates the length of every street with a fixed grey mist, receding as you advance. But when some rays of sun happen to fall on this artificial atmosphere, its impure mass assumes immediately a pale orange tint, similar to the effect of Claude Lorraine glasses – a fluid golden hue, quite beautiful. The air, in the mean time, is loaded with small flakes of smoke, in sublimation – a sort of flower of soot, so light as to float without falling.

Some, such as Haydon and Fuseli, found the spectacle of this grimy conurbation sublime. Constable's friend John Fisher thought it nightmarish. 'There is a deep cellar in the

infernal regions that is reserved for the most desperate. London in March is a type of it. See Milton's *cold* Hell.'

A celebrated meteorologist named Luke Howard, whose system for classifying the clouds had made an international impression, had noticed the unique atmospheric conditions of this magnificent and hellish city. From Plaistow outside London he made daily observations to support his current thesis: that the capital of Britain was so huge that it actually affected the weather. Thomas Forster assisted him by sending additional data from Clapton. Howard's book on the subject, when finally published, would be called *The Climate of London*.

To Constable, the great city remained an alien and lonely place. He described it to Maria as 'this gloom of solitude, which (however paradoxical it may seem) I find London to be'. He quoted the poet James Thomson, a favourite of his: 'I am alone amidst thousands.' Constable was a man who sharply felt the need of love and companionship.

Despite his dislike of the place, the lives of Constable and his family were bound up with London. The Constables were not unusual in this. As the enormous town expanded it drew more and more lives into its orbit. His mother's family were Londoners; for much of his life he lived and worked in the metropolis. His father, Golding, was virtually allergic to London: when he approached closer than Ilford in Essex, his lungs began to be affected by the poor quality of the air. But Golding's business – one half of it at least – concerned supplying flour to the capital. His brig, *The Telegraph*, plied regularly between Mistley and London. The previous year it had been marooned at Pickle Herring Dock on the south bank of the Thames near London Bridge when the master was captured by a press gang; Golding had wanted Constable to ask Charles Bicknell to intercede in the case at the

Admiralty. Tantalizingly, the documentation does not reveal whether he did.

The phenomenon of urban growth was connected to the parallel development in art and literature of a cult of the countryside. Nature was many things to eighteenth- and early nineteenth-century Europeans: a deity, a refuge, a fashion, a standard of truth. In 1812 the English had already been contemplating, discussing, depicting and remodelling their landscape obsessively for a hundred years.

Gentlemen's parks, such as Stourhead, had been re-arranged to look more like the landscapes of Claude. Then, in some cases, the same place had been changed again according to the dictates of theorists such as Sir Uvedale Price and Payne Knight and the designs of Humphrey Repton, to look more *natural* and more *picturesque*. It was, as the second term implies, in part an effort to make the landscape look like another kind of picture, one more artfully rustic and less classical than a Claude.

This was a mania of the times. In *Mansfield Park* Henry Crawford, spokesman of urban sophistication, spends much time suggesting improvements to the landscapes he sees. At Thornton Lacey, where Edmund Bertram is to become the parson, Henry Crawford sees the parsonage as a dwelling ripe to be given 'the air of a gentleman's residence'. All that was necessary was to do away with the farmyard, have the garden moved, the aspect changed, the adjoining meadows bought and incorporated, and the stream – 'something must be done with the stream'. Henry Crawford could not quite determine what, 'I had two or three ideas.'

Of course, a modern city was hopelessly unpicturesque. In *Northanger Abbey* the heroine, Catherine Morland, is so naïve as to know nothing of the picturesque, but she is given

a crash course in landscape art by the hero, Henry Tilney. 'He talked of fore-grounds, distances, and second distances.' Catherine learns so rapidly as they walk through the countryside that, when they get to the top of Beechen Cliff, 'she voluntarily rejected the whole city of Bath, as unworthy to make part of a landscape'.

Constable might be seen, in one way, as a radical follower of the picturesque movement. He selected objects much more humble and humdrum – ordinary details of workaday countryside – than normal as subjects for his pictures; that is, he thought them *picturesque*. But there was a deeper level to his feeling for landscape. In company with some of his contemporaries and many since he found it balm for the stresses, frustrations and artificialities of social life. Thus Fanny Price found herself slipping into a reverie in Mrs Grant's shrubbery. 'When I am out of doors,' she explains to Mary Crawford, 'I am very apt to get into this sort of wandering strain. One cannot fix one's eyes on the commonest natural production without finding food for a rambling fancy.'

To fix one's eyes and attention on nature provided a relief from psychological pressure. The composer Ludwig van Beethoven wrote to a friend of exactly such feelings, mingled with religious awe, 'How glad I am to be able to roam in wood and thicket, among the trees and flowers and rocks ... In the country, every tree seems to speak to me, saying "Holy! Holy!" In the woods, there is enchantment which expresses all things.'

As in many matters, Rousseau spoke for his epoch about the consolation of landscape. He described his almost mystical experiences when, in 1765, he took refuge on the Swiss island of Saint-Pierre, an uninhabited knob of dry land in the middle of the Lake of Bienne. Often, he would go and sit in 'some secluded spot' on the shore.

There the noise of the waves and the movement of the water, taking hold of my senses and driving all other agitation from my soul, would plunge it into a delicious reverie in which night often stole on me unawares. The ebb and flow of the water, its continuous yet undulating noise, kept lapping against my ears and my eyes, taking the place of all the inward movements which my reverie had calmed within me, and it was enough to make me pleasurably aware of my existence, without troubling myself with thought.

John Constable would have understood the experience described there, however little sympathy he had for the political opinions of the French philosopher. The reflections of light on water remained a theme not only in Constable's painting, but in European art and music until the era of Monet and Debussy.

The most important of Constable's exhibition pictures in 1812 was another view of Flatford Mill, a subject with which he had had a success two years before and the very view that Maria herself had once attempted. It was a scene he was to paint more frequently than any other and, ultimately, gave him the widest fame. (See endpapers.)

For this picture he had chosen a vantage point on the other side of the river from the mill and a little further upstream, just behind the lower gate of the lock. From this position, the buildings of the mill itself were visible on the islet in mid-stream to the left and in the centre the same twin Lombardy poplars, a pair of plumes punctuating the landscape. A barge was moored beside the mill to load some of his father's flour.

The place was full of associations for Constable – with his boyhood, his father's business, his family. The radical author

Thomas Paine had made a profound observation about the relation between the thing seen and the person seeing. 'It is a faculty of the human mind,' Paine stated, 'to become what it contemplates, and to act in unison with its object.' In Constable's case, the early memories of Flatford Mill, the Stour and the lock seemed to have fused with his deepest feeling. To him, those sights and sounds weren't just examples of happiness, beauty and serenity: they *were* those things.

Constable had looked at this scene from childhood: the little group of buildings, the lock, the divided stream, the poplars, the willows. By shifting up and down the bank and across the river, over the years he found the themes for many of his greatest pictures.

As an artist he concentrated his attention on a few places and a few people, finding more and more in them. In this he resembled the Dutch, such as Ruisdael and Rembrandt, whom he called 'a *stay-at-home* people'. But there had never been quite such a stay-at-home artist as John Constable. No painter had ever found so much of his material in the landscape of his upbringing, indeed in one small corner of it.

He had studied this view of the mill from the lock in a series of little sketches done the previous year in East Bergholt. For his Royal Academy submission, he worked from these studies to make a more considered and finished painting. If necessary, he altered reality a little: thus he broadened the angle of vision to take in more of the view than an actual spectator beside the lock would have seen, or than he had included in his sketches.

Beside the lock he placed a young yellow-waistcoated angler, fishing line in hand. Just like this lad, the young Constable had fished on the Stour, a river full of coarse fish such as pike, perch, tench and rudd. Anglers, especially boys

and young men, appear in a remarkable number of Constable's landscapes. The sport was a calm one. *The Compleat Angler* by the seventeenth-century author Isaac Walton had as its subtitle *The Contemplative Man's Recreation*.

Angling was a perfect preparation for landscape-painting, which also involved sitting patiently in the countryside, waiting to capture something. Sitting by a river with a rod in his hand, an imaginative boy would absorb impressions – the reflections on water, the shadows beneath the willows, the smells, the sounds – while waiting for a bite. All of this was stored in his memory and re-emerged in richly concrete detail when prompted by some sensation or thought, just as the hero of Proust's great novel suddenly recalls his past when eating a biscuit dipped in tea.

Thus, praising a painting by the Dutch master Jacob van Ruisdael of a mill beside a stream, Constable described the whole image with the eye of a miller and relish of a connoisseur: 'a man & boy are cutting rushes in the running water (in the "*tail* water") – the whole so true clear & fresh as champagne'. There his mind passed from a technical description to a taste which brings with it a feeling: the exhilaration of sparkling wine. Looking at another watermill by Ruisdael, he could 'all but see the ells [eels]' in the pool of painted water.

Much the same could be claimed of the tranquil mill pond Constable himself painted now. Like many Dutch and East Anglian waterways, the Stour abounded with eels; the bargemen would spear them with a fearsome, bristling spike called a 'pritch'. One of the barge boys once caught thirty-one in a single hour at Nayland.

The most famous of all Constable's statements was sparked by the topic of fishing. In 1821 the younger John Fisher wrote, mentioning that he had been up to his middle in a

fine, deep New Forest river and as happy as a 'careless boy'. He caught two pike and thought of John Constable.

In reply, Constable produced an amazing sequence of free sensory associations: 'the sound of water escaping from Mill dams ... Willows, Old rotten Banks, slimy posts, & brickwork, I love such things'. He would, he went on, 'never cease to paint such places. They have always been my delight.' But much as he would have enjoyed the scene described in the New Forest, 'I should paint my own places best. I associate my "careless boyhood" with all that lies on the banks of the Stour.'

While Constable was completing his pictures in Charlotte Street and leading a domestic life with his sister Mary, Maria was pining for a letter. Since the enterprise of painting was now inseparably linked in his mind with a future with Maria, Constable did not feel he was neglecting her. In any case, until the paintings reached a satisfactory point he was not in the mood for writing. In times to come, he imagined, she would join Joseph Farington in offering valuable suggestions and criticisms of his work.

On 21 March, he finally broke silence after nearly a month. 'You are now too well acquainted with the pleasures and pains of my profession,' he told her, 'not to be aware of this anxious time. I am sure you will not only pardon me when I tell you my time and almost my thoughts have been so much occupied with the pictures which I intend for the Exhibition, that until I had in some degree conquered them I could not write to you with so much satisfaction.' Now that the painting crisis had passed, he longed to see her. When would they meet again? 'How the summer is to pass away (perhaps without seeing you at all, but that is impossible) I cannot bear to think.'

The separation, originally intended to stifle their relationship, was naturally having the effect of intensifying it. Longing, yearning, anxiety and affection were all increased in both their minds by the absence of the other, and particularly Maria since she had less to occupy her mind. In the interval between leaving London at the end of February and replying to Constable's letter at the beginning of April, she had become somehow warmer and fonder. Her salutation had changed from 'My Dear Sir' to 'My Dear John' (while his had mutated from 'Dear Miss Bicknell' to 'My Dearest Maria').

Maria resumed the correspondence with a confession: 'I began to be anxious to hear from you, distance is too apt to create imaginary ills. You will easily believe how happy I was to hear you express yourself pleased, and satisfied with your pictures.' She had now become a partner in his artistic enterprise, looking forward to hearing his comments on the other work in the exhibition.

There was little to report about life at Spring Grove. He already knew what an 'agreeable charming companion' Maria had in her half-sister Sarah. 'How backward to me appears the spring,' Maria noted a little wanly, 'but it is delightful to anticipate so charming a season, the gradual advance of the buds are very amusing to me in my often solitary walks.'

Twelve days later, not hearing again from him, she wrote once more, playfully demanding, in a manner very unlike the Maria of a few months before, another letter. 'You will be surprized to hear from me again so soon, but you know, it is quite proper you should see, what an impatient mortal I am.'

The paintings for the Royal Academy exhibition had to be submitted at the beginning of April. It was by no means certain that Constable's would be accepted by the jury as he

was not a member of the Academy, but he was feeling unusually sanguine. When he had dispatched the paintings to the RA, he told Maria, 'I go so far as to say, I was "pleased and satisfied with them." These are new sentiments to me, but I have done my best and they are gone to their audit.'

Fortunately, all four were accepted, so Constable moved on to the next worry, which was how they would be placed by the hanging committee. A good position helped a picture to be noticed, a bad one consigned it to near oblivion among the other thousand or so exhibits. The previous year, his quietly – too quietly – beautiful view of the Stour valley in early morning had failed to attract any attention – being hidden away, hung low in the anteroom. When Constable discovered where it had been put, he visited Farington in a terrible state: 'much uneasiness of mind' the older man had noted in his diary.

In East Bergholt itself, where the rectory garden was being altered, an amusing little scandal had arisen, 'a droll matter' as Mrs Constable described it. Peck the gardener had been making alterations to the lawn behind the house, and had taken it into his head to dig out two new flower beds there in the shape of a couple of large hearts. This piece of garden design was pronounced by Mrs Everard, who was embarrassed but perhaps not really all that displeased, to be 'truly ridiculous'. 'If he must make these places for flowers, why not ovals or squares – but two *monstrous* hearts!'

Mrs Constable imagined that the hearts were taken by 'commonalty' to stand for Dr Rhudde's and Mrs Everard's. 'Methinks,' she wrote to John, 'I have no objection to the Doctor's being touched by Cupid – as it may cause him to have a fellow feeling for *others* in the same situation.'

★

On Tuesday, 21 April Constable went to the King's Concert Rooms in Hanover Square to hear the first performance of a new work by William Crotch – a huge oratorio entitled *Palestine*. Since the composer had been renowned from childhood, and was already a famous man, though only a year older than Constable, there was considerable anticipation of this première.

Constable had reason to look forward to it himself. He was a friend of the composer, indeed the two men had collaborated on a performance of *Hamlet* for which Constable painted the scenery. It was, perhaps, one of the puppet productions which the versatile Crotch staged with music specially composed for the occasion.

Constable himself was musical, a fact that had some bearing on his art. In his youth, he had played the flute, although now that painting took up all his energies he had passed the instrument on to his brother Abram. But he remained unusually conscious of sound as an aspect of landscape.

One day, when he was writing to Fisher a rook happened to fly over Charlotte Street and triggered a flood of memory. 'His caw – (happening at the moment of writing to you) made me start; it was a voice which instantaneously placed my youth before me.'

Paradoxically, Constable's landscapes are full of sounds. There are birds – he was so fond of quacking waterfowl that, when his children finally arrived, his pet name for them was 'duck' – the rustle of leaves in the trees, the lapping of the stream, the noise, of course, of water leaking from the lock. His paintings contain a gamut of sensations: auditory, visual, physical, emotional and spiritual.

Constable was apt to think of painting in musical terms, perhaps because music is the most directly emotional of all artistic media. Could the histories of the fine arts be

compared, he thought, 'we should find in them many striking analogies'. Thus Elsheimer introduced a 'softer and richer style' of painting, which was brought to perfection by Claude, in the same way that Corelli prepared the ground for Handel. Constable described – beautifully – a painting of St Jerome by Domenichino in terms of distant harmony. 'The placid aspect seems like a requiem to sooth the spirit: its effect is like solemn music heard from an adjoining apartment.'

He wrote to Fisher of the sky in a landscape painting as 'the "key note", the standard of "scale" and the chief "organ of sentiment"'. By that, he meant that it gave the fundamental emotional tone in the same way that the key – C Minor, D Major – did to a piece of music. It might be a serene summer morning, a bright windy day in spring, a dark and stormy winter evening. The sky was also – here he changed the musical metaphor slightly – the most powerful voice in the orchestra (as it was in Crotch's *Palestine*), the rumbling and roaring organ.

Constable used the same analogy when describing a great landscape – again, a mill – by Rembrandt. Its 'powerful chiaroscuro', that is, the drama of light and dark, of this picture, he thought, was 'its chief organ'. To change the lighting of the picture – from dusk to full day, for example, would be as absurd as to think Beethoven's Sixth Symphony, the Pastoral, of 1808 'could be played by a trumpet, key bugle or any other boisterous & tumultous instrument'.

Constable's own *Flatford Mill from the Lock* was not a painting that could be compared to the sound of organ or brass. It was a visual equivalent to the Second Movement of Beethoven's Sixth, 'The Scene by the Brook', with its evocation of purling water and singing birds. Beethoven, whom Constable approvingly noted liked to compose out of doors, was a close contemporary, only six years his senior.

At the Hanover Square Rooms, there was some confusion at the start of Crotch's oratorio. The work began softly with pianissimo violins and double basses, over which the wood-winds slowly stole in – a subtle effect that was unfortunately not noticed by a large section of the audience, who did not realize the music had begun until silenced by a loud 'Hush!' from the others. A delicate and lyrical landscape painting could be overlooked at the Royal Academy exhibition in just that way, amid the tumult of clashing paintings.

At the concert hall Constable bumped into a fellow land-scape painter, Augustus Wall Calcott. Three years younger than Constable, Calcott had been a full Academician since 1810. Constable's four paintings, Calcott reported reassur-ingly, 'had very respectable situations' and he – fairly – kindly added, 'they looked very well, but rather dark and heavy'. Constable passed on the mixed compliment to Maria.

To add to Constable's rare satisfaction with his own achievements, he met Benjamin West, president of the Academy, in the street. West stopped to say that he had been 'much gratified' by the picture of the mill. 'He said it had given him much pleasure and that he was glad to find I was the painter of it. I wished to know if he considered that mode of study as laying the foundation of real excellence. "Sir" (said he), "I consider that you have attained it."'

The day after the première of Crotch's oratorio, 22 April, Constable made a record of the little household he had lived in that spring, consisting of himself and his sister Mary, which was now breaking up. Already, Mary had briefly left to visit their aunt, uncle and cousins of the Gubbins family in Epsom. On her way back to Suffolk, he 'detained' her, as he told Maria, for a few days more.

On that Wednesday he drew Mary three times in his lodgings at 63 Charlotte Street. In one sketch, Mary wears a

Mary Constable

dark dress with a thick fur collar as she sits reading a letter at an open drawer. The weather remained almost wintry, the temperature that day not climbing above 50° and dropping almost to freezing overnight. Even though she is indoors, Mary looks well wrapped up. In two of these tender little drawings she is wearing gloves.

By the end of April, the arrangements at Somerset House were complete. Officially, the Royal Academy was intended to inculcate a style of art derived from French and Italian old masters and classical antiquities: a manner based largely on depiction of the human figure. This was what the word 'academic' – with the overtones of conventional and boring – came to mean. That was the idiom upheld by Sir Joshua

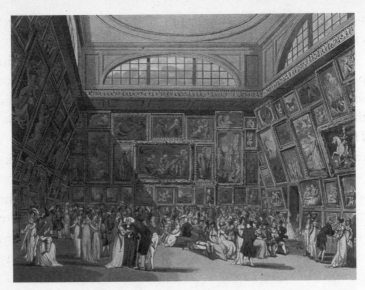

The Royal Academy: The Great Room

Reynolds in his *Discourses* (a book revered by Constable, even if he did not entirely follow its precepts).

The annual exhibition, however, revealed that there was no genuine stylistic harmony between the artists of the Royal Academy. Instead, there was a cacophony of diverse manners and idioms, each calling out for attention. In practice few artists produced the depictions of past battles, Bible stories and classical myth – collectively known as History Painting – that were theoretically encouraged. The reason was that there were few customers for such works. The majority of the exhibits were portraits and landscapes.

The pictures were hung four or five high, from floor to ceiling, in the Great Room in Somerset House at the top of the grand curving stairs, and five other spaces. Artists intrigued and sometimes furiously fell out in an effort to obtain prominent positions in this mosaic of diverse elements. But as Calcott had informed him, Constable had done

well in the hanging this time. 'My own landscapes have excellent situations,' he told Maria.

This year it was not Constable who was agitated about the position that his work had been given, but Turner, who had sent an extraordinarily audacious picture to the exhibition, the most daring so far of his career. Its title was *Snow Storm: Hannibal and his Army Crossing the Alps* and it depicted a cataclysmic tempest breaking over the mountains. The sky was darkened, the sun a copper disc, most of the canvas – seven feet across – was covered by the grey streaks of the blizzard scything down on the teeming, cowering figures of the Carthaginian army. This was not a contest between man and the elements so much as a metaphor for humanity entirely at the mercy of mighty natural forces.

It echoed recent history, since Napoleon had crossed the Alps with a French army fifteen years before, in 1797. The war, which had already continued for two decades, seemed to stretch out interminably into the future, with British defeat the only possibility in view. No one foresaw

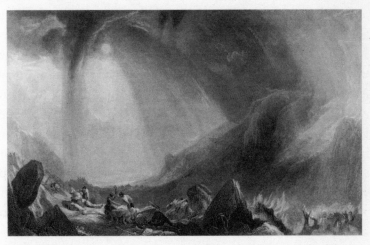

Engraving of J. M. W. Turner's *Hannibal Crossing the Alps*

that the final phase was about to unfold. At the end of June Napoleon's Grand Armée advanced eastwards towards Moscow. Within six months, Turner's picture of troops at the mercy of savage and unmerciful cold became reality.

Turner was extremely fussy about the position of his prophetic work. Farington and the other Academicians on the hanging committee were just remarking that it was seen to great advantage over a door leading from the Great Room, when Turner's emissary Calcott came along to say that unless *Hannibal* was hung beneath the line (that is, at eye level), Turner would withdraw it from the exhibition. They tried it in that position, thought it looked very bad – 'a scene of confusion and injuring the effect of the whole of that part of the arrangement'.

Finally, a compromise was reached and the picture put low down in a different room. As soon as the Academy exhibition opened at noon on 4 May, Turner's landscape was surrounded by a crowd of people. Constable, not being an Academician, had to wait for the opening before he could see the exhibition himself.

By the time he wrote to Maria on the Wednesday he had made two quick visits. He thought Farington's efforts 'heavy and crude' but better when seen from a distance; he admired the portraits by Lawrence and William Owen and some mythological pictures by Harry Thomson. But his most complex reaction was to Turner's *Hannibal Crossing the Alps*. He did not entirely know what to make of this, but he was impressed. 'It is,' he told Maria, 'so ambiguous as to be scarcely intelligible in many parts (and those the principal), yet as a whole it is novel and affecting.'

The truth was that in 1812, Constable was outgunned by his great contemporary, at least in terms of sensation and impact. In contrast to Turner's cosmic drama, *Flatford Mill from*

the Lock was tender, lyrical and true to a particular place.

It would have come as a surprise to every visitor at the Royal Academy that year to hear that in the opinion of posterity Turner and Constable were the twin giants of British art in that era. It would even have startled John Constable himself.

In his review in the radical *Examiner*, Robert Hunt, brother of the editors Henry and Leigh, was not entirely positive. 'Mr Constable,' he wrote, 'has much originality and vigour of style, but bordering perhaps a little on crudeness of effect.' However, he acknowledged, without that vigour of brush stroke, Constable would 'considerably diminish that originality and vigour so peculiar to himself. What he would gain in sweetness, he might lose in decision.'

Hunt seemed to know Constable was a flautist and perhaps had heard him compare painting with orchestration, because he went on to add that if Constable softened his 'tones and touches' his brush marks might resemble more the gentle timbre of a 'flute, but they would enfeeble their affinity with the trumpet. He would display more melody, but less brisk-ness.' This was acute and quite sympathetic criticism.

Exiled to the rural quiet of Spring Grove, Maria was obliged to follow these events from afar. She read the poem by the Bishop of Calcutta from which Dr Crotch selected his libretto for *Palestine*, and she imagined the delight Constable must have taken in this work of genius.

In her imagination, she walked through the exhibition rooms at Somerset House. Maria was a keen reader of the press, though she claimed that 'Newspaper criticisms I rarely attend to, for or against pictures, tho' their remarks are frequently entertaining'.

A little teasingly, she mentioned *Sadak in Search of the*

Waters of Oblivion, the title of a fiery, apocalyptic landscape by John Martin (a painter Constable particularly abominated). Were those memory-obliterating waters within her reach, Maria continued, she could not drink them. 'I have too long known the pleasure derived from a certain Gentleman's society to relinquish it.'

Just as Maria tracked John through London in her imagination, he was mentally accompanying Maria in her daily excursions into the park. 'I cannot tell you how glad I am that I have seen Spring Grove. You are by no means so lost to me as before – I can now walk with you to almost any part of the grounds, and I do not allow an hour to pass without being with you.'

He looked forward to the day when they would see the exhibition together, and she would comment on his work. 'I may have the happiness of enjoying and profiting by your real criticisms of some of my future pictures for other Exhibitions.' And he dreamed of telling her about his affairs, 'with your arm fast locked in mine', quoting – slightly wrongly as usual with his quotations – some lines from Cowper's *The Task*, evoking the pleasures of a long and close relationship.

Cowper imagined a couple arm in arm, their relationship cemented by twenty years' experience of each other's worth and virtues. Constable reminded Maria that at least they had talked, arm in arm. 'We have had that pleasure and may yet again.' For the present, he was happy, both with the exhibition and to be at least in intimate and loving correspondence with Maria. 'I have every reason to be satisfied with myself – especially when I consider how the last twelve or eighteen months have passed with me – but we must not think on troubles which I hope are past, but look forward to brighter *prospects*.'

★

On cue, nature began to smile. The cold winds and low temperatures that had prevailed for so long began to improve. By Friday, 8 May, Joseph Farington noted, the thermometer stood at 73°. Abram Constable, up in town from East Bergholt, reported that until then the oaks had shown scarcely any promise of leaf. The warm weather would soon change that. Shortly after the buds began to open, Constable encountered the poet William Wordsworth.

The two men were roughly of the same generation – Wordsworth was six years older than Constable – and they shared a patron in Sir George Beaumont, so it was inevitable that the two of them should meet from time to time. But Constable's first impression of Wordsworth had not been entirely favourable. He was introduced to him, in company with his fellow poets Coleridge and Southey, in 1806 on his expedition to Cumberland funded by his uncle David Pike Watts.

On his return, he remarked to Farington 'upon the high opinion that Wordsworth entertains of himself' and the sycophancy of Coleridge. Wordsworth had asked a lady to note 'the singular formation of his skull', and Coleridge had remarked that 'this was the effect of intense thinking'. Farington commented that, if so, 'he must have thought in his mother's womb'. Eventually, however, Constable, an enthusiastic reader of poetry, became more admiring of Wordsworth and Coleridge (he thought the latter's 'Ancient Mariner' 'the very best modern poem').

In the late spring of 1812 Wordsworth was staying with Sir George and Lady Beaumont at their London house, 34 Grosvenor Square, from 23 April to 8 June. One day, the poet and painter went for a walk together – the most likely venue being Hyde Park, conveniently close to the Beaumont mansion.

Then Wordsworth made a remark which stuck in Constable's mind so that he later repeated it to Maria and also to the engraver David Lucas. As the two men were walking 'by the side of a hedge the branches of which were just putting forth their green boughs', the poet remarked that wherever he turned his eyes, 'that profound expression of the Scriptures, "I am the Resurrection and the life" seems as if uttered near to me'.

The two men indeed had much in common. Wordsworth's 'Tintern Abbey' evoked a spirit in the natural world of the kind Constable sensed in the Poussin landscape.

> A sense sublime
> Of something far more deeply interfused,
> Whose dwelling is the light of setting suns,
> And the round ocean and the living air,
> And the blue sky, and in the mind of man;
> A motion and a spirit, that impels
> All thinking things, all objects of all thought,
> And rolls through all things.

But their native landscapes were unalike – the poet's bare sublime Cumberland as against the painter's cosy, agricultural East Bergholt – and so too were their media. Wordsworth's poetry was reflective, as he famously defined it, 'emotion recollected in tranquillity'. In contrast, Constable's paintings were packed with direct observation of detailed reality. He noted the surfaces of things – worn plaster on the wall of Willie Lott's house, gleaming light on water, the sun catching a mass of cloud, a dog trotting by. His paintings took you right into the natural world.

Maria touched on the blossoming of May and Constable's failure to appreciate it in Suffolk. 'Now shall I be cruel

and expatiate on the beauties this charming weather calls forth?'

On 8 May, young John Fisher wrote a letter inviting Constable to pastoral pleasures. On the first Sunday in June Fisher was to be ordained, and suggested Constable should accompany him to Wiltshire. 'You know I take no refusals,' Fisher added. 'All obstacles be they of whatsoever nature they may must be overcome by my impetuosity. But as some kind of animals lead better than they drive & as perhaps you belong to that class, I will try & coax you here by an account of the life we will lead.'

He and Constable could repeat the activities of the previous September. 'We will rise with the sun, breakfast & then out for the rest of the day – if we tire of drawing we can read or bathe & then home at nightfall to a short dinner.' They would have tea in the close or walk in the great cathedral. 'If the maggot so bites puzzle out a passage or two in Horace together. I think this life of Arcadian or Utopian felicity will tempt you, so come & try it.'

One of the bonds between them was that Fisher, like his uncle, was an amateur artist.

I took out a few colours the other evening & drew & coloured a landscape on the spot & am really pleased with it. It is rough of course – but it satisfies in some measure my eye. But tho' I am paying myself the compliment – I owe this pleasure to you – you fairly coached me & taught me to look at nature with clearer eyes than before I possessed.

Fisher was almost the first to experience what in the future many others would: through Constable's eyes he saw things he had not noticed before.

★

The spring season in London was interrupted by melo-dramatic horror. A little after five o'clock in the afternoon on Monday, 11 May, Spencer Perceval was just about to enter the lobby of the House of Commons. As he stepped through the door a tall man of about forty approached him, pressed a loaded gun to his chest and fired. The chief minister in the British government called out, 'I am murdered,' sank to the ground, groaned twice heavily, and died.

Many, both conservatives and radicals, imagined that the long anticipated and feared British revolution was upon them. In a London tavern, the poet Coleridge heard violent talk. 'More of these damned scoundrels must go the same way, and then poor people may live.'

At Spring Grove, Maria was just finishing a letter to Constable when the news arrived the following day. 'We have just heard the most alarming and dreadful piece of intelligence,' she wrote at the end, 'that Mr. Perceval is shot, tonight I fear will confirm the horrid truth.'

It soon transpired, however, that Perceval had been killed not by a revolutionary plot, though Luddites had vaguely thought of killing him, but by a lone madman, John Bellingham – who, despite his obvious derangement, was found guilty and executed on 18 May. The Bicknells, whose house in Spring Gardens Terrace was at the centre of official London, lived surrounded by soldiers for a while. Maria's mother wrote to her daughter, congratulating her on missing this bother. 'How happy you are to be enjoying the beauties of Spring Grove, while we have been living (at least for the last week) in constant alarms & confusion, surrounded by Guards as our only chance of security.'

In Constable's internal world there was a sudden squall, brought on it seemed as much by a persistent toothache as by overwork and a number of irksome tasks. More than

ever mindful of the need to make money, he was engaged on several commissioned portraits. One was of Bishop Fisher – a matter of gratification, as Fisher was a man of great prominence – and another of his uncle David Pike Watts. The latter job was proving more lengthy than it should have been, since the kindly but garrulous sitter insisted on their taking a walk together. The most tiresome task, however, had been dreamed up by Lady Heathcote (one of the Dysart clan), who had decided to ask him to make a copy of a portrait of herself as Hebe.

'She will not sit to me though she wants many alterations from the original,' he complained to Maria, 'but I can have prints, drawings & miniatures, locks of hair, &c &c without end.' Her sister Lady Louisa Manners soon came up with an even worse idea, namely that he repaint 'a wretched copy by Hoppner from Sir J. Reynolds'.

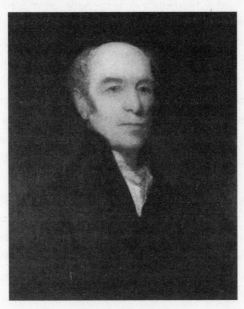

David Pike Watts

In a state of constant nervous tension and exhausted by the effort of preparing for the exhibition, Constable suddenly lost patience with waiting for Maria to send another letter and wrote her a curt accusation: the constant disappointed expectation of post from Spring Grove was making him ill. 'I need not add how much pleasure it would give me to hear that you are well, and that I may expect a continuance of your correspondence as it so materially affects my welfare.'

As it happened, this letter crossed with a loving one from her. This she followed up with another, making a counter charge of her own, that he had worried her about his health.

Why did you not my dear John write to me by Saturday's post, and take from my mind the weight of uneasiness that I feel on your account? You tell me that you are advised to try a change of air, and yet leave me more than a week without letting me know how you are, surely you would write before you left Town, and if you do not feel well, why delay immediately going to Bergholt, where good air and kind friends will combine for your recovery? I have so much faith in the place, that to know you are gone, is sufficient to think you well, even you cannot be fonder of it than I am. Believe me, in future you shall have no cause to complain of my silence, I have already suffered sufficiently from it.

John replied with what amounted to an apology. He had been in Epsom with his aunt and uncle the Gubbins, and he now felt back to normal. 'Perhaps I had confined myself too much, or what is more likely have been over anxious.' He quoted Milton's *Lycidas*: 'Fame is the spur.' The quotation, as Maria would know, continued to describe the desire for fame as 'that last infirmity of noble minds/To scorn delights

and live laborious days' – a fair description of Constable's London life.

His letter contained another accusation, however, not against Maria but her family. Visiting the Royal Academy with his sisters Mary and Martha, he had bumped into Maria's younger sister Louisa and they spent a good deal of time together before the Constable sisters departed to go shopping, which, John noted, they were 'bent on', and he left to spend the rest of the day with John Fisher.

Subsequently, however, he brooded. Why had Louisa not mentioned this meeting to Maria? If she had, surely Maria would have commented on the matter to him. 'I doubt not,' he exclaimed bitterly to Maria, 'but my hated name is completely anathematized' in the Bicknell household.

After observing Constable for many years, John Fisher gave his friend this wise character analysis: 'We are all given to torment ourselves with imaginary evils – but no man had ever this disease with such alarming paroxysms as yourself. You imagine difficulties where none exist, displeasure where none is felt, contempt where none is shown and neglect where none is meant.'

In fact, it turned out that Louisa had written to Maria just before setting out for Somerset House and hadn't corresponded since. When she did, as the latter touchingly replied, 'I cannot but think she will mention having seen you, knowing it will be pleasing to me.'

Constable could be thin-skinned to the point of paranoia, but his sensitivity also gave him an eye for absurdity. He told Maria about Fisher's whimsical letter – his 'enthusiastick friend' amused her – and repeated a comic example of ingratitude from East Bergholt. Mrs Roberts, the old lady who lived opposite the Constables, had died during the winter. One of her servants, being left a mere thousand pounds, was

outraged. 'My Mistress', this man expostulated, 'had better have left in her will that they should have been all hanged on a stage in front of her house'.

On Friday, 5 June Constable got up at dawn, left Charlotte Street at six and went for a country walk with his older friend the painter Thomas Stothard. Deafness made ordinary social life difficult for Stothard, who was now in his late fifties. Nature was his main release from the drudgery of book illustration, his main source of income. Sometimes he would call on Constable in the afternoon, full of high spirits and declare, 'Come, sir, put on your hat, my boys tell me the lilacs are out in Kensington Gardens.'

On this occasion, the two artists breakfasted at Putney, went over Wimbledon Common and spent three hours in Coombe Wood, south of Richmond, where Stothard caught butterflies – another hobby – and Constable sat down and made a delicate drawing of a gate, with hedges on both sides and trees arching over it. He had never, he told Maria, seen the trees in 'greater perfection', freshly in leaf, than on this early summer's day.

Maria knew the area well, since her family often stayed there in summer, and she thought Wimbledon and Putney 'the most beautiful place that the environs of London afford'. Touchingly, however, when she heard of it she worried about his taking such an arduous excursion. 'Perhaps you smile at my fears, who think it by far too long a walk for you to undertake.'

The food for the expedition – sandwiches – had been provided by Stothard and was carried by Constable, who was a keen trencherman when not pining for Maria. He began to eat one when they arrived at the wood, whereupon Stothard teased him for being a 'young traveller' unable to

resist breaking into their stores early. When the time came to eat, they settled down beside a spring.

As Leslie later recounted the tale, 'They found the water low and difficult to reach; but Constable took from his pocket a tin cup, which he had bought at Putney unnoticed by Stothard. The day was hot, and the water intensely cold; and Stothard said, "Hold it in your mouth, sir, some time before you swallow it. A little brandy or rum now would be invaluable." "And," Constable replied, "you shall have some, sir, if you will retract what you said about my being a 'young traveller'; I have bought a bottle of rum from town, a thing you never thought of."'

On this afternoon or, according to a variant of the story, on another such walk, as they sat 'in the shadow of a tree of rich foliage, Stothard looking up through the branches to the clear blue sky remarked to his companion, "You see Constable, it's all glazing, all glazing."'

It was an artist's insight – the beauty was just such as could be produced by floating transparent layers of paint, one above another. It was an effect that delighted Constable in a picture by Watteau, which looked, he thought, 'as if painted in honey, – so mellow – so tender – so soft & so delicious'.

On the way back, they went through Richmond Park and Constable drew another sketch of the prospect of the winding Thames on a sheet of paper a few inches across.

6

Birthday wishes from Maria arrived on Wednesday, 10 June, the day before the anniversary itself. Constable had hinted that his birthday was approaching, in case she had forgotten. But this, Maria protested, was quite unnecessary.

> I am sure my dear John you could never for a moment think I should forget the 11th, you might as well imagine the good wishes, you will receive on that day, to be more sincere than mine; who have felt for so long a time, the liveliest interest in your welfare, whose joys I have made my own, and whose sorrows I would gladly have borne. I wish you then the highest honors in your profession; and every bliss this life can bestow.

The sun shone on Constable's thirty-sixth birthday, and the temperature climbed to 76°. He had every reason to feel blessed, especially in comparison with his miserable situation a year before. Now he had regular assurances that Maria loved him dearly. Though they were separated by a day's journey, they were in close, indeed almost domestic, communication. His work was once more attracting attention.

The 11th was not only a hot day, but – something that always mattered to Constable – a day of spectacular skies. At Clapton Thomas Forster noted fleecy cumulus and light cottony cirrus clouds during the day, and towards evening also some level banks of cumulostratus. 'By sunset,' Forster observed, 'the clouds were highly coloured with a crimson

tint.' Constable was soon to turn his attention to setting suns.

The following day, his mother sent a prediction with her good wishes.

I thought of you particularly yesterday, it being the anniversary of *your birth*, which I still hope was under the influence of an auspicious planet. It will prove so, if you obtain a good wife – a gift, which a wise man tells us, comes from the Lord, & for which, you must think you cannot wait too long – therefore Patience must be your guide.

As high summer approached, Sarah Skey was keen to take her two sons to the sea, with Maria accompanying the party. The plan was that they would stay in London a while, then move on to the coast. This would obviously provide an opportunity for John and Maria to meet for the first time in four months. Constable, for his part, was chaffing to get away – not to the sea but to East Bergholt, where he could paint. The trees, he heard, were in a state of perfection there.

He delayed his departure partly because of the possibility that Maria and the Skey family might turn up, partly because of a number of tasks he had to complete. There was the portrait of the Bishop of Salisbury which he had finished by 10 June to the satisfaction of Fisher and his wife, who then kindly ordered a duplicate for the bishop's palace at Exeter, his previous see.

More tiresome were the chores he had agreed to do for Lady Louisa Manners and her sister Lady Heathcote – hack copying and alterations to other artists' work. As a result, he lamented to Maria, 'I shall lose all the fine weather, and I am making sad ravages of my time.'

137

On Wednesday, 15 June he was surprised by a call from his mother, who was staying with her daughter and son-in-law, the Whalleys at East Ham. This was an opportunity for her to inspect his new lodgings at 63 Charlotte Street, take a look at his work and – most enthralling no doubt – read his cherished collection of letters from Maria.

The sight of these led her to lament with renewed eloquence the harshness of their predicament. They had, indeed, few allies. Constable's father, as his mother made clear, still feared that this unsuitable romance would be the 'ruin' of his wayward son.

Unfortunately the review in the *Examiner* had come to the eyes of Golding Constable senior. The critic's remark that the picture of Flatford Mill 'wants a little more careful-ness of execution' had coincided exactly with his own doubts about John's efforts as a painter. Lack of diligence and attention to detail were faults that he as a businessman could easily appreciate.

To his father's mind, the agitation that love for Maria had caused in John – very obvious on his last visit to East Bergholt the previous winter – was the last thing that an artist needed. He required to be settled, and the endless anxieties of the affair were, to say the least, disquieting. David Pike Watts thought much the same.

Maria was stricken when Constable casually repeated Golding Constable's words. 'What can I say to what you tell me about your Father's sentiments? It distresses me more than I can say,' she sighed. 'Only tell me if it is in my power to avert any *ruin* from you, and I will do it.'

Mrs Constable was returning to Suffolk by the new fast coach the following Friday, and Constable, maddened with impatience at seeing the summer pass, decided to accompany

her. He planned to come back to London in the first weeks of July if Maria arrived in town.

The night before his departure, he dined at Joseph Farington's house. It was a delightful occasion, he told Maria, with several other artists present. Constable was seated between Lawrence and Benjamin West – agreeably exalted company – and the conversation was tinged with *schadenfreude*. The main theme was the pride and recent fall of Benjamin Robert Haydon.

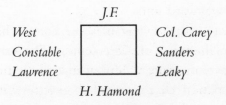

	J.F.	
West		*Col. Carey*
Constable		*Sanders*
Lawrence		*Leaky*
	H. Hamond	

In the absence of a more deserving winner than Haydon, the British Institution decided not to award the first prize of 300 guineas at all, nor the second prize, but to give another painter, named Joseph, a hundred guineas. Haydon and the other contenders got a derisory thirty guineas to cover the price of their frames.

Haydon's astonishment was 'extreme'. He had worked on the picture of 'Macbeth' for two years, and had counted on winning the 300 guineas with it, then selling it for 500 more. Since then, Constable related to the dinner guests at Farington's house, Haydon had been 'troubled with bowel complaints which are attributed to anxiety of mind'.

The feeling of the table was that Haydon had been shabbily treated by Beaumont and the connoisseurs of the British Institution: he had deserved to win, and had been thwarted only because of personal feeling. Benjamin West condemned the British Institution for withholding the award

from Haydon; Constable himself felt, he confided to Maria, that 'the judges had shown very bad passions'.

On the other hand, they had little affection for Haydon. He had attacked the Academy, which they revered, and had offended Constable with his arrogance. One day Haydon asked him why he was so anxious about his landscape work. 'Think,' Haydon said, 'what *I* am doing!' Haydon, Constable complained, 'is possessed with a notion that the eyes of the world are upon himself'. Not long after that exchange, the two men had stopped speaking to each other.

On Friday, 19 June, Constable and his mother caught a coach to Colchester in the afternoon, and by ten on a wet and windy evening they arrived at East Bergholt. Mrs Constable was amazed by the speed of the new conveyances. One had sped past her with such velocity that she did not have time to notice that her son Abram was seated on the roof.

Back in East Bergholt, little had changed. Except that next door to the Constables on the main street a girls' school was to open, run by Miss Taylor – related to Revd T. G. Taylor, the vicar of Dedham, who was in turn the nephew of Constable's old schoolmaster.

As always, much of the gossip revolved around Dr Rhudde. He was still being pursued by various middle-aged ladies in the locality, notably Mrs Everard, the same lady who had once sent a letter to Maria, 'favor'd by Dr Rhudde'. The sway that Mrs Everard held in the rectory Mrs Constable considered 'really surprising'. The previous week, there had been a party at the rectory, at which Mrs Everard had 'presided' as hostess, the main dish being a fine turbot sent by Maria's parents as a gift. The Constable family was not invited.

Dr Rhudde's attitude to the Constables in general was the subject of frequent analysis on Mrs Constable's part. She remained deeply suspicious of his motives and true feelings. 'Altho' he smiles and bows to us,' she mused, 'yet something still *rankles* at his heart, which I trust will never burst out whilst I live. I will at least be cautious to avoid it.'

Durand Rhudde was prone to harbour mysterious grudges. He denounced the late Mrs Roberts, a kindly friend to the Constables. 'She died,' fulminated Dr Rhudde, 'the greatest hypocrite in the world.' Next the rector became angry with the squire, Mr Godfrey, who, Constable told Maria, had committed a crime for which he would not easily be forgiven. Namely, he had had 'the temerity to visit Mr Eyre', an eccentric parishioner who kept a pet bear.

The rector's choleric disposition was perhaps an inherited trait, although this was an aspect of his family history that Durand Rhudde had little reason to advertise. Surprisingly, John Rhudde, the father of this pillar of the Church of England and virulent loather of Calvinism, had begun his career as a Nonconformist minister.

Indeed, had it not been for the contentiousness of John Rhudde, the career and perhaps opinions of his son Durand might have been very different. The elder Rhudde had been brought up as a Trinitarian dissenter – that is, a Protestant sect whose views about the nature of the Trinity were unacceptable to the Church of England.

In 1732, two years before the birth of Durand, John had found employment as the lecturer of a meeting house on Broad Street in the poor dockland district of Wapping. To support himself, he offered private tuition. In a note on the end of a *Lecture on Worship* John Rhudde published, it was discreetly advertised that 'The author at his house in Ratcliff Street in Ratcliff High Way London boardeth and fiteth lads

for trades the offices of the Revenue and the University. He teacheth the children of honest poor *gratis*.'

Two years later, his views on the Trinity had changed, and he was overheard expounding them at a coffee house, whereupon his congregation at the Meeting House immediately excommunicated him, finding 'our brother Rhudd guilty of heresy'. John Rhudde responded to this with sulphurous fury, expressed in the postscript to another published tract.

He excoriated the 'reverend *Machiavels* at the head of this particular Baptist interest; they are for doing as much mischief and murder, it seems, as they can, with as little noise as can be'. He became a Unitarian – that is, as he put it, a believer in 'one God, one mediator' – then a few years later regained his faith in the Trinity, was ordained into the Church of England and became vicar of Portesham in Dorset.

A man of varied talents, the older Revd Rhudde also published light verse, including an eccentric combination of gallantry, humour and religious allegory entitled '*The moral auctioneer; or, life a sale: verses occasioned by the sale of the house and furniture of Solomon Margas, Esq. at Melcombe Regis*', addressed 'to a Lady'. Over the years this clergyman added first an 'h' and subsequently the final 'e' to the family name, a piece of 'singularity' on his part in the view of his brother, who remained more plainly Sayer Rudd.

Thus the young Durand Rhudde and his brother Anthony grew up both members of the established church and with a silent 'e' adding lustre to their surname. Durand had a successful career, both academically and socially, at King's College, Cambridge, where he studied as a poor scholar. Both he and Anthony Rhudde made money by adroit manoeuvre, especially the strategic marriage of their sister

Deborah to Maurice Bogdani, Cambridge contemporary of Durand's and heir to the manor of Hitchin.

The married couple both soon died, leaving the estate to the Rhudde brothers. The Rhudde family frequently defended their interests in the law courts. Anthony and his wife endlessly contested a bequest in the Court of Chancery against Dr John Taylor, a wealthy clergyman from Ashbourne, Derbyshire and friend of Dr Johnson, who counselled, correctly, that the case was hopeless.

In short, the available evidence suggests the Rhuddes were eloquent, intelligent, vain, upwardly mobile, quarrelsome, litigious but with a romantic temperament. Such was the family of Maria's grandfather. Fortunately, of all those qualities she appeared to have received only the intelligence and eloquence – and perhaps the romantic disposition.

The morning after John arrived in Suffolk, his mother sent him over to the rectory to give his compliments to Dr Rhudde. The rector was soon to depart in his coach, with an entourage including his daughter Mrs Farnham, grandchildren, Mrs Everard, another village lady, the ex-curate Henry Kebbel and one of the present curates, for his summer rest at Cromer. He had recently bought a new pair of horses for his coach, the equivalent in Regency terms of a limousine. Though these cost £130, this was not quite as lavish a purchase as his daughter, Maria's aunt, had stipulated.

Mrs Constable wondered what Mrs Farnham would 'say when she laid such a *positive* injunction on her Father, not to think of a pair under eight years old – & these were only five'.

Mrs Farnham had inherited rather more of the Rhudde tendencies than Maria. She was snobbish, buoyed up by her marriage into the landed gentry of Leicestershire. She was

also – it might be deduced – avaricious. A marriage between Maria and John Constable, with the likelihood of poverty-stricken children resulting from it, was not a welcome prospect from her point of view. Any such great-grand-children to Dr Rhudde would be a drain on the inheritance her offspring had every reason to expect. Mrs Farnham, a frequent visitor to East Bergholt and also to Dr Rhudde's London house on Stratton Street, had her father's ear. Thomas, the rectory coachman, a useful source of information, confided that 'If it was not for some other people' – perhaps a reference to Mrs Farnham – 'the Doctor would not be so bad.'

On the Saturday morning, however, Dr Rhudde greeted Constable amiably, though the painter – like his mother – did not entirely trust his affability. 'Am I to argue from this that I am not entirely out of the pale of salvation?' he mused to Maria. Probably not, but this pretence of civility between the Constables and the rector was better, he suggested, 'than open war'.

Having paid this courtesy visit and others to the two curates, Constable resumed his quiet country life. In the mornings he went for walks with the three Constable dogs – his favourite was a pug named Yorick – whose behaviour was delightfully ridiculous, so joyful was the animals' anticipation of the treat.

He resumed his socially unsuitable friendship with John Dunthorne, the plumber, glazier and amateur artist, whose children were thriving and rapidly growing up. Constable took to one of Dunthorne's children, a fourteen-year-old also called John. This boy, Constable told Maria, was 'a clever little fellow and draws nicely all "of his own head"'. He was soon put to work as an assistant, grinding colours

in Constable's rustic painting room, next door to the Dunthorne cottage.

Most of all, Constable just took pleasure in the countryside around him, in 'this delightfull place'. 'Nothing,' he told Maria, 'can exceed the beautifull appearance of the country at this time, its freshness, its amenity – the very breeze that passes the window is delightfull, it has the voice of Nature.'

Constable obviously enjoyed both the coolness of the wind and its sound. Temperature was one of the qualities he appreciated in landscape, whether painted or real. A favourite of his from Sir George Beaumont's collection was a Claude with a goatherd piping under the trees on a hot day. Constable called it 'a noon day scene' which 'diffuses a life & breezy freshness into the recesses of the trees that make it enchanting'.

When the trees at the bottom of the younger John Fisher's garden blew down he mourned their demise as he had promised himself 'the passing of many summer noons in their shade'. Fanny Price, heroine of *Mansfield Park*, had similar tastes: she thought 'to sit in the shade on a fine day, and look upon verdure, is the most perfect refreshment.'

Constable and Maria continued to live a virtual life together. Two hundred miles away, she imagined his walks with the dogs even before he had taken them and his painting in the fields before he had even arrived. They co-ordinated their reading. Having seen Maria at Spring Grove reading *Thinks I to Myself*, a popular novel subtitled *A Serio-Ludicro, Tragico-Comical Tale* – not a bad description of their own romance – John read it too. He declared himself not disappointed. It was, he thought, something in the spirit of *Sandford and Merton*, the children's fable extolling virtue and the simple life, written by Thomas Day, one-time tutor

and suitor of Sabrina Bicknell, and read by all educated children of the day, including the young John Constable.

Hearing that John was reading Cowper's letters, Maria took them out again herself. The poet's emphasis on the pleasures of quiet countryside and pious love was just the note for that early summer. How could she not love Cowper, wrote John, 'for he is the poet of Religion and Nature'? 'I am always flattered, and pleased,' wrote Maria, 'when I find my taste coincides with yours.' She altered her salutation at the beginning of her letters from 'my dear John' to 'my dearest John'. They looked forward to meeting when the Skey family came to London, en route for the seaside.

Unexpectedly disaster struck at Spring Grove. Samuel, eldest son of Mrs Skey, suddenly died at the age of twelve. Unlike his younger brother, Arthur, he had not been a likeable child. Maria and Constable had thought him tiresome and spoiled. Indeed, she had been relieved when he had been sent to Bromsgrove to stay with a family who had 'kindly undertaken to do all in their power to amuse him, and keep him quiet'.

His sudden death altered everything. The calm, quiet household in which Maria had lived for the past year was thrown into grief and perhaps – Mrs Skey having sent the unfortunate Sam away – guilt. The balance of the relationship between the sisters altered. Rather than Sarah Skey advising and cheering Maria in her romantic troubles, Maria was now the one to comfort and console. Naturally, the plans for the holiday at the coast were suspended for the moment. There was therefore no immediate prospect of John and Maria meeting in London. Instead, a long summer of painting stretched ahead in Bergholt.

★

Disappointed in his hope of seeing Maria, Constable commenced what he termed 'a hermit-like life though always with my pencil in my hand'. He imagined himself, as he explained to Maria by letter, a second 'Swanevelt', thinking of a seventeenth-century Dutch painter who had lived in Rome and was known as the '"hermit of Italy"', from the romantic solitudes which he loved and which his pictures so admirably describe'.

Whether East Bergholt, a busy East Anglian village with a thousand inhabitants, could objectively be described as a 'romantic solitude' was doubtful. But to Constable it was. As far as possible he saw nobody, except his family and the Dunthornes, father and son, and devoted himself to painting nature.

It was a summer of sun and rain. The temperature often climbed over 70° but, as Thomas Forster noted in Clapton, in the last part of June and first three weeks of July the weather was 'changeable, and generally showery; at least there have been more days in each week that it has rained than there have been wholly dry days'. This incessant damp led to a bad harvest, which in turn resulted in raised grain prices, higher taxes and rates, greater hardship for the poor and increased social discontent. Metaphorical as well as real storm clouds began to pile up over the English countryside.

From the point of view of landscape painting, however, the wet summer was by no means a disaster. The combination of rain and warmth made the English countryside look richer and more lush than usual, meanwhile creating majestic cloud-dramas in the sky. Constable found the season 'charming'. 'How much real delight,' he exclaimed to Maria on 22 July,

I have had with the study of Landscape this summer! Either I am myself improved in 'the art of seeing Nature' (which Sir Joshua Reynolds calls painting) or Nature has unveiled her beauties to me with a less fastidious hand – perhaps there may be something of both, so we will divide these fine compliments between us – but I am writing this nonsense to you with a really sad heart, when I think what would be my happiness could I have this enjoyment with you. Then indeed would my mind be calm to contemplate the endless beauties of this happy country.

Constable had a paying job to do, a portrait of William Godfrey, the squire's son, who was a naval officer. This was completed just before the young man set sail for the West Indies, to everyone's satisfaction. Mr and Mrs Godfrey wrote Constable a letter thanking him and praising the painting, which he himself thought the best he had done. But he didn't want praise for his portraits, he wanted it for his landscapes. 'My father is always anxious to see me engaged in Portrait, and his ideas are most rational, but you know Landscape is my mistress – 'tis to her I look for fame, and all that the warmth of imagination renders dear to man.' The catch, of course, was that the poverty that his artistic mistress brought with her made a future life with his flesh-and-blood love, Maria, far less feasible.

Constable was 'perverse enough to be vain' of some of the studies he was doing at this time, going out in the early morning and late afternoon as he had found in the past that painting in the noon-day blaze hurt his eyes. On 4 July, a cool clear day, he painted the setting sun above a field of hay, the sky a delicate sequence of pinks, oranges, mauves and fading blues over a dark green land. Three days later, on the 7th, he made another study of a similar moment – the

sun a whitish blob in a salmon pink sky, a line of slate blue just above the horizon.

Constable was becoming more and more interested in the weather. The study of the clouds was a newly fashionable pursuit among gentleman scientists such as Thomas Forster and Luke Howard. But it had always been of enormous practical significance to those who made their livings from the land and sea. Often farmers could do little about bad conditions, such as the wet summer of 1812, though plough-men and shepherds were famously expert weather forecasters and could put their knowledge to practical use. To millers, as to sailors, a shift in the wind can mean catastrophe; the Constable family, of course, was concerned with both mills and boats.

As a teenager, Constable had been responsible for supervising the post mill on East Bergholt Common – the one visible from the rear of the Constables' house. This task he performed, it was reported many years later by his friend C. R. Leslie, 'carefully and well'. One of his first surviving works of art was incised with a pen-knife on the wood of East Bergholt Mill – the outline of the mill itself, plus his name, J. Constable, and the date 1792 (when he was sixteen years old).

The responsibility of looking after the mill, for which John was more suitable than his strange elder brother, Gold-ing, involved some of the skills required of the master of a sailing ship. A great deal depended on the strength of the wind. Too little and the mill would not turn; too much and its canvas sails must rapidly be furled, otherwise they might be blown to pieces like those of a ship in a tempest.

This was an operation that had to be performed on each sail individually as it was brought within reach of the

ground. The process took time, so advanced knowledge of what the weather was about to do was of enormous help. If the mill was turning fast in a strong breeze, it was difficult to stop it. There was a danger of the brake catching fire; sometimes the millstones were smothered with excess grain to act as a damper.

Brantham Mill

Thunder could be especially dangerous to a windmill, as the wind was apt to reverse as the storm passed over, ripping the sails to tatters if they were not quickly turned to a 90° angle from the blast, a manoeuvre known as 'quartering'.

When Constable looked at a painting by his beloved Ruisdael of windmills in the snow, he did not see just a pretty winter scene, but a specific set of conditions. He saw it, in fact, from the miller's point of view: the picture represented an approaching thaw. One of Ruisdael's mills had its

sails furled and was turned 'in the position from which the wind blew when the mill left off work'. The other, he went on, still has 'the canvas on the poles, and is turned another way, which indicates a change in the wind; the clouds are opening in that direction, which appears from the glow in the sky to be the south, (the sun's winter habitation in our hemisphere), and this change will produce a thaw before morning'.

So, in a landscape where others would see little more than an attractively picturesque view, Constable saw a description so accurate as to deserve the word 'scientific'. It illustrated a dictum that he profoundly believed: 'We see nothing till we truly understand it.' Ruisdael had understood so well what he had seen that his picture could be the basis of a weather forecast.

The same came to be true of Constable's own work. Late in life he had engraved and published a picture called *Spring*. The mill he depicted there was the one he had once supervised on East Bergholt Common. This was intended to give

an idea of one of those bright and animated days of the early year, when all nature bears so exhilarating an aspect; when at noon large, garish clouds, surcharged with hail or sleet, sweep with their broad cool shadows the fields, woods and hills; and by the contrast of their depths and bloom enhance the value of the vivid greens and yellows, so peculiar to this season.

Having described the beauty and the 'playful change' brought to the spring landscape by these clouds, he went on to describe what he called their 'natural history' and particularly that of those hail squalls.

Engraving of *Spring: East Bergholt Common*

The clouds accumulate in very large and dense masses, and from their loftiness seem to move but slowly; immediately upon these large clouds appear numerous opaque patches, which, however, are only small clouds passing rapidly before them, and consisting of isolated pieces, detached probably from the larger cloud. These floating much nearer to the earth, may perhaps fall in with a much stronger current of wind, which as well as their comparative lightness causes them to move with greater rapidity; hence they are called by wind-millers and sailors, 'messengers' being also the forerunners of bad weather.

Now, the painter's problem was of course not the same as a miller's. His aim was to integrate closely observed meteorologically accurate skies into paintings. Constable's originality was not in the accuracy with which he painted skies – Dutch painters such as Ruisdael had come close to that. It was in his realization that each fleecy billow and silky wisp, every silvery glint and mulberry shadow in the atmosphere above corresponded with a nuance of human feeling.

In the sky, Constable found more than just a metaphor for emotion in the billowing forms and constantly changing light. What he saw above could actually change his mood, leading him to break off a gloomy letter to exclaim in exhilaration: 'what beautiful silvery clouds are rolling about to day!!!'

In time the sky would indeed become the 'chief organ of sentiment' in his pictures – the element in his landscapes that set the emotional key for the rest. But to find out how to do this took him years, including much patient observation and experimentation.

During the showery summer of 1812, he painted rosy sunsets and rainbows, those perennial signs of hope. But by rainbows he meant, as he explained while praising the ones painted by Rubens, 'more than the rainbow itself, I mean the dewy light and freshness, the departing shower, with the exhilaration of the returning sun'. In other words, Rubens and Constable were evoking an experience that was meteorological and moving at the same time.

On 28 July, Constable painted a double bow leaping over East Bergholt common and the mill he used to run, set against lowering storm clouds of a rich dark blue-grey. And in this case, the promise of good fortune was not a delusion. Soon he would be seeing Maria again.

At the end of the third week in August Maria was briefly in London staying with her parents at Spring Gardens Terrace. She was passing through with her sister, Sarah Skey, and surviving nephew, Arthur, on the way to their delayed and now – after the death of Samuel – sad seaside holiday at Bognor. Constable hurried up from Suffolk to see her, which he succeeded in doing more than once. He called as in previous years on the Bicknells at Spring Gardens Terrace,

where there was, as he reported to his mother, an agreeable gathering.

Holidays were naturally one of the topics discussed. The rest of the Bicknell family had recently been in Brighton, and Mr Bicknell had heard from Dr Rhudde, who was still at Cromer with his party of ladies and curates. As it happened, Constable's friend Joseph Farington had also just begun a lengthy stay in the same resort on the Norfolk coast.

Dr Rhudde would have been mortified to know that, when Farington enumerated the people of note in Cromer that summer, he listed Constable's patroness the Countess of Dysart and other notable figures such as Dr Pearce, the Dean of Ely Cathedral, but not the rector of Bergholt-cum-Brantham, who was merely included among the 'respectable families & individuals but not of any rank above that description'. He might be nicknamed 'the grand Caesar' in his parish, but the elderly clergyman did not cut such a figure in the wider world.

Dr Rhudde had had the annoyance that one of his two new, but not very young, horses had died, apparently because of the exertion of pulling the Rhudde carriage with all the luggage and paraphernalia necessary for a long stay beside the sea. He decided to sell the other animal and in future hire horses – and always have four of them.

Constable managed to see Maria once more, on Tuesday 25th, in company with Mrs Skey, so it was possible to talk a little more easily. Perhaps because of the emotion of the occasion he walked off with her gloves, which she had given him to look after, in his pocket. It was doubtful, he wrote the following day, whether this meeting had made them any happier. The situation seemed as hopeless as ever. Many of his friends urged him to give up the attempt to make his way in 'a profession so unpropitious' – he had his father no doubt

particularly in mind – but that was impossible. 'Time seems very slow in helping us,' he summarized their discussion, 'and I thought we could scarcely discover the most distant gleam of sunshine on our prospect. Yet deplorable as our case is, I would not be without it for the world.'

In fact, the immediate effect of seeing each other again was to make both Constable and Maria more miserable. She arrived at Bognor in Sussex on a chilly day with a bad cold and in a state of depression. He found, when he had got back to Bergholt, that he didn't have the lightness of heart – the 'vivid pencil' as he put it – for landscape painting. Instead, he got on with another of his more lucrative local portrait commissions, to paint the little daughter of a local landowner, General Rebow of Wivenhoe Park outside Colchester.

Maria's spirits recovered as her cold diminished and the weather improved. Bognor, she discovered, was a delightful spot and essentially a brand-new one. It had been a speculation on the part of Richard Hotham, a successful hatter who had made a fortune, beaten Mr Thrale, husband of Dr Johnson's friend Mrs Thrale, to become MP for Southwark, and been knighted. Happening to visit this part of the Sussex coast between Brighton and Worthing, then only occupied by fishermen and farmers, he saw scope for developing it as a fashionable resort.

This Hotham did, constructing many elegant buildings, but with disappointing results financially. Profits failed to accrue and his fortune sank. Trying to recoup something, he entered into a long law suit with the Admiralty, in which Mr Bicknell naturally had a hand, to obtain part of the prize money from an enemy ship captured within sight of one of his own vessels. Eventually he lost, and faced with a huge bill for costs, died.

Bognor, on the other hand, flourished. Maria and the Skey family took up residence in No. 4 Rock Buildings. These were, as a guidebook explained, 'from their immediate contiguity to the sea and the comforts and accommodation they combine, generally the first let during the bathing season'. From Rock Buildings, which the same guide felt formed 'a handsome object on the coast', Maria and her companions could look over the beach to the Isle of Wight 'rising majestically from the ocean, its blue hills stretching out to the west' and beyond it the headland of Selsey Bill.

Constable, Maria and their contemporaries were drawn to the coast and the sea for similar reasons to those that attracted them to the inland countryside: it was simple, natural and therefore healthy, and also, if your mind had a scientific cast, of considerable geological, zoological and botanical interest. The benefits to the visitors' wellbeing were of obvious importance to Maria and her party since her own health was delicate and young Arthur had also been ill – though Constable hoped he would soon grow too big to be picked up and carried across the muddy London streets, as the painter had done last time he saw the lad. Mrs Skey, of course, was still recovering from her bereavement.

Bognor, according to the guidebook, was known for its mildness of climate and healthiness. The hills of the South Downs protected it from the cold northern winds. As a result, trees and shrubs grew luxuriantly on its shore, including such exotics as the tamarisk. Whereas – and here the guidebook went a little far – in rival Brighton 'exposed to the impetuous blasts of the ocean, scarcely a tree is to be seen'. At Bognor the invalid therefore soon found 'an increase of appetite and a renovation of health'. And indeed Maria soon felt better.

She did not have high hopes of the library provided by the late Sir Richard for visitors – containing 'a collection of the best modern publications' plus the daily newspapers and several reviews. Maria, who was inclined to be serious-minded, thought that 'a circulating library at these places very rarely furnishes much instruction'. But nonetheless she found 'a very entertaining correspondence' between Lady Hartford, to whom the poet Thomson dedicated his 'Spring', a favourite of Constable's, and Lady Pomfret.

She spent time with young Arthur on the beach. Mr Dally, author of the guidebook, was forced to admit that on the shore at Bognor 'the fossiologist will not receive much gratification'. Conchologists might sometimes come across 'a few scarce specimens' of shells, but only rarely, after storms. Marine botanists would find some interest in unusual aquatic plants such as *Focus albinus* or white seaweed. But he recommended the place unreservedly for its interesting pebbles.

Maria wondered whether John was a connoisseur or learned amateur in the study of these – geology being a fashionable branch of natural history. 'Arthur and I,' she told him, 'have amassed a fine collection, but we do not in the least understand their merits, but I am told some of them when polished are very curious, we have a noble Lord here, that does nothing but grope about for them, from morning to night.'

Geology came to be one of Constable's main interests later in life. It was an obsession of the age, which was crammed with amateur scientific investigators. The son of William Clarke, the blind master of East Bergholt school, known to the Constables as 'young Billy Clarke', grew up to become a clergyman, the Revd William Branwhite Clarke, famous as the father of Australian geology.

In 1812 Maria took more interest, as Constable did, in

meteorology. She had noticed the phenomenon, noted and analysed by Thomas Forster, of the ring, or corona, that forms about the moon in cloudy weather. The fishermen in Bognor, she informed Constable, 'call it a moonhound, but I suppose the learned have another name for it, it is a sure sign of bad weather, and it has certainly proved so'. There was indeed a scientific name, by which Constable named it when writing about rainbows, years later: 'that most beautiful and rare occurrence, "the lunar bow"'.

By the end of September, Maria was feeling very well and enjoying herself at the seaside 'exceedingly'. She took up her drawing again, which had been abandoned after the death of young Samuel Skey in the early summer, and began to sketch the scenery of Bognor. It was not, in her opinion – Mr Dally's enthusiastic descriptions notwithstanding – a particularly pretty place; she thought the 'greatest recommendation' of Bognor was that it was 'perfectly quiet'. The landscape around was very flat; she and the Skeys had not ventured far away, though Maria, who had a literary turn of mind, was interested by the village of Eartham seven miles away because the poet Cowper had once stayed there.

Constable was naturally intrigued by her account of the Sussex coast; he imagined Maria out with her paints just as she immediately thought of him sketching in East Bergholt when the weather was fine. 'A sea coast,' he told her, 'is always a subject enough for a pencil. I have a print hanging up in the room where I am now writing, a view of the shore at Skevening by Ruisdael, which gives me great pleasure. The waves are so well done that it is impossible to look at it without thinking on Bognor and all that is dear to me.'

He did not add that underneath his print were written some verses in French. They began,

> the ebb and flow that covers this beach
> Is a perfect image of the effect of love.

So perhaps as he looked at the picture on his wall in Bergholt, he thought of Maria and his heart, as the poem put it, was 'agitated like the waves of the sea'.

In Bergholt, the village community was returning to normal after the summer. A general election was in the offing. A carriage and four, festooned with blue and white Tory ribbons, appeared in the village and the Constable family's elderly gardener Prestney, who happened to be a hereditary freeman of Colchester and thus eligible to vote, was forcefully canvassed.

Constable did not express a political allegiance himself, though as he grew older he became more reactionary and more attached to the Church of England in its unreformed late Georgian condition. In this he resembled many of his contemporaries, such as Wordsworth, Jane Austen and Coleridge, though not others, including Byron and Shelley. The generation posterity has named 'Romantic' was split, politically, with some individuals migrating, as Wordsworth did, from one camp to the other. Broadly, one group hoped for a better state of society in the future, the other saw only chaos and danger in the modern age and sanctuary in the past.

With his instinctive preference for the landscape in the condition in which he had first set eyes on it, and his dogged affection for the Royal Academy despite its persistent rejection of him, Constable was a natural member of the second group. That did not prevent him from being a radical in his art, any more than it did Wordsworth or Jane Austen.

As he aged, he became capable of fits of splenetic prejudice

strangely reminiscent of Dr Rhudde. To Fisher, twelve years later, he wrote the following outburst:

A Calvinist is capable of anything – the *Revd* Dr Richardson of Dunmow, late of Dedham, was caught by Mrs Richardson – in bed with *their favourite* servant Bridget Hursell. Nobody however is surprised at the circumstances but Mrs R. herself, to whom he has of late been so very *affectionate*.

He disapproved of the Diorama, a novel entertainment invented by the Frenchman Louis Daguerre, on several grounds. Though 'very pleasing', he told Fisher, 'it is without the pale of art because its object is deception'. Then, 'the style of the pictures is French, which is decidedly against them'. Also, when he paid his visit, 'the place was filled with foreigners – & I seemed to be in a cage of magpies'. That last comment would have gone down well with Doctor Rhudde's old congregation, the Laudable Order of Anti-Gallicans.

Dr Rhudde returned from Cromer in a terrible temper after his exasperating experience with the new horses for his carriage. He was irritated by Squire Godfrey and infuriated by an elderly woman who intended to rent a house in the parish and insisted that she had once entertained the rector in Exeter. Dr Rhudde emphatically denied that he had ever been anywhere near that city. 'Is it not very shocking,' Constable observed dryly of the venerable clergyman and his female admirers, 'that at the age of four score we cannot descend quietly into our graves for the kindness of a number of old women?'

When Golding Constable senior tried to tell him about the success his son had had in painting General Rebow's

little daughter at Wivenhoe, and the gratifying respect he had been given by that gentleman, Dr Rhudde wouldn't listen to a word of it. 'The Doctor would not hear my name,' he told Maria, 'I fear I must have committed some new sin, or revived some old one.' Perhaps the rector had heard of his visit to Spring Gardens Terrace.

Dr Rhudde's mood, however, was volatile, possibly reflecting the progress of the election (he was a diehard Tory). A few days later, Abram Constable returned from a visit to the rectory, reporting that the old man was 'in the highest possible good humour'. John ran there until he was out of breath, he told Maria, so as to arrive before this propitious moment passed. He was 'graciously' received.

Mrs Constable paid a visit to the Bicknells in London; Mr Bicknell and Maria's brother Samuel were expected in Bergholt for Christmas and might return the call. Constable, however, did not hope for a softening of Maria's family's attitude to him. Their hostility was 'not to be affected by a few outward civilities'. But his mood was brightened by the prospect of seeing her once more.

Mrs Skey intended to pass the winter at Brighton. Maria, however, was increasingly concerned about the health of her poor mother, who had been an invalid for years, and was keen to see her again. She planned therefore soon to return to Spring Gardens Terrace. Constable accordingly prepared to leave Suffolk for London.

The Tory candidate was returned for Colchester, and the Whig, Mrs Godfrey's brother, for Suffolk (Abram gave an amusing account of the chairing of the triumphant member in Ipswich). The government, with Lord Liverpool now prime minister, remained Tory and its policy just the same.

Mr Eyre's bear died, mourned by its owner despite the fact that his body was covered by its bites. Constable

took Yorick and the other dogs for some final morning walks. On 31 October he painted another rosy sunset above the valley of the Stour. The next week he returned to London.

At quarter past five in the morning on 10 November 1812 Joseph Farington was woken by his servants. A fire was raging across Charlotte Street at No. 63, the house of an upholsterer named Richard Weight – and also of course Constable's London lodging. The blaze had begun about an hour before in the upholstery workshop behind the house, and spread with alarming rapidity despite the fact that there was no wind and the night was frosty.

When the inhabitants of the house discovered their peril, their first thought was simply to save themselves and get out. Then, seeing that there was a little time available, they tried to rescue what they could. Constable's first thought was not for his paintings but his writing desk, which contained his greatest treasures, Maria's letters. Then he turned his attention to calming down Mr and Mrs Weight, the latter in an advanced state of pregnancy, and both almost hysterical.

That done, he and Richard Weight, soon aided by neighbours, set about removing what they could. By this stage, the flames were roaring behind the house, and the staircase was beginning to smoulder. They were just carrying down the copy of Hoppner's portrait of Lady Heathcote, a tiresome job that Constable had been putting off finishing for months, but an awkward one to have burned, when the window over the stairs exploded with the heat, showering Constable with glass. Nonetheless, they got the picture out and Constable ran over the road with it to Farington's house.

On his return, he encountered the servant who lived in the attic and had been nursing the heavily expectant Mrs Weight. This poor woman had left all her wordly possessions in her room, and was especially distressed at the thought of losing her savings, which she kept under her pillow. Gallantly, Constable plunged into the building, which was now filled with smoke, and emerged a few minutes later carrying her valuables. Only then, an hour after the alarm had been raised, did the fire engines arrive.

At that date, there was no municipal fire service, but since the Great Fire of London there had been private arrangements organized by the five London insurance companies. These would come to the aid of their customers – Mr Bicknell, for example, insured his house at 3 Spring Gardens Terrace with the Sun – but naturally with less alacrity to the uninsured. Mr Weight, it turned out, was covered against fire, but not fully protected. The ex-Thames boatmen employed by the insurance company managed to extinguish the flames and save the front part of the structure. The back and the workshop were severely damaged and their contents destroyed, so the Weights had suffered a heavy loss.

Constable, though somewhat blackened by smoke, was unhurt and had managed to save all his property. His first thought, after a largely sleepless night and a good deal of drama, was to dash off a letter to Maria in case, looking through the newspapers in the library at Bognor, she should see a mention of the fire in Charlotte Street and be alarmed.

In fact, though the major conflagrations common in London at the time were reported in the press, Maria did not find this one in the newspapers at Bognor, though she was touched that Constable rushed to reassure her. She did not have a high opinion of journalism, though she read a good deal of it. 'They are always glad of news and I believe

the more melancholy the better, if one may judge by the list of accidents that too generally shock our feelings in the public papers.'

Constable's life quickly returned to normal. His uncle David Pike Watts offered him a bedroom, and Mr Henderson, a dentist who was also a neighbour in Charlotte Street, let him have a room to paint in. He wondered whether to join the Weights, whom he felt sorry for, in temporary accommodation. Meanwhile, his longing for Maria was becoming almost frantic.

How would his journey to London have been cheered, he lamented in a letter to Maria, if he had been travelling to meet her,

the only object of my affections, in comparison with whom every other person is indifferent to me, and on whom I have so long fixed all my hopes of happiness in this world – after a hideous and melancholy absence. But inexorable fate has ordered it otherwise, and observations upon it are worse than useless – for I have long since learned a silent submission to its dictates.

But this of course did not prevent him from continuing to inveigh against their cruel fate.

While fire disturbed the microcosm of life at 63 Charlotte Street, a great conflagration and a much more prolonged and icy frost were slowly changing the direction of history. The Emperor Napoleon and his Grand Armée had successfully invaded Russia during the summer. They reached and captured Moscow at the end of the season. It looked, briefly, as many in London had predicted, like a fresh triumph for Napoleon. But the Russians failed to surrender. Then on

14 September the huge city, largely built of wood, caught fire: either because of Russian sabotage or French looting, or a combination of the two.

It burned for four days, destroying the French army's winter quarters. Napoleon and his vast force were forced to retreat, under enemy attack, through territory already pillaged of supplies. Soon, as temperatures fell, a cataclysmic disaster unfolded in the manner prefigured by Turner's painting of Hannibal in the Alps: a battle as much of man against the elements as of man against man. Soon, rumours circulated in London of terrible scenes. French troops died in tens of thousands. Joseph Farington heard a report from Vilna of 16,000 corpses piled up in one place while enough fuel was collected to burn them. There were other such funerary heaps elsewhere. The streets of Vilna were almost impassable, so full were they of the bodies of men and horses.

The war that had waged for almost all of Constable's and Maria's adult lives was entering its final stages. It would last for some years yet, but the conclusion was coming into sight. The Battle of Salamanca in July, at which Lord Wellington, at the head of British and Portuguese troops, inflicted a serious defeat on the French army in Spain was another indication that Napoleon's power was faltering.

Constable took little apparent interest in such matters, except when his own cousins of the Gubbins and Allen families were engaged in battle. He was of a naturally patriotic and conservative turn of mind, but his attention was directed during these years to the struggles of his private and professional life. His talent, in any case, was not suited, like Turner's, to painting epic conflicts between man and fate, but to quiet contemplation of fields, trees, clouds, old locks and small rivers.

Constable did, however, think of his own dogged campaign for acceptance as a painter in military terms. That summer his father had offered him a 'pretty little house' in Dedham if only he would leave London – an attractive offer to a man who hated the metropolis and loved to live as a hermit in rural seclusion. But, like a general in a last-ditch defence, he told Maria that such a retreat from the urban art world was impossible: 'I will never leave the field while I have a leg to stand on.' The military analogy stuck in his mind; on another occasion he wrote to Fisher, 'I am in a field that knows no flinching or affection or favor. "Go on", is the only [voice] heard – "aut Caesar aut nullus"': either Caesar or nothing. Painting, to him, was a struggle for glory.

But he was about to be diverted from his other campaign – to bring Maria to the altar – by a naval engagement of a painterly kind. His portrait of young Lieutenant William Godfrey had been so well received that Mrs Godfrey, the sitter's mother, a great supporter of Constable's, had persuaded another officer in the area, Captain Thomas Western of Tattingstone Place, to sit for a portrait.

Constable was inclined to make a joke of this commission. To paint Western's maritime complexion, he told Maria, 'I must procure a supply of the crimson, ruddy, and purple tints and of the deepest dye.' The picture might take a long time as it was to be full-length and the captain was a very *large subject* (this remark, originally made by Mrs Constable, he thought good enough to repeat to Maria). He had arranged to leave London for Suffolk on 14 December to start this important but unwelcome task, but he very much hoped to see Maria before that.

She was now on the point of leaving Bognor, where the 'boisterous weather' of late autumn was rapidly driving the

company away. The winter there was, she heard, damp and 'aguish', which was not an environment for someone whose lungs were as delicate as hers.

In October Constable had suggested he might make a flying visit to the resort – repeating his successful descent on Spring Grove the previous year. Gently and reluctantly, Maria had forbidden this. Even the compliant Mrs Skey might draw the line at such a move.

How shall I reply to what my heart would give so ready an assent to, were we differently situated, but as it is, had you not far better, not, 'find me at Bognor', I do not think my sister would like it, and as we shall meet so soon in Town prudence whispers you had better not come, unless indeed you could produce the certificate of a physician that sea bathing was recommended to you, but I am far happier in finding you are perfectly well.

Though Constable protested that he had in mind only meeting her, as if by accident, on the street or beach, she thought it better to wait for a few more weeks. But she, more than he, was conscious that even this more cautious policy was risky. For the last year they had been in constant communication, and occasionally met, but during that time she had lived almost always in the company of the kind and understanding Sarah Skey.

This would soon change. Maria would leave her half-sister and nephew to winter in Brighton, which Mrs Skey probably felt a less melancholy way to spend the dark months than alone in Worcestershire, and return to her parents' house in London. There would be far more pos-sibility of seeing John; on the other hand, she would be under the eye of her mother and father, neither of whom

had changed their minds about this unsuitable romance.

The only alteration was that her mother's health had further deteriorated, making it all the more painful for Maria to deceive her and go against her wishes. Maria was under emotional siege by her parents on one side and John on the other. He had become dependent on her calm and sanity, 'that peace of mind' as he put it, 'so peculiar to yourself and which you have so much the power of bestowing upon others'. But that equanimity would be hard to maintain in Spring Gardens Terrace, with her mother pitifully ailing inside and John striding fretfully in the park in case Maria went out.

She hoped, however, that it would work out all right, though at the same time she feared it would not. 'How much pleasanter,' she began, 'it will be than having so great a distance to part us.' Only to recall immediately that they had previously agreed that 'the reverse was the better plan, so that I rather doubt the proposition I am now going to make, but however my dear John we must try it'. And that improbable scheme was 'not meeting often in London'. 'You perfectly well know,' she continued brightly, 'what terrible havoc it makes with your time, indeed it will not be such a season for walking so that the temptation will not be so great.' This optimism was soon put to the test.

On 1 December, Maria, Mrs Skey and Arthur arrived in London – the Skeys only to pay a brief visit. The next day, Constable, lurking in the drizzle, met Mrs Skey, Louisa and Catharine Bicknell while they were taking a walk, but not Maria, who was confined indoors with a cold which had gone to her chest.

Maria was stricken; Constable's disappointment and

agitation can be imagined. He immediately wrote with a proposal for an appointment. 'My time is not so valuable as yours, I will walk in St. James Square at 2 o'clock whenever I can get there till I see you.' But it was apparent that, though twenty-four years old, intelligent, well-read and in a profound relationship which had now continued for three years, Maria was virtually a prisoner.

'Suppose,' she suggested tentatively,

We say Friday, if it is tolerably fine, if not I shall have no chance of getting off the Terrace, for I never go out without first having permission from Mamma. Thus, my dearest John, have I detailed to you some part of my difficulties, which certainly increase, instead of diminishing. To see dear Mamma in such a bad state of health is a very great sorrow to me, to know and feel the wretched uncomfortable state you are placed in on my account is more distressing to me than any thing I feel myself.

They finally met the following Saturday. Maria considered that, under the circumstances, it was no bad thing if their trysts were infrequent. Mrs Bicknell after all had a point: a young woman with a weak chest and a cough had no business going for walks on damp December days in the London gloom.

The difficulty of escaping from Spring Gardens Terrace and the well-intentioned tyranny of her Mamma was compounded for Maria by the knowledge that Constable was wasting time that should be spent on painting, instead hanging around the long since vanished pond in St James's Square, hoping she might come in view. She made light of the question.

I am well convinced for our mutual benefit that we should not often see each other, it is this alone makes me support the privation with tolerable *good humour*, but your time is infinitely valuable to me, I cannot have it lost, *the genius of painting* will surely one day or other rise up against me for *too often* keeping one of her *favourite* pupils from a study that demands his exclusive attention.

They managed one more encounter, on the 11th, before Constable departed for Suffolk. Understandably, in the frustrating circumstances, it was fraught. 'I was happy to meet you yesterday,' Constable wrote,

and yet it is impossible to part without a pang. Our fate is hard to meet so seldom and then only to add to our mutual discomfort.

How much I regret the absence of her who never sees me (even in this unpropitious scene) without a smile of affection and kindness – surely that heart which never meets me without benignity and love must prove a lasting solace and comfort to me in future. When shall I ever be worthy enough to make it amends – but my Maria let us think on happier times, when we shall look back to all this as a storm that is past. I am always distressed and vexed with myself when my sudden sensations escape me, that look like impatience or anger – but you know my heart & I trust you will forgive me.

Maria worried, in an almost wifely manner, about the 'cold, sad journey' he would have on the coach to Suffolk. To save money, Constable was often in the habit of riding outside the vehicle. But Maria hoped 'the *new great coat*' she had seen him wearing would keep him warm. They were

now in the strange, and unsustainable, position of being at once quite a cosily established couple and simultaneously being forbidden – like teenagers – to meet or communicate.

Christmas in East Bergholt was a season of conviviality. The day itself was always kept at East Bergholt House as a serious family occasion. Golding Constable senior liked to see as many of his offspring as possible gathered around his table. No other guests were invited except his old and trusted confidential servant Mr Revans and his wife. In 'former years Revans used to dance the youthful John Constable on his knee. The old country greeting of 'Merry Christmas' was heard in the home and in the village.

After Christmas, Constable went back to Tattingstone Place to complete the portrait of Captain Western. The finished result resembled a large, upright lobster wearing naval uniform and showed conclusively how little the painter was suited to this style of formal portraiture (more relaxed and intimate images of people were another matter).

When he returned to East Bergholt he found the neighbourhood in the middle of a New Year round of balls and routs. Mr Wainwright gave a dance on the evening of Friday, 15 January to which Constable, who usually avoided such occasions, was invited as well as his more sociable siblings Abram and Mary. The latter so overdid the party season that she returned from a ball in the nearby village of Bures completely done in. As Mrs Constable reported some time later, 'Mary has not yet overcome her Bures trip on the light fantastic toe, such an instance of debility I think I never saw – she seems scarcely but half alive, tho' I am thankful to see she is gaining ground.' At Mr Godfrey's house one of her dance partners was Maria's brother, Samuel Bicknell.

At the rectory, Dr Rhudde, now a hale octogenarian, had

long been maintaining in the most respectable way a circle of female admirers. On reflection, he had replaced his set of horses after all, and his coach was used to transport his favourite, Mrs Everard, and her 'fair friends', as Mrs Constable called them, backwards and forwards. When calling at the vicarage, Mrs Constable found 'Mrs. Everard and her fair friends, sitting with their work table, *quite at home*'.

Mrs Everard explained that the doctor was so fond of one female acquaintance, Mary Francis, that he wanted to have her there almost always, and 'she was so delicate that she could not bear the evening air' – hence the need for the coach. There was a slight threat in this to Maria's inheritance – and her siblings' and cousins', for that matter. What if the old man should marry again to one of these 'village maidens', to use Mrs Constable's term?

That, however, was not what worried Mrs Constable. There was an ominous element in the jollifications, like the low rumble at the beginning of the fourth movement of Beethoven's Sixth Symphony, which announces the coming tempest to the merry-making peasants. The sixteen-year-old Samuel Bicknell had been a visitor in the village for over a month, and had not once called on the Constables, though he had been friendly enough when they met elsewhere. Obviously, his grandfather hadn't sent him. Therefore, as Mrs Constable explained to John, 'I was obliged to suffer that violence to the real courtesy of my nature, and not ask him, for fear of a refusal.'

Dr Rhudde was affable enough. When shown the portrait of Lieutenant, soon to be Captain William Godfrey, he remarked in a kindly, though perhaps rather condescending fashion, what an excellent likeness it was, and said to Abram that if his brother John could 'paint such portraits as these he may get *Money!*' The underlying message, however,

was clear: without money, no romance, no marriage, no Maria.

At Spring Gardens Terrace, all the Bicknells had colds. Maria had not seen John, nor heard from him for over a month. She wrote wistfully, almost coquettishly, asking for news and regretting their separation. 'I think I may say without *flattering myself too much*, that you have regretted not being able to write to me, it is a month now, since we have heard of each other, we, that used to write so frequently, but I trust this new year, will not steal on much farther, without my having the great satisfaction of knowing you are well.'

Constable replied, looking forward to the pleasant walks they might have in the park or St James's Square – always assuming that Maria's invalid Mamma would let her out – as the winter was a mild one. He returned to London in the third week of January, and almost immediately the impending catastrophe struck. Maria's cold had, as usual, gone to her chest. Constable was filled with anxiety. He sent a cascade of worried messages to the Bicknell house. As ill luck would have it, Mr Bicknell, not Maria or one of her sisters, was the one who received them from the postman.

There was the predictable row. Mr Bicknell had never given his permission for this correspondence. It had continued surreptitiously, with the connivance of Mrs Skey, for over a year. The unsuitable romance which he had intended to halt had carried on and become deeper until now he found a frantic and unwanted suitor virtually hammering at his door.

The tone of Maria's next letter shifted from fond to agonized. She wrote to explain that she could not keep the tryst he urgently requested. 'The weather will account to you, for not seeing me this morning. I cannot think what it

is you have to communicate to me, my heart is too much shut to joy, to admit it easily.'

Her message was bleak:

You know not the mischief my dear John you are doing both yourself and me by writing so frequently, it has always so happened that Papa has been the bearer of your letters, and he has consequently expressed his disapprobation of it, then let me beg, and intreat you will not suffer me to feel the pain of hearing your conduct blamed, or myself reproved, by a Father who even in anger is mild. I am sorry I grieved a heart as feeling as yours by a *childish* recital of maladies, which a little care, and attention, will I doubt not entirely remove.

All she could suggest was patience:

Farewell dearest John, *may* every blessing attend you, and in the interest I feel in your welfare, forgive the advice I have given you, who I am sure are better qualified to admonish me. Resolution I think, [is] what we both stand most in need of, to refrain for a time (for our mutual good) from the society of each other.

The letter ended with a plea: '*Pray do not answer this.*'

And that, for the time being, was that. Charles Bicknell wrote barring Constable from 3 Spring Gardens Terrace. His letter was, Constable felt with justification, an insulting, humiliating document, a terrible letter. There was to be no more correspondence with Maria, so meetings by pre-arrangement were impossible. It was a return to the position of eighteen months before – except now at least they knew they loved each other.

★

The winter and early spring passed gloomily. Constable completed his main picture for the Royal Academy exhibition. Once more – for the third time in four years, and by no means for the last – he returned to the small stretch of the river Stour around his father's first watermill. 'I am sure you will laugh,' he had written to Maria in the more carefree mood of the previous summer, 'when I tell you I have found another very promising subject at *Flatford Mill*.'

In fact, he had merely turned through 180° from the angle of vision in last year's picture of the mill, so that he was now looking up the river with the wooden gates of the lock in the foreground. A few yards along the bank, two young boys sat angling, peering down into the stream.

Once more, he returned to his 'careless boyhood'. The phrase, which rapidly became a cliché, seems to have

Engraving of *Landscape: Boys Fishing*

originated in a poem called 'Retrospection' published by Charles Abraham Elton in 1810.

> Is there who, when long years have past away
> Revisits in his manhood's prime the spot
> Where strayed his careless boyhood, nor in trance
> of recollection lost, feels silent joy
> flow in upon his heart?

The whole poem is close to Constable in spirit, so much so that it could almost be a description of his painting. Elton's Thames-side idyll includes a 'well-known tuft of trees', 'grassy bank', 'whispering sedge', 'faint bird's note', 'the ripple of the stream' and 'elms whose high boughs murmur with leafy sound that sooth'd me when a child'. It is hard to believe that Constable and Fisher did not have this in mind when they put quotation marks around the phrase 'careless boyhood'.

But the notion that childhood was a time of innocence and happiness was part of the intellectual spirit of the age. Wordsworth felt it too: 'trailing clouds of glory do we come'. It lay behind Rousseau's idea that education should emerge from within, rather than be imposed from outside (and hence the unfortunate upbringings of Dick Edgeworth and Sabrina Bicknell). John Constable clearly felt his own early life had been a time of idyll on the banks of the Stour.

It was one of those winters when everybody seemed to be ill: not only the Bicknells had colds, but so too did Thomas Lawrence. Sir George Beaumont complained of influenza. Turner was seriously ill with an infection prevalent at the time named 'Malta Fever'. Joseph Farington suffered from a long and debilitating stomach disorder causing diarrhoea

and cold sensations on his face and hands. The Bishop of Salisbury, Constable thought 'much out of order' and 'much altered in his look', attributing it to the bad behaviour of the bishop's charge, Princess Charlotte, daughter of the Prince Regent and heir to the throne. There was a lot of talk about Princess Charlotte. Lawrence, who had been introduced to her, thought she had the manners of a 'hoydon'.

There were good reasons why the inhabitants of London should be unhealthy, quite apart from the epidemic of tuberculosis. They were living in a city of a million inhabitants – in many ways the first modern industrial city – but with medieval arrangements for sewage, water supply and burial of the dead and with an atmosphere heavily polluted by coal smoke. According to Constable's friend Fisher, the surgeon John Abernethy thought that 'there is not a healthy man in London, such is the state of the atmosphere & mode of life.'

Constable had other, more personal reasons for illness. He went down with 'rheumatism' in his head and face, which his mother attributed to 'standing about'. She was probably right and this complaint resulted from loitering in the park, Spring Gardens Terrace or St James's Square in the faint hope that Maria might suddenly appear and they could snatch a few words of conversation.

Very occasionally, they did. But by mid February, Constable had more than just neuralgic pains. He, too, had gone down with a miserable streaming cold. His mother felt just then 'all the world has had a cold of some sort' but her son's was 'the worst sort, because the most painful'.

It was less draining, however, than the emotional situation in which he found himself.

Your virtuous & honorable love is so sadly requited as not to obtain for you the admittance of a Gentleman to her

Father's house, never having been guilty of anything to for-
feit that character. While you are thus harassed, thus opprest,
thus unsettled ... your every ideas so clouded, that should
be bright – how can I be otherwise, than sad, on your
account?

On 22 April, a legal epic finally came to its conclusion. On
that day Charles Bicknell and his legal partner Anthony
Spedding finally had funds ready for distribution to the heirs
of Richard Smith. It was now thirty-seven years after he had
died and seven after the death of Charles Bicknell's client,
Charlotte Smith. Two of her children, Charlotte Mary and
Lionel, had continued the case in Chancery. It was a victory,
but a Pyrrhic one: of the original fortune of £36,000 little
more than £4,000 remained.

It was not until 3 May, the day the Royal Academy ex-
hibition opened to the public, that Constable plucked up
courage to write to Maria once more. By that time the
private view had come and gone, attended by, among others,
Princess Charlotte accompanied by her lady attendants and
the Bishop of Salisbury. Constable's paintings were very well
thought of.

Benjamin West had told him, most gratifyingly, that it
was his opinion and that of the entire council of the RA that
this year he had made 'an advance'. In the admittedly slightly
biased view of John Fisher, now the incumbent of Osming-
ton, a parish on the Dorset coast, Constable's *Landscape: Boys
Fishing* was exceeded by only one other painting, Turner's
main exhibit that year, *A Frosty Morning. Sunrise.*

In this uncharacteristic but marvellous piece of work,
Turner abruptly switched from the sublime apocalyptical
mood of his triumph of the previous year, *Snow Storm:*

Engraving of J. M. W. Turner's *A Frosty Morning*

Hannibal and his Army Crossing the Alps, *Frosty Morning* was a picture of ordinary English countryside, precisely observed. It amounted, like Constable's landscapes, to the portrait of the light and air at a certain moment in time: in this case, a winter dawn.

It was, Turner later said, a scene that he had seen and sketched while travelling by coach to Yorkshire. Day was just breaking in a clear, milky sky. The trees were leafless. Some workmen had commenced digging in the hard ground; their cart and some horses were waiting close by, one trying to graze some withered grass from the ground. A man leaning on a gun and a young girl stood watching these unexceptional activities. Looking at it, the viewer seemed not just to see the landscape but also to *feel* the morning – its icy clarity, the exhilaration of the new light, the delicate transparency of the air.

As John Fisher put it to Constable, *Frosty Morning* was 'a picture of pictures', but he added quickly, 'you need not

repine at this decision of mine; you are a great man like Napoleon and are only beaten by a frost.'

Despite the praise he had won, the account of the exhibition Constable gave to Maria was woebegone, almost despairing. 'I am afraid all these fine things come too late to make any impression upon me,' he lamented. 'Life indeed hangs very heavy on my hands.' He was in a mood in which even his success made him gloomy. 'Might I not do much more could this load of grief and despondency be removed from me and I be once more put in possession of my own mind – would this might happen before it is too late!'

That last phrase sounded ominous indeed. Was he hinting that without Maria he would die or simply give up the struggle to paint? However, within a week, Constable's mood was transformed because he had been to a dinner.

On the afternoon of 8 May a distinguished company assembled in the galleries of the British Institution at 52 Pall Mall. The occasion was the grand opening of an exhibition devoted to Sir Joshua Reynolds. It was the first such retrospective ever to be held in Britain, and the first ever to honour the work of a British artist.

One of the leading spirits in this commemoration of Reynolds had been Sir George Beaumont, who revered Sir Joshua greatly. A friend and disciple of the great man when young, Beaumont had adopted from Reynolds a mission: to found in Britain a great school of painting in the tradition of the old masters. Sir George strongly recommended his own friends and protégés, such as Wordsworth and Constable, to read Reynolds's *Discourses*.

The works of Reynolds had been gathered together from stately homes, royal palaces and noble collections. At the opening, some of his subjects were also reunited, looking

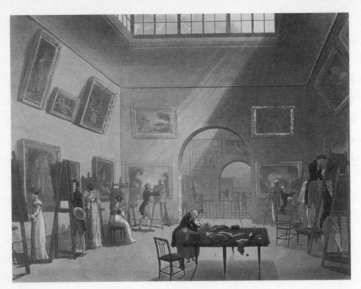

The British Institution

older than when they had sat for their portraits. The politician, courtier and playwright Richard Brinsley Sheridan was there, and pointed out to Joseph Farington that Sir Joshua had reckoned his own portrait one of the best.

The prime minister, Lord Liverpool, was present; so too were Viscount Castlereagh, the Bishop of Salisbury and the great collector and arbiter of taste Thomas Hope. All the Royal Academicians had been invited, and most – Turner, Lawrence, Nollekens, Flaxman, West, Ward – had come. So too had John Constable, who had been given a ticket to the reception and dinner by his rich uncle, David Pike Watts, who preferred to present gifts in kind rather than cash, perhaps not wanting to blunt his nephew's ambition.

At five o'clock, the Prince Regent arrived and was led up the stairs to the galleries, then around the exhibition by the Marquess of Stafford, president of the British Institution. He seemed, Constable thought, agreeable in manner. He

watched him shake hands with many guests, in 'an easy familiar manner'. The prince seemed, Constable thought, 'to admire the pictures and particularly some portraits'.

Dinner followed at seven. The whole company walked from the galleries down the narrow street of King's Place to Willis's Rooms in King Street where the meal was to take place. A covered way had been set up to protect the guests from the weather. Once there, they milled around searching for the places where they were to sit, which were marked with cards.

The Marquess of Stafford took his seat in a gilded chair, with Flaxman's statue of Reynolds placed behind it. The banquet comprised two courses, each consisting of numerous dishes, accompanied by champagne, claret, hock, Madeira and port, and followed by a dessert of ices and oranges. While the meal was eaten, musicians played soft airs. Next came the toasts, to the king, the royal family and then – extraordinary honour for art – a painter, 'Sir Joshua Reynolds, to whose superior abilities (which had carried painting almost to perfection) was added the great *urbanity* of manner.'

Constable thought the elegant young Earl of Aberdeen made an excellent speech, arguing that, although Reynolds's art looked very different from the masterpieces of ancient Greek sculptures and the Renaissance, yet he ranked with them and shared the same aim, 'namely the attainment of *Nature, Simplicity & Truth*'. So modern British art could rival the best of the past, and did so through just those qualities which Constable himself valued: simplicity and truth to nature.

At half past nine the prince returned to the exhibition, followed by the rest of the diners. There they joined the ladies, not invited to the actual dinner. Among these was the great actress Sarah Siddons, whose portrait by Reynolds

as *The Tragic Muse* was among his most ambitious works.

Constable stayed on after the prince left at about eleven. He talked at length to Sir George Beaumont and the Bishop of Salisbury. The Hon. Augustus Phipps, brother of Sir George Beaumont's friend and Haydon's ex-patron the Earl of Mulgrave, approached him, introduced himself and thanked Constable for the pleasure that his painting in the RA exhibition had given him.

Then the newly famous poet Lord Byron was pointed out to him. Byron was there to see Lady Melbourne, who had recently been his ally in the affair – now ended – he had conducted with her daughter-in-law, Lady Caroline Lamb. (He may also have had a fling with Lady Melbourne herself, though she was over sixty.)

Byron's letter to arrange the meeting was certainly flirtatious. 'I <u>must</u> see you at Sir Joshua's.' Reynolds's portrait of Lady Melbourne at seventeen hung on the wall, and the poet gallantly claimed to fear the sight of her in youth as she did enough damage more than forty years later.

Byron's poetry 'is of the most melancholy kind', Constable mused, but showed 'great ability'. He left after midnight in a state of exaltation, which was still apparent five days later when he wrote once more to Maria. It was dangerously soon after his previous communication, but surely the occasion – a vindication of everything he believed in – merited it? 'You are well aware,' he told her, 'that every event of my life that delights me I partake of in imagination with you.'

In the enthusiasm of the moment he felt that Reynolds's paintings showed 'the finest feeling of art that ever existed'; here was 'no vulgarity or rawness and yet no want of life or vigor'. In short, this was 'the triumph of genius and painting'. He exhorted Maria to see the exhibition and form her

notion of great painting from it, and said he longed to see Reynolds's pictures with her.

Constable and Maria met briefly at the Royal Academy exhibition. She was worried by his appearance: he was once more looking pale and thin, as he had two years before, and as he did in the self-portrait he had given her then. He, on the other hand, was heartened by seeing her. She looked so reassuringly healthy and contented that he began to feel happy himself.

'Believe me,' he told her,

> my beloved Maria I will make every exertion to render myself worthy of you, and will endeavour to bear my sorrows like a man – for your sake, who have suffered so much for mine. A man should be cast down for nothing but *guilt* and where is the crime of loving you? On the contrary I congratulate myself on being capable of loving one who is so virtuous, wise and just. I know not that I have acted otherwise than as a man of honor from the moment when I first declared that I preferred you to all the world.

No longer cast down, Constable wrote boldly to Maria's father, asking in polite terms for permission to communicate with her, and for an appointment to talk to him about the situation. Mr Bicknell replied, agreeing to neither request. He was a man who understood very well how to deal with such matters.

Charles Bicknell also knew – none better – how marriages were arranged. As it happened Joseph Farington's friend Daniel Lysons, a clergyman, antiquary and literary figure, who had inherited lucrative family estates in Gloucestershire, was preparing for his second marriage. He was to wed

Josepha Cooper, who was nineteen years his junior and had a fortune of about £4,000. Miss Cooper had been recommended to him as a spouse by a third party, and had agreed after briefly hesitating about the proposal. Mr Bicknell and his legal partner, Anthony Spedding, had been engaged to draft the documents for this businesslike arrangement.

Charles Bicknell had a hidden legal hand in a surprising number of people's affairs; he even played a tangential role in an illicit romance of Lord Byron's. There were murky secrets in the poet's private life, Farington heard. In his youth there had been 'deviations from propriety which would not have been excused at another period of life' – by which he meant affairs with fellow pupils at Harrow. Now, having already broken with Lady Caroline Lamb, Byron was about to begin an affair, not only adulterous but also incestuous, with his half-sister Augusta Leigh. This took place in the following months at her husband's house in Six Mile Bottom, a place described by the poet as 'a bleak common near Newmarket'.

Augusta's husband, Colonel George Leigh, had been, like Charles Bicknell, a member of the Prince Regent's entourage. In 1809 His Royal Highness had scribbled a note to his secretary, Colonel McMahon, for Bicknell to arrange the settlement putting Leigh 'in possession of the premises of the Six Mile Bottom, which I have given him'. This, the prince added petulantly, despite 'the ungrateful return I have met with from this man'. Shortly afterwards Leigh cheated him over the sale of a horse and they ceased to speak.

On 24 May 1813, Constable and Farington went to pay a visit to Turner's private gallery. This was an imposing space in his house on the corner of Harley Street and Queen Anne Street, seventy feet by twenty, extending into the back garden. Turner was not the only artist to have such a personal showroom – Fuseli, West and Northcote had similar arrangements – but it was impressive evidence of his professional success. Most years he put on a parallel exhibition of his own work here at the time of the Royal Academy show.

There, they ran into Turner's father, sixty-eight and generally referred to by Turner himself as 'Daddy'. The relationship between the Turners, father and son, was close and curious. The older man, retired from his former occupation of running a barber's shop on Maiden Lane near Covent Garden, now acted as cook, handyman and gardener for his famous offspring. He had, he announced, that morning walked the eleven miles from Turner's newly built villa at Twickenham.

Another visitor to the Turner gallery was interrupted, while being shown round by the artist himself, by Turner senior, insistently announcing that the painter's supper – a chop or steak – was ready. Constable's friend C. R. Leslie related this anecdote: 'Turner's father looked in through a half-open door and said, in a low voice, "That 'ere's done."' Turner took no apparent notice, and continued to attend to his visitor. 'The old man's head appeared again after an

interval of five or six minutes, and said, in a louder voice, "That 'ere will be spiled."'

Turner was not particularly welcoming to casual visitors; potential customers might be a different matter. On a later occasion, when Constable called to canvass his support in a Royal Academy election, Turner was unwilling to let him in. 'He held his hands down by his sides – looked at me full in the face & asked me what I wanted, *angry* that I called on a Monday afternoon ... he then held fast the door.' Constable himself, more sociable, was apt to be distracted by callers who dropped into his painting room, then stayed chatting. 'Morning flies', Maria called them.

There was another person who might sometimes be spotted by visitors to Turner's house, a young girl who was thought 'to be a relation' because of her resemblance to the artist. This was the twelve-year-old Evelina, the elder daughter of Turner and his mistress Sarah Danby.

The painter's private life was a well-concealed secret. He lived with a motherly older woman, a widow named Sarah Danby nine years his senior, and her children, two of whom were his, the rest fathered by the late Mr Danby, a musician. This *ménage* had existed for nearly a decade before even that assiduous noser-out of information about everybody, Joseph Farington, caught a whisper of what was going on. Turner never married Sarah Danby, nor acknowledged her existence in public, but one daughter was apparently included in his work: a friend who noticed Evelina hanging around in the background thought she had a resemblance to the little girl in *Frosty Morning*.

Turner and Byron were very different, but in matters sexual the two great men's attitudes were similar. Both had enough money to do as they wished and neither had conventional religious beliefs. Byron came from a class above

that at which chastity and marital fidelity were considered of great importance. Lady Melbourne condemned only the scandalous openness of her daughter-in-law's affair with the poet; the liaison itself was to be expected.

Turner behaved with the freedom that later became known as 'bohemian'. His private drawings demonstrated an interest in the female body at least as strong as Constable's life studies; some were openly pornographic. But his art shows no interest in women as people (which Constable's did). In Turner's *Venus and Adonis* attention is focused sensuously on the naked body of the goddess, but her face (except for one eye) was oddly, indeed disturbingly, obscured.

Turner's feelings about women may have been coloured by the fact that his own mother had been so difficult, angry and apparently deranged, that he and his father had eventually consigned her to Bedlam, where she had died. He seems to have transferred his filial attachment to the Royal Academy, which he had first attended as a student at the age of fourteen. Haydon attacked the Academy by which he felt slighted, for which Turner never forgave him, muttering passionately, 'He stabbed his mother!'

Turner positively disapproved of marriage. 'I hate married men,' he grumbled to James Whitmore the engraver. 'They never make any sacrifice to the Arts, but are always thinking of their duties to their wives and families or some rubbish of that sort.' His view about this couldn't have been more different from Constable's. There was in fact as wide a range of attitudes about sexual relationships in early nineteenth-century Britain as there was about every topic of importance: art, politics, religion, nature.

At this time Maria was concerned with family affairs. The Bicknells went to Brighton for a day to see Mrs Skey, whose

step-daughter Mary was going to marry an officer in the County Clare militia. Another family excursion was to the speech day at Harrow, where Samuel was happily at school. Soon, she, her mother and sisters would depart for rural Richmond for their health.

In between, Maria managed to get to the British Institution to see the Reynolds exhibition, which 'delighted and enchanted' her, though she would have liked to see it in the evening by candlelight, as some of the Bicknells' friends had done. These nocturnal viewings were extremely popular. Joseph Farington went twice, on both occasions finding the room full of art-lovers such as Sir Uvedale Price, the celebrated pundit on the picturesque, the collectors Samuel Rogers and John Julius Angerstein, and the Bishop of Salisbury and his wife.

Constable too was planning to leave for Suffolk, but his departure was delayed by an unexpected flurry of work. For almost the first time in his life as a painter he was making a little money, though from portraits not landscapes. He charged fifteen guineas a head, which was little enough, but he told Maria with a touch of pride, 'I am tolerably expeditious when I can have fair play at my sitter.' As a result, for once he had some surplus cash, was out of debt and hadn't had to call on his father for money for some time.

He had eventually completed the two copies for Lady Heathcote – one of a portrait of her mother by Reynolds, the other of a picture of Lady Heathcote herself by Hoppner (the canvas which had been begun the year before, abandoned and rescued from the fire). Although these were not in a full sense his own works, Constable was nonetheless pleased that they dominated Lady Heathcote's drawing room at Grosvenor Square. 'They have magnificent frames,' he boasted to Maria, 'and make a great dash.' There was to be

what Lady Heathcote described to Constable as 'a little dance' (that is, a grand ball) at the beginning of July, when Constable's pictures would be seen for the first time in public.

Lady Heathcote was also taking a friendly interest in the redecoration of 63 Charlotte Street after the fire damage. Constable was planning a modest version of the sort of painter's showroom that Turner had at Harley Street. He was himself, he told Maria, 'indifferent to show' but everyone insisted on it. The drawing room would have salmon-coloured wallpaper and, on Lady Heathcote's advice, a crimson sofa and chairs. The painting room would be in purple-brown, 'not sparing even the doors or doorposts, for white is disagreeable to a painter's eyes, near pictures'.

Another of the Tollemache clan, the countess's brother, Henry Greswold Lewis, of Malvern Hall, Solihull, suddenly showered work on Constable. Lewis was a man of some acumen and discernment who fastened on artists of great talent. He was apt, however, to set them strange and unsuitable tasks.

He had met the architect John Soane while on the Grand Tour in Italy, and subsequently gave him numerous commissions, some of which were never executed, others built then afterwards demolished when Lewis took against them. One wonderful architectural oddity that survived was a brick barn designed in the primitive classical style of the Greek temples at Paestum.

Some of the tasks he gave Constable were equally bizarre. Lewis was obsessed by his teenage ward, Mary Freer, of whom Constable painted a delightfully fresh and charming portrait – showing what he could do in the face-painting line given a congenial subject and the right mood. However, Lewis also suggested the weird idea, which he got from a

London jeweller, that Constable might paint one of Miss Freer's eyes on a shirt stud for him to wear.

Lewis was a vain man as well as an odd one, and had ordered another version of his own portrait – the third to date – from Constable. He also wanted a portrait of a relation, the Revd George Bridgeman. This, Constable told Maria with pride, 'far excells any of my attempts in that way, and is doing me a great deal of service, as these are people connected with all higher circles'. No doubt, he was making the best of things, but still he was in far better spirits than he had been for most of the previous six months.

Just before he left London for Suffolk, on Monday, 28 June, Constable dined in the Council Room at the Royal Academy. This in itself was a fresh sign of acceptance and sufficient reason to improve his mood. The dinner was for Academicians, associates and a few prominent exhibitors at the exhibition (who might be expected to become members of the Academy in due course). Farington presided at the head of the table, with James Northcote at his left. Constable had the architect Jeffery Wyatt on one side, Turner on the other and Wilkie, West and Lawrence across the table.

The evening was a success. The food was good, the wines approved, and Constable, for the first time, had an opportunity for a lengthy conversation with Turner. He was, he reported to Maria, 'a good deal entertained' by the other, much more celebrated landscape painter. 'I always expected to find him what I did – he is uncouth but has a wonderful range of mind.'

It is not quite clear what he meant by 'uncouth'. It did not then necessarily mean coarse and bad-mannered, as it would in the twenty-first century. Dr Johnson's eighteenth-century *Dictionary* defined the word as meaning 'odd, strange,

	A Chalon
Bone	J Chalon
H P Bone	Moses Haughton
Dawe	Arnald
Drummond	Heaphy
Simpson	Green
Bigg ·	Jackson
Wilkie	Wm. Daniell
Stothard	Shaw
West	Howard
Dance	Turner
Lawrence	Constable
Woodforde	Jeffery Wyatt
Thomson	Edridge
Calcott	Westmacott
Northcote	Philips
	Owen

J. Farington

unusual'. Other contemporary meanings included 'awkward or clumsy in bearing' and, of literary style, 'unpolished'.

Turner could be all of these. He was notoriously hard to understand. 'Turner's thoughts,' his friend George Jones remarked, 'were deeper than ordinary men can penetrate and much deeper than he could at any time describe.' 'The same mystery,' felt the painter David Roberts, 'that pervades his works, seemed to pervade his conversation.' Turner's lectures on perspective at the Academy were famously impossible to follow, partly because of his muttered delivery, from which only his directions to Sam Strowger the porter searching through his rolls of drawings – 'Next illustration please; no, not that one, *that* one . . .' – clearly emerged. Those illustrations, though, were beautiful.

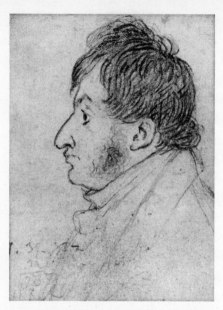

J. M. W. Turner by C. R. Leslie

A cockney genius nurtured in a Covent Garden barber's shop, Turner was a man of great intellectual power hampered by inarticulacy. At first glance, he looked nondescript: 'short and stout', according to Leslie, with 'a sturdy, sailor-like walk'. Indeed, his whole demeanour suggested a Thames boatman. But a second look would reveal how mistaken this first impression had been. There was 'far more in his face than any ordinary mind . . . that peculiar keenness of expression in his eye that only belongs to men of constant habits of observation'.

Constable constantly changed his mind about Turner and his work. Sometimes he was doubtful, as he had been over *Hannibal* in 1812, sometimes exasperated, sometimes torn. 'Turner is stark mad – but with ability,' he exclaimed one year, as his 'picture seems painted with saffron and indigo'. Another summer, 'Turner has never given me so much

pleasure – and so much pain.' Eventually, he made the best comment ever uttered about his great rival's late works: 'he seems to paint with tinted steam, so evanescent, and so airy.'

At bottom Constable respected Turner, while at the same time being wary of him. 'I deeply feel the honour of having found an original style & independent of him who would be Lord over all – I mean Turner – I believe it would be difficult to say there is a bit of landscape that does not emanate from that source.' Turner's view of Constable was not recorded, but is unlikely to have been so favourable.

The two men, nearly exact contemporaries and equally great as painters, were in many ways opposites. Turner was a natural watercolour painter, master of delicate transparency – Constable's phrase 'tinted steam' was exactly right. Indeed, this very tendency had caused a prolonged attack on Turner and his followers by Sir George Beaumont, ever opinion-ated, who called them 'the white painters'. Constable, on the other hand, was one of the supreme manipulators of oil paint, thick and glutinous, excelling at the evocation of earth, foliage and heavy masses of cloud.

He was, even more than the seventeenth-century Dutch, the painter of a specific terrain. Constable was almost as rooted to the banks of the Stour as the willows he depicted. Turner, on the other hand, was a wanderer, ranging over Britain and, when hostilities permitted, France, Germany, Switzerland and Italy in search of subject matter. He never had a conventional household of the kind Constable so wanted to set up.

All in all, it is tantalizing that the letter to Maria did not describe more of what these two painters had to say to one another. Few conversations would have held such interest for future art historians.

★

On the last day of June, Constable departed for Suffolk. Two days later, there came news that Lord Wellington and his army had won a great victory over the French near the Spanish town of Vittoria. Farington was at the British Institution viewing the Reynolds exhibition by candlelight at the time. The news rippled round the room, which contained the prime minister, Lord Liverpool, the campaigning MP William Wilberforce, the exiled Swiss-French authoress Madame de Staël, a renowned opponent of the French Emperor, plus Lawrence, Uvedale Price and others. There was 'much mutual congratulation'. Napoleon's power was beginning to crumble.

For the next few days, London was illuminated in celebration with special splendour at Carlton House and the Spanish embassy. In this atmosphere of euphoria, Byron who, as a proponent of Napoleon's, was not elated, attended the waltzing party at Lady Heathcote's house in Grosvenor Square on the evening of the 5th. The event turned out to be memorable, more so indeed than the hostess had expected. Lady Caroline Lamb, spurned by Byron, either did – or according to her own account, did not – attempt to commit suicide in the supper room. Varying rumours rapidly started to circulate. She had stabbed herself with scissors; she had tried to cut her throat with a broken jelly glass; she had had to be removed from the premises in a straitjacket.

Byron kept his invitation card as a memento of the night 'Ly. Caroline performed ye dagger scene of indifferent memory.' Understandably, neither he nor anybody else took much notice of Constable's copied portraits in their smart frames dominating the drawing room.

The summer and autumn passed quietly; Maria in Richmond, Constable in East Bergholt. She visited Hampton

Court to see the Raphael Cartoons and inspected Lord Fitzwilliam's collection of paintings. As a complement to the Reynolds exhibition, Maria read James Northcote's life of the painter, whom he had known well. He had mentioned the publication to Farington while Constable was talking to Turner at the Academy dinner. Northcote confided that it was too close to Reynolds's death for him to write as freely as he otherwise might have.

Farington, and his friends Lawrence and West, all of whom had known Reynolds, thought it a poor performance, 'vulgar and made up by compiling from others'. They met on 20 July to eat dinner at the Inn on Shooter's Hill near Greenwich to celebrate the fiftieth anniversary of Benjamin West's first meal in England on arrival from America, via Italy, and his first view of the vast sprawl of London.

West observed that over that half century artists had 'become a different description of men, so much more decorous in their deportment and in their reception in society' (a generalization that did not entirely apply to Turner). The establishment of the Royal Academy had done much, he thought, 'in giving dignity to the Arts'. In other words, painters were going up in the world. This was a point Constable was most anxious to convey to the Bicknell family.

Lawrence assured West that he had maintained more personal dignity in society than Reynolds, his predecessor as president of the Academy, ever had. Reynolds, thought Lawrence, was a 'very worldly man'. Both he and Northcote, in hinting that he could not write openly, perhaps had in mind the late Sir Joshua's close friendships with various famous courtesans. Maria, knowing nothing of all this, thought the book 'extremely entertaining' – and the reading public agreed. She recommended it to Constable for the long winter evenings.

Her family continued to ail. Louisa, the sister one year her junior, was suffering from headaches and staying with Mrs Skey at Hastings. Mrs Bicknell's health was deteriorating still more; she made a note to herself that she would spend next summer at Brighton, 'if still alive'. For the first time Maria wondered, though with gentle humour, whether Constable's love of his art might be a rival to his love for her. 'What charming weather you have for sketching,' she wrote, 'I wonder which you have thought of most this summer, landscape or me (am I not a sad jealous creature?)'

There was indeed a potential conflict between his love of Maria and all that family life would bring, and his other love, for painting nature. Turner had a point: the fierce commitment required to create great art – 'aut Caesar aut nullus' – did not leave much time for a wife and children. But Maria was essential, as Constable stressed in letter after letter, to his happiness and emotional equilibrium.

In East Bergholt, Constable led his usual rustic existence, sketching and strolling with the family dogs. This season, he kept what he described to Maria as a journal, but it consisted not of words but of images drawn in a little bound sketch-book 3½ in by 4¾ in. He wrote that it might divert her if she could see it, 'you will then see how I amused my leisure walks, picking up little scraps of trees, plants, ferns, distances &c &c.'

In the end each page contained a dense pencil drawing (or more than one) full of light, air and space. At the end of July, as he often did, he sketched the annual fair. Then, every year on the village green, just outside the entrance to the Constable house, an avenue of tents and booths appeared on both sides of the street. It was a bucolic entertainment as cheery and traditional as the peasants' dance in

Willie Lott's Cottage Seen over the Stour by Moonlight

Study of Cows

Dedham Vale from Langham

the Third Movement of Beethoven's Pastoral Symphony.

The various entertainments vied to attract attention with noisy drums and trumpets. After dark the stalls were illuminated by lamplight, making a pretty effect that Constable had painted. There were travelling players, performing on a portable stage with a red proscenium arch, erected in the centre of the green; he drew a play being performed, the audience standing in a knot in front of the stage.

The Constable family were keen attenders of the fair. Dr Rhudde and his church wardens, on the other hand, very much objected to the tendency of the fair to extend its run beyond the time-honoured two-day period. The rector frequently placed notices in the local newspaper, the *Ipswich*

Journal, threatening prosecution of stall-holders who did so, though his fulminations had little effect as the fun often carried on into early August.

Since Constable knew that Maria was not returning to London until late autumn, he lingered on in East Bergholt. He drew the threshing that followed the harvest. Of all the little drawings he made on the forty-five sheets of his sketch-book that year, it was a couple of studies of men ploughing fields with teams of two strong Suffolk horses that lodged in his mind and became the germ of the painting he planned for next year's Royal Academy exhibition. Ploughing was a matter of local pride, and new technology.

Suffolk farmers had been among the first to adopt a more efficient four-phase crop rotation. This meant that certain fields would be planted with clover and wheat, left fallow during the summer and then ploughed up for sowing with winter wheat. In one of his drawings from the previous year, a pair of breeches hung on a pole outside the White Horse Inn, the traditional prize for a ploughing competition. Constable had also drawn one taking place. The agricultural writer Arthur Young in his *General View of the Agriculture of the County of Suffolk*, published that very year of 1813, described the ploughing contests, 'a favourite amusement', for which the usual prize was 'a hat or a pair of breeches, given by alehouses, or subscribed' amongst the contestants as the reward for the straightest furrow.

Suffolk ploughmen, especially those who worked the lighter soils on the eastern side of the county, were re-nowned. Sam Strowger, the porter at the Academy, knew all about this, and would recognize the high gallows wheel plough, used in East Bergholt, that Constable carefully

depicted. He was not merely lost in a poetic, pastoral reverie during these months; he paid close attention to the detail of farming life.

In mid September and October Constable made several trips to nearby Colchester, where he drew the Roman walls and the old churches. While he was producing minute, atmospheric images of St John's Abbey and St Mary's Church in that town on 18 October, a decisive and terrible battle was in its final stages outside Leipzig. The forces of German states, Russia and Sweden defeated Napoleon's army, with a loss of life perhaps exceeding 100,000 men.

By the middle of November, both Maria and Constable were back in London, but she prudently rationed them to one meeting per month and infrequent letters. They met for 'one brief morning', and Constable, obediently, did not even try to hang about on fine days in hopes of another meeting, though he was tempted to do so. They met again in the second week of December; on this occasion, Maria was in the company of her mother, whom she feared Constable would find painfully thin.

A few days later she sent him a ticket for Covent Garden. If he took it to the box-keeper on any night, having filled in the day and month, she explained, he would be assigned a seat. The Bicknells had long had a close association with that theatre, as Mr Bicknell was a good friend of the manager, Thomas Harris. In future she hoped they could go again together. 'I do not at all despair of passing an evening with you at Covent Garden, I am sure it is the only way a play will have any charm for me.'

Constable, not disposed to go out on his own, merely left this ticket in his desk. If he had used it the following night – Friday, 17 December – he would have seen Lord Byron

once more. That evening, the poet received an insight into society – not from the play but from the audience.

Went to my box at Covent-garden tonight; and my delicacy felt a little shocked at seeing S★★★'s mistress (who, to my certain knowledge, was actually educated, from her birth, *for* her profession) *sitting* with her mother . . . in a private box opposite. I felt rather indignant; but, casting my eyes round the house, in the next box to me, and the next, and the next, were the most distinguished old and young Babylonians of quality.

The great ladies of society, he realized, were no better than the strumpets who sat in the same theatre. Here was divorced Lady X, and soon to be divorced Lady Y. 'What an assemblage to *me*, who know all their histories. It was as if the house had been divided between your public, and your *understood* courtesans', that is, the intriguers of high society, but the latter 'much outnumbered the regular mercenaries'.

'Now,' the poet asked himself, where lay the difference between the trollop and her *mamma*, 'and Lady ★★ and daughter? except that the two last may enter Carleton and any *other house*, and the two first are limited to the opera and bawdy-house. How I do delight in observing life as it really is! – and myself, after all, the worst of any.'

There was a moral chasm between the raffish cynicism of Byron and the circles of Constable and Maria. Yet they inhabited the same city and might even on occasion sit in adjoining boxes.

By this stage, a harsh winter had begun to set in. 'You must,' Maria conjectured to John, 'have found the weather lately very unfavorable to painting, so dark, and now so cold, that I should think you could hardly feel the brush.' As the light

diminished and the temperature fell, Constable's mood slumped, though he wrote in one of his rare rationed letters, 'one consolatory idea is always present with me – our hearts are one – this is the lot of few upon earth, and this it is out of the power of the world to give or take away.'

On 23 December, two days before Christmas, he stationed himself furtively by the railings opposite Spring Gardens Terrace, and suffered the mortification of having to watch Maria and her youngest sister, Catharine, walk down New Street from St James's Park and go straight past him into No. 3. Constable was unable to attract their attention. He lingered, hoping that Maria might come out again to join her mother, who was still in the park. But she didn't, although Louisa and Catharine Bicknell did. He told her dolefully,

> When I saw your Sisters without you, I gave up hope of seeing you and I began to get very cold as I had been out hours without a great coat. After such an excursion you may judge how I feel when I return to my room – I detest the sight of my wretched pictures or rather canvases, though you will forgive me when I say I ought to love them almost entirely – in short I endeavour to bear up against such feelings which are almost enough to turn a *painter's* mind.

It was a humiliating way for a man of thirty-seven, an artist of some note, to spend his time. Constable left to spend Christmas in East Bergholt with very little merriness in his heart.

It was a time of gloom, in which day succeeded day of darkness and fog. Maria and Constable did not write to each other, nor because of the severity of the conditions could they meet outside. By the last day of January the Thames

had frozen over. A Frost Fair was declared on 1 February. It lasted for a few days only, but thousands came to see it. Booths and swings were set up and there was dancing in a barge; an elephant was led across the ice. It was the last time this traditional, though infrequent event, was ever to occur.

The world was changing. The climate was becoming milder, the landscape of the city was beginning to alter in ways that made the freezing of the river less likely – and in many other ways too. Eventually, it was the demolition of Old London Bridge and the building of embankments that prevented the Thames from turning to ice ever again.

The architect John Nash, like Mr Bicknell a member of the Prince Regent's retinue, had drawn up plans for the remodelling of the urban landscape of London. His project called for a large new park to be built on Marylebone Farm, the fields north of Portland Place where Constable's uncle David Pike Watts lived. Already work had begun on this – to be called the Regent's Park – and on Park Crescent just to the south.

From there, Nash had proposed a long, grand street that turned and curved until it arrived outside Carlton House (that is, almost at Maria's doorstep in Spring Gardens Terrace). The objective of this was, Nash's proposal explained, to create 'a boundary and complete separation between the Squares and Streets occupied by the gentry, and the narrow Streets and meaner Houses occupied by mechanics and the trading part of the community'.

The new street, the necessary legislation for which had passed through Parliament the previous year, was to be a frontier between east and west, poor and rich. It was also intended to remodel parts of London in the style of paintings by Claude, much as Stourhead had recast rural Wiltshire in the guise of the countryside of ancient Rome. In Nash's

vision of the new park, great classical façades transformed terraced houses into majestic palaces.

When the weather had improved, Joseph Farington took a stroll among the building works of this 'Regency Park', as he thought it was called. He found himself in the company of many other Londoners, walking in the vicinity or 'sitting quietly with pipes and ale in the open air at small taverns'. He was struck by their dress, 'almost all the men were dressed in black or dark blue cloaths'.

A soberer epoch was beginning. Such alterations in the mood of society take time to occur; this one had been brewing for a long while. The Spartan reforming severity of Thomas Day, disciple of Jean-Jacques Rousseau, was an early indication of this sea change in sensibility. Within three decades the earnestness of moral crusaders such as William Wilberforce MP, friend of Joseph Farington, and the energetic charitability of David Pike Watts would become the norm.

Their attitudes would typify an age named after a little girl, not yet born, the daughter of the Bishop of Salisbury's old charge, the Duke of Kent: Victoria. In this slow movement of mind and heart, Maria and Constable, with their respect for virtue, nature and the happiness derived from domestic life, were more attuned to the future than the libertines of the Prince Regent's circle or Lord Byron.

In her latest novel, *Mansfield Park*, begun in 1811, about the time that Constable and Maria started to correspond, and not yet published, Jane Austen dramatized this contrast. On one side were the dutifully conservative hero and heroine, Fanny Price and Edmund Bertram, and on the other, the charming and cynical Crawford siblings, Mary and Henry.

★

On 25 January, amid snow and sharp frost, Maria went to see a demonstration of teaching at one of the new National Schools. These were intended to bring more education to the children of the poor, the initiative coming from a group of high church Anglicans who had formed The National Society for the Education of the Poor in the Principles of the Established Church a little over two years before in Clapton.

The objective was not, it is clear in retrospect, a wide education. The aims were defined as, firstly, 'to teach them the doctrine of Religion according to the principles of the Established Church, and to train them to the performance of their religious duties by an early discipline', then, secondly, 'to communicate such knowledge and habits as are sufficient to guide them through life in their proper station'. Nonetheless, it was better than no education at all.

A National School was to be established in the parish of St Martin-in-the-Fields – which included Spring Gardens Terrace and the Royal Mews, but also a crumbling warren of cheap cook shops and prostitutes' rooms clustered around the old church. This was among the most run-down areas of central London. 'I think I shall take some of the children under my tuition,' Maria wrote to Constable. 'Will it not be a good way of employing some of my time?'

Outside the lodging houses of John Nash's grand thoroughfare, to be named after the Prince Regent, there would be a colonnade, and above the colonnade a balustrade, forming balconies to the lodging-rooms over the shops, 'from which the occupiers of the lodgings can see and converse with those passing in the carriages underneath, and will add to the gaiety of the scene'. This sociability Nash hoped would encourage single men to choose to live there.

Such Mediterranean conviviality was certainly very far

from the bachelor Constable's current mood. The fact that Maria was living so close and yet he could not see her – she said they might not meet until May – made his return to London gloomy. 'I am always sad when I return to this great town, that I find not one face to greet me – especially when I know that it contains one whom I may surely say is never one moment absent from my thoughts.'

He was invited to a party by his uncle David Pike Watts, but, he explained when he finally wrote to Maria, 'as I am turned hermit I declined – the fact is such scenes only distract me, and I find my melancholy only encreased by them. Could I see you there the case would then be different – as it now is a mixed party only seems to remind me the more forcibly of my being alone in the world.'

His loneliness was accentuated by a sharp disagreement he had had with his mother, whose constant well-meaning advice had evidently got on his nerves during his long sojourns in Suffolk. As usual his anxiety and depression made him easily exasperated; she in turn was hurt and touchy. 'It is a pity to vex me, who wish well to every one – & only give advice from affection and a desire to do what I deem right, to my maternal duty, and the experience of years.'

A further flashpoint was Constable's latest plan to ease his solitary life. In place of his sister, who had kept him company two years before, he suggested that the teenage son of his friend the village plumber and glazier, John Dunthorne, might come and stay in Charlotte Street. He found the lad quick-witted and good at such tasks as grinding colours and setting palettes.

Dunthorne senior had been his oldest companion in painting and the only person in his native village he could really talk to on that subject. The elder Dunthorne was himself an artist of some talent and came from a similarly humble

background to many successful painters, including Turner. But his background and attitude were just the problem as far as Mrs Constable was concerned.

Dunthorne was exactly the type of individual who stirred up trouble in rural societies such as Bergholt. He was an intellectual artisan, and as such under suspicion of harbouring radical ideas. Furthermore, he was irreligious, treated his wife badly and had an illegitimate child. He and Mrs Constable did not get on. The last time she had called at his cottage, the previous October – presumably to remonstrate – he had laughed her out of the door.

Constable's plan to take Dunthorne's son into his house struck her as emphasizing just the most disturbing aspect of the artistic life: the possibility of losing status. 'He may be company,' she warned, 'but he cannot be a companion, & that is what you want to ascend, my dear John – not descend.' The scheme would not in any case be good for the boy, who would probably imitate Constable himself in breaking with his family and 'never again regard his home & parental ties'. Then there was the cost of the boy's keep, which would double his expenditure, which already far exceeded his means, and not a penny did Mrs Constable hear of new income. 'How this can end, God knows.'

Constable thought Johnny Dunthorne would be 'very amusing to me, and I intend he should be usefull – he is not at all vulgar and naturally very clever'. And, he added, 'had he not these good qualities I should love him for his father's sake'. But he conceded the point. Young Johnny Dunthorne came for a visit but did not stay for long.

If only, Constable sighed, Maria would defy her parents and join him in his lodgings. 'Could you make a noble effort in my behalf, you could never regret it – you would make the latter years of my parents happy, and save me to the Art

for which I have made many sacrifices.' But, from the start, she had been firm that marrying him without money or the permission of her family would not be in the interests of either of them. She still wished that they could find 'that most necessary evil money', otherwise, she could only recommend patience to him 'and another person' – herself.

In the dark and the cold, Constable continued to work on his two Academy pictures for that year. One, yet again, represented Flatford – this time with a small ferry boat crossing the mill pond towards Willie Lott's farm. The other represented a solitary ploughman, stoically turning over a furrow in a wide, autumn field.

In the third week in March, Maria wrote with heartening news. Somehow, she had arranged to meet Constable for an evening at the theatre. Just how is not quite clear. It seems impossible, since Mr Bicknell had banned Constable from his house with hard words that mortified and infuriated the painter, that he would be willing to invite him to watch a play.

Maria sent Constable his instructions. On Saturday night, the 19th, he was to go to the place where orders for seats were taken in at the Royal Theatre, Covent Garden, and wait ''till you see someone that you will know'. She hoped it would not be too many minutes, but did not see how else it could be managed. She would bring him tickets for them both. Places had been secured 'in box 36 up one pair of stairs'.

The theatre was new and huge. The previous Covent Garden auditorium had burned down six years before, in 1808, and this opulent replacement had been erected within a year to a design by the young architect Robert Smirke, four years Constable's junior, and son of a painter friend of

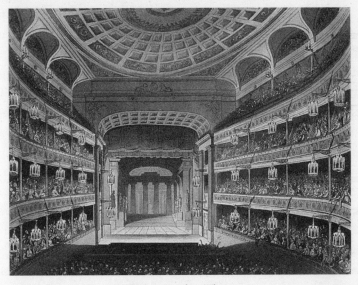

Covent Garden Theatre

Farington's. Taking advantage of the opportunity provided by the destruction of the old building, the owners had increased the seating capacity and the luxury of the appointments. The boxes were lined with crimson velvet, to match the curtains.

This enlargement, however, had been to the detriment of the cheaper galleries, the uppermost of which was now squeezed enormously high up, under the coving of Smirke's austerely neo-classical ceiling. The prices were also put up, by a shilling in the boxes and sixpence in the pit, further infuriating the less affluent members of the audience. When the doors finally opened on 18 September 1809, just as Constable was pledging his love on the fields of East Bergholt, there were riots, which continued for over sixty nights. No performance was possible because of a fusillade from the pit and gallery of 'barking, shouting, groaning, cat calls, cries of off! off! old prices!'

This, the only audience-strike in British theatrical history, was eventually successful, and performances resumed. While it lasted, Covent Garden was assiduously attended by Haydon, who found the turmoil fascinating but not being able to afford the tickets had to persuade his pupil Charles Eastlake to pay for them. It was a remarkable reversal: the audience, not what was happening on stage, became the real performance.

The British public of 1814 was in any case a gripping spectacle. Aristocrats such as Byron sat in the finest boxes; the middle classes, including Constable and Maria, in the less expensive, lower ones (into which more customers were now packed). The least wealthy were high up or low down. Louis Simond, the French-American visitor to London, noticed prostitutes 'selling and delivering the article they deal in' just behind the upper rows of boxes, in the side galleries. With the exception of the very poorest – manual labourers, the destitute – all of society was here.

An intense dispute about acting style, with echoes of similar controversies about painting and poetry, had broken out less than two months before Constable and Maria's night out. At the end of January 1814 a new star had appeared overnight at the rival, and even larger, Theatre Royal, Drury Lane. He was twenty-four, his name was Edmund Kean and he introduced a novel naturalism into London drama.

Kean was small and had, as Leigh Hunt noted, 'a voice like a hackney-coachman's at one in the morning'. But the vividness of his performance as Shylock in *The Merchant of Venice* had aroused immediate and tumultuous excitement. Notwithstanding the fact that Britain was engaged in wars with two separate enemies – Napoleonic France and the USA – the newspapers found space for lengthy discussions of Kean's acting style.

Covent Garden, the headquarters of a quite different manner of acting, was obliged to riposte. John Philip Kemble, brother of Mrs Sarah Siddons, was the leading actor in the company and also part owner of that theatre. He was the opposite of Kean – tall, dignified, in manner, declamatory, mannered, artificial. He rapidly returned to the stage in his most celebrated role as Coriolanus in which he had been painted by Lawrence.

The Times admired Kemble's performance while complaining about his habit of breaking off to acknowledge 'vulgar applause'. But the same newspaper felt that Kean's Richard III was supreme: 'We had no perfect idea of the consummate art, wickedness and treachery of the character' before witnessing Kean's 'magical address'. Covent Garden therefore quickly staged its own production of the play, starring Kemble's younger follower and imitator, Charles Mayne Young. This was what Constable and Maria were to see.

Jane Austen, who was in town to discuss the publication of *Mansfield Park*, which she had recently completed, saw Kean on 8 March, and arranged to see Charles Mayne Young's Richard III at Covent Garden with her sister Cassandra on the very same night as Constable and Maria.

Interesting as the comparison in acting styles was, a blood-soaked tragedy was not the right entertainment for Maria and Constable in their current gloomy mood. On reflection, she felt she would have preferred a concert in the Lenten series; the previous evening they could have heard the first part of Haydn's *Creation*.

Constable agreed. 'The play we saw was not calculated to chear one, but I hope the next will be a comedy, for I never go to see the other things by choice. I don't wonder at your preferring an oratorio – the melancholy must help to depress

a spirit already cast down – but we will not talk of our sorrows.'

That same night, Saturday, 19 March 1814, while Constable, Maria, Jane Austen and her sister Cassandra were all watching *Richard III* in London, between eight and nine o'clock, Mr Golding Constable junior was set on by two foot-pads. According to the *Ipswich Journal*, Constable's eccentric elder brother was returning to East Bergholt when he was accosted at a place called Crane Hall Hill. They took from him a canvas bag containing fifteen shillings and some receipts for corn which had been delivered.

The robbers seem to have supposed that these pieces of paper were bank notes and therefore allowed Golding Constable to depart 'without further molestation'. This was not a very serious incident, then. The loss was small. But who were these men? It was scarcely likely that they were professional criminals hanging about in this rural spot in hopes of finding a victim. The probability was that they were local men.

The society of East Bergholt was not quite as idyllic as it sometimes appeared in Constable's pictures. There was crime, theft, resentment and hardship in the countryside. The poor and indigent were removed to the workhouse at Tattingstone (of which Golding senior was still a director). In the village itself there was a cage or pound for the restraint of minor offenders and animals. The prisoner's friends would bring a pot of beer to refresh him; this could not be drunk through the grating so it would be sucked up by pipe.

More serious cases were dealt with elsewhere. Mrs Constable had been exercised for a while by a 'nest of rogues' including a man named John Stollery, who was sent to Ipswich Gaol by Squire Godfrey, the magistrate, for stealing

a pig worth £1 5s. He was eventually transported to Australia for seven years. Another member of this 'very notorious set', Mrs Constable suspected, was a man named John Goodrich who paid rent to Golding Constable senior. Yet another was John Stollery's brother Thomas who, she complained, had seven brace of hares to sell – with the result that 'true sportsmen' would have to comb the country for 'little or no game'.

What Mrs Constable meant was not that Thomas Stollery killed the hares in an unsporting manner, but that, unlike Golding Constable, for example, he did not have a game certificate and was therefore a poacher. The ownership of the land of the village and the creatures that lived on it was established by law. Not everyone could wander over the fields free from challenge like Constable, a local gentleman with his paints and sketchbook. Outsiders and the poor might well be accused of trespass.

9

On 9 April, it was announced that peace had been concluded with France. Napoleon had agreed to renounce the Imperial throne and accept exile on the island of Elba. 'Thus,' Joseph Farington noted with satisfaction in his diary, 'terminated the reign of one of the most malignant and remorseless tyrants that has ever existed.' Public buildings were illuminated in celebration.

That same day, the spring exhibition at the British Institution closed. Constable had submitted two works – the painting of two boys fishing at Flatford lock and a little picture of polecats. The latter, which delighted Maria when she saw the exhibition, was done to please his brother Golding, who had caught the creatures in the woods.

Not surprisingly, Constable failed to win the one hundred-guinea prize for landscape painting awarded by the organizers. But when the show closed, a book dealer called James Carpenter who had a shop in Bond Street approached him with an offer. This man liked the painting of the boys fishing, but explained he could not afford to buy it outright. Therefore, he proposed a deal: twenty guineas in cash plus books in kind to make up the price. It was not much. Even taking the books into account, this amounted to less than the humblest farm-worker's annual wage. But it was the first time that Constable had ever sold a landscape to anyone who was not a friend or relation. On reflection, he accepted. By such tiny steps was his progress measured.

★

Just after the British Institution exhibition closed, David Pike Watts had sent his nephew some well-meant words. 'Allow me,' Constable's kindly Polonius of an uncle had begun, 'to offer that unpleasant thing, *advice*. It is that you will place or paint a little *Starling* on your Easel with the words "*Finish! Finish!*"

'What,' Mr Watts asked himself, 'is any thing *unfinished?* It is as it were *Nothing* because a Thing does not exist as a Whole, that is incomplete.' He had had, he went on, an internal struggle over Constable's painting of the boys fishing at Flatford Lock. On the one hand, he wanted to buy it to oblige his younger relation, on the other hand was 'the Revolt which will check such a desire when the Eye perceives *Unfinished* Traits. Will any Person voluntarily prefer an imperfect Object when he can have a more perfect one?'

Mr Watts put this fatal flaw down to procrastination, and he lamented it.

Year after Year rolls on and you candidly allow that you lose time, and find yourself *driven* to a day, to an hour when the Exhibition Room is open'd and the Pictures *must* be sent in or be excluded. *Then* and *not till then* you are flurried, hurried, pursued, actually *chased*, yet cannot gallop fast enough. The Picture *must* go in; wet, smear'd, confused, *unfinished* – *the* Old Error, re- re- repeated.

And what had caused this backsliding, this lack of moral fibre? In Mr Watts's opinion, though he did not quite say so, the problem lay in Constable's vain and debilitating love of Maria. Only time and wisdom would cure that. 'This Victory may be obtain'd as Reason prevails and Passion subsides – as Age matures the Intellectual Powers, and Youth resigns the Sensual Phantoms.'

It was with some satisfaction that Constable was able to

reply to this that Mr Watts's kind solicitude over this paint-
ing might now cease, as it had been bought by Mr Carpenter
the bookseller. 'He is a stranger, and bought it because he
liked it.' But he was inclined to agree with the diagnosis that
there was something awry with his pictures because his inner
feelings were in turmoil.

> You say truly that my mind is not at ease. Perhaps there may
> be something constitutional – but it is certainly much
> increased since I have had the misfortune to involve the
> happiness of the most amiable being on the face of the earth
> in my own fate.
>
> The excellent lady to whom I allude continues faithfull
> to me in my adversity – and that too amidst a scene of per-
> secution and unkindness, which has continued many years
> – therefore I may yet be happy.

He did not really resent Mr Watts's criticism, coming as it
did, with so much help and hospitality. 'Believe me my dear
Uncle, the great kindness which you have always shown
me at your table and elsewhere, as a friend and relation, has
not a little contributed to support my mind through much
trouble, which I believe has been increased by an extra-
ordinary susceptibility of feeling . . .'

The sensitivity that made him an artist also added to his
sufferings – or at least that was how he saw it. 'You have
always allowed for my "wounded spirit",' he thanked Maria,
'knowing as you do that I was formed with a mind (unfor-
tunately perhaps) of the most excruciating sensibility.'

Both Constable's paintings were accepted by the Royal
Academy, and their progress monitored by Sam Strowger,
the porter, who, as an ex-Suffolk farm-worker was well

placed to appreciate the niceties of the scene of ploughing. In the days before he had left the land Strowger had himself had the reputation of being 'a beautiful ploughman' (that is, skilful, rather than handsome, though he was that too).

Sam Strowger reported to Constable that the pictures were being treated with respect by the hanging committee; indeed the arrangement had been altered so they could be seen to advantage. Slowly, very slowly Constable was advancing in the respect of his peers.

Maria departed for a week in the rural peace of Barnet, intended to improve the condition of her mother. She was spending a lot of time with Mrs Bicknell, who was now her walking companion. This 'airing' she felt at least amused Mamma, so perhaps did her good, but her health did not improve. Constable went to Suffolk briefly, and returned to see the exhibition when it opened.

He was pleased with his new pictures, particularly the small one of the ploughman. The title was *Landscape:*

Engraving of *A Summerland*

Ploughing Scene in Suffolk, which he altered later, when he had a mezzotint made of it, to the more agriculturally precise *A Summerland* (that is, a field which is ploughed in spring, left fallow all summer and sowed with wheat in autumn). Beside the title in the catalogue he printed two lines from the poem *The Farmer's Boy*:

> But unassisted through each toilsome day
> With smiling brow the ploughman cleaves his way.

The author, Robert Bloomfield, was a fellow East Anglian from the Breckland, the other side of Suffolk, on the border with Cambridgeshire and Norfolk. Ten years older than Constable, Bloomfield was born in 1766, the son of a tailor. Too small and frail to work on the land, when he was fourteen he moved to London to live and work with his brother George, who was a shoemaker. While living in an attic off Bell Alley in the City of London, he was lent a copy of James Thomson's *The Seasons* by a fellow lodger, and reading this inspired him to become a poet. After a brief return to his native village, he wrote his masterpiece, *The Farmer's Boy*, in a London garret. It brought him passing fame, but no lasting wealth.

Bloomfield, and Constable too, belonged to a current in Georgian culture that went back to *The Georgics*, a poem composed by the Roman author Virgil between 36 BC and 29 BC. This work is a mixture of agricultural advice – when to sow, how to deal with parasites – and tender bucolic poetry. The life of a tenant farmer in harmony with nature, it teaches, is simple, moral, uncorrupted and full of wholesome beauty and pleasures.

This ancient work was the inspiration for Thomson's

Seasons, which first appeared in 1726. In turn that greatly affected many others, providing the libretto for Haydn's oratorio of 1802, *The Seasons* – which was, with its peasant dance, bird calls and thunderstorm, the predecessor of Beethoven's Pastoral Symphony – as well as influencing many other works of verse, prose and, in John Constable's case, paint.

Virgil's Latin was translated by agricultural reformers such as the East Anglian nobleman 'Turnip' Townshend, who introduced four-field crop rotation – wheat, barley, turnips and clover – to Britain. And Virgil was taken seriously enough to be attacked by Jethro Tull, inventor of the seed-drill, who disapproved of his recommendation to leave land fallow in alternate years. 'I think it impossible,' Tull fumed, 'for any scheme to be worse.'

The Virgilian combination of down-to-earth practicality with pastoral idyll appealed greatly to the eighteenth-century British mind and to the sensibility of Constable. He quoted Thomson and Virgil, as well as Bloomfield. His paintings had the same precise details of cultivation as the poems – and the same lyrical evocation of changing seasons and weather.

The basic Virgilian message that the life on the land is the good life is perhaps not wholly an illusion. It appealed to those who, like Bloomfield and Constable, came from real agricultural communities, and it still appeals to many in the twenty-first century. But in the England of 1814 there were many ploughmen who found their existence was anything but idyllic, as they would soon show with violence, anger and fire.

Constable was proud of his *Ploughing Scene*, even though it was not the landscape that everybody was talking about at the exhibition that year. 'A large landscape of Turner's seems

to attract much attention.' He reported to Maria, with a mixture of self-satisfaction and sarcasm,

Should we ever have the happiness to meet again it may afford us some conversation. My own opinion was decided the moment I saw it, which I find differs from that of Lawrence and many others entirely – but I may tell you (because you know that I am not such a vain fool) that I would rather be the author of my landscape with the ploughmen than the picture in question.

Vanity apart, he had a point. Turner's *Dido and Aeneas* was a disappointing successor to *Hannibal Crossing the Alps* and *Frosty Morning*, the contrasting masterpieces of the two preceding years. It was, in Constable's favoured term, 'mannerist'. That is, it was an extremely competent, indeed brilliant essay in the style of the great seventeenth-century master Claude. Graceful classical trees framed the view, porticos and palaces were elegantly screened by vegetation – much as the villas and terraces of John Nash's new park were intended to be. But, in complete contrast to *Frosty Morning*, this was imitation, not observation.

The contrast was to Constable's advantage, but he still needed to find a way to present his fresh way of seeing the landscape in a manner that overwhelmed viewers and made them exclaim, as John Fisher had of Turner's *Frosty Morning*, 'This is a picture of pictures.'

Throughout the spring, Constable had lamented his failure to meet with Maria. When he heard that she had been with her father to see Benjamin West's latest biblical extravaganza, *Christ Rejected*, he was pained. It was on show in the painter's private gallery at his house in Newman Street, and

Newman Street was a minute or two's walk from Charlotte Street. It anguished him to think of Maria being so close and not seeing her. One day at Somerset House, however, he did bump into her, which was fortunate. Much less so was the fact that he also encountered her father, and completely mishandled the meeting.

Seeing Charles Bicknell approach, Constable could not think how to react. The lawyer had barred him from the house at Spring Gardens Terrace, with words Constable found not only crushing to his hopes of happiness but insulting to his slightly fragile dignity as a gentleman. So what should he do now? To acknowledge Mr Bicknell was to invite a further snub. Constable resolved not to make the first move, so he did not bow.

Charles Bicknell noted the discourtesy and, worse, so did Maria. She told him that it was his place, as the younger man, to bow first. Constable miserably replied that if he had had any notion that her father expected him to bow, he would of course have immediately done so. What more could he say? He was contrite and miserable. He apologized.

A few days later, on 13 May, he was even more anxious about the affair since Maria had not communicated with him in the meantime. Was she still angry? He apologized again, several times.

I can only repeat to you, that not the smallest disrespect or slight was intended by me in passing Mr. Bicknell – and could I have had the least idea that any notice from me could have been looked for it should not have been withheld for a moment.

But let me hope my dearest Maria that as you love me – and so you know my heart better than any body else – your mind will forgive me any inclination to an ill disposition,

and that your kindness & affection which have been my only consolation through years of sorrow & adversity will still be exerted in my behalf.

Perhaps she could plead with her father for an interview in which he might put his case – that was what he had hoped for from the moment Mr Bicknell first dismissed him from his door.

But Maria had already forgiven and forgotten the incident 'in which you have made every apology that was possible to make, indeed you have taken up the subject much more seriously than I ever thought of'. He should never be anxious about not hearing from her; as she had often explained, it was a difficult, almost impossible, matter for her to send letters. Presumably, she had to write and post them without attracting her parents' attention.

As the successor to the Joshua Reynolds exhibition, there was at the British Institution that summer a show devoted to three other notable British painters of the recent past: Thomas Gainsborough, Richard Wilson and William Hogarth. Maria was in no doubt which would please Constable the most of these. 'I suppose,' she wrote on 13 May, 'you must live in Pall Mall, with the charming Gainsboroughs.' Indeed, four days later, Joseph Farington attended one of the popular candlelit evening viewings of the exhibition, and there he found the galleries much crowded between ten and eleven o'clock. Present, among many others, were Lord Liverpool, the prime minister, Sir George Beaumont, Mrs Siddons and Constable with his painter friend John Jackson.

The next day, Maria lamented that he was not in Suffolk. 'The country is so pleasant it would be a thousand pities you

should not enjoy it, particularly as you will see it with the eyes of a Gainsborough.'

In fact, there had been a time when he had done precisely that. In 1799, fifteen years before, he wrote from the house where he was staying, just outside Ipswich, 'I am in the most delightful country for a landscape painter, I fancy I see Gainsborough in every hedge and hollow tree.'

Thomas Gainsborough (1727–88), born a dozen miles up the Stour from East Bergholt, was indeed his most eminent predecessor as a painter of East Anglian landscape. They had much in common: gifted Suffolk painters, loving the land and following the example of Dutch masters such as Ruisdael. Gainsborough's landscape, Constable declared years later in a lecture, 'is soothing, tender and affecting. The stillness of noon, the depths of twilight and the dews and pearls of morning are all to be found on the canvases of this most benevolent and kind-hearted man. On looking at them one finds tears in one's eyes, and knows not what brings them.'

Gainsborough's career, however, followed a very different course from that of Constable. After an early period of natural landscape which produced the masterpiece *Cornard Wood*, well known to Constable since it was in the collection of David Pike Watts, he became a professional portrait painter. Gainsborough's later landscapes were not derived from observation, they were imaginative fantasias – and consequently Constable did not like them so much. They were, he complained to Farington, 'so wide of nature'.

So Gainsborough was an equivocal ancestor. He had deserted the truth of nature for a style closer to the rococo of Fragonard that Constable despised. Richard Wilson (1714–82) also set a worrying precedent in a different way. Wilson had founded the British school of landscape painting, and in Constable's mind was a great precursor. He repeated

an anecdote about Wilson told by his older friend Stothard, 'which showed how much he was disposed to turn to nature even in the midst of art'. A student at the Royal Academy asked Wilson to recommend something for him to copy. 'Wilson was at the moment standing at one of the windows, which as the quadrangle of Somerset House was then unfinished, commanded a fine view of the river.' Wilson pointed to the animated scene, saying, 'There is something for you to copy.'

But, in worldly terms, Wilson was a failure. As an old man he had told Farington that 'the country was not prepared for me'. Wilson's works, Constable thought, were 'truly original' in that 'he showed the world what existed in nature, but which it had never seen before'. That was what Constable meant by originality. Wilson's fate, however, had been to be overlooked; Constable came to suspect his own would be the same. 'It is the nature of man to hate a benefactor.'

There was much to admire and discuss at the British Institution, even though, as Constable reported to Farington, many painters thought that poor examples of Wilson's work had been chosen. Constable obtained a further ticket for the exhibition on 24 May. Maria finally succeeded in seeing it in the evening – as she had hoped to see the Reynolds the previous year – towards the end of June, but the experience was not up to her expectations. 'I was disappointed in the effect by candle light,' she told Constable, 'I prefer it infinitely by day, it was crowded to excess, certainly a very fine place to see, and be seen.'

The relations between Constable and Maria were becoming strained, which was not surprising as the situation was not only difficult but had been going on interminably long;

it was now nearly five years since he had declared his love in 1809. They met again, and quarrelled once more. He pressed her again to marry him no matter what the financial consequences.

In the shorter term, he suggested that, when the female members of the Bicknell family went once more to stay in Richmond, he and Maria might meet at the house of a Mrs Ward, who happened to be a friend of his sister Mrs Whalley. Maria thought this stratagem would not do. John told her that she no longer seemed like the Maria he used to know. She was hurt and upset. They made up the quarrel, as usual, by affectionate letter, and both retired into the country – she for a short stay in Richmond, he to Suffolk and then to stay for a while with a clergyman friend of his father's, Revd Driffield. This kindly clergyman had baptized John Constable thirty-eight years previously in a hurry when he was a new-born baby not expected to live, and was now living nearby.

Though he had a house at Feering, near Colchester in Essex, Revd Driffield was the incumbent of Southchurch, on the southern coast of Essex, soon to be engulfed in the town of Southend. He had to pay a visit to this place, and Constable accompanied him, which gave him a rare opportunity to look at the sea.

'While Mr. D. was engaged at his parish,' he told Maria, 'I walked upon the beach at South End. I was always delighted with the melancholy grandeur of a sea shore.' Perhaps, while gazing at the waves he thought, as he did when he looked at his print of Ruisdael's view of the Dutch coasts, of love and Maria.

'At Hadleigh there is a ruin of a castle which from its situation is a really fine place – it commands a view of the Kent hills, the Nore and North Foreland & looking many

miles to sea.' Here he had found, though he could not know it, one of his great subjects, which would come to rank with Flatford and Salisbury Cathedral amongst the themes of his work.

He and Revd Driffield went for long rambles, the latter, though over seventy, being 'a most active and restless creature'. He could out-walk and out-run Constable, and could never be persuaded to stop at one place and contemplate it, as the painter liked to do.

One evening in late June Constable was sketching Revd Driffield's house at Feering, which he had promised to draw for the old clergyman. The vicar went to bed early, looking out of the window to say goodnight to his guest, who sat working until the last ray of the sun disappeared. Constable rose early and returned to the spot where he had been painting the night before so that Revd Driffield, when he got up himself, presumed that Constable must have been at work all night.

Meanwhile, in London, the Prince Regent was making preparations to do what he did best – throw a lavish party. The war having been won (for which he naturally assumed much of the credit), it was time to celebrate the peace. The monarchs of the victorious powers were summoned to London. There had already been a procession through London by the new king of France, Louis XVIII, accompanied by the Regent. Now, on 7 June, the grand arrival of the Tsar and the king of Prussia was awaited by huge crowds. However, they were disappointed to discover late in the afternoon that Alexander I of Russia and Wilhelm III of Prussia, attended by Marshal Blucher, Prince Metternich, Prince of Liechtenstein, and Prince Leopold of Saxe-Coburg-Gotha, had already arrived in the capital by another

route. This was rumoured to be a revenge on the Regent's part for having been hissed at a few days before by that same London crowd, who disapproved of his harsh treatment of his estranged wife, the Princess of Wales.

It was arranged that the monarchs' portraits would be painted by Thomas Lawrence, the greatest commission of the age. Maria imagined that Constable would not bother to come to see these famous visitors, as 200,000 others had; 'I suppose you intend consoling yourself with a view of their pictures.'

Marital affairs were destined to interfere with the festivities. A suitable match for the eighteen-year-old Princess Charlotte had been arranged some time before with the Prince of Orange, heir to the Dutch throne. Initially, she had agreed to it. But the high-spirited and unmanageable, princess had second thoughts. At a banquet at Carlton House she encountered and fell in love with the dashing and handsome Prince Frederick, nephew of the king of Prussia. Abruptly, she announced that she was calling off the match with the Prince of Orange. The Prince Regent was mortified; the courtiers in charge of the princess, of whom the Bishop of Salisbury was the chief, were horrified.

The princess's family background was not ideal. She had been conceived almost miraculously, during the two nights her parents had spent together before her father rejected her mother, Caroline of Brunswick (complaining, among other matters, about her personal hygiene). The Prince of Wales and his wife had lived apart for years, neither remotely faithful to the other. Opposition to him naturally centred around her.

Farington heard about Princess Charlotte's behaviour after the national service of Thanksgiving at St Paul's on 7 July. The Bishop of Salisbury was said to have a 'broken

look', his mind most uneasy about the matter. Present at the cathedral were the royal family, except of course the mad king, the peers of the realm, the bishops, the government, and all of London society, including Farington and Sir George Beaumont. Farington heard that on the way the Regent had been violently hissed at again by butchers from Fleet market, who rudely shouted, 'Where's your wife?'

Two days later, on Sunday, 9 July, a victory feast was held in East Bergholt. Nearly 800 people sat down at long tables on the green where the fair usually took place. Above the seated villagers fluttered the Royal Standard of Britain and the white flag of Bourbon France bearing the fleur-de-lis. The meal consisted of roast beef, plum pudding and beer – paid for by the Constables and other wealthy inhabitants so that the poor might commemorate the blessings of the

The Village Feast, East Bergholt

peace. There was music and fireworks, and afterwards several private parties. Constable drew and painted the scene.

John Lott, brother of Willy Lott whose house Constable so frequently painted, noted in his diary that not everything had gone smoothly. 'Mishaps: one of the bells was out of repair and would not ring and the band did not arrive until after the dinner having lost their way and there was too much bread and too little meat.'

Worse calamity threatened in London. Infuriated by the princess's conduct, the Regent descended on her at Warwick House, her rather dingy residence on a side street round the corner from Spring Gardens Terrace. He did not know of her romance with Prince Frederick, but suspected as much. She had already had one affair with a Captain Hess she had met while out riding. In the presence of the Bishop of Salisbury, the Regent delivered his judgement. Her ladies-in-waiting and companions were dismissed; in future she was to live in seclusion in Windsor Great Park, allowed to see no one except the queen once a week.

Warwick House

The princess was maddened by this. She fell to her knees exclaiming, 'God Almighty grant me patience!', and shortly afterwards dashed out of the building, jumped into a hackney carriage and asked to be taken to the West End house of her mother, the Princess of Wales (or to Constable 'the royal strumpet'), in Connaught Place. There was consternation. The princess was pursued and eventually run to ground by two royal dukes, her uncles, the increasingly harassed bishop, the law officers of the crown and her mother's political ally Henry Brougham. Eventually, her mother being absent, late in the night the princess yielded.

The *Courier* remarked the following day that the whole town had been 'thrown into considerable confusion' by this extraordinary event. This drama of conflict between parental authority and personal feeling, between love and duty, convention and feeling, had begun within two minutes' walk of Maria's front door in Spring Gardens Terrace. Unlike the princess, despite great provocation, Maria remained patient.

The case of Constable's missing bow to Mr Bicknell was an example of what the painter called 'form' – by which he meant the formalities of polite society. Constable hated it. That was his only misgiving about the plan that he should spend some time during the summer at the country mansion of Sir Thomas Barrett-Lennard at Aveley in Essex. This was a delightful spot, he told Maria, for making studies of the landscape, 'if the forms of the house do not break in upon my time'.

Polite manners, or rather, the lack of them, were grounds for criticism of the arts as well as behaviour. While the admirers of Edmund Kean, such as Sir George Beaumont, rejoiced that a performer had appeared on the stage 'to bring it back to truth and nature', his detractors found only lowness

and vulgarity in his art. Farington's friend Taylor roundly dismissed the new star as 'humbug', his performances without classical taste, 'a pot-house actor'.

There was a similar complaint raised regularly about Constable's paintings, by his family and others: that they were not properly 'finished'. This was a criticism that came up once more in the reviews for this year's Academy exhibition. Robert Hunt of *The Examiner* noted that Constable's landscape *The Ferry* was 'still deficient in finishing'. This had become a standing objection to the painter's admission to the Royal Academy.

Constable had put his name forward for the election of associates year after year, without attracting much support. The previous November he had had no votes in his favour. He spoke to Farington of the great importance to him, his career and his personal life of attaining this modest success. However, when Farington and his fellow Academician Henry Thomson met and discussed future candidates, they thought William Collins and Reinagle stood the best chance of being elected associates. The work of Constable's friend Jackson they considered in good taste; against Constable's own name Farington noted 'too unfinished'.

He told Constable as much when he came to call at breakfast time a few days later. 'I told him the objection made to his pictures was their being unfinished; that Thomson gave him great credit for the taste of his design in his larger picture last exhibited & for the indication shown in the colouring; but he had not carried his finishing far enough.'

This was, of course, exactly the question that exercised Constable's father and uncle David Pike Watts. 'Finish' was a word that had long figured in artistic debate, and was to do so for much of the rest of the nineteenth century and beyond. It has two meanings. In one, which is still current, it

denotes the resolution of a work of art according to its own inner rules. In that sense, in the twenty-first century artists still speak with pride and relief of 'finishing a picture'; like all serious painters John Constable was certainly concerned about completing his works properly in this manner.

There was however, another meaning of 'finish', conveying something more like 'polish'. Used in this way, it meant smoothly painted, suitably detailed, lacking any uncouth roughness of surface and looseness of brush stroke. In the seventeenth century, great artists such as Rembrandt had been criticized for failure to 'finish' – although of course, by the other criteria, their paintings were completed incomparably well. By Constable's day a consensus had grown up that Rembrandt and other masters whose paint was thickly and freely applied, though great in their way, were a bad example to follow. Such qualities might be acceptable in a sketch, but not in a painting for public exhibition.

For the moment, Constable seemed willing to accept the criticism from Farington and Thomson. Farington recommended him to go and study the paintings of Claude once more, attending 'to the admirable manner in which all the parts of his compositions are completed'. Constable thanked him for the conversation, from which he thought he would derive much benefit. He accordingly made an appointment to view the collection of the banker and connoisseur John Julius Angerstein in his house on Pall Mall.

The latter, now nearly eighty years old, was a man rich both in money and taste. Born in St Petersburg in Russia, he had come to London as a teenager, worked as a merchant and become chairman of Lloyds. Angerstein had watched the startling growth of London in the previous half century. Nothing demonstrated it more, he felt, than the remarkable increase of music shops and fishmonger's stalls. He remem-

bered when there was only one fishmonger between St Paul's and Charing Cross and only two music shops in London.

Angerstein owned many great paintings, including a beautiful Claude depicting the lovers Cephalus and Procris. With its melting blue distances and sky so clear it seemed like some delicious liquid, this picture was just the kind of Claude that Turner used directly as a starting-point in pictures such as *Dido and Aeneas*.

Constable never did that; neither did he add stories from myth or history to his landscape. Nor did he ever entirely give up his fresh and vigorous brushwork, and his rawly truthful view of landscape – any more than he ever actually renounced his unsuitable friend John Dunthorne the glazier and his son, Johnny.

His lack of 'finish' was in fact one of the most profound aspects of his art. In time, he developed it more and more, using flecks and dabs of paint to evoke the tangle of vegetation, the sparkle of light on leaves and water. This, conveyed by a spatter of white paint, struck his contemporaries as looking like specks of frost. He mimicked the elderly Fuseli, who became an admirer of his art (and whose Swiss-German accent was a standing source of amusement at the Royal Academy); 'I *like* de landscape – of Constable – but he makes me call for my great coat.'

But the roughness and looseness of his brushwork, which varies from picture to picture, were his way of conveying the texture and feel of landscape and above all light. 'Its light cannot be put out,' he wrote with pride to Fisher of *The Lock* when it was exhibited at the RA in 1824, 'because it is the light of nature.' The 'language of the heart', he went on, 'is the only one that is universal – and Sterne says that he disregards all the rules – but makes his way to the heart as he can'. Constable's 'execution' annoyed most of his

fellow painters 'and all the scholastic ones'. Perhaps he made too many sacrifices for 'lightness and brightness', but 'any extreme' was better than what he called 'dado painting' – flat and dull as a drawing-room wall.

It was precisely this liveliness of handling and the freshness of his colour that impressed younger French artists such as Eugène Delacroix (1798–1863) when some of Constable's work was shown in Paris in 1824. Delacroix noted in his journal, 'this man Constable has done me a power of good.' Later in the nineteenth century, Delacroix's own colour and brushwork were greatly admired by artists such as Van Gogh and Gauguin.

The longer Constable lived, the freer his paintings became. Two centuries on they bring to mind the names of Jackson Pollock and Lucian Freud; his lack of 'finish' is one of the reasons he still seems a modern artist.

Constable's failure to finish – in the eyes of his contemporaries – was connected with one of the most mysterious powers of great painters. That is, the ability to make a mark with a paint brush which doesn't just look like an object, but actually seems to *become* it. The twentieth-century master Francis Bacon was fascinated by this strange metamorphosis, whereby, as he put it, 'there is a complete interlocking of paint and image, so that the image is the paint and vice versa'.

Rembrandt and Velazquez could do this, and so could Constable. For example, he could dab some white pigment on a piece of board which clearly was nothing but paint – with the traces of the bristles still visible – but at the same time just *was* a small cloud catching the light as it floated over East Bergholt Church. He was something of a conjurer with his brush, Constable confessed to Maria – but more than that he preferred not to say.

★

Both Constable and Maria left town again – she for Wimbledon, he for East Bergholt – just before the peace celebrations came to their climax, on 1 August, the anniversary of the start of the Hanoverian dynasty. The Prince Regent's favourite architect, John Nash, had worked hard to devise temporary structures for the occasion. In Green Park one such was erected, 100 feet in diameter and 130 high. A bizarre creation resembling a cake decoration or baroque church as much as a temple, this was designed to transform itself from a Castle of Discord to a Temple of Concord. While this transformation occurred, the top section revolved mechanically to reveal the apotheosis of the Prince Regent and the Triumph of England to the accompaniment of fireworks. On the sides were transparent paintings representing, as Farington approvingly noted, the 'Devastations of War and the Evils of Despotism and Tyranny'.

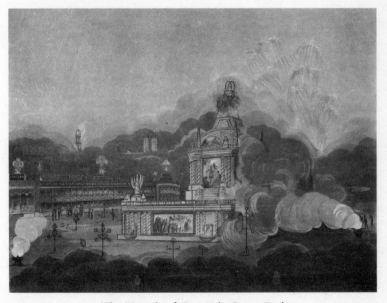

The Temple of Concord, Green Park

In St James's Park a re-enactment of Nelson's victory at the Battle of the Nile took place on the canal, which was spanned by a bridge in the Chinese style, with nearby seven-storey pagoda. There were booths, a balloon ascent, cake houses, bands, taverns, vast milling crowds, so that Joseph Farington became separated from his fellow artists and had tea in a tent with a stranger. When the pagoda was illuminated by the new gas light, it unfortunately caught fire and two spectators were killed. It was just as well that the increasingly ill Mrs Bicknell and her daughters left before all this tumult happened on their doorstep.

Constable, for his part, was becoming increasingly averse to society. He wanted only to immerse himself in nature. With the exception of the brief return to London when he saw Maria and discussed the question of finishing his pictures with Farington, he spent the entire summer and autumn, as he put it, calmly and uninterruptedly pursuing his studies; it was many years since he had 'worked with so much steadiness & confidence'.

Back at East Bergholt, he avoided all his neighbours with the exception of the squire, Mr Godfrey, and his wife. 'I love the trees and fields,' he confessed, 'better than I do the people' (a sentiment that echoes Beethoven's remark, 'I love a tree more than a man'). During the harvest days of August, he read a book which made a deep impression. This was *Essays on the Nature and Principles of Taste* by Revd Archibald Alison, a prebendary of Salisbury Cathedral some twenty years Constable's senior.

He preferred this now forgotten volume, which the author himself feared the reader might find tedious, to the classic, lucid and witty *Philosophical Inquiry into the Origin of Our Ideas of the Sublime and Beautiful* by Edmund Burke. And if one compares the ideas set out in each book, it is easy

to see what Constable found of such value in the *Essays* of Revd Alison.

Both authors considered the fascinating and elusive question of why it is that human beings obtain great pleasure from some things they see such as landscapes and works of art, and also from music, natural sounds and literature. This was, obviously, of fundamental importance to Constable. His whole life, except that part of it spent longing for the company of Maria, was spent either looking at landscapes or depicting them. Now, just what was it about those activities that made them important and significant?

Edmund Burke, a brilliant Anglo-Irish thinker, had made his name with the *Inquiry*, published in 1757, almost two decades before Constable was born. Essentially, Burke divided aesthetic feelings into two distinct varieties – the Sublime and the Beautiful – both of which he rooted in common emotions. The Sublime he connected with fear, indeed terror; Beauty he believed arose from the feelings connected with such sensations as smallness, smoothness, roundedness.

The pleasure in both lay in getting a low dose of the passion in question. To stare over a cliff might well fill you with painful dread, but to view such a drop from a safe distance, or in a painting, agreeably braced up your nervous system; 'a delightful horror,' he called it, 'a sort of tranquillity tinged with terror'. Viewing beauty did the opposite: it made you inwardly swoon and melt, but just a little bit, enough to be pleasant.

Burke gave a number of diverse examples of sublimity. It might arise from the experience of looking down from a precipice, or confronting a huge and gnarled tree, from darkness and obscurity, infinity, solitude, silence and power such as that of kings and God. All of these were sublime.

His notions of beauty, however, all tended to suggest to the reader a single item: an attractive woman's face and body. This was a young man's book; Burke was twenty-seven when it was published.

This analysis fitted quite well with the work, for example, of Turner – at least some of it. It was a little hard to see how the beauty of *Frosty Morning*, apparently neither sublime nor beautiful, could be explained on this theory. But a picture such as *Hannibal Crossing the Alps*, with its mighty mountains, savage storm, darkness and obscurity, was, you might say, very sublime indeed.

Burke's account, however, had nothing to say about the kind of sight that Constable so loved: old mill ponds, lock gates oozing water, slimy posts, the mellow but quite ordinary walls of the Mill House at Flatford. Indeed, the Irishman explicitly ruled out angular items such as triangles and squares – and thus presumably lock gates and posts – from the category of the beautiful. A triangle could not be beautiful, any more, he claimed, than 'it is possible to imagine a giant the object of love'. His book abounded in such charming but questionable assertions.

Alison, on the other hand, did not believe that there was any intrinsic beauty or sublimity in any natural object. The qualities we seemed to find in objects, places and people we actually give to them ourselves. Or rather, we love and appreciate them because of the associations they bring. Thus, argued Alison, the inhabitants 'of savage and barbarous countries' cling to the deserts and rocks in which they were nursed. Put such a man in the regions of 'fertility and cultivation' and he will find there no 'memorials of early love'. He will seek to hasten back to the barren wilderness 'amid which he recognises his first affections and his genuine home'.

This was precisely what Constable believed about himself and East Bergholt. Of course the pretty scenery thereabouts could hardly be described as a barren wilderness, but he loved it because it was the scene of his happy childhood days. He also wholeheartedly concurred with Alison's further contention that no thing in nature was intrinsically beautiful or the reverse. It was painters who discovered beauty where it had not hitherto been seen. 'The mind of the spectator follows with joy the invention of the artist.'

Years later, according to his friend C. R. Leslie, Constable was looking at an engraving of a house with a certain lady. She remarked that it was 'an ugly thing', to which he replied, 'No, Madam, there is nothing ugly; *I never saw an ugly thing in my life* for let the form of an object be what it may, light, shade and perspective will always make it beautiful.' He found raw material for art in the most surprising places. Revd Trimmer, Turner's friend, recalled Constable would stand gazing at 'the bottom of a ditch and declare that he could see the finest subjects for painting'.

Finally, and most inspiringly, Alison argued that 'while the objects of the material world are made to attract our infant eyes, there are latent ties by which they reach our hearts' and thus call forth 'our moral sensibilities'. Thus looking at natural beauty – and by extension painting it – was a spiritual, ethical and religious exercise. And Alison concluded:

Wander where we will, trees wave, rivers flow, mountains ascend, clouds darken, or winds animate the face of heaven; and over the whole scenery, the sun sheds the cheerfulness of his morning, the splendour of his noonday, or the tenderness of his evening light. There is not one of these features of scenery which is not fitted to awaken us to moral emotion.

This, again, was exactly what Constable thought. When he was painting, he explained to Maria, he was not only occupied by what he loved, but he felt he was 'performing a moral duty'. Alison's final essay, he believed, was 'by far the most beautifull thing' he had ever read. He quoted part of it to her, in which Alison claimed that the study of nature, amid all the trials of society, provided 'one gentle and unreproaching friend, whose voice is ever in alliance with goodness and virtue, who is alone able to sooth misfortune.'

'Have we not,' he added, 'my beloved Maria both felt this?' They had the same taste as the fictional couple – Fanny Price and Edmund Bertram – in Jane Austen's *Mansfield Park* (published that July). At one point early in the novel Fanny and Edmund turn away from a noisy room full of social activity to gaze out of the window, 'where everything was solemn and soothing, and lovely, appeared in the brilliancy of an unclouded night, and the contrast of the deep shade of the woods. Fanny spoke her feelings. "Here's harmony!" said she, "Here's repose!"'

In the early summer, Maria seemed likely to visit the famously sublime scenery of Wales with her relations the Arnolds. Constable was keen for her to undertake this journey – the change of scene, the air and the sublimity would all do her good – though he regretted not sharing it with her. 'I did hope that we might have visited these delightful places together for the first time.'

Perhaps the notion of gazing on Snowdon and Cader Idris in the company of Maria made such an expedition seem attractive. But later, Constable came to the conclusion that this brand of sublime landscape was not for him. He liked to live like a 'hermit', but in a populous pastoral landscape. C. R. Leslie heard him say that 'the solitude of mountains

oppressed his spirits'. Constable's nature, Leslie thought, was 'peculiarly social and could not feel satisfied with scenery, however grand in itself, that did not abound in human associations'. He needed cottages, churches, fields, farms – in other words, something rather like East Bergholt. With or without Maria, he never again ventured out of southern England.

Constable's aversion to travel was one of his characteristics as a man and, in an era that saw the beginning of modern tourism, a preference that was verging on eccentric. Even later on, when his art was acclaimed in Paris, he was strangely unwilling to cross the Channel and receive the praise in person (and in doing so increase his fame and wealth). He would rather be a poor man in England, he insisted cantankerously, 'than a rich man abroad'.

Some of his contemporaries – Turner, Shelley, Byron – restlessly roamed the world, and in that wandering found inspiration. Constable was a different kind of man and artist. His exploration was of a circumscribed terrain, but in greater and greater depth. It could be compared to Jane Austen's 'little bit (two inches wide) of ivory' on which she worked 'with so fine a brush'. But within that microcosm of provincial life, she observed so much of human behaviour.

Constable greatly admired another sort of microcosm: Revd Gilbert White's *The Natural History and Antiquities of Selborne*, an examination of the wildlife of a Hampshire parish, carried out over a lifetime. 'A single page alone of the life of Mr White makes a more lasting impression on my mind than that of Charles the fifth or any renowned hero.' This 'serene & blameless' existence 'so different from the folly & quackery of the world' must, he thought, have fitted Gilbert White 'for such a clear & intimate view of nature'.

That was a concise description, of course, of exactly what he aimed for himself.

When the mood took him Constable produced studies of the natural world as detailed and precise as any description in the *Natural History of Selborne*. An example was the drawing in his sketchbook from that summer of a clump of rhubarb leaves, presumably from the family vegetable patch. At other times he picked a bunch of flowers from the garden at East Bergholt House and the surrounding hedgerows, choosing ornamental poppies, veronicas, honeysuckle, meadowsweet, roses, carnations and placing them in a hyacinth vase.

The result was an art-historical rarity: a distinguished English flower painting. Despite the British love affair with gardens and landscape, the nation's artists had not executed pictures of blooms and bouquets in anything like the quantity produced in the Netherlands, France or Spain (and

Rhubarb Leaves

did not until the twentieth century). Constable's flower studies were different in mood – more rustic and informal – but if he had wanted to he could have been a great flower painter.

Constable had a tender sympathy for living things, particularly from the plant kingdom. Late in life, in 1836, he described the fate of an ash to a lecture audience in Hampstead. His words suggest a feeling for the graceful tree that was so intense as to verge on romantic.

Many of his friends from that neighbourhood, he began, might

remember this *young lady* at the entrance to the village. Her fate was distressing, for it is scarcely too much to say that she died of a broken heart. I made this drawing when she was in full health and beauty; on passing some time afterwards, I saw, to my grief, that a wretched board had been nailed to her side, on which was written in large letters, 'All Vagrants and Beggars will be dealt with according to Law.' The tree seemed to have felt the disgrace, for even then some of the top branches had withered. Two long spike nails had been driven far into her side. In another year one half had become paralysed, and not long after the other shared the same fate, and this beautiful creature was cut down to a stump, just high enough to hold the board.

Maria never really believed that the Welsh excursion with the Arnolds would really happen. And, in fact, it didn't. Her mother was now too ill to travel in that way, and equally not well enough for Maria to leave her. Although Maria, who – unlike Constable – made an effort to maintain a cheery tone in her correspondence, did not emphasize the point, a lot of her attention was now devoted to the care of her inexorably declining parent.

Wimbledon proved too dull for poor Mrs Bicknell. There was nothing there to distract her from her ill-health. Eventually in September, to Maria's relief, since life in Wimbledon with an invalid can have had little entertainment, the Bicknell ladies moved on to Brighton.

Meanwhile, Constable was immersed in an unprecedented painterly experiment. He had written to his much disapproved of friend John Dunthorne of a plan he had long had in mind: 'I am determined to finish a small picture on the spot for every one I intend to make in future. But this I have always talked about but never yet done – I think however my mind is more settled and determined than ever on this point. Hitherto (as Shakespeare says) "I have been too infirm of purpose."'

That autumn, he set about a rather more ambitious version of this project: to paint a picture, rather than just a study, entirely out of doors. He drew a sketch of his chosen subject on 7 September. It was a scene neither sublime nor conventionally beautiful, but mundane, ordinary, workaday. Near Flatford Mill, on the bank of the Stour, one of his father's barges was being built. These small horse-drawn boats, known locally as lighters, plied the Stour from the port of Mistley on the estuary the twenty-three miles to Sudbury.

They carried wheat and barley down to the coast to be sent on to London, and such things as coal for heating and London horse manure for the fields up to the riverside communities. The Stour was, in other words, a vital part of the local economy, and one that owed everything to modern 'improvements'. The trade had become possible only when the river was turned into a canal, with locks and towpaths, a century before in 1713. Golding Constable senior was one of the commissioners who supervised the management of the

river. John Lott complained more than once to them about the condition of the towpaths and the stiles over which the horses had to jump.

Golding Constable's business was also intimately connected with the traffic on the river, so much so that he made use of an ingenious little dry dock near the mill. This could be flooded from the river by opening the gates, but also drained through a pipe that led under the Stour, which was raised above the surrounding landscape at this point, and into a low-lying ditch. There a new boat was nearing completion. It was an outdoor workshop in a landscape thoroughly transformed by man in every detail.

This was the subject that Constable chose for a technical experiment of his own. The problem with his ambitious pictures for exhibition at the Academy and elsewhere was, everybody agreed, that they lacked finish. He himself was clearly conscious that they did not have the freshness of his outdoor studies. This new painting was an attempt to correct that problem: to make a 'finished' painting that retained the open-air light and sparkle of direct observation of landscape, while having the more carefully considered arrangement of paintings done in the studio. It was a dilemma that would continue to tax painters for over a century.

Constable's effort to solve it that autumn was a bold one. The canvas he chose was not a huge one – two feet across – but was considerably larger than any of his studies.

He worked every day at the dry dock. He was always informed, he later remembered, 'that it was time to leave off by the film of smoke ascending from a chimney in the distance'. This showed that the labourers' evening meal was being cooked so work would soon be over. He finished the picture, he also recalled, entirely on the spot. Was that really true?

No painting, however quick, can ever be instantaneous – as photographs were later to be. Clouds drift, light changes, passers-by move on. The final picture, *Boat-building near Flatford Mill*, was pondered in the manner of a studio picture. It presents at least two different stages in progress simultaneously. The hull of the boat as he shows it has been completely caulked with pitch and oakum. And yet Constable included a boy sitting rolling the oakum still, and the cauldron of pitch heating over a fire at the side. Both of these add necessary elements to the design; on the other hand, the adult workmen, the ones who had applied that pitch, have disappeared, perhaps off to their dinners, leaving their tools lying on the ground. He must have decided they would confuse the composition.

Nonetheless, this picture had a convincing feel of being

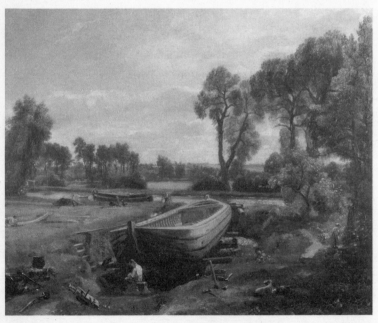

Boat-building near Flatford Mill

beside the Stour on a bright, early autumn day, with the light on the water and the shimmer of leaves. You can, as somebody said, almost smell that pitch. This was a distinct advance in Constable's painting: from now on he obtained that sparkle and shimmer in his exhibited work. It became a trademark and, for those who disliked it, a point of criticism.

Constable himself, in moments when he felt down, was much more conscious of the discrepancy between the reality of nature and any painting. 'Nothing can exceed the beauty of the country,' he felt, which made 'pictures seem sad trumpery'. 'Good God – what a sad thing is this lovely art – it is so wrested in its own destruction – only used to blind our eyes and senses from seeing the sun shine, the fields bloom, the trees blossom & to hear the foliage rustle.' In comparison, what were paintings? 'Old black rubbed-out dirty bits of canvas.'

Philadelphia, daughter of Squire Godfrey and his wife – who'd always been great supporters of Constable's – was to marry a Mr Fitzhugh of Denbighshire. Maria, with her female interest in matrimony, was curious about the details of this match. 'The gentleman is extremely rich,' Constable explained, 'Mr. Fitzhugh, and a college friend of Mr. Godfrey's. I believe he is near thirty years older than Miss G. but in the plenitude of his wealth that was not *thought* of.' There was, he was told, a great attachment between them. Perhaps there was.

Mr Fitzhugh commissioned a painting from Constable as a wedding gift. She wanted a landscape to remind her of her native village after she had moved to Wales. He planned a view over the Vale of Dedham from just outside the grounds of the Godfrey house, Old Hall.

★

Maria was enjoying herself rather more in Brighton, where life was quite lively and the Bicknell party were right in the middle of it. They were staying at No. 3 Marlborough Row, a line of nine terraced houses that had been built in the grounds of the Prince Regent's Marine Pavilion. On 24 October, a royal party arrived containing the queen, princesses Sophia and Mary and the royal dukes of Clarence and York. The town was illuminated, the entertainments lavish.

The Bicknells had friends in Brighton and Charles Bicknell had of course been engaged in the prince's various schemes there. His signature, along with that of Colonel Leigh, the brother-in-law cuckolded by Lord Byron, was on the deed of conveyance by which some land had been sold. On this plot was built the Theatre Royal, Brighton – an auditorium almost as grand as its namesake in Covent Garden.

When he later visited Brighton, Constable did not think much of it. It was, he felt, 'the receptacle of the fashion and off-scourings of London'. The beach was merely Piccadilly by the sea, the 'magnificence' of which was 'drowned in the din & lost in the tumult of stage coaches'. He told his friend John Fisher that beauty and nature were obliterated by

> ladies dressed & *undressed* – gentlemen in morning gowns and slippers on, or without them altogether about *knee deep* in the breakers – footmen – children – nursery maids, dogs, boys, fishermen ... rotten fish & those hideous amphibious animals the old bathing women, whose language both in oaths & voice resembles men – all mixed up together in endless and indecent confusion.

If East Bergholt was nature adapted by man, Brighton was high society – and low – beside the sea. At the very time

of the Bicknells' stay a decision was made to remodel the prince's Marine Pavilion in the most extravagant fashion. John Nash submitted designs for the building in a mingled Indian and Chinese taste, resembling a permanent version of his temporary structures for the peace celebrations of the summer. This was a style for which neither Burke nor Alison had a word: not sublime, not beautiful, but fantastic, freakish, bizarre, almost what was later called surreal.

In East Bergholt, the Gubbins family came to stay. Mr Gubbins had died earlier in the year; this was an opportunity for Mrs Constable to console her bereaved sister. Since he stayed out painting all day long, Constable himself was regarded as unsocial. He paid more attention to the guests after the arrival of his cousin Captain James Gubbins, who

James Gubbins in Church Street,
East Bergholt by Moonlight

had been fighting with Wellington in the Peninsular War. His regiment, the 13th Dragoons, had taken part in the great allied victory at Vittoria the previous year.

'We were brought up children together,' Constable explained to Maria, 'and you may imagine how that interest was encreased by a safe return after so long an absence and so many dangers.' At least, one of the brothers was home safe. The Gubbins remained very anxious about the other, Richard, who was still involved in the other half-forgotten war against the USA that dragged on.

Richard Gubbins had fought in the taking of Washington that August, after which he had been promoted to lieutenant-colonel and taken command of his regiment, as his superior officers were all killed or injured. 'They are delighted with Richard's promotion, but full of anxiety lest he should be knocked on the head by those wretched Americans.' Constable drew James standing in the village street by moonlight, a shadowy, almost spectral figure, and marked it half past eight at night.

By 25 October he had almost finished the painting ordered by Thomas Fitzhugh as a gift for his bride, a prospect of the Stour valley with Dedham in the distance. The sun shone brightly in the painting and the foliage was densely green, showing the results of his intensive studies from nature. A field of golden corn, the subject of such fierce dispute, ripened in the middle distance. In the foreground two men methodically shovelled manure from a dung heap into a cart drawn by two handsome horses – an unexpectedly earthy subject for a marriage gift, but then Georgian landlords took a close interest in the question of fertilizer. This kind of dung heap had a nicely technical local name: a runover dungle, meaning a mound that a cart could be

A Cart with Two Horses

run up to discharge its load, then go down the other side.

A farm dog sat waiting beside the workmen, the men's coats laid on the ground in front of it. The group was beautifully and precisely seen. (In preparation, Constable had made a series of horses and carts which were miniature masterpieces in themselves.)

The men were individuals, like the boy in the boat-building scene. Indeed, especially when he was working out of doors, the people Constable painted were probably known to him by name. East Bergholt was not a large place; early in his career as an artist he was advised by an older painter, J. T. Smith, not to invent figures. 'You cannot,' Smith had counselled, 'remain an hour in any spot, however solitary, without the appearance of some living thing that will in all probability accord better with the scene and time of day than any invention of your own.'

However, the figures in Constable's landscapes were always incidental to the larger picture. Behind the diggers in the foreground extended an orderly and fertile prospect –

the fields and hedgerows, the carefully managed river and, in the distance, the tower of Dedham church.

'In the landscape of the painter,' Archibald Alison wrote in the essay that had so impressed Constable, 'the columns of the temple or the spire of the Church rise amid the ceaseless luxuriance of vegetable life, and by their contrast, give the mighty moral to the scene.' Constable's paintings seemed to have a moral: this valley, so patiently tended by human labour, was natural, true and ordained by God.

Seen with the eye of an historian or an ecologist, however, this was a landscape showing an extremely high level of human exploitation. The banks of the Stour were carefully cleared of trees and vegetation so as to aid the passage of boats such as Golding Constable's barges. For all Constable's rhapsodizing over the foliage, the fields were much barer of trees than they would be at any point in the next century and a half, and the trees themselves were stripped of lower branches by villagers shinning up the trunks for firewood. This was a landscape of intensive agriculture, the product of a war economy which had been operating at full stretch for nearly twenty years.

Early in November Constable returned to London and shortly discovered that once more he attracted no support in the election for associate Academicians. In life, he saw himself as content with the simplicities of nature, happy to paint it, but giving up all worldly ambition. He wrote as much to Maria. 'I never fail to find encreasing delight in the walk I have chosen for life – but who are seeking for its honours I know not. It is sufficient for me to know that I am not – though I will allow *to you* that four or five years ago when I was more youthfull, I was a little on tiptoe both for fame and emolument.'

Neither his mother nor Maria thought much of this attitude. Mrs Constable scolded him gently for 'avoiding notice'. Maria was a good deal brisker. 'You have sent me such a strange letter,' she wrote from sociable Brighton,

that I cannot forbear sending you my sentiments upon it.

It appears strange to me, that a professional man should *shun society*, surely it cannot be the way to promote his interest. Why you should have been anxious 'four or five years ago after fame & emolument' and now to have given up the idea, is what I cannot comprehend, it is certainly paying me a very ill compliment, if you like to remain single it will do very well.

I must have you known, and then to be admired will be the natural consequence. *I* do not know how you will like my strictures on your conduct, but I cannot help that. It is better you should know my mind now, than afterwards, it is now not too late to quarrel. It is your turn next to accuse me, and I am sure I stand convicted of numberless errors, so that I would not have you believe I *think myself perfection*.

She would be in St James's Square at noon on 23 November, and then they could meet again after many months – but on a note of some asperity.

Mrs Constable continued to fuss over all her family, and perhaps most of all over John, with whom her dispute of the previous year had long been happily settled. Constable quite often received food from home – a Suffolk chicken, ham, cheese. Now his mother sent him a turkey, one of the last of the Christmas flock, and a Suffolk hare to eat in his London lodgings, which he correctly guessed from examination had been killed by a dog. His mother confirmed that it had been caught by the black greyhound named Spring as it was walking over the meadows with his brother Golding. Thus even the food on his table carried with it associations of much-loved places and country life. 'Poor puss,' Mrs Constable called the hare, with the true rural mixture of sentimentality and ruthlessness in the matter of game.

His mother's Christmas present to him took the form of six shirts, four of hemp, which he had said he would like to try for work, and two Sunday ones for best, with collars like the ones on Captain James Gubbins's fashionable shirts. (Maria gave him a pretty pocket book, which was sent to East Bergholt for inspection by the ladies of the Constable family.)

The question of the fashionability of John's shirts had always worried Mrs Constable. It was difficult for her as a woman living in a rustic village to keep up with such things. James Gubbins was a reliable indicator of the current style, being as he was an officer in a smart cavalry regiment. On the other hand, she did not want John to imitate other

aspects of Captain Gubbin's way of life, such as getting into debt. Evidently, James didn't have enough money to compete with his brother officers, or, as Mrs Constable saw it, was led astray by 'the weakness of poor Human Nature led away by the false glare of appearances in this world'.

'O my dear John,' she cautioned, 'pray keep out of debt, that earthly Tantalus.' No doubt Mrs Constable meant Tartarus, or Hell – she too had a touch of Mrs Malaprop about her. But how was John's financial future to be secured? She did her best to look after his interests. It was apparent to everyone that her husband, Golding Constable senior, was slowly reaching the end of his life. He was now seventy-seven and his circulation was beginning to fail. Every winter he fell ill with a chest infection; he'd probably contracted Miller's Lung from years of inhaling flour dust.

Mr Constable too was naturally concerned about his painter son, and how he would survive. His own solution was to buy an annuity in John's name so that he would be safe from actual poverty. This, Mr Constable said, would make his deathbed easy. Mrs Constable replied that he assuredly had the right to dispose of his property as seemed best to him, 'But if I might speak, *my* sentiments – on this subject – were not in strict unison with *his*.' She looked upon this plan as sinking capital and not adding to John's respectability since the annuity would assure only a modest way of life. Her hopes for her son were higher, and she was sure John himself would not approve of the plan. But there the matter rested; Mr Constable was not persuaded, and pursued his idea.

The moment when his final wishes would be known seemed to be approaching. Towards the end of January, Mr Constable fell more severely ill than before. It was evident that blood was no longer properly reaching his extremities

and one of his feet was badly affected. For a while, Mrs Constable feared he was about to die.

'My feelings are indescribable,' she wrote to John, although she had 'no weight or neglect of duty' on her conscience. The Constables' marriage had been a happy one, despite always being marked by an old-fashioned distance and formality between them. 'A widow, is at best a forlorn woman,' she continued, 'my earthly hope must be in my children!' After a few days, however, Golding Constable, a man of great robustness, rallied once more and his life seemed no longer in danger.

Another perennial source of worry to Mrs Constable was her son John's difficult temperament. Anxiety and depression, in his case, led to a sharp tongue and a short temper. 'A meek & quiet spirit,' she advised, by no means for the first time, 'will suit better than irritability, which only harasses and wears out.' But as often happened in the dark, cold winter months, his mood was sinking.

No sooner had he returned the previous November to the 'brick walls and dirty streets', than he began to miss 'the endearing scenes of Suffolk'. The impasse with Maria had gone on unendurably long. The opportunity to see her illicitly for an occasional snatched few minutes while she was walking was not enough to raise his spirits. Her birthday – 14 January – came and went. The years were passing. Life, for other people at any rate, was moving on.

The charming Mrs Skey of Spring Grove announced that she was going to marry the Revd Joseph Fletcher, a curate who was currently chaplain to the Earl of Huntingdon. He was about a dozen years her junior, and plainly without any fortune but Mrs Skey, who possessed her own ample resources, did not have to take account of that. Not so poor

Maria, a great deal of whose attention was in any case directed towards her invalid mother.

On Tuesday, 21 February, a cloudy, overcast day, she and Constable met, as they were sometimes able to do, on her walk. He accompanied her back to the door of her house on Spring Gardens Terrace. His mood was bleak, his manner to her distant. He suggested that they should meet again in six months' time – six months! – and, most hurtful of all, he inquired whether she had any other suitor in mind.

On this occasion, Constable's tendency to cutting, bitter remarks, which often, as his mother feared, did him harm, worked, instead, to his benefit. Maria stepped inside the door of Spring Gardens Terrace, her emotions in turmoil. For a long time – two years – she had kept Constable waiting, with a rare letter and a meeting from time to time. There was not, as she saw it, anything else they could do but wait until other aspects of the situation resolved themselves. Her grandfather could not live for ever, nor could Constable's father. Eventually her financial position, and his, would become clearer. Then, with good fortune, they would be able to marry.

This calculation was now overturned. She was, it seemed, in danger of losing him altogether. Something must be done. Desperate and distraught, Maria set about changing her father's mind – to some extent at least. By Thursday, she was able to write announcing that Mr Bicknell's mortifying ban on Constable stepping inside the house in Spring Gardens Terrace was now formally lifted.

I have obtained from Papa the sweet permission of seeing you again under this roof to use his own words as an occasional visitor. From being perfectly wretched I am now comparatively happy. I cannot tell you what I felt last

Tuesday when you left us at the door now to be no longer closed, is it not delightful, but what an uncomfortable walk was it to me. I had longed anxiously to see you & when we met how cold & dissatisfied you appeared, and then *you coolly ask me if I have* any other *plans* in view, can you imagine my heart would change?

Even this sweet letter and the concession it relayed did not entirely reverse Constable's grimness of mood. As he saw it, he had been grossly insulted by Mr Bicknell, and he was inclined to resent the matter more now, two years after it had occurred, than he had at the time. Before replying to Maria, he asked his mother for her opinion, assuring her that he would never do anything compromising to the family dignity.

Mrs Constable, it turned out, was delighted by this development, which she had never expected to see. She was not inclined to bear a grudge against Mr Bicknell. 'You must,' she advised John, 'make every kind allowance for Mr. B. who is most assuredly not a free agent in this matter. He is under rigid restriction, from which, for the *sake of his family*, he must not appear to swerve.'

Whether, as she implied, she was quite right to put all the blame on Dr Rhudde is not clear. It might, at the very least, have been convenient to Charles Bicknell that Dr Rhudde was so opposed to this unsuitable attachment.

The upshot was that Constable rather sulkily accepted the invitation to take tea at Spring Gardens Terrace, and was received there for the first time in two years on Friday, 10 March. While the romantic affairs of John and Maria were taking this small turn for the better, the international situation of Britain and Europe suddenly became ominously

much worse. The ex-Emperor Napoleon had escaped from the island of Elba at the end of February and arrived on mainland France on 1 March. The king of France, Louis XVIII, had sent a regiment, the Fifth of the Line under Marshal Ney, to meet him at Grenoble.

When Napoleon came within sight of the troops he dismounted and stood before them. 'Soldiers of the Fifth, you recognize me. If any man would shoot his emperor, he may do so now.' After a brief pause, to a man they shouted '*Vive l'Empereur!*' The peace, so extravagantly celebrated, was destroyed at that moment. To the glee of his supporters, such as Byron, and the horror of many others, such as Constable's younger brother, Abram, 'that scoundrel Bonaparte' was at large again.

Suddenly the world seemed in a very unsettled state. Combined with the ever unpredictable effects of the weather, the peace had been disturbing to the balance of life at home. The problem turned on the crucial commodity on which the modest Constable fortune was based: corn. The war years had been good ones for farmers, with high demand for food and little foreign competition. The price of grain had been above 100 shillings a Winchester quarter; four bad summers pushed it up to 155 shillings.

More and more land, especially in southern Britain, was put under wheat cultivation. There was a frenzy for the enclosure of common and marginal areas. But the bumper harvest of 1813 sent the value of grain tumbling. A late drought in the following year forced many landowners to sell cattle. Rents, fixed during the boom years, still had to be met. The result was an attempt to reduce costs: that is, the wages of farm labourers. There was political pressure for a law against the importation of foreign grain except with a punitive duty.

At the same time, demobilized soldiers and sailors were searching for a job and the industries of war – ship-building and armaments – were contracting, while improved technology was destroying yet more jobs. The result: unemployment, poverty, hardship and bitter anger against the attempt to raise the price of the most basic necessity of life, bread. Nearly 2 million people signed a petition against the new legislation. As the Corn Law was being debated, rioting broke out in London. An angry crowd assembled around the Houses of Parliament on 6 March and the residences of those proposing the bill had to be protected by soldiers. The disturbances went on for several days.

The houses of Lords Eldon, the Lord Chancellor, and Castlereagh were attacked; so too was that of Sir William Rowley, the local MP (in whose interest the Constables' home had been decorated with Tory ribbons). Most of the furniture was destroyed by the mob in the house of Mr Robinson, the vice president of the Board of Trade, who introduced the bill. As Abram Constable, increasingly the manager of the family business, reflected, the world was in an unsettled state. These were awkward times. He hoped they would improve.

Dr Rhudde's eighty-first birthday – 9 March – found the Rector in London, as was his habit in early spring, staying in his house on Stratton Street. Mrs Constable exhorted John to call and pay his respects to the old man, as he entered 'on this eighty second year of his long pilgrimage thro' this world, in which he has had so much sunshine as to this world's goods'. After all, he was Constable's 'your Grandfather *in expectation*'. But of course it was the clergyman's ample fortune that had prevented, year after year, that expectation becoming a fact. She herself sent a letter of

birthday greetings to this man whose moods and changing attitudes she had watched so anxiously for many years.

On the very morning of Dr Rhudde's birthday a letter from Constable arrived at East Bergholt House. Abram brought it into the parlour from the counting house, where it had been delivered. Mrs Constable and he read it and she was quite pleased to hear of his progress. Her only concern was that he should not go out into the streets, which according to the newspapers were full of rioters and armed troops.

Despite the cold, Mrs Constable went out into the garden behind East Bergholt House after breakfast and did some gardening. There was a neat little lawn there, surrounded by shrubs, and a flower bed laid out in a circle. To the right of this flower garden there was a large area containing rows of vegetables and fruit trees.

After a while, Mrs Constable felt dizzy; once or twice she almost fell over. She came back into the house and lay down on the sofa. Her condition was worrying enough for Travis,

Golding Constable's Garden

the surgeon, to be sent for. He bled her and afterwards she seemed somewhat better, though her pulse was fast and erratic and – the most ominous symptom – she was partially paralysed on her left side.

It was plain that she had had a stroke, though a relatively mild one since her mind seemed alert and her speech was only slightly affected. Naturally, the Constables were extremely worried, though there seemed to be a fairly good chance that she would survive. Golding Constable, over a decade older than his wife, who was sixty-six, and barely recovered from a brush with death himself, was stricken with anxiety. Ann and Mary at once wrote to their married sister, Martha Whalley, and the following day Abram sent a letter to John.

On Sunday the 12th, at her own request, prayers were said in East Bergholt Church for Mrs Constable's recovery by Mr Roberson, one of the curates. That afternoon, she seemed better and said herself that she felt she had improved. Her husband and family were somewhat cheered, though the doctors still warned that she was in considerable danger. And so, sadly, it proved. By Tuesday her condition had worsened so sharply that Abram summoned Constable urgently to her bedside. He suggested he take either the Times or Eclipse coach from the City of London the following afternoon.

Martha Whalley had already arrived. She remained until Monday, 20 March, when she thought there was little point in staying as her mother's condition had deteriorated so much and that she ought to return to her family. Constable too seems to have come to Mrs Constable's bedside, stayed for a while, then returned to his painting-room in London. While he was in East Bergholt, he talked to Abram about the question of his returning for the funeral.

Mrs Constable died at the end of March, and her burial was set for 4 April, the very day, as ill luck would have it, when the paintings for the Royal Academy exhibition had to be handed in. As usual, Constable and the other painters of London were in a state of extreme nervous tension as this most crucial moment of the year approached. Only a little time remained to put the finishing touches to works on which so much thought and effort had already been spent, and on which so much depended.

Constable made the decision, which under the circumstances seems shocking, not to come back to Suffolk to pay his final respects. Abram, his sisters and grief-stricken father were astonished by this response. Abram wrote to his brother:

I know you are not a whit behind any of us in real affection, therefore it is unnecessary to urge your coming, enough has been said to induce you at the moment to resolve to throw yourself into the Mail on Monday night to be with us on Tuesday, to pay the last rites, however it may break into your time, at this critical period; – but I trust you will have done all the time would allow you to do, – & there is only this thing to be consider'd, that there are duties, to which & before which every thing gives way.

That, one might have thought, was a plea so dignified, heartfelt and just as to be impossible to turn down. Yet Constable continued in his refusal, and did not come to the funeral. Furthermore his answer, which did not survive, was sufficiently eloquent and touching to make all the family forgive him, sympathize with him and even apologize to him.

'I only express'd the sentiments of the rest of the family,' Abram responded,

& we did not like to leave any chance of reflecting on ourselves or that you should not know what was doing, as it was impossible we could tell how very urgent your business was – but it is all right, no one thinks of it only as it really is, that to come was out of your power. So there is nothing in it to make you uneasy.

What was so imperative to John to finish his pictures that he missed his own mother's funeral? Did he really feel his artistic affairs were so very urgent as to make attendance impossible? It is true that he convinced Abram and the others that was so, and it is true that the event was badly timed from the point of view of the Royal Academy calendar. But another possibility exists, that Constable simply could not face it; that his mother's illness and the impending demise of his other parent had thrown him into a state – always threatening – of anxiety and depression. It was moreover the case that Mrs Constable, to whom his progress as a painter had been the cause of so much concern, would have approved of his decision.

Towards the end of April, Mr Bicknell's name was mentioned in the Houses of Parliament. It was one of the eccentricities of King George III to take a strong interest in agriculture, a preoccupation he shared, it was fair to add, with many of the greater and lesser landowners of the kingdom. Farming and farming improvements were not merely a topic of discussion in East Bergholt but a national obsession.

In happier days before his mental affliction took its final hold, the king had been fond of raising sheep and cattle on his royal estates at Windsor, and chatting with the stockmen. This quirk had earned him the nickname 'Farmer George'. But now that he was no longer capable of running these

establishments, it was thought best to put in place a committee with power of attorney to do so. This consisted of John Nash, the architect, Charles Bicknell and Lord Yarmouth, rakish son of the Prince Regent's middle-aged mistress, Lady Hertford.

To political opponents of the Regent, this arrangement – sensible enough in reality – could only appear to be another encroachment on royal power. It is true that the trio appointed was an odd one. Yarmouth, in later life, provided the model for the lecherous, power-hungry and corrupt Marquess of Steyne in Thackeray's novel *Vanity Fair*.

Vice-chancellor of the Regent's household, he was prepared to do anything for money, including eloping with the heiress Maria Fagiani, illegitimate daughter of the Marquess of Queensbury. Known as 'Red-herrings' from his rubicund face and whiskers, Yarmouth was, like Byron, a frequenter of Manton's shooting-gallery, where he wagered large sums on his skill. He was very fast company for Mr Bicknell and, like most of the Regent's circle, an unwise person to lend money to, if that was what Maria's father was doing.

On 25 April, pointed questions about the arrangement were asked in the House of Commons by a Mr Whitbread. Another member named Tierney asked, rather sharply, what an architect such as Nash would know about the subject of parks and farms. Yarmouth was forced to make a statement in the Lords. During the exchanges, however, it was kindly remarked that no better legal advice could be had than from Charles Bicknell.

This unsolicited testimonial, however, probably did little to cheer the solicitor since in his house on Spring Gardens Terrace, similar scenes were occurring to those in East Bergholt. Maria's mother's long decline was reaching its end. Maria sent Constable a letter saying that, under the

circumstances she could not see him. Not quite grasping the situation and taking advantage of his new permission, he nonetheless called on the Bicknells, but was told at the door that Mrs Bicknell had died on 12 May.

He wrote to Maria in a way that suggested that his absence from his own mother's funeral was not the result of lack of mourning.

> That we should both of us have lost our nearest friends (the nearest we can ever have upon Earth) within so short a time of each other is truly melancholy – and more than ever do I feel the loss of your society. Indeed I never felt the misfortune of our being apart more severely than at this moment, as I am convinced that we should be a mutual comfort to each other – I assure you I sincerely feel the want of that comfort which your excellent and religious mind could only afford me.

The opening dinner of the Royal Academy exhibition that year was accompanied by an unexpected mishap. It was now three years since the ornate bronze chandelier presented by the Prince Regent had been installed, its lighting meticulously fussed over by Joseph Farington. Suspended from the ceiling of the Great Room at Somerset House, it was a formidable contraption; immense, in the recollection of the novelist Walter Scott, who happened to attend the dinner that year, with 'several hundred burners, weighing three or four tons at least'. 'Beneath it was placed,' Scott continued, '. . . a large round table, or rather tier of tables, rising above each other like the shelves of a dumb waiter, and furnished with as many glasses, tumblers, decanters, and so forth, as might have set up an entire glass shop – the numbers of the company, upwards of 150 persons, requiring such a supply.'

The dinner began – Benjamin West presiding at the head of the table, with the Duke of Norfolk on one side and one of the royal dukes on the other.

We had just drunk a preliminary toast or two when – the Lord preserve us! – a noise was heard like that which precedes an earthquake – the links of the massive chain by which this beastly lump of bronze was suspended began to give way, the mass descending slowly for several inches encountered the table beneath, which was positively annihilated by the pressure, the whole glassware being at once destroyed.

What was very odd, the chain, after this manifestation of weakness, continued to hold fast; the skilful inspected it and declared it would yield no further – and we, I think to the credit of our courage, remained quiet, and continued our sitting. Had it really given way, as the architecture of Somerset House has been in general esteemed unsubstantial, it must have broke the floor like a bombshell and carried us all down to the cellars of that great national edifice.

Farington's diary broke off after he had recorded that in the morning he went to Somerset House and arranged the place-cards for this almost catastrophic banquet. Perhaps because of the horror and mortification of the experience, he wrote no more for the next three weeks.

Even in the absence of Mrs Constable, there was excitement in the household of East Bergholt House about the coming exhibition. Abram keenly anticipated a sight of the catalogue; even Golding Constable junior, that hunter and man of the woods, planned to pay a visit.

Golding senior, the ailing father of the family, sent a letter to his second son, addressed as 'honest John', recording that,

though his loss had almost brought him to the grave, he was slowly recovering. Although old age was steadily encroaching on him and his breath was short, his feet were healed – his toes had briefly turned black – and he had been out in the gig. Mrs Coyle from Dedham lent them a catalogue of the exhibition – Constable himself had neglected to send one – and spoke highly of his paintings.

Soon after hearing the sad news of Mrs Bicknell's death, Constable returned to East Bergholt, where he thought his father was looking 'uncommonly well', and began a portrait of him, which greatly pleased and entertained the old man. Constable himself thought the picture was turning out well. Not for the first or last time, a painter found that painting his family was an ideal way of making contact.

Golding Constable senior had been applying his mind, under the tactful guidance of Abram, to the pressing matter of his will. Mr Mason, the solicitor from Colchester whose pretty daughters Constable had once painted, made several visits to East Bergholt House. The problem was how to divide the property equally, given that most of the capital was sunk in the business, which Abram would continue to own and run, and much of the rest was tied up in the house. But Abram, practical, energetic, kindly and loyal, saw a way through the difficulties. The offensive clauses, such as the one setting up an annuity for John, would be omitted.

On Sunday Doctor Rhudde preached a sermon on the impropriety of long lamentation on occasions such as the death of his daughter, Mrs Bicknell. Some might have found this Christian stoicism verged a little on heartlessness; Dr Rhudde had a tendency to select controversial texts. On the eve of Philadelphia Godfrey's wedding he had preached on 'Lovers of pleasure more than lovers of God'. But Constable found this latest sermon 'most consolatory' and exchanged

polite words with the rector, who asked after Mr Constable's health.

In accord with Dr Rhudde's homily East Bergholt House was no longer deep in mourning. Mr Constable was recovering from his shock; the younger members had regained such high spirits that when Miss Taylor gave a ball at the school for young ladies she had established next door, Abram took his sisters and they did not get back until half past three in the morning. John, more fond of fields and willows than dances and routs, did not join them.

Towards the end of the month he returned to London, where Parliament had been debating whether to embark yet again, after all these weary years, on war with France. Opinion was divided in the Commons and Lords – and outside. The painter Smirke remarked to Farington how extraordinary it was that Benjamin West and others were always ready to think favourably of Bonaparte and that 'men who professed themselves advocates for liberty should be so warped in their opinions'. Farington heartily concurred, though many others such as Byron sided with President West. In the end, the supporters of war were in the parliamentary majority.

Meanwhile, in the world of painting there was a sharp intellectual battle going on. Constable's landscapes in the exhibition had been greeted with measured praise and mild censure, but Turner's had set off aesthetic warfare. Sir George Beaumont and his circle denounced them with savagery. They said Turner 'did not comprehend his art'. Both artists and the press had extravagantly praised Turner's *Dido building Carthage*, a work which to Sir George's eye was in the manner of Claude's seaport scenes. Sir George went especially to the Royal Academy to look hard once more at this picture. He was reassured that his criticisms were correct.

Engraving of J. M. W. Turner's *Dido Building Carthage*

'The picture,' he told Farington, 'was painted in a false taste, not true to nature; the colouring discordant, out of harmony.' *Crossing the Brook*, another of Turner's most notable exhibits, he considered to be of a 'pea green insipidity'. This was a more pastoral work in the Claudean mode, again with the painter's illegitimate daughter posing for the figure of a young woman. 'These are my sentiments,' Sir George declared, and he had as good a right to express his opinion as anyone. Not everyone agreed with that view however.

An anonymous pamphlet soon appeared, purporting to discuss the exhibition at the British Institution of Dutch and Flemish paintings, the successor to the Reynolds, Gainsborough, Hogarth and Wilson retrospectives, and not, as some artists noted, very British. This publication defended Turner, remarking that there had been a virulence of criticism directed at his work such as should be reserved for *crime*. The tussle between artists and gentlemen connoisseurs was heating up. As so often the argument turned on what was natural, and on who understood nature and therefore art.

Sir George grew thin with chagrin. At dinner on 9 June, he told Farington that he thought that the authors or printer of this vexatious publication might be sued. He suspected a confederacy of four or five writers ranged against him. Unfortunately, none had added their name to the attack.

Wordsworth was among the other diners; he expressed great apprehension about the outcome of this new contest with Napoleon.

Constable himself had a sharply critical turn of mind, and tongue, which was perhaps one of the traits that prevented his acceptance by the Royal Academy. When Mrs Godfrey asked him to mark a catalogue of the RA exhibition for her 'to assist her judgement', he wasn't quite sure where to start, as he told Maria. 'I don't know at which end I must begin – had I not better mark the whole of them? They probably wish me to omit the bad ones – but was I to mark a catalogue for myself, those I should fix upon first, for they are by far the most amusing to me.' His verdicts on other painters' works could be wonderfully, and savagely, dismissive.

William Collins, father of Wilkie, who was named for a painter friend, David Wilkie, was a target. 'Collins exhibits a coast scene as usual, and a landscape like a large cow-turd – at least as far as color & shape is concerned.' No surprise then that his little son was not named Constable Collins. Ramsay Richard Reinagle, the painter of his portrait in youth and for a short time a friend, also regularly infuriated Constable with his work. Not surprisingly, this was the case when Reinagle was elected to the Academy and asked Constable to look at his diploma picture. 'It is such art as I cannot talk about – heartless – vapid – and without interest. In landscape this is abominable.'

Such views were the result of his fastidious sensibility, and consciousness of the worth of his own overlooked master-pieces. But they did not make him popular. The painter Richard Redgrave recalled the 'bland yet intense sarcasm of his nature', though 'soft and amiable in speech, he yet uttered sarcasms that cut you to the bone'.

During June, Constable was engaged in a job that empha-sized his intermediate position in this contest, as would-be artist and aspiring gentleman – even if he was not always treated as such by Mr Bicknell. He was helping an older painter, George Dawe, with a portrait of the Irish actress Eliza O'Neill as Juliet, in which part she had scored a great success at Covent Garden. Dawe conceived the composition and depicted Miss O'Neill leaning lovelorn in the light of the moon; Constable was responsible for the landscape background and the passion flowers which twisted over the classical balcony.

He found this task testing, giving up a projected visit to a friend named Spilsbury who had a cottage in the Words-worthian territory near Tintern Abbey in Wales. Often, Constable was on the step of Dawe's house in Newman Street, round the corner from his own, as the clock struck six in the morning. This kind of work earned him money but also wasted his time and talents. Furthermore, it was an indignity to his sense of status.

The trouble was, he confided to Maria, that Dawe was not a gentleman. But, on the other hand, he had 'sold himself' for the work he was engaged upon. The sooner he did it, the sooner he could return to 'dear Suffolk' for which he pined. 'My heart, as you know too well, is certainly not there – at least not all of it – but you say you would not give a farthing for a divided heart.'

Maria had long realized that her chief rival for Constable's affections was a stretch of East Anglian countryside. It was an odd position for a young woman to find herself in.

At this time she was staying on the rural outskirts of town in Putney, where Charles Bicknell had taken a country cottage, with her sisters and a Mrs Burminster, who took on the role of housekeeper and companion after Maria's mother's death. There was a new tranquillity in Maria's relationship with Constable from this point onwards. The final outcome no longer seemed in doubt; he was less fretful. They met and walked on the common, Maria accompanied by Mrs Burminster, who harboured no hostility to Constable. On his way back, he walked to Chelsea, where he visited his Aunt Allen, one of the late Mrs Constable's younger sisters, and stayed the night. Mrs Allen was in a state of anxiety since all four of her sons were in the armed forces, posted abroad, and Britain was once more at war.

Neither she nor anyone in England knew it, but at that very time the crisis – another of the hinges of history – was approaching. The allies who had defeated Napoleon the year before had agreed to carry out another invasion of France. The armies of Russia and Austria would arrive on the borders in July; British and Prussian forces were already stationed south of Brussels. Rather than await a massed attack, Napoleon had decided to move quickly and secretly north in hopes of destroying the enemy already in place under the command of Wellington and Blucher.

He succeeded in taking the allies by surprise. On 15 June a French army of 125,000 men stood between the Prussian and British contingents. Wellington moved west, thinking that Napoleon would attack his flank – the wrong direction – and discovered his mistake while at the Duchess of Richmond's ball in Brussels on the evening of the 15th. He

immediately began to redress his error. There was heavy fighting on the following two days, and a decisive battle on the third, Sunday, 18 June, near a place called Waterloo.

Constable wrote to Maria saying that he had decided not to pay a visit to Putney on Sunday the 18th, as Charles Bicknell was likely to be there and could not but find the sight of his daughter's suitor unpleasant. As he was avoiding this awkward encounter, and instead visiting the Whalleys in East Ham, Captain James Gubbins with the rest of the 13th Dragoons took up a position in a wood behind the Château of Hougoumont with two other cavalry regiments. This was a strong point of the British lines, and from 11.30 it was under intense attack by French forces under Prince Jerome Bonaparte, Napoleon's wild and unpredictable brother.

Thomas Lawrence's assessment of a conflict between Napoleon and Wellington – that it would be a struggle between cunning and wisdom, and wisdom would win – was not entirely correct. That was a portrait painter's view, based on character (after Wellington had sat for him). There were other factors involved, some – such as the rainy night and consequent wet ground that made it difficult to manoeuvre the French heavy artillery into position – more comprehensible to a landscape painter (or indeed, a former mill manager).

Clouds played their part in the battle. But so too did a multitude of factors, among them erroneous decisions resulting from Napoleon's low opinion of Wellington's abilities, and also perhaps his painful haemorrhoids, Ney's bad judgements, and Jerome Bonaparte's impetuosity. The last of those caused a fusillade of high explosives, shrapnel and spheres of hot flying metal to rain on the Château of Hougoumont, which nonetheless did not fall. The 13th

Dragoons made several gallant and effective charges, but sustained heavy losses.

On 22 June, at ten o'clock in the morning, the guns at the Tower of London and St James's Park were fired to announce the news of victory. There was rejoicing everywhere, though not, of course, among the supporters of Napoleon. On Monday 26th, there was a dinner celebrating the king's birthday at Somerset House, beginning at 6.45.

Constable was again present, though he did not have such an interesting companion at table as Turner had been the year before. He sat between the sculptor Francis Chantrey and his erstwhile friend Reinagle. Nonetheless, he had a pleasant time. Conversation naturally turned on the latest news from Paris. Napoleon had abdicated once more. Public sentiment had turned against him and people were walking about in the streets carrying newspapers and exulting over this triumph.

Still, he told Maria, there was no information about the fallen.

We are full of anxiety about our relations who were in the late dreadfull battle – we can get no account of them whatever – beside what are made publick they have a list of 800, killed & wounded, at the War Office which they will not publish. My poor Aunt at Chelsea is almost shaken to pieces, with anxiety, but she hopes for the best.

As it happened, her son Lieutenant Thomas Allen had fought in the battle and survived. Worse news was coming to her sister, Mary Gubbins, at Epsom.

A week later, on 3 July, Constable spent a day with Maria west of London. They arranged to meet on Putney

Bridge at eleven in the morning. Later, on the back of one of his cards, bearing the name *Mr J Constable, 63 Charlotte St, London* on the front, he drew a small perfect, peaceful landscape of Wimbledon Park. Pools of shadow lay under the clumps of trees, fluffy cumulus clouds hung in the sky above.

On the afternoon of 6 July, Constable returned to his other love, East Bergholt, and did not see Maria again for many months.

The remainder of the year passed quietly. Constable told Maria on his return that he thought he had never seen 'dear old Bergholt half so beautifull before as now'. But he repeated this observation, in almost exactly the same words, virtually every time he went home. As in the first movement of Beethoven's Pastoral Symphony, he experienced 'The awakening of cheerful feelings on arrival in the country': the landscape always seemed even more delightful than he had remembered it.

The villagers, or at least the wealthier ones, were in a celebratory mood. And, Constable told Maria, 'the youngest man among them is Dr. Rhudde'. An excursion was organized to travel from Bergholt and Dedham to Harwich by boat. Unfortunately, it turned out to be a rough day, and everyone was very seasick. 'One lady was so bad that she was obliged to be left at Harwich,' Constable observed with a touch of Jane Austen's sharpness, 'but she was old and of course found no one to pity her – she was left to find her way back to Dedham as she could.'

He did not go himself as he was busy on a picture. It was painted from an upper window at the back of East Bergholt House, looking down on the flower garden where his mother had suffered her stroke and beyond that across

278

the family fields to the Constables' barn and some distant cottages among the trees. It was lit by an evening sun, long shadows stretching across the lawn and Mrs Constable's flower bed.

This was perhaps a valedictory picture in two senses: a farewell to his mother and also to East Bergholt House. For his whole life he had been looking out at that view. Now it was becoming increasingly clear that, when his father died, the family home would have to be sold so the capital could be divided.

There was, too, a technical aspect to the exercise. By working in this way, but inside looking out, he could conveniently complete a whole landscape with the subject before his eyes. This picture was beautifully finished, full of detail, but entirely truthful and accurate. At the beginning of August, he journeyed to the village of Brightwell to paint a small landscape in a similar vein that had been requested by a local antiquary named Barnwell – such a commission was in itself an encouraging sign – then returned to paint a second picture from the back of the Constables' house.

This was painted from a higher position, in the attic or on the roof. It looked east over the vegetable garden and then across the fields to the windmill and the rectory – the location so closely connected in his mind with Maria and their trysts six years before. In the morning light exuberant, fleecy clouds were poised in a hot summer sky. This picture looked towards a hopeful future.

Dr Rhudde, Constable heard, had changed his will. He was now leaving the portion previously intended for Maria's mother to Charles Bicknell. This too was an encouraging sign. If Mr Bicknell could be won round, then there would be one fewer obstacle to their marriage. Maria believed it would be useful for Constable to have another conversation

with her father, but as for Dr Rhudde, 'I can say nothing, but that I believe it the wisest to leave him to himself.'

There was a playful tone to their correspondence now, different from the gloom and anguish that had so often been expressed before. 'I was very much pleased with your letter,' she wrote on 20 July, 'a circumstance that does not always happen to me. I daresay you can return the compliment but I will easily explain to you what I mean, you appeared calm, resigned, affectionate, and happy, it communicated the same feelings to me.'

She and her family went to stay with General Sir Samuel Hulse, the Prince Regent's treasurer, at West Heath House near Erith in Kent. The Hulses lived in a princely style, Maria thought, and she enjoyed it. Lady Hulse was happy only in the company of her dogs, of which she had many, but fortunately Maria too was fond of dogs. After that diversion, Mrs Henry Edgeworth Bicknell, wife of Maria's cousin, came to stay with her little girl, who was not well and might benefit from the air of Putney Heath. Then, Maria went to stay with the Lamberts, friends of her father's, also in the country near Croydon (which made her feel closer to John since he had spent so much time with his relations the Gubbins nearby in Epsom). So the summer passed, Maria a little wistful that she was not in Suffolk with Constable.

Constable spent August observing the climax of the rural year, the harvest. 'I live almost wholly in the fields,' he told Maria, 'and see nobody but the harvest men.' The harvest involved almost the whole of the village – the labouring part of it at least – and was carried out according to an ancient ritual with overtones of paganism.

A Hay Cart

The first step was the agreement of a contract between the men on each farm and the owner of the land, as to terms and conditions. The man who made this agreement and led the team of workers was called the Lord of the Harvest and the

next in line of authority – a little weirdly and archaically – was called his Lady. The Lord took charge of the reapers, each with his scythe. The rate of work and the direction of the cut was set by the Lord at the head of the line. At harvest time the men would work from first light until dusk, with breaks for food at eleven and four, when a boy would bring refreshment, known as elevenses and fourses.

Beside the men who cut the corn worked women, who were paid out of the men's wages and were generally their wives. They raked the cut stalks into rows, and were known as gavellers. These were then bound into 'shuffs' or sheaves. Girls worked with the women as bind-pullers, helping to tie the sheaves, which were then carted to the barns, such as the handsome brick one owned by the Constables.

When the harvest was all gathered in and the local vicar or rector had taken his tithe, there was a feast or frolic, sometimes known as the Largesse Spending, with songs and games. The Largesse was gathered from strangers passing the field, who were asked for contributions, as were the corn-factor and miller. Golding Constable, being both of those, was a regular contributor to the frolic.

This sounded Arcadian, and so it looked in Constable's sketches of the gavellers and bind-pullers at work on the shuffs. But there was another side to the harvest. The work was appallingly hard, as it had always been, but – worse – increasingly, there was not enough of it. A combination of factors – the return of men from the army and the navy, the introduction of new machinery – was causing rural unemployment. Simultaneously, the price of food was rising. Already, there were ominous signs. Earlier in the year, and close to East Bergholt, there had been trouble at Gosbeck, north of Ipswich, where men had smashed farm machinery.

That August another twelve farm workers were sen-

tenced for committing the same crime at Holbrook, near Tattingstone, where Constable had painted the portrait of (the newly promoted) Admiral Western. They had little to urge in their defence, according to the newspaper report, 'except the difficulty of gaining employment, which they attributed to the use of machines'.

Storm clouds were gathering over the apparently peaceful countryside. Meanwhile, however, Constable grew bronzed in the fields. He was happy, he said, to lose his beauty in one way, so as to gain it in another – by which he meant in paintings.

Maria was quite playful, almost frivolous, in mood. She made over part of one letter to her cousin Harriet Arnold, who attempted to convert Constable to a more evangelical, Methodist variety of religion (of which, like Dr Rhudde, he had a low opinion). In another letter she copied out a list of awful punning combinations of painters and titles of pictures which she had seen in a magazine (Maria was a great reader of the press): 'A view of the sea coast – Sir W. Beechey, The Siege of Troy – Ten-iers, Copy of Sir Joshua Reynolds' Laughing Girl – Smirke, Gathering Hemp – Flaxman', and so on. She was studying French.

The Bicknells bought a terrier named Frisk. The puppy was 'a *great torment*, and a *great pet*, he bites & destroys every thing he can lay hold of, we flatter ourselves that as he grows older, he will leave off all these tricks, even in trifles hope befriends us, it is the rainbow of the shower.' That last comparison showed how her mind had become entwined with that of Constable, painter of rainbows.

More soberly, in the *Gentleman's Magazine* she found an obituary note on poor James Gubbins. Constable's cousin had at length been presumed dead although his body was

never found. He had been struck by a cannonball while leading his men. 'The moment of his death was that of victory,' according to the writer, a family friend named Liptrap. 'His life was closed in conscious virtue as he had lived in the admiration of all who knew him.' Mrs Constable's misgivings about his debts were now understandably forgotten.

Constable, who hadn't seen this magazine, was pleased to read this touching account of his cousin: 'I am at times very much affected by the recollection of him. We were brought up from children together, & he was one of the most interesting men I ever knew.' His poor sister Ann, who had evidently cherished tender feelings for her dashing cousin, would never cease to mourn him. But the servant of James Gubbins's friend, Lieutenant Pym, who also died, told a different, darker story about Gubbins's fate: that he had been carried behind enemy lines by his runaway horse and been shot, cruelly and casually, by a French officer after surrendering. In an event so confused and complex as that great battle, it was hard to know where the truth lay.

The autumn came and went, and still Constable was engaged with painting in Suffolk. His father's health was slowly failing; already in the early summer Mr Travis, the apothecary, had warned the family to prepare themselves for a sudden sharp deterioration, but the old man remained well enough while the season was still warm. Maria, also worryingly susceptible to the cold, caught a chill as the result of staying out in the early evening. She quoted, very aptly, from the Earl of Chesterfield's *Advice to a Lady in Autumn*: 'The dews of the Evening carefully shew, those tears of the sky, for the loss of the sun.' And she added playfully but feelingly, 'is it not a sad thing to be so *delicate?*'

Constable, of course, was worried by this. For the most part, however, his mood remained optimistic, even buoyant. He continued to work on a new painting – a harvest scene, based on his observations in the fields that August, with women gavelling the sheaves, a boy and his dog watching over the elevenses, and reapers toiling at the end of the richly golden field. It was a study of ripeness, the completion of a cycle.

Another, smaller picture showed just a humble cottage standing in the centre of a cornfield, some of which was still green, suggesting he painted most of it in July. There were no figures, no hint of a literary subject. It was a trans-figuration of the ordinary; in the sky above great cumulus clouds billowed exultantly. Later on, at the beginning of December, he returned to the field to make a study of a

Engraving of *A Cottage in a Cornfield*

donkey he wanted to introduce in the foreground, standing by the gate of the field.

He went up to London for a few days in the second week of November. Maria arrived back from Putney Heath on the 7th, and they were able to see as much of each other as they wished. He paid a visit to Spring Gardens Terrace, during which he was greeted graciously by Maria's aunt, Mrs Arnold, whom he had not met before, which somewhat salved his raw feelings about his treatment by the Bicknells. He offered her a choice of drawings.

As usual, Constable had failed in his attempt to become an associate member of the Academy, but even there he was making a little progress. For the first time, Farington reported, several Academicians at least considered supporting him. With some justice, Constable felt that his painting was going better than ever, and partly for that reason he was happy to return to Suffolk, where he could bring his harvest painting to fruition. On 15 November he caught the one o'clock coach and was seated by the fireside in East Bergholt House by ten in the evening.

'Here everything is calm, comfortable, and good – and I am removed at a distance from you, that effectually removes the anxious desire I always feel when you are in London to meet, perhaps too often at least for each other's comfort 'till we can meet for once, and I trust for good.' That was the other reason why he was suddenly content: he was inwardly sure now that eventually they would marry. Indeed, he wrote to her about their coming happiness. An acquaintance of his, the Revd George Driffield, son of his father's old friend and four years older than Constable himself, had finally been able to marry on getting a living in Lancashire. 'They have waited for each other 'till they were both almost mad,'

he told Maria, 'but I hope and trust they are now both happy.' Their story might soon have the same satisfactory conclusion. 'We shall still be happy! – and will not a retrospect of these few sad years and what we have suffered for each other greatly enhance the happiness of our married life?'

Maria agreed, though she was getting weary of hearing about art. 'It is painting that takes up all your time & attention,' she complained, half seriously. 'How I do dislike pictures, I cannot bear the sight of them, but I am very cross, am I not?' She felt their eternal letters were a poor substitute for real conversation. On the other hand, she did not want to abuse letters, they were a delightful invention for lovers. She quoted again, most suitably, from Pope's 'Eloisa to Abelard':

> Yet write, oh write me all, that I may join Griefs to thy
> griefs, and echo sighs to thine
>
> . . .
>
> Warm from the soul, and faithful to its fires,
> The virgin's wish without her fears impart,
> Excuse the blush, and pour out all the heart,
> Speed the soft intercourse from soul to soul,
> And waft a sigh from Indus to the Pole.

Perhaps modestly, perhaps genuinely forgetful, she claimed to recall only the last of those lines. A comparison between Constable and the medieval monk Peter Abelard was certainly fitting. The painter had contentedly resumed the life of a hermit in East Bergholt. His sister forced him out to a party at the house of Mr Roberson, the curate. But though he tried to play cards, he could not manage the games. 'I therefore had no alternative but to fall asleep, or take French leave.

A Woman Writing at a Table

I did both – I hope they will not ask me again.' Much as he loved the village as a subject for his pictures, he was highly unsuited to the social life of the place.

Around Christmas time, Charles Bicknell met with an accident which was at once nasty and a little ridiculous. Returning on foot late at night from dinner at the Chelsea Hospital with his friend General Hunt, he had the misfortune to tumble into the deep open area in front of the basement of a house. *The Times*, which found space to report this incident among the more serious events of the winter, commented that he might easily have been killed since the drop was of ten feet. As it was, fortunately the solicitor of the Admiralty was only bruised.

Whether the accident was caused by Mr Bicknell having overdone the claret, port and Madeira at General Hunt's table, or by the darkness – the new gas lighting, introduced a few years before, was still confined to the centre of London

– is hard to say. It leaves the impression, at least, that Mr Bicknell was accident-prone. He had had a similar mishap the previous year, involving a fall from a gig, also reported in the newspapers. But his greatest piece of ill fortune, in retrospect, was his bad judgement of his prospective son-in-law.

In times to come, none of his legal distinctions, his grand friends, his dinners and functions attended would be remembered, only his shabby treatment of a great artist. Was it really Mr Bicknell's fault or merely his misfortune? Or was it, as Mrs Constable had believed, all the doing of Dr Rhudde? Dr Rhudde's opposition was a very good reason to prevent a match which undoubtedly looked like a bad one, and the loss of a favourite daughter who, in his heart, Charles Bicknell did not want to lose. He was, professionally, used to avoiding blame for the outrageous manoeuvres of the Prince Regent, his master. Similarly, he may well have placed all responsibility for Maria's romantic difficulties on her grandfather. But, a pliant man, under pressure from his daughter, he had allowed Constable an occasional visit, without being especially cordial to him. This concession was carefully kept secret from the ears of the rector.

Constable resented his behaviour, though he wisely assured Maria that he did not. When his mood was sunny, he even made a joke of it. 'When your Papa comes to introduce me to the Prince Regent who can do no otherwise than give me a bit of red or blue riband for my very excellent landscapes – you may justly be proud of the connection you have chosen.' 'How very gay,' Maria replied, 'you will look decorated with a blue riband.'

In mid December, Mr Constable's condition took a sudden alarming turn for the worse. The surgeon, Travis, believed that he might die at any moment; Mrs Whalley was sent for

to attend his bedside. Constable was deeply moved by this spectacle: the nearing to death of, as he saw it, an entirely good man.

It is impossible to contemplate, without satisfaction, the beautifull frame of mind my father has been in all through his illness. His pious resignation in what appeared his hour of death, his calmness, and his thankfullness for all the blessings (which he says are endless) which he has had in his life, will I hope be always before me & prove a guide to my future life.

Once more, Golding rallied. Within weeks he was able to get out of bed and hobble across the room to inspect his son's new painting of a subject with which he had been so closely concerned throughout his life: the harvesting of corn. The only demise that occurred just then was that of Maria's poor puppy Frisk, who had been ailing for some time and whose end Constable had predicted. She would have a new dog, he decided, from East Bergholt. And so the New Year of 1816 began, the seventh since he had declared his love.

With the dark, cold days of January Constable's mood slumped, as it so often did at that time of year. On the eve of Maria's twenty-eighth birthday – 15 January – he wrote her a letter that was anything but celebratory. An old friend, William Hurlock, had been staying at Dedham with his wife and family. He walked over to visit the Constables at East Bergholt House, and Constable accompanied him back over the fields to Dedham. This courteous act had an unfortunate effect, since the sight of the two delightful little Hurlock boys made Constable feel miserable. He desperately yearned for children of his own; in six months' time he would be forty.

Hurlock went on to describe the joy that marriage had brought him, which Constable passed on to Maria, 'his encrease of virtue & usefullness, from being almost a wanderer before – and all this in comparative poverty – I could not help deploring our lot, and the extreme ill usage we have met with – for all these blessings were certainly within our reach situated as we both are'. Of course, he added, he did not want to cause Maria a moment's sadness on her birthday. But that was exactly what he did.

The description had the same effect on her as it had had on him: it made her melancholy. 'Therefore,' she told John, 'I wished Mr. Hurlock had remained at home.' Maria had enough to make her feel down. As usual at that time of year she had a cold. Her father had been to East Bergholt over Christmas – where her brother Samuel was staying with the rector. Mr Bicknell had talked to Dr Rhudde about her attachment to Constable, and 'foolishly, romantically', she had hope for some good news. There was none. The only bright point was that she was accompanying her younger sister to a dance. But, while Catharine, now fifteen, thought this treat 'the height of human felicity', Maria needed more to cheer her. As it happened, Constable and Catharine between them were soon inadvertently to bring her much worse trouble.

On Saturday, 20 January, Constable made a rapid trip to London, having some pug puppies to deliver to his aunt Allen in Chelsea. At four in the afternoon, he planned to call at Spring Gardens Terrace. Maria presented him with a work box she had decorated as a gift for his sister Mary; he arranged to have some books delivered to her by Smith the bookseller – lives of artists such as Claude, suitable reading for a prospective painter's wife.

This visit gave them an opportunity to discuss their

situation at length. It was apparent that Dr Rhudde and his surviving daughter, Mrs Farnham, were entirely 'inveterate' against Constable. Indeed, it was suspected that Mrs Farnham stiffened the elderly doctor's resolve in this matter. She and her children had a good deal to gain, even more if, as Mr Bicknell feared, Maria's brother and sisters were also punished by being cut out of the clergyman's will.

One point that had been brought up against Constable was his friendship with the elder John Dunthorne. This social connection had, of course, been a point of sharp disagreement between Constable and his late mother. Maria, it turned out, was in complete agreement with Mrs Constable on the matter.

The association with Dunthorne was damaging in several ways. It was not that the man was from a lower social class: an artisan, not a gentleman. He was also, as Maria put it, 'destitute of religious principle'. Dr Rhudde accused Constable himself of being likewise, an atheist – one of his most damaging lines of attack. Probably, like many farm labourers and workers of the time, Dunthorne did not bother to attend Dr Rhudde's church. The Church of England in the countryside had become largely a congregation of the middle classes. Then, Dunthorne was an adulterer, the father of a bastard (in other words, he behaved very much like the members of the Prince Regent's circle). Furthermore, as a skilled artisan, Dunthorne was precisely the kind of individual suspected of fomenting dissent and insurrection in the countryside. He was, or seemed to be, a freethinker and a radical.

'It has certainly been the astonishment of many that a man so every way your inferior, should be allowed and honored with your time and company,' Maria told him. 'I assure you it has been a subject of wonder to me.'

Constable read Maria's views to his invalid father, who declared that she must be 'a sensible and good woman'. Dunthorne could never be a fit companion. Constable insisted that he had never connived in any of Dunthorne's detestable views. On the contrary, 'I have all my life combated them in him, 'till at last the sight of me became a monster to him, and he wished to be rid of me.'

Accordingly, after his return Constable asked his friend Travis to summon Dunthorne and tell him that he was never again to call on East Bergholt House except in his capacity as a plumber, and that Constable would never again call on him 'without he chooses to alter his conduct, both at home & abroad – but he is so bent on his folly that I see no probability of any change'.

Not surprisingly, Dunthorne responded to this declaration rudely. As it happened, the break between these two men did not last long as they had an important interest – landscape painting – in common.

No one could say that Constable was not doing everything he could to placate the doctor. Unfortunately, he inadvertently did precisely the reverse. Making conversation, in the way that people do, Maria passed on the information that it had been suggested that her sister Catharine might join the young ladies at Miss Taylor's school next door to the Constables. It would, after all, be convenient for her to study in the village where her grandfather lived.

On his return, Constable happened to mention this notion to Miss Taylor – a kindly act, since she was short of pupils – and she immediately went to the rectory to discuss it, adding that she had heard this good news from Constable.

There followed an alarming explosion of rage. Dr Rhudde was utterly infuriated that this upstart parishioner

who had had the effrontery to pay court to his grand-daughter was now poking his nose into his private family business. Moreover, since as far as Dr Rhudde understood the matter, Maria and Constable were not in communication, how had he heard about the choice of school for Catharine?

'My dearest John,' wailed Maria,

you have now got yourself, and me in a *most terrible scrape*, the Doctor has just sent such a letter, that I tremble with having heard only a part of it read, poor dear Papa, to have such a letter written to him, he has a great share of feeling and it has sadly hurt him.

I thought you would know the Rector better, than to *suppose he would allow* you to interfere with Catharine's school, O, why did you mention it to Miss Taylor, and suffer her to go to the Rectory about it. I am so sorry I told you the subject was ever mentioned, but I like to tell all I know, and then I do not mean it to go any farther.

It has for our mutual advantage been kept a *secret from the Doctor your visits here*. You have now unluckily my dear John dissolved that charm, and I now know not how it will end, perhaps the storm may blow over, God only knows.

Constable was sorry that anything should happen to cause any concern 'from that terrible quarter' – a strange, though understandable, way to refer to an octogenarian clergyman. But he believed that the doctor and his party were merely seizing on an opportunity to do him down. 'I am clearly convinced (from the anxiety there was shown to convert this nonsense into a heinous offence) of the disposition there exists to ruin us if possible.'

Another letter arrived, like an explosive device lobbed into Spring Gardens Terrace. Dr Rhudde announced that he no longer considered Maria his granddaughter. Mr Bicknell predicted that were Maria and Constable to marry, the rector would be so choked with ire that he would have to leave East Bergholt.

The crisis had the unexpected effect of stiffening Constable's resolve. He wrote setting out his financial position. He would soon, it was clear, inherit a sixth part of his father's property, which would amount to at least £4,000. He expected to inherit more in due course from Mrs Smith of Nayland. Once made happy, by marrying Maria, he hoped to earn more from his profession.

'I shall remain a few weeks longer (perhaps three) in the country – and when I have got my pictures to the Academy, I trust you will not hesitate another moment what conduct to pursue.' This letter, he added defiantly, could be shown to anybody, even if she wished to her father. He gave it to Beaumont the postman, who sounded his horn outside the door, and waited anxiously for a reply.

This was some time in coming, because Maria had gone to Greenwich to visit her cousin John Laurens Bicknell and his wife. John Laurens, now thirty, was a successful lawyer living in a substantial house with greenhouses and, as the novelist Maria Edgeworth noted when she came to visit, all the appurtenances that went with £2,000 a year. Maria's aunt, Sabrina Bicknell, lived next door. Professionally, John Laurens had followed the example of his uncle Charles, and indeed eventually succeeded him as solicitor to the Admiralty. In his spare time, however, he imitated his father, John, in industriously writing spoofs, satires and pamphlets.

The late John Bicknell's most outrageous literary performance was strangely linked with the future fate of his family. In 1774, he had published an amusing and obscene satire on the great musicologist Dr Charles Burney under the title of *Musical Travels through England*, attributed pseudonymously to one Joel Collier, Organist. This parodied the *Musical Tour* of Burney himself and attacked his proposal to teach music to the girls of the Foundling Hospital in the manner of such foreign institutions as the Pietà in Venice, where the all-female choir and orchestra were famous, and the composer Vivaldi had worked.

This proposal had struck John Bicknell and his friend Thomas Day as a decadent notion, undermining the noble simplicity of British culture. The little book, however, was not confined to musical criticism; it was rudely personal. The author decides to change his name 'from *Collier* to *Coglioni* or *Collioni*, as more euphonious'.

Thus named after the Italian word for testicles, he proceeded to lose his own. Collier, now Coglioni, was advised 'by all means to undergo the operation – to become a castrato for the good of his voice – as the doctor had done in *Italy*, tho' his excess of modesty prevented him from boasting of it in his excellent treatise'. This procedure is eventually performed, in an unplanned manner, by an enraged barber who finds Joel Collier *in flagrante* with his wife. After this, Collier/Coglioni finds his 'powers wonderfully improved'.

Like much cruel mockery, this little book proved very popular and went quickly through four editions, causing considerable anguish to poor Dr Burney. It was therefore surprising when John Bicknell died in straitened circumstances a decade later that it was Burney's second son, also named Charles, who came to the rescue of Sabrina Bicknell and her children. This charitable act, however, might have

been prompted by a hidden alliance with the author of *Musical Travels*.

The younger Charles Burney went, like John Bicknell, to school at Charterhouse, and was similarly dissipated in his youth. In 1777 he was discovered to have stolen and sold a number of books from the library of his Cambridge college, Gonville and Caius, perhaps to settle gambling debts. Charles Burney junior may, therefore, have been an ally of John Bicknell in his ribald assault on Dr Burney senior. But, whatever the truth of that, the younger Burney went on to redeem himself, becoming a schoolmaster, clergyman and eventually professor of ancient literature at the Royal Academy.

To Sabrina Bicknell's heartfelt gratitude, he took her two sons as pupils in his boys' school, giving them an education she would not have been able to afford. He also engaged her as housekeeper to the school, where she earned her living and tips of a guinea a student each Christmas, enabling her to provide for her family. She became a favourite in the Burney family, frequently asked over by other members, such as Charles Burney junior's sister, the novelist Fanny Burney. When Joseph Farington came to dine at the Burney house in Greenwich, he found Sabrina Bicknell seated at the table along with Thomas Lawrence and the sculptor Joseph Nollekens.

She and the boys, however, heartily loathed the way the story of her strange education at the hands of Thomas Day kept being retold. When Maria Edgeworth came to see her, Sabrina asked for the shameful secret of her origin in the Foundling Hospital in Shrewsbury to be omitted from Richard Lovell Edgeworth's memoirs. Her son John Laurens was very sore still about the matter. There had been a piece in a magazine, 'half-true, half-false', which ended up by

saying Mrs Bicknell was dead. This enraged him. (In fact, she did not die until 1842, aged eighty-five.)

Maria Edgeworth said she could 'easily alter a sentence or two so as to avoid repeating or tearing open the wound'. Of course, Mrs Bicknell was far from dead, but she was very different from the beautiful young girl with auburn curls whom Day and John Bicknell had once singled out from a gaggle of abandoned children. 'I was struck with a great change in Mrs Bicknell's manner and mind,' Maria Edgeworth noted. 'Instead of being as Mr Day thought her, helpless and indolent, she is more like a stirring housekeeper – all softness and timidity gone!'

Day's eccentric experiment had been successful in an unexpected manner. The foundling child whom he had selected on a whim, then lost patience with, had developed, just as Rousseau's educational theory predicted, into an independent, virtuous and cultured woman. She, however, shuddered at the memory of him. She spoke to Maria Edgeworth of Thomas Day 'having made her miserable – *a slave* etc!' The leaders of the French Revolution, also following Rousseau's ideas, got a similar response on a much larger scale.

There was a good deal of interest to be had from a visit to Maria's relations in Greenwich. She, however, was not in a state to appreciate it. Not only was her private life in crisis, but she found their neighbourhood on the river 'a damp, unhealthy place'. She returned to Spring Gardens Terrace with a nasty cold which required her to be blistered and eventually to have an uncomfortable burgundy plaster applied to her chest. Constable's defiant letter was awaiting her, and also a second more anxious one wondering why she hadn't answered.

'Your affection,' she wrote back a little wearily, 'is a source of the greatest happiness to me, but may I intreat that you will not wish to hear very, very frequently from *me – the only use* of it is to make you uncomfortable if I do not write just to the day you imagine.' As to his proposal of marriage, was that really wise? Charles Bicknell told her that if she and John did nothing hasty, he doubted Dr Rhudde would actually change his will. So she said, 'let us await any time sooner than that you should experience the misery of being very much in debt, added to having a *very delicate wife*.'

Constable came up to London for a weekend at the beginning of March, by which time Maria was well enough to leave her bed and see him, but she did not go out of the house for another three weeks. Thinking, she complained, hurt her chest. The doctors gloomily reported that mortality in London that winter was higher than at any time since the Great Plague. She read a novel by Mrs Opie, widow of the painter, which turned out to be extremely depressing. 'I think it is scarcely fair to write such things,' she complained, 'it is called *Valentine's Eve*, I wish no more would come in my way, or that I could resist such temptation.'

Constable remained determined that they should marry before much more time had passed. 'It is not my intention to wait longer than the summer – then in spite of A, B, or C let us for God's sake settle the business – then let those divide us who can.' He would do anything she asked, 'but cease to respect, to love and adore you I never can or will. I must still think that we should have married long ago – we should have had many troubles – but we have yet had no joys, and we could not have starved – so it is now.'

But having made this ardent declaration, he became immersed in his submissions for the Royal Academy

exhibition, which were due on 4 April, and it was Maria's turn to grow fretful at the lack of post. 'I must make some allowances, must I not? I am idle while you are employed, but yet admitting this, *a few lines* are so very soon written, and you know what a *sad fidget* I am.'

At the Royal Academy, the porter Sam Strowger was very much taken with Constable's harvest scene. As an ex-farm labourer from Suffolk, he greatly admired the accuracy with which the reaping had been depicted, with the Lord of the Harvest leading the gang of men with their scythes. In due course, he pointed this aspect to the hanging committee as his position as general factotum, model and valet to the artists enabled him to do. Nonetheless, despite his intervention, the picture was not placed as prominently as Strowger thought it should be. He consoled Constable and apologized for the arrangement of the exhibition, saying, 'Our gentlemen are all great artists, sir, but they none of them know anything about the *Lord*.'

At that moment, those artists themselves were absorbed by two controversies. The first involved Lord Elgin's marbles, the second concerned Lord Byron's marriage.

Over a decade before Lord Elgin, who at the time was ambassador to the Ottoman court in Constantinople, had removed a large number of sculptures from the Parthenon temple in Athens. On their arrival in London, these had caused enormous excitement among some artists – Haydon above all. For some years Elgin had been trying to sell them to the British government so as to recoup some of the costs he had incurred. During March a Select Committee of the House of Commons had been taking evidence about the matter.

Richard Payne Knight, the eminent connoisseur and angry

critic of these sculptures, had given evidence. The Elgin marbles, he insisted, were 'of little value'. They were so mutilated as to be hard to judge. The finest he put 'in the second rank' of art; probably they were late work, done under the Roman Emperor Hadrian. When it was printed, Joseph Farington and Thomas Lawrence read this opinion with satisfaction. They were pleased that this 'presumptuous' connoisseur had made such a public fool of himself. It was agreed Payne Knight would not be invited to the Royal Academy dinner this year.

As well as a skirmish in the battle between artists and connoisseurs, this was a turning-point in the history of taste. At the root of Payne Knight's objections was the roughness of the marbles – the fact that they were broken, worn and thus imperfect. The antiquities owned by his circle might have come out of the ground in pieces, missing limbs and appendages, but they had all been skilfully restored so as to appear almost new. To appreciate any object in this damaged state required a small revolution in sensibility. The change was similar to that needed before rough, 'unfinished' pictures such as Constable's could be admired.

Byron was a fierce opponent of Lord Elgin, believing that the carvings should never have been wrenched from their setting on the Athenian temple. But scandal was also swirling around his own affairs. The poet and his wife, Arabella, née Millbanke, had separated after less than eighteen months of marriage. There were rumours of his incestuous relationship with his half-sister, wife of Charles Bicknell's associate Colonel Leigh, and of his debts, his dissolute life and his lack of religion.

At dinner on 17 April, Farington heard a view quite favourable to Byron from Thomas Lawrence, who had obtained his information from a friend of Lady Byron's.

Lawrence explained that Byron had never settled into the role of a husband. His habits 'had never been of a domestic kind & since his marriage he has gone on as before, his hours uncertain, breakfasting, dining etc irregularly and as his inclination led him'. Nonetheless, he and his wife had parted quite amicably. It was her family who had turned her against him.

Byron published two poems. One, to his estranged wife, 'Fare thee well! And if for ever/Still for ever' made Princess Charlotte, a Byron fan, 'cry like a *fool*' (she was soon to be married herself to a suitable foreign prince, Leopold of Saxe-Coburg-Saalfeld). The other poem, 'Sketches from Private Life', was a violently snobbish attack on their governess, Mrs Clermont, whom he suspected of intriguing against him and encouraging the separation. Both of these verses were 'reprobated' at a dinner attended by Farington and Turner on 23 April. By that time, the poet had fled into exile, never to return.

Constable joined in that execration. When Byron died in Greece eight years later, he thought the world well rid of him. Even then, he wrote to his friend Fisher, 'the slime of his touch remains'. Certainly, no two men, though both in the view of posterity Romantics, could have differed more in their attitudes to love and marriage. Byron could never have written, as Constable did to Maria:

I am happy in love – an affection exceeding a thousand times my deserts, which has continued so many years, and is yet undiminished. How can I ever repay it? Never will I marry in this world if I marry not you. Truly can I say that for the seven years since I avowed my love for you, I have never done any thing that I have considered could have made you any way uncomfortable – that I have forgone all company,

and the society of all females (except my own relations) for your sake.

The exhibition opened. Constable's pictures gained some attention, though as usual there were complaints of their 'crudeness'.

All the time, Golding Constable's sturdy body was slowly failing. Constable went to Suffolk for a short visit, then returned to London. After his return his father's condition suddenly took yet another sharp turn for the worse. On the 12th his brother Abram wrote to tell him the end seemed very close. The day before Golding had talked to the family circle around his bedside.

He said he felt he was 'gradually sinking' and that 'if it was the will and pleasure of God he was ready & wish'd to be released, that Religion had been his only great support through his long confinement & made him look forwards with hope for happiness hereafter'. These, Abram added, 'were grand sentiments from a man in his situation & most consoling to us, his children'. Golding died on the 14th, one day short of his seventy-eighth birthday.

This was, in the view of his family, the admirable end of a thoroughly good man – straight in his business dealings, virtuous in his private life, kindly to his employees. Constable told the story of one of his bargemen who lived in a cottage owned by Golding Constable, who wished him to move to another dwelling. 'For some time he could not get the man to stir or give a reason for his refusal to do so. At last the man said, "If I remove from this place I shall never be able to shave again."' This 'singular remark' made Mr Constable most curious. Eventually he extracted the reason. The man explained that for many years he had sharpened his razor on the top step of the stairs each Sunday, and could not

do without it. 'Well,' responded Golding Constable, 'if that is the only reason my carpenter shall take up the step for you to carry with you and the stairs too if you want them.'

Not all his neighbours, however, would have agreed with that assessment of the late Golding Constable. As he lay dying, the countryside of East Anglia was breaking out into anger and violence. Threshing machinery and barns were set alight, farmers set round-the-clock guards on their property. At Needham Market, some miles to the north of East Bergholt, a flour mill was attacked on 7 May by one hundred rioters. Millers and corn factors such as Golding Constable were often targets since they controlled the grain whose price was rising, causing suffering to the poor. On 14 May, the day that Golding died, there were riots in Bury St Edmunds. Before the month was out, there was armed insurrection in the Fens, with troops deployed in Ely and Downham Market. The insurrections were followed by execution or transportation of the ringleaders.

East Bergholt did not experience such a revolt, which was lucky for the Constables, since if it had they might well have found themselves under siege along with Mr Godfrey the magistrate and Dr Rhudde the rector. Nonetheless, in future years Abram was to see fires started by the mob all around in the surrounding countryside.

In that very spring East Bergholt Common was being enclosed, a process that was often the trigger for trouble. The land, previously in general ownership, was assigned to local landowners, large and small. Constable himself got a sliver as his share of his father's property. It was, he told Maria, an allotment about the size of his bedroom, which he would make over to Abram. By chance, it was near the windmill he had once supervised and often painted. But some of the leading villagers 'have shown such extreme

greediness and rapacity', he went on, 'as to make themselves obnoxious'.

Their objective was to assemble usable portions of land by a process of purchase and swapping. It was a privatization of what had previously been, as the name suggested, held in common. The landless, the humble workers in the fields, were automatically excluded from the opportunities of enclosure. It did not necessarily make them poorer in the long run – though sometimes it did. But it fed a sense that they were being done out of their ancient rights, which was one of the grievances of the rioters, along with the high price of food and the scarcity of work.

The real-life equivalents of the reapers and gavellers in Constable's *Wheatfield*, now hanging in the Royal Academy, were not tranquil figures in a pastoral idyll. They were full of anxieties and resentments. The painter and his subjects, however, had one thing in common. Neither wanted the countryside to change, but to remain as they believed it had always been.

Constable went up to London again at the beginning of June. The time for decision had come. He calculated that he would now receive £200 a year from his inheritance from his father, which he hoped he could make up to £400 with his earnings and other expectations from Mrs Smith of Nayland. This was, he believed, enough to marry on without more waiting and live not lavishly, let alone fashionably, but sufficiently well.

Another spur was the marriage of his friend John Fisher to Miss Mary Cookson, daughter of Canon Cookson of Windsor (a friend of Farington's). Admittedly, this younger couple would have precisely twice as much per annum – £800 – and even that would not be considered nearly

enough in the West End of London. But Constable envisaged a simple domestic existence.

Fisher and his bride, Mary, were married in London on 2 July, with Fisher's uncle the Bishop of Salisbury officiating at the service. Fired by the sight of his younger friends at the altar, the very next day Constable announced to Farington that he had decided he and Maria should wed without further delay and take the risk of Dr Rhudde cutting her out of his will.

At this time Constable painted a portrait of Maria – grave, grey-eyed, thoughtful – in a lace blouse with a fine gold chain dangling from her neck. The sittings for this were themselves a sign of the couple's growing boldness and an opportunity for long conversation. There were still many points to consider: how to win Maria's father round, when

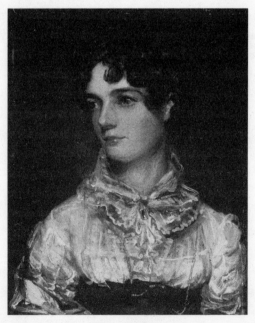

Maria Bicknell

and where they were to marry, and who should conduct the ceremony. They came to some agreement on at least the when of the matter, since Constable gave Farington a further update on his matrimonial plans. The date was set, provisionally at least, for September.

At that point, they separated again. Maria went to Putney, where the Bicknell *pied à terre* was now so extended that in the family it went by the name of 'castle' rather than 'cottage'. Constable returned to East Bergholt, sitting on the top of a stagecoach in a rain storm.

Soon an advertisement appeared in the *Ipswich Journal*:

To be sold in the delightful pleasant village of East Bergholt, a Capital Brick Mansion Freehold, with about 37 acres of land, pasture and arable, in excellent condition, communicating with excellent roads. The Mansion consists of 4 very good rooms & spacious entrance hall on the ground floor, 4 excellent sleeping rooms, with light closets & spacious landing on the second floor, 4 exceeding good atticks, most capital cellars & offices, brick stables & coach house, & every convenience that can be thought of, &c.

Two Studies of East Bergholt House

Not surprisingly Constable's spirits were low. He could not, he told Maria, contemplate the house 'without mixture of old associations inseparable to all sublunary affairs'. The final break was fast approaching with his old life in East Bergholt, with the house so full of memories of his boyhood and of his parents. 'So used have I been on entering these doors to be received by the affectionate shake by the hand of my father and the endearing salute of my mother, that imperceptibly I have often found myself overcome by a sadness I could hardly restrain.'

Soon there was another source of sadness: one more of those 'removals' of which the late Golding Constable had once spoken. Since late in June, David Pike Watts, so kindly, so maddening, had been ill with retention of urine, the symptom of some grave disease of the bladder, prostate or kidneys. Constable had visited him and found him weak and sinking. On 29 July he died, at the age of sixty-two.

These events indicated the ending of an epoch in Constable's life. So too, in a positive way, did his impending marriage, which would inevitably bring with it a completely different manner of life. This was the last time he would spend week after week in Bergholt with no other responsibility than to walk into the fields and sketch. To Maria, he wrote yet again the almost ritual sentence, 'Nothing can exceed the beauty of the village at this time.'

He had with him, however, a talisman of the future in the form of his portrait of Maria. He found it was almost like having her there with him, and, as her actual presence did, the picture soothed his fretful nerves. 'The sight of it soon calms my spirit under all trouble and it is always the first thing I see in the morning and the last at night.'

The image of Maria, placed close to his bed, was 'so extremely like that I can hardly help going up to it. I never

had an idea before of the real pleasure that a portrait could offer.' Quoting Cowper, that favourite poet of Maria's and his, he called his picture 'this sweet remembrancer of one so dear'. It created a sensation at a party attended by the curates Mr Roberson and Mr Wainwright. The likeness was 'extreme', in the opinion of Roberson. Mrs Godfrey, who was ill, asked to see it. So Constable carried Maria's picture across the village green to Old Hall through the bustle and music of the fair. He was a little anxious that Dr Rhudde should hear of this fresh outrage – a portrait of his granddaughter! – but he felt that they should not allow his opinions to affect their behaviour.

In fact, Dr Rhudde soon had a graver cause for complaint. David Pike Watts's will was published, and it turned out that he had left his entire fortune of some £300,000 to his daughter, with the exception of two small legacies to nieces. Neither Constable nor any of his siblings got a penny; nor, knowing his uncle as he did, had he expected anything.

The rector, however, affected to be outraged on Constable's behalf – as was everybody else who heard of this shocking will – while making a series of insulting assumptions about his affairs. Dr Rhudde had always been interested in Mr Watts, naturally respecting a man of such wealth and ostentatious piety (Mr Watts, for his part, had disapproved of some of the doctor's preaching).

Now the doctor was saying, Constable heard, that he had depended on the late Mr Watts leaving something substantial to his nephew, as no doubt he had always supported this hopeless relation, dealing 'very handsomely' with him, paying his rent, feeding him at his table, etc. In fact there was little truth in this. An invitation to dine with Mr Watts in Portland Place had arrived at Constable's lodgings about once

a quarter; all his other expenses had been covered by his father.

'I really think,' he wrote to Maria, 'my poor uncle's memory is disgraced for ever. I now almost feel it a misfortune to have belonged to him – not that I (as you well know) ever had any real dependence upon his principles or actions either dead or living.' It was all a little unfortunate. In Mr Watts, Constable had lost his only advantage in the doctor's eyes – a rich relation. Nor could it be denied that even a small bequest from that huge fortune would have made a big difference to John and Maria.

He feared they ought to steel themselves for a rebuff from another will, one in which Maria had a much greater claim than he had ever had on his poor uncle. On the other hand, the doctor might well live for a long time yet, long enough to change his mind. The old man was amazingly vigorous.

In early August Constable went up to London with the spaniel puppy, named Dash, which he had selected for Maria (she said she thought John an unsuitable name 'for a *dog*'). She had been looking to the arrival of this pet with a characteristic touch of irony. 'I am sadly afraid I shall love Dash too much. I hope he is pretty behaved, and will not tear up the garden, and then there will be a chance of Papa's being fond of him too.'

The little dog would be a constant reminder of him in the Bicknell household, just as her portrait was a surrogate for herself in East Bergholt. Maria sent back another work box, this time for his older sister, Ann. Bonds between the families, despite all opposition, were increasing.

On this occasion, perhaps, or around this time, Constable was bold enough to sit next to Maria in the presence of

Charles Bicknell and take her hand in his. 'Sir, if you were the most approved of lovers,' said the outraged solicitor, 'you could not take a greater liberty with my daughter.' 'And don't you know, sir,' Constable replied, as he later told the story, 'that I *am* the most approved of lovers?'

After his return, there was an exchange by letter about young Dash's feed. Constable took advice from the boy who looked after the dogs at East Bergholt House, which were famous for their freedom from mange and distemper. 'His food should be bread or a little barley meal well scalded with extream boiling water, and a bit of fat mixed with it – no more meat than what I speak of. It is the scalding that agrees so well with the stomach of dogs, if not it ferments with them.'

Maria had difficulty in deciphering these instructions, as Constable's writing was sometimes close to illegible, especially when he was scribbling fast at the end of the day (he joked he had two styles, one only he could read and one that no one could read).

Dash – unlike poor Frisk – was full of health. 'I will get him some scalded barley meal,' complained Maria, 'but really what I am to mix it with I cannot make out, I am *very affronting* but what can I do? I have just made out it is fat, am I right?' A couple of weeks later, she sent a further report: 'We have a great deal of entertainment in Dash, he certainly is not very fond of barley meal, but however he manages to eat it.'

Constable had written to his friend John Fisher, asking him if he would conduct the marriage service. On 27 August, Fisher penned a characteristically forthright reply. He would be arriving in London late on Tuesday, 24 September.

I shall go directly to my friend W. Ellis's at no. 39 Devonsh: St Port: Place. And on Wednesday shall hold myself ready & happy to marry you. There you see I have used no round-about phrases; but said the thing at once in good plain English. So do follow my example, & get you to your lady, & instead of blundering out long sentences about the 'hymeneal altar' &c; say that on Wednesday September 25 you are ready to marry her. If she replies, like a sensible woman as I suspect she is, well, John, here is my hand I am ready, all well & good. If she says 'yes' but another day will be more convenient, let her name it; & I am at her service.

Fisher added a further offer to this brisk set of instructions. If after the wedding they had a little money in hand to take a trip, why not come and stay in his vicarage in Osmington, on the Dorset coast? It was a mere sixteen hours by coach from London. 'The country here is wonderfully wild & sub-lime & well worth a painter's visit. My house commands a singularly beautiful view: & you may study from my very windows.'

Constable could have his food brought and put beside his easel; Fisher's own wife sat quietly reading, no doubt Maria would do the same. 'Of an evening we will sit over an autumnal fireside, read a sensible book perhaps a Sermon, & after prayers get us to bed at peace with ourselves & all the world.' It sounded like a delightful painter's honeymoon – though perhaps a little lacking in excitement for Mrs Fisher and the new Mrs Constable.

This letter was forwarded to Maria, with an additional proposal from Constable. 'I repeat my friend Fisher's words "that I shall be happy & ready to marry you", at the time he mentions . . .' Maria sent back a sweet and formal acceptance set out, like so much of their romance, on paper. She could

hardly let Revd Fisher suppose she was *not* a sensible woman. 'You, my dear John, you who have so long possessed my heart, I shall be happy to give my hand.' However, a few days later would suit her better. How long, she wondered, did the kindly Fisher stay in town?

Constable suggested, and she agreed, that he ought to write a formal letter to Dr Rhudde announcing their intentions. 'I fear there is not a ray of hope to be expected from him,' Maria predicted, 'but yet pray write. I do not think I could read his answer.'

Constable spent a while at Wivenhoe Park, the house of General Rebow, his wife and daughter near Colchester. The general had commissioned some pictures, and, knowing Constable had urgent need of money, kindly said that he would pay for them in advance. Despite Constable's aversion to gentlemen's estates, the painting of the general's park turned out rather well. The reason was the one he gave many years later when someone described a picture of his as 'only a picture of a house'. He smartly corrected this discourteous person, pointing out it was 'a picture of a summer's morning, *including* a house'.

Much the same could be said of his picture of Wivenhoe Park since the actual mansion was barely visible behind a clump of trees in the distance. Most of the painting was taken up by subjects most congenial to Constable – cows in a field, fishermen on the lake, that stretch of water (itself grander than the mill pond on the Stour but essentially similar), and the leafy elms of the estate. He had some trouble fitting in all the topographic features that his clients required, but by enlarging the canvas he managed to do so and began to like the picture himself.

Above was a bright midday sky, a dark cloud passing over,

the sun playing on frolicking cumuli scattered across the blue. As Constable's life moved towards its full fruition, the time of day in his pictures seemed to advance, from early morning a few years before into the blaze of noon.

Despite Constable's love of the simple life, he enjoyed being a guest in a grand household and being treated with due respect. He wrote to Maria, he explained somewhat proudly, seated in a magnificent drawing room, looking over the distant prospect of Colchester. These paintings took time, however, and on his return to Bergholt he became engrossed in another painting, this one done, *con amore*, for himself.

The setting was once more Flatford Mill, viewed this time in the distance down the towpath from beyond the lock. A barge boy sat in the foreground on his horse, the tow rope dangling behind. The barge itself was manoeuvring

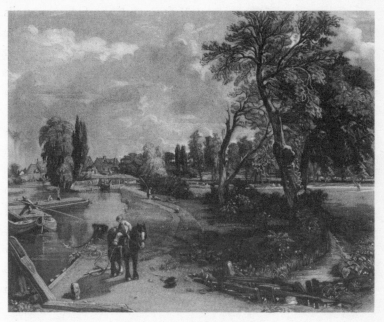

Engraving of *Flatford Mill*

in midstream. Silvery clouds paraded in the sky. A tree towered to one side. This was a more mature painting than he had yet achieved, the closest he had come to the heart of what he meant as an artist. Naturally, it filled his attention. The wedding would have to be postponed while he completed it. In addition, he had been offered some portrait work which it would be sensible to accept.

Without actually suggesting they postpone the ceremony, Fisher's presence in London being such a good opportunity, he hinted that he would rather like to. It would be a shame to lose 'my time (& reputation in future) at this delightfull season. But do not think my dear that I wish any alteration in our plan – every other concern of mine is second to yours.'

This was too much even for mild and patient Maria. That after they had been through so much John himself should suggest further delay! Understandably, she wrote an intemperate letter accusing him of unkindness – which, perhaps for that reason, he did not keep, unlike so many of her others.

Immediately, Constable apologized. 'How sorry I am my dearest Love that any thing should have escaped me that could have caused you one moment's uneasiness at such a time as this.' Although not yet married, he seemed to be taking the tone of a husband already – always liable to put his foot in it, but equally anxious to placate the irritation he aroused. Writing to Fisher, while firmly accepting his offer to conduct the marriage, he explained carefully that he deferred to Maria about the arrangements for the honeymoon. Delightful as it would be to stay in Osmington, 'everything would of course be *according to my dear Maria's feelings on this occasion*'.

This obedient sentence he copied in his apologetic letter

to Maria; already he had asked his landlord to redecorate the stairs and front room of his lodgings, in preparation for her arrival. With some reluctance and trepidation he composed a civil and respectful letter to the rector announcing their intentions. This was far from expressing his true feelings about that man, but as he said, 'the very idea of a sneak into the family is shocking.' Maria approved this document, and it was sent.

Almost everything was now set, but there remained some questions about the ceremony itself – such as what Maria would wear and whom, if anyone, they should invite.

As to the first question, Constable, who was very far from being a dandy, and in any case was still in mourning, replied that he himself always wore black, and thought she looked well in it. The least they encumbered themselves with expense for such frippery, the better. Maria, not surprisingly, did not accept this. 'Will you tell me how long your family remain in mourning?' she inquired. 'You cannot think that I would wear black for any other occasion, for I dislike it very much.'

Then it was Maria's turn to falter. She confessed her previous letter had been very hasty. At home in Spring Gardens Terrace, she was faced with quiet hostility. Her father, suffering from rheumatism, would not give his approval for the marriage. Her sister Louisa was angry with her and John about it, only her aunt Kittie Arnold was on her side – would indeed have liked to come to the wedding, but did not dare to go against the feelings of the rest of the family. A letter arrived from Mrs Farnham, her mother's sister and Dr Rhudde's closest ally, but did not mention this rebellious match. Did she know about it? Maria's nerve wavered. '*Once more* and for the *last time*,' she asked John, 'it is not too late to follow Papa's advice & wait?'

317

This time, it was he who was resolute. 'The die is cast. Nothing must now alter our plan even for one hour – it was very wrong of me to let anything else to allow me to suggest what I did to you.' His father's old friend, the Revd Driffield, gave him advice about how to get a wedding licence. Then there was the question of which church to marry in, and who the witnesses were going to be. It was apparent that none of Maria's family would come, and Fisher would not do since he was the presiding clergyman.

Dr Rhudde returned from one of his regular sojourns in Cromer, and his coach passed Constable in the village street. The rector bowed politely and said nothing, but his coachman Thomas, who had always been an ally of Constable's, laughed down from his seat. Evidently, he knew all about it. So too now did Mrs Everard, Maria's companion in her country walks long ago, and subject of so much village gossip about her friendship with Dr Rhudde. Mary Constable went to see her, and she gave her opinion that John and Maria had waited long enough and the doctor would never relent.

That clergyman himself had obviously decided to ignore the matter; he encountered Constable again in church, bowing graciously. He had mentioned the proposed wedding to no one, perhaps hoping that Maria's father would deal with the problem. He did not answer the letter.

Constable felt, and Maria agreed, that he should write to Mr Bicknell to give formal notice of the impending marriage. 'For your sake & my own character I shall take *some* opportunity of writing to your father – but not because I think he deserves it – for I find he has quite lost himself with the Doctor who treats him with every indignity. How wretched.'

Maria didn't think the letter would make any difference.

She showed Fisher's letter, and Constable's to her father, but 'he merely says that without the Doctor's consent, he shall neither retard, or facilitate it, complains of poverty & so on.' She hastened on to a more pleasing scene.

It was now the last week in September. They were supposed to get married within days. Still no arrangements had been made. Constable was fussed about the portrait of an elderly clergyman living near Woodbridge he had suddenly been asked to paint. Loath though he was to turn this job down, he arranged to be in London on the afternoon of Saturday, 28 September. Should he come to Spring Gardens Terrace? No, Maria thought that would be awkward, since her father would be there. She would come to Charlotte Street, accompanied by her aunt Kittie.

Her life was intolerable. 'We shall soon finish with all these tiresome worrying plans,' she wailed, 'or they *will drive me wild*, these few days are and will be wretched. Louisa hardly speaks, Papa can neither bear me to laugh, or to be melancholy.' At least, she had established that there was no reason for her to wear mourning, so she certainly wouldn't wed in black. Perhaps, she thought, they could stay in Weymouth for a few days before joining the Fishers in Osmington – nice and quiet, though that sounded.

And so, in a state of muddle and confusion, at last they made their way towards the altar. The ceremony was set for Tuesday, 1 October, then moved to Wednesday. The church was to be St Martin-in-the-Fields, Maria's parish church and also that of the Admiralty. Constable's sister Martha Whalley would have liked to come, but owing to shortness of notice did not make it. Two witnesses were pressed into service – Mr and Mrs Manning, neighbours of Constable's on Charlotte Street. Abram Constable also wanted to come, but he too seems to have missed the occasion.

On the night of the Tuesday Maria had a steaming row with her father; hot words were exchanged. On the next day she found herself standing under the grand interior of St Martin's, surrounded by empty galleries, boxes and pews, unaccompanied by any of her family and indeed any of her husband's. It was a wedding, John Fisher remembered, without much state but a happy one. After seven long years, endless opposition and obstruction, at last Maria and John Constable's married life could now begin.

St Martin-in-the-Fields

Married Life

After the wedding the newly married Mr and Mrs Constable departed on their honeymoon, accompanied by Dash the dog. They spent a little time in Salisbury with Bishop Fisher and in Southampton with John's aunt Mary Gubbins before arriving at Osmington, where they enjoyed a snug autumn in the vicarage with John and Mary Fisher.

True to his word, Fisher provided paints and Constable, inspired perhaps by married love, was extremely busy. He sketched and drew Weymouth Bay, Osmington itself and the downs above. Ann Constable wrote a friendly letter addressing Maria as 'my dear sister' and mentioning that she was 'a little aware of the *palpitation* of an artist's head'. As Ann hinted in a sly but friendly fashion, this was a subject about which Maria was already an expert.

Meanwhile, in East Bergholt attempts were being made to placate Dr Rhudde. Ann and Mary Constable went to visit him. But love, the rector told them, was not a sufficient reason to get married. What had happened was a sad waste from every point of view. Both of them might have done better; a fine handsome man such as Constable could easily have caught a woman of fortune. The sisters departed.

Next Mr Travis, the village medical man, delivered a moral lecture to the elderly clergyman, strangely, many might think, since the doctor himself was supposed to be in charge of the spiritual welfare of the village. 'I'll not leave her a shilling,' declared Revd Rhudde. 'For God in 'eaven's sake Doctor,' exclaimed Mr Travis, 'think of what you are

doing, persecuting her in your life & after your death too.'

Somewhat chastened, the rector agreed to leave something to Maria and her children but cut her husband out. Mr Travis made Dr Rhudde swear to follow this charitable course, but was worried that Mrs Farnham, Maria's aunt – thought by many to be the true villainess in the affair – might get to hear of it.

In London, however, matters were looking better. By chance, in Putney Charles Bicknell ran into a painter named William Owen and asked about Constable, of whom he said he knew very little – an amazing remark to make about the man who had been paying suit to Maria for the previous seven years.

Owen took the opportunity to praise Constable, at which Mr Bicknell seemed to brighten. He wondered whether regal and legal influence could facilitate his unwished-for son-in-law becoming a Royal Academician (Mr Bicknell naturally thought in terms of hidden pressure and secret deals). Owen explained that nothing of the kind would make any difference in the Academy, which had its own internal politics, but that Constable had increasing support.

John and Maria finally returned to London on 9 December. Shortly afterwards Abram called for tea and met his new sister-in-law. Noting that they lacked sugar tongs, he immediately bought some as a belated wedding gift. There were naturally thoughts that they might spend Christmas in East Bergholt, but the atmosphere at the rectory had once more turned ominous.

Mr Travis tested the waters on a visit. 'I hear, Doctor,' he broached the delicate subject, 'Mr and Mrs Constable would much like to visit Bergholt.'

'If they do,' replied his host, attempting to finish it, 'and call on me, I will not see them.'

The venerable clergyman observed that he could not avoid seeing them if they came to his church, but would not have the couple in his house. So it was decided that on the whole it would be better if John and Maria did not make a Christmas visit. In East Bergholt, the view – expressed by Abram – was that Charles Bicknell was not to be blamed for all that had happened. 'He is a most kind-hearted good man, but for the good of his children whom he tenderly loves he is obliged to submit to the Doctor's tyrannical yoke.'

On New Year's Day 1817 a small milestone was reached. Mr Farington gave a little dinner party at six p.m., and for the first time he drew a seating diagram including not only Constable but also Maria.

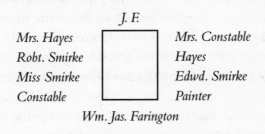

J. F.

Mrs. Hayes		Mrs. Constable
Robt. Smirke		Hayes
Miss Smirke		Edwd. Smirke
Constable		Painter

Wm. Jas. Farington

The next evening she dined with her father, who forgave the warm words spoken between them on the night before the wedding. Charles Bicknell was not one to battle against established facts. He may also have been swayed by the fact that Maria was now expecting a baby – the first grandchild from his second family.

In Bergholt, the diplomatic offensive continued. Abram Constable visited the rectory and delivered, according to his sister Ann, a veritable sermon on the text 'The duty of Forgiveness when error was acknowledged'. Mr Travis followed this up, and extracted – when the doctor was in

one of his good moods – he had never seen him in 'higher feather' – a promise that if Constable would write a proper letter of apology to himself and Mr Bicknell 'all would be well'.

Unfortunately, this was something Constable found hard to do. He felt he had done no wrong; on the contrary, that the fault was all on the other side. Whatever he wrote to Dr Rhudde, it was not sufficient. His allies were downcast. Abram urged that 'there is nothing degrading in endeavouring to conciliate an *old man* of 84'. Poor Travis visited the rectory once more, only to be informed that 'If you can see a simple apology in this letter it's more than I can.'

Dr Rhudde's objections now came down to the fact that he believed Constable had mocked him in church and drawn caricatures of him. The old accusation of atheism was dropped. Part of the problem, probably all along, was that there was pride and touchiness on both sides. Mr Bicknell wrote to the rector, without mentioning the matter of the will, showing himself ineffectual either as an opponent or an ally.

Once more Constable wrote, in a more openly apologetic vein. This time, his letter was better received. Abram anxiously asked if it was satisfactory. 'Pretty well, very well,' replied Dr Rhudde. He wished them both to be happy, and would try to make them so. Meanwhile, he didn't want to have the matter mentioned again until he departed for his annual visit to London. On the whole, things seemed to be going well.

Unfortunately, they weren't. Maria had a miscarriage in late February, after which her condition was briefly worrying. Dr Rhudde arrived at his house on Stratton Street mysteriously angry once more – either because of a cyclical

change of mood or as a result of conversation with his daughter Mrs Farnham, a hidden but malign factor throughout the whole affair.

At the Royal Academy, Constable showed his largest and most impressive array of work to date, including the splendid new picture, *Flatford Lock, Wivenhoe Park* and *A Cottage in a Cornfield* – all products of that burst of activity in Suffolk just before the wedding. Maria had become pregnant again shortly after the miscarriage, and Constable began looking for a house in the expectation of soon having a family.

After anxious deliberation with Farington about his income and outgoings he rented a little dwelling at 1 Keppel Street, near the British Museum. There began the best time of his and Maria's life together. 'The five happiest & most interesting years of my life were passed in Keppel Street,' Constable reminisced later, 'I got my children and my fame in that house, neither of which I would exchange with any other man.'

On 4 December, less than nine months after her miscarriage, Maria gave birth to a son, who was named John Charles after his father and his grandfather Charles Bicknell. Dr Rhudde was somewhat mollified by this. Travis, ever the ambassador, told him the news, 'You are a great-grandfather, Doctor,' at which he seemed not displeased, but said, 'You must now approach me with additional respect, as I am a Patriarch.' He mentioned his intention of leaving the baby something.

Constable was joyful; indeed no father could have been more pleased. Confronted with the offspring of a Mrs Wilkinson, he reported to Maria that 'It is a nice little baby – but no more to compare with our sweet duck than if it did not belong to the species.' (Constable, while calling his

children 'ducks', was inclined to call his paintings 'children'.)

The marriage of John and Maria was evidently close physically as well as emotionally. The frequency of Maria's pregnancies was evidence of that. When he was away he missed her at night and he dreamt of his *Fish*. 'I am heartily tired of being away from my love – I miss you at night and once thought I had you in my arms, how provoking.'

In the summer and autumn of 1818 much time was taken up with the drawn-out sale of East Bergholt House. Towards the end of the year, Constable made one more effort at reconciliation with Dr Rhudde. This time he left the rector with no further grounds for resentment. The elderly clergyman's mood slumped. At tea in Mrs Everard's house it was remarked that the doctor was 'very *flat* & dull', his spirits lower than had ever been known. Mr Wainwright, one of the curates, asked Mrs Everard the reason, and she replied that perhaps some letter had done it.

On 24 December, Dr Rhudde changed his will, leaving an equal portion to Maria and each of her siblings (granted that Catharine married according to her father's wishes). It was only just in time, both for the inheritance and for the state of the doctor's soul.

In the New Year, the rector began to appear bewildered. Towards the end he wandered constantly from room to room, searching for Mrs Rhudde – dead for eight years – and complaining that he had no money (betraying an inner anxiety that might explain much of his behaviour). He died on 3 May 1819, and Constable arrived on a visit just as the bell was tolling for him.

Dr Rhudde's legacy, on which so much thought and anxiety had centred for so long, turned out to be rather smaller than might have been hoped. It amounted to £120 a

year, which gain was offset by the fact that, when it began to be paid, Charles Bicknell immediately, and characteristically, cancelled a small allowance he had been paying Maria.

That year, 1819, was the pinnacle of Constable's happiness. At the Royal Academy he exhibited *The White Horse*, the first of his six-foot canvases which marked a further step up in the power and ambition of his art. It was bought by his friend John Fisher for 110 guineas.

On 19 July, Maria gave birth to a second child, a little girl christened Maria Louisa after her mother and her aunt, but shortened to Minna. The year was brought to a final climax on 1 November, when Constable was at last elected an associate Royal Academician, by one vote – nine years after he had first put himself forward.

The Constables began renting a house in Hampstead during the summer, so Maria and the children could retreat from London. It was an additional expense and one that Constable had not included in his calculations of income. But these months spent in the countryside north of the city brought great contentment. Constable found a new subject, and a new obsession: painting the shifting clouds in the sky, which he did again and again, taking a vantage point on Hampstead Heath.

He fixed up a makeshift studio in the garden shed, and made several quick studies of the infants and their mother in the garden, images of earthly felicity painted as rapidly as those of the skyscape above. Twice he started to paint a group of Maria and the children, but he never completed it.

This was partly because of pressure of work, as this was the time when he painted the paintings by which he is now best known. In 1821 he exhibited *The Haywain* at the Royal Academy and there was another addition to the Constable

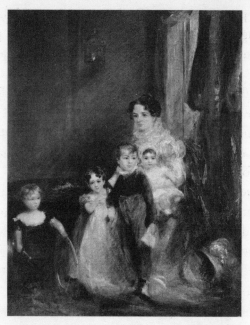

Maria Constable and Four of her Children

family – a second son, named Charles Golding after both his grandfathers.

However, that year also brought a darkening of the clouds. Samuel, Maria's surviving brother, fell ill and died of consumption with great rapidity. At the end of the year, Joseph Farington died too, at the age of seventy-four, and with him went his wise advice, guidance through the political machinations of the Royal Academy, and careful description of every conversation and dinner party in which he took part. After hard thought, the Constables decided to move into Farington's old house on Charlotte Street, No. 35, where yet another baby – Isabel – was born in August.

'Though I am in the midst of the world,' Constable wrote to his friend Fisher, 'I am out of it, and am happy, and endeavour to keep myself unspoiled. I have a kingdom both

fertile & populous – my landscape and my children.' The underlying problem was that the ever-increasing population of the young family was steadily weakening Maria.

In the summer of 1824 she was badly affected by the heat and departed with the family for Brighton. From there she wrote in June, perhaps with a faint note of protest. 'I am reading a book on education for the advantage of my children, & I am perfectly satisfied with my four without wishing for any more.'

That year was the point when Constable came closest to real fame in his lifetime. For a couple of years an art dealer had been suggesting that he should exhibit in Paris, and eventually he agreed. Several paintings, including *The Haywain*, were sent to France, where they caused a small sensation. His fresh vision of nature and loose, brilliant handling of paint were immediately hailed by avant-garde painters and collectors. He was understood across the Channel in a way that in Britain he still was not.

Indeed, some of Constable's work looks like a prediction of the future of French art. A little sketch of Maria and two children could almost be by Monet. After seeing *The Haywain*, Delacroix quickly repainted part of his latest picture, *The Massacre at Chios*; the following year Delacroix himself paid a visit to tell him of the pleasure his paintings had given. Constable was awarded a gold medal by the king, Charles X.

'They seem determined to make a Frenchman of me,' he commented, not very impressed, to Maria. Perversely, but characteristically, Constable failed to build on this success; he never went to France. He would rather be a poor man in England, he told his friend John Fisher, than a rich man abroad.

In March 1825 Maria gave birth to a fifth child – Emily – but prematurely, and was 'in a sad weak condition'

afterwards. Constable's happiness in his family and his paintings turned into a torment of conflicting loyalties. 'My life is a struggle between my "social affections" and my "love of art",' he wrote to a collector.

I dayly feel the remark of Lord Bacon that 'single men are the best servants of the publick'. I have a wife (daughter of Mr Charles Bicknell of the Admiralty) in delicate health, and five infant children. I am not happy apart from them even for a few days, or hours, and the summer months separate us too much, and disturb my quiet habits at my easil.

Nonetheless, the following November brought another pregnancy and a third son, Alfred Abram (the second name for his uncle). Even Constable now felt that six children was enough, 'I am willing to think of them as blessings,' he wrote to John Fisher. 'Only, that I am now satisfied and think my quiver full enough.'

As contraception was unthinkable, Maria's fate of incessant child-bearing was the common lot of Georgian wives. Soon she was expecting a child yet again, and for the last time. Did Constable love her too much? Would she have had it any other way? Leslie recalled that she bore the sufferings of her illness 'with that entire resignation to the will of Providence that she had shown under every circumstance of her life'. A little boy, Lionel Bicknell Constable, was born in January 1828.

Charles Bicknell, who had been ailing for some time, died that spring, and turned out to be much richer than he had led everyone to expect, though the subsequent legacy came too late to brighten the life of his eldest daughter. His colleague John Wilson Croker attended his burial in the coffin-crammed vaults of St Martin-in-the-Fields.

When the minister came to 'dust to dust' one of the undertaker's men stepped up on the lower coffin of the pile, to enable him to throw a handful of dust on poor Bicknell's. This looked very irreverent, and the sight of these piles of mouldering coffins excited most disagreeable ideas. Some of them were falling to pieces, and I almost dreaded to see them burst open and lay bare the awful secrets of our dissolution.

By the autumn it became clear that Maria's consumption, so long held in check, had reached the final, 'galloping' stage. It is impossible to say whether she would have lived longer if she had not had eight pregnancies in twelve years; tuberculosis is an unpredictable disease. Leslie visited the Constables in Hampstead a few days before the end. 'She was then on a sofa in their cheerful parlour, and although Constable appeared in his usual spirits in her presence, yet before I left the house, he took me into another room, wrung my hand, and burst into tears, without speaking.' She died on 23 November 1828.

'I shall never feel again as I have felt,' Constable wrote three days later. 'The face of the world is totally changed to me.' His siblings pressed him to come to stay in Bergholt, but he felt the place, especially the sight of the rectory amid dark trees, would be too full of unhappy associations.

He was finally elected a Royal Academician the February after Maria's death. 'It has been delayed,' he commented, 'until I am solitary and cannot impart it.' For the rest of his life Constable wore mourning, and his days were filled with the care of his children, his painting and the affairs of the Royal Academy.

His paintings became freer and more 'unfinished' than ever; the one he exhibited the following year – of Hadleigh

Castle near Southend, which he had seen years before while staying with Revd Driffield – seemed to grieve for Maria. The sky is stormy, the ruined stronghold shattered on a rocky shore, the air full of flapping seagulls.

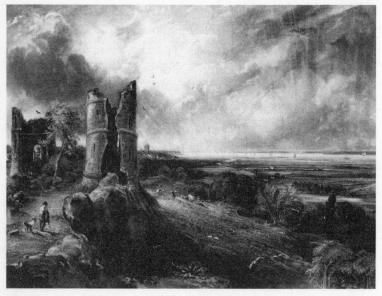

Engraving of *Hadleigh Castle*

There was more loss to come. In 1832, John Fisher died aged forty-five also, it seems likely, of tuberculosis. Could anyone wonder, Constable asked, that all his skies were stormy? His children gave him joy but also anxiety. In 1835 Charles Golding, a 'delightfully clever boy, who would have shone in my own profession', decided to become a sailor and departed for the sea aged only fourteen. The oldest, John Charles, reminded him of his mother: 'in this sweet youth I see all that gentleness – affection – fine intellect & indeed all those endearing qualities'.

His other solace was the Royal Academy. Now that he

had become a full member he became one of its pillars. His greatest friend in those years was Leslie, who replaced Fisher as a companion of the heart – though not of course Maria.

In March 1837, it was his turn to be the visitor officiating in the Life Room, where he sketched with the students. The last night of the season was Saturday, 25 March, and Constable gave a little speech of farewell. He was as usual, wrote Richard Redgrave, who was painting there that evening, 'full of jokes and jibes, and he indulged in the vein of satire he was so fond of'.

He died suddenly a few days later on the night of 31 March 1837 at his house in Charlotte Street, probably of a heart attack. Leslie saw his body the following morning.

I went up to his bedroom, where he lay, looking as if in a tranquil sleep; his watch, which his hand had so lately wound up, ticking on a table by his side, on which lay a book he had been reading scarcely an hour before his death. (It was a volume of Southey's *Life of Cowper*, containing many of the poet's letters.) He died as he had lived, surrounded by art, for the walls of the little attic were covered with engravings, and his feet nearly touched a print of the beautiful moonlight by Rubens.

Afterword and Notes on Sources

This book consists of historically ascertainable facts, with the absolute minimum of conjecture. My hope is that the result offers some of the same pleasures to the reader that a novel would, but – although I have selected and emphasized some incidents from the historical record and omitted others – nothing is invented. It is at once a book about making art and a romance. My aim and hope have been to bring together two main currents in Georgian culture: the landscape art we sometimes call romantic, and the dramatic and ironic world of the novel, especially Jane Austen's.

John Constable is, if anything, even better documented than Van Gogh, the subject of my previous book, *The Yellow House*. The eight volumes of letters to and from Constable, plus journals, lectures and other sources of information, constitute a vast mass of rich material about his own life and Regency England that has still not been fully absorbed and utilized. Constable's correspondence with Maria Bicknell alone, before and after their marriage, amounts to a tome a good deal thicker than this one. It is only such a mass of information that makes this kind of detailed microbiography feasible.

However, like all collections of historic correspondence, Constable's has limitations and gaps. Thus, although he frequently kept letters from members of his family in East Bergholt, those he sent to them have not on the whole survived. As a result we have only one half of the conversation between Constable and his mother, Ann. The love

letters of Constable and Maria Bicknell – treasured by both parties – are much more completely preserved. But even in those there are gaps, and – understandably – when they were able to see each other face to face they felt less need to write.

The majority of their letters therefore date from the lengthy stretches they were forced to spend apart, and certain periods – notably the long interval between 1809 and October 1811 – are silent. Their correspondence is a series of traces they were forced to leave on paper because of enforced separation. Their bad luck is the good fortune of posterity.

In general I have followed the text in R. B. Beckett's magisterial edition of the letters (and its successor, *Further Documents and Correspondence*, edited by Ian Fleming Williams et al.). Occasionally I have made a small emendation: for example, fairly obviously Maria intended to attribute her quotation from Alexander Pope's 'Eloisa to Abelard' to Pope, not as in Beckett's reading 'Papa'.

Somewhat less logically, I have modernized some but not all of the spellings. John Constable – and the Fishers – consistently used 'ei' where in modern English 'ie' is used, so he wrote about 'sweet feilds' and signed his letters off, 'beleive me', etc. I felt that this was too distracting, and hence have changed it, and have also altered various other oddities of grammar and punctuation where they might cause confusion to the modern reader. But most of Constable's and the other correspondents' words are left as they originally wrote them.

Much of the fresh information in this book is to do with Maria and her family, rather than the more thoroughly researched Constables. Understandably, art historians have paid less attention to the Bicknells and Rhuddes, who are peripheral from their point of view. For my purposes,

however, they were important characters and, as it turned out, remarkably interesting and well-documented figures in their own right.

Charles Bicknell, in particular, popped up all over the place as soon as I started to look for him. Not only were there copious references, as one might expect, in the papers of his royal clients the Prince Regent and Princess Amelia, but also all manner of other documents. In the records of naval trials Charles Bicknell is a frequent presence. He had a walk-on part in the memoirs of Thomas Dibdin, a successful dramatist of the early nineteenth century, and a larger role in the story of John Laurens, a hero of the American Revolution. He was the (notably ineffectual) legal representative of a prominent novelist, Charlotte Smith, and sat on a committee with the architect John Nash.

Several hitherto unknown discoveries – at least to writers about Constable – allow Maria's formidable grandfather, Durand Rhudde, to speak with his own voice. These comprise two published sermons and a remarkably frank and pompous letter to the prime minister, William Pitt (Public Record Office, *Chatham Papers*, 170, reprint in Aspinall & Smith, see Bibliography).

The arresting story of Charles Bicknell's sister-in-law, Sabrina Sidney, her adoption by Thomas Day and unsuccessful education according to the precepts of Rousseau's *Emile*, has been told quite frequently. Most versions are based on the accounts by Anna Seward and the Edgeworths. Roger Lonsdale took the story further in his excellent essay on John Bicknell, as did Rowland in his life of Thomas Day.

For those in pursuit of more information about the intriguing Sabrina – who could be the subject for a book in herself – there are many avenues to pursue, more indeed than I had time to investigate. There are letters from and to

her (and Charles Bicknell) among the Edgeworth papers in the National Library of Ireland.

The amount of her annual tip from the boys at Dr Burney's School is set down in the Prince Regent's accounts (he was paying for the education of two pupils, for un-explained reasons). Her real name, Anna, plus the location of her marriage to John Bicknell and the fact that she did not die until 1843, at eighty-five, are all noted on – of all places – a website devoted to the antecedents of W. H. Auden (whose mother was descended from the Bicknells).

Posted by Nicholas Jenkins of the English Department at Stanford (www.stanford.edu/~njenkins/archives/07com mentarywhauden family ghosts), this website contains a great deal of genealogical information about not only Sabrina but also the rest of the Bicknell family.

The play that Maria and Constable saw at Covent Garden in early 1814 is not identified in the correspondence, neither indeed is the year. But all the circumstantial evidence – the day of the week, the presence of both in London at the relevant time, the depressing nature of the drama – makes it nearly certain that they were in the audience for Charles Mayne Young's performance of *Richard III*.

The fact that Jane Austen and her sister Cassandra were, or at any rate were planning to be, there too was a bonus as far as I was concerned. As the reader will have noticed, I have used Austen's fictional world in general, and *Mansfield Park* in particular, as a fictional counterpoint to the real romance of John Constable and Maria Bicknell.

Neither Constable's love of music nor the influence of that art on his thinking have previously been stressed. It has not, as far as I can see, been pointed out for example that when, in a celebrated phrase, Constable speaks of the sky being 'the chief organ of sentiment' in a landscape, he had in

mind the keyboard instrument. That he did is clear both from the musical metaphors of the rest of the passage and from the closely similar imagery of his remarks on Rembrandt's Mill (in *John Constable's Discourses*, Appendix B). Of course, Beethoven's Pastoral Symphony is – like Jane Austen's *Mansfield Park* – a contemporary work in a different medium that I have used at intervals as a point of reference for Constable and his painting.

I think I am the first to suggest that the most famous passage in Constable's letters – referring to his 'careless boyhood' – was sparked by a quotation from a now forgotten poem by Sir Charles Abraham Elton. This is a small footnote to Constable studies, but emphasizes the degree to which he, and also John Fisher and Maria Bicknell, tended to think in terms of their favourite poetry.

The young John Constable who is encountered in these pages is not entirely the mellow figure of C. R. Leslie's classic *Memoirs of the Life of John Constable*, until recently the only biographical work about him; this Constable is neurotic, driven and depressive. The darker side of Constable was first brought out in Anthony Bailey's *John Constable: A Kingdom of His Own* (2006). Of course, Constable was also witty, urbane, brilliantly talented and in many ways admirable, not least in his determination despite very little encouragement to continue on his chosen path as a painter. But the more I worked on the subject, the more regard I formed for the wise, patient, intelligent and astute Maria Bicknell, a true and not just a nominal heroine.

Selected Bibliography

Exhibition catalogues

Landscape in Britain, by L. Parris and C. Shields, Tate Gallery, 1973

Constable: Paintings, Watercolours & Drawings, by L. Parris, I. Fleming-Williams and C. Shields, Tate Gallery, 1976

Constable, by L. Parris, I. Fleming-Williams and S. Cove, Tate Gallery, 1991

From Gainsborough to Constable, with essays by M. Kitson and F. Owen, Gainsborough's House, Sudbury & Leger Galleries, London, 1991

Constable: A Master Draughtsman, edited by I. Fleming-Williams, with essays by J. McAusland, A. Lyles and P. Heron, Dulwich Picture Gallery, 1994

Constable's Clouds, edited by E. Morris with essays by J. Gage, A. Lyles, M. Sargent, John E. Thornes and T. Wilcox, National Galleries of Scotland and National Museums and Galleries on Merseyside, 2000

Constable: le Choix de Lucian Freud, with contributions by W. Feaver, J. Gage, A. Lyles, O. Meslay, L. Whitely and R. Ur, Grand Palais, Paris, 2002

The Solitude of Mountains: Constable and the Lake District, with essays by S. Hebron, C. Shields and T. Wilcox, The Wordsworth Trust, Grasmere, 2006

Constable; The Great Landscapes, edited by A. Lyles, with essays by S. Cove, J. Gage, A. Lyles and C. Rhyne and additional catalogue contributions by F. Kelly, Tate Britain, 2006

Works consulted

Alison, Archibald Revd, *Essays on the Nature and Principles of Taste*, London and Edinburgh, 1790

Aspinall, Arthur (ed.), *The Correspondence of George, Prince of Wales, 1770–1812*, 8 vols., London, 1963–71

Aspinall, A. and Smith, E. Anthony (eds.), *English Historical Documents 1783–1832*, London, 1959

Austen, Jane, *Mansfield Park*, edited and with an Introduction by Tony Tanner, Harmondsworth, 1966

—, *Jane Austen's Letters to Her Sister Cassandra and Others*, edited by Deirdre Le Faye, New York and Oxford, 1995

Bailey, Anthony, *Standing in the Sun: a Life of J. M. W. Turner*, London, 1998

—, *John Constable: A Kingdom of His Own*, London, 2006

Barrett, C. R. B., *History of the XIII Hussars*, Edinburgh and London, 1911; www.pinetreeweb.com/waterloo.htm

Bates, L. M., *Somerset House: Four Hundred Years of History*, London, 1967

Beckett, R. B., *John Constable's Correspondence: I The Family at East Bergholt*, Suffolk Records Society, 1962

—, *John Constable's Correspondence: II Early Friends and Maria Bicknell*, Suffolk Records Society, 1964

—, *John Constable's Correspondence: III The Correspondence with C. R. Leslie*, Suffolk Records Society, 1965

—, *John Constable's Correspondence: IV Patrons, Dealers and Fellow Artists*, Suffolk Records Society, 1966

—, *John Constable's Correspondence: V Various Friends, with Charles Boner and the Artist's Children*, Suffolk Records Society, 1967

—, *John Constable's Correspondence: VI The Fishers*, Suffolk Records Society, 1968

—, *John Constable's Discourses*, Suffolk Records Society, 1970

Bicknell, John, 'To Miss Firebrace', *Gentleman's Magazine*, September 1808 (p. 822)

Bloomfield, Robert, *A Selection of Poems*, edited and with an Introduction by Roland Gant, London, 1947

Bradley, Ian, *The Call to Seriousness: The Evangelical Impact on the Victorians*, London, 1976

Brewer, John, *The Pleasures of the Imagination: English Culture in the Eighteenth Century*, London, 1997

Britton, John et al., *The Beauties of England and Wales, Or, Delineations, Topographical, Historical, and Descriptive, of Each County*, London, 1813

Brown, Richard, *Church and State in Modern Britain 1700–1850: A Political and Religious History*, London, 1991

Burke, Edmund, *A Philosophical Inquiry into the Origin of Our Ideas of the Sublime and the Beautiful*, London, 1759

Byron, George Gordon, *Byron's Letters and Journals: The Complete and Unexpurgated Text of all the Letters Available in Manuscript and the Full Printed Version of All Others*, edited by Leslie A. Marchand, 12 vols., London 1973–94

Childe-Pemberton, William S., *The Romance of Princess Amelia: Daughter of George III, 1783–1810,* including extracts from private and unpublished papers, London, 1910

Collins, Tony, Martin, John and Vamplew, Wray, *The Encyclopedia of Traditional British Rural Sports*, London, 2005

Croker, John Wilson, *The Croker Papers: The Correspondence and Diaries of the Late Right Honourable John Wilson Croker*, edited by Louis J. Jennings, London, 1885

Dally, Richard et al., *The Bognor, Arundel and Littlehampton Guide: Comprising a History of Those Places and of the Castle of Arundel*, Chichester, 1828

Derriman, James P., *Marooned: The Story of a Cornish Seaman*, Polperro, 2006

Desmarais, Jane, Postle, Martin and Vaughan, William (eds.),

Model and Supermodel: the Artist's Model in British Art and Culture, Manchester, 2006

Dibdin, Thomas, *The Reminiscences of Thomas Dibdin: of the Theatres Royal, Covent-Garden, Drury-Lane, Haymarket, &c., and Author of The Cabinet, &c.*, London, 1827

Douthwaite, Julia V., *The Wild Girl, Natural Man, and the Monster: Dangerous Experiments in the Age of Enlightenment*, Chicago and London, 2002

Dubos, René and Jean, *The White Plague: Tuberculosis, Man and Society*, London, 1953

Edgeworth, Richard Lovell, *Memoirs of Richard Lovell Edgeworth, esq begun by himself and concluded by his daughter, Maria Edgeworth*, London, 1820

Elam, J. F., *St Mary's Church, East Bergholt: A Building and Its History*, East Bergholt, n.d.

Elton, Sir Charles Abraham, *Tales of Romance: With Other Poems, Including Selections from Propertius*, London, 1810

Evans, George Ewart, *Ask the Fellows Who Cut the Hay*, London, 1962

Farington, J., *Diary 1793–1821*, 16 vols.: vols. 1–6 edited by Kenneth Garlick and Angus Macintyre; vols. 7–16 edited by Katherine Cave, New Haven and London, 1978–84; index by Evelyn Newby, 1998

Fenton, James, *School of Genius: A History of the Royal Academy of Arts*, London, 2006

Gamlin, Brenda, *Old Hall: East Bergholt: The Story of a Suffolk Manor*, East Bergholt, 1995

Gray, D., *Spencer Perceval*, Manchester, 1963

Hamer et al. (eds.), *The Papers of Henry Laurens*, 16 vols., Columbia, S. Carolina, 1968–2003

Haydon, P. M., Benjamin Robert, *The Diary of Benjamin Robert Haydon*, edited by W. B. Pope, 3 vols., Cambridge, Mass., 1960–63

Hone, William, *Facetiæ and Miscellanies*, London, 1827

Howard, Luke, *The Climate of London*, 2 vols., London, 1818

Hutchison, Sidney C., *History of the Royal Academy 1768–1968*, London, 1968

Ivy, J., *Constable and the Critics 1802–1837*, Ipswich, 1991

Kebbel, T. E., *Lord Beaconsfield and Other Tory Memories*, London, 1907

Knight, Ellis Cornelia, *The Autobiography of Miss Knight, Lady Companion to Princess Charlotte*, edited by Roger Fulford, London, 1960

Kroeber, Karl, *Romantic Landscape Vision: Constable and Wordsworth*, Madison, Wisconsin, 1975

Leslie C. R., *Autobiographical Recollections*, 2 vols., edited by Tom Taylor, London, 1860

—, *Memoirs of the Life of John Constable (1843/1845)*, edited by Jonathan Mayne, London, 1951

Lonsdale, Roger, 'Dr Burney, "Joel Collier", and Sabrina' in Wellek, René and Ribeiro, Alvaro (eds.), *Evidence in Literary Scholarship: Essays in Memory of James Marshall Osborn*, Oxford, 1979

MacCarthy, Fiona, *Byron: Life and Legend*, London, 2002

Macfarlane, Alan, *Marriage and Love in England: Modes of Reproduction 1300–1840*, Oxford, 1986

Olivier, Edith, *The Eccentric Life of Alexander Cruden*, London, 1934

Owen, Felicity and Blayney Brown, *David, Collector of Genius: a Life of Sir George Beaumont*, New Haven and London, 1988

Parkes, Samuel, *Chemical Essays: Principally Relating to the Arts and Manufactures of the British Dominions*, London, 1823

Parris, Leslie, Shields, Conal and Fleming-Williams, Ian, *John Constable: Further Documents and Correspondence*, London and Suffolk, 1975

Paterson, Thomas Frederick, *East Bergholt in Suffolk: Giving Some Account of Early Times*, Cambridge, 1923

Peacock, A. J., *Bread or Blood: A Study of the Agrarian Riots in East Anglia in 1816*, London, 1965

Reynolds, G., *The Later Paintings and Drawings of John Constable*, 2 vols., New Haven and London, 1984

—, *The Early Paintings and Drawings of John Constable*, 2 vols., New Haven and London, 1996

Rhudde, Durand Revd, DD, *The Love of Our Country Recommended and Inforced, Sermon Preached before the Several Associations of the Laudable Order of Anti-Gallicans*, London, 1757

—, *A Sermon Preached at the Anniversary Meeting of the Sons of the Clergy, in the Cathedral Church of St. Paul, on Thursday, May 20, 1790*, London, 1790

Rhudde, John, *A Lecture on Worship Read at the Meeting House in Broad Street Wapping London at a Church Meeting Held on Thursday the Thirtieth of November MDCCXXXII*, London, 1733

—, *A Letter to the Protestant Dissenting Congregation, Meeting in . . . Wapping, London: Occasioned by Their Late Procedings against the Author, on His Profession of Unitarianism*, London, 1734

—, *The Moral Auctioneer; or, Life a Sale: Verses Occasioned by the Sale of the House and Furniture of Solomon Margas, Esq; at Melcombe Regis, MDCCLII. Addressed to a Lady*, London, 1763

Rhyne, C., *John Constable: Toward a Complete Chronology*, Portland, Oregon, 1990; www.reed.edu/~crhyne/papers/jc_procedure.pdf

Rivero, Albert J., 'From Virgilian Georgic to Agricultural Science' in *Augustan Subjects: Essays in Honor of Martin C. Battestin*, Newark, Delaware, 1997

Rosenthal, M., *Constable: the Painter and His Landscape*, New Haven and London, 1983

Rousseau, Jean-Jacques, *The Confessions*, translated and with an Introduction by J. M. Cohen, Harmondsworth, 1953

—, *Reveries of the Solitary Walker*, translated and with an Introduction by Peter France, London, 2004

Rowland, Peter, *The Life and Times of Thomas Day, 1748–1789: English Philanthropist and Author: Virtue Almost Personified*, Lewiston, NY, 1996

Rudd, Mary Amelia, *Records of the Rudd Family*, Bristol, 1920

Sandby, William, *The History of the Royal Academy of Arts from Its Foundation in 1768 to the Present Time: with Biographical Notices of All the Members*, London, 1862

Seward, Anna, *Memoirs of the Life of Dr Darwin: Chiefly during His Residence in Lichfield, with Anecdotes of His Friends, and Criticisms on His Writings*, London, 1804

Shepherdson, Anthony, *How to Fish the Suffolk Stour*, London, 1960

Simond, Louis, *Journal of a Tour and Residence in Great Britain: during the Years 1810 and 1811*, Edinburgh, 1817

Slive, Seymour, 'Constable and Ruisdael' in *Jacob van Ruisdael: Master of Landscape*, London, Philadelphia and Los Angeles, 2005

St John, Ian, *Flatford: Constable Country*, East Bergholt, 2000

—, *East Bergholt: Constable Country*, East Bergholt, 2002

—, *Dedham: Constable Country*, East Bergholt, 2005

Stanton, Judith Phillips, *The Collected Letters of Charlotte Smith*, Bloomington, Indiana, 2003

Stone, L., *The Family, Sex and Marriage in England, 1500–1800*, London, 1977

Stuart, Dorothy Margaret, *The Daughters of George III*, London, 1939

Summerson, John, *The Life and Work of John Nash Architect*, London, 1980

Thomson, James, *The Complete Poetical Works of James Thomson*, edited by J. Logie Robertson, London, New York, Toronto and Melbourne, 1908

Thornes, John E., *John Constable's Skies: A Fusion of Art and Science*, Birmingham, 1999

Tomalin, Claire, *Jane Austen: a Life*, London, 1997

Virgil, *The Georgics*, translated into English verse with Introduction and Notes by L. P. Wilkinson, Harmondsworth, 1982

Waller, Ambrose J. R., *Suffolk Stour*, Ipswich, 1957

White, Jerry, *London in the Nineteenth Century: a Human Awful Wonder of God*, London, 2007

Wilton, Andrew, *Turner in His Time*, London, 1987 and 2006

Acknowledgements

As with my previous book, I owe an enormous debt to my wife, Josephine, who heroically read drafts far too unpolished for me to dare show to anyone else. My agent, David Godwin, and his staff at DGA were hearteningly positive about this project from the very beginning. So too was my editor at Fig Tree, Juliet Annan, who – in addition to making numerous shrewd suggestions for improvements to the text – went beyond the call of editorial duty by brilliantly solving a crucial structural problem that had me completely stymied. Bela Cunha, my copy-editor, helped enormously in improving the accuracy and concision of the manuscript, and in curbing my excessive taste for dashes.

I am grateful to Lucian Freud – once more – for sharing his thoughts on Constable and also for setting me off on this trail with his exhibition *Constable: le Choix de Lucian Freud* held at the Grand Palais in Paris in 2002. Two other contemporary painters – David Dawson and John Virtue – have done much to enhance my feeling for Constable as a figure who still remains current and vital after 200 years.

Sandy Nairne, Sarah Tinsley and Sophie Clarke at the National Portrait Gallery gave me an additional reason to delve deeper into Constable's life and art by accepting my proposal for an exhibition devoted to his portraits. My co-curator on that project, Anne Lyles of Tate Britain, has been hugely generous with her help, knowledge and enthusiasm in every way – not least in kindly undertaking to read my text (of course, I am responsible for any errors that may continue to lurk in it). Graham Reynolds, doyen of Constable scholars, kindly gave up his time to talk to me (and

provided a suitable Suffolk pub lunch) as I set off on this road. In company with everyone who writes and thinks about Constable, I have been greatly dependent on his magisterial catalogues, *The Early Paintings and Drawings of John Constable* and *The Later Paintings and Drawings of John Constable*.

Similarly, I was hugely assisted by the pioneering editorial work of the late R. B. Beckett on Constable's literary remains. Jeremy Purseglove provided me with some valuable insights into the landscape history and botanical aspects of Constable's works, and my son Tom gave guidance on the military history I found myself venturing into (and undertook some useful research into the sad fate of James Gubbins).

I would like to thank the Suffolk Records Society for giving me permission to quote from the published text of Constable's correspondence, and Yale University Press for giving me permission to quote from Farington's Diaries and reproduce four of his table diagrams.

Index

Illustrations are indicated by *italics*

Abelard, Peter 287
Aberdeen, Earl of 183
Abernethy, John 178
Admiralty 28–9, *29*, 155
Advice to a Lady in Autumn
 (Chesterfield) 284
Alexander I of Russia 228
Alison, Revd Archibald 238–9,
 240–42, 254
Allen, Mrs 275, 277
Allen, Lieutenant Thomas 277
Amelia, Princess 48, 54, 60–62
'Ancient Mariner' (Coleridge) 127
Angerstein, John Julius 190, 234–5
angling 113–15
Ann Constable 80
Arnold, Harriet 283
Arnold, Kittie 286, 317, 319
art 33–8
 finish 233–6, 246, 301
 and music 118–19
 and nature 56–60, 74, 104
 see also landscape
Assassination of L Dentatus, The
 (Haydon) 106
Austen, Cassandra 213
Austen, Jane 7, 49, 159, 213, 243
 Mansfield Park 11, 22, 30, 53,
 77–8, 110, 111, 145, 206,
 213, 242

Northanger Abbey 110–111
Persuasion 40
Sense and Sensibility 11
Austria 275
Aveley 232

Bacon, Francis 236
Barnwell, Mr 279
Barrett-Lennard, Sir Thomas 232
Barry, James 84
Beaumont, Sir George
 British Institution Reynolds
 exhibition 181, 184
 British Institution summer
 exhibition 224
 Claude paintings 13–14, 145
 and Constable 13, 14, 44, 70
 and Haydon 105–6, 139
 influenza 177
 and Kean 232
 national service of
 Thanksgiving 230
 portrait *43*
 and Turner 195, 271–2, 273
 and Wordsworth 127
Beauties of Britain 70
Beauties of England and Wales, The
 18
beauty 239–40
Beethoven, Ludwig van 111, 119,
 173, 198, 221, 238, 278
Bellingham, John 130

351

Bellini, Giovanni 35
Benjamin Robert Haydon (Wilkie)
 32
Bewdley 1–2, 70–71
Bicknell, Mrs (mother)
 death 267–8
 ill-health 55, 169, 170, 198, 202,
 219, 245–6
 mother's death 67
 opposition to courtship 72,
 75–6, 92, 93
 Perceval's murder 130
Bicknell, Catharine (sister) 9, 55,
 204, 291, 293–4, 326
Bicknell, Charles (father)
 accident 288–9
 Admiralty 38, 109–110, 155
 and art 38
 bans Constable from Spring
 Gardens Terrace 174, 175,
 185
 Brighton 250
 cancels Maria's allowance 327
 career 28–30
 Constable takes Maria's hand
 311–12
 country cottage 275
 death 330–31
 and Dr Rhudde 291, 299, 324
 first wife 93, 94
 initially permits courtship 33,
 80
 looks and personality 26–8
 Lysons' marriage 186
 Maria's marriage 317, 318–19,
 320, 323
 marriage portion 50
 meets Constable at Somerset
 House 223–4

mentioned in Parliament 266–7
Mrs Rhudde's funeral 67
opposition to courtship 1, 3–4,
 82, 92, 289
overturns ban 259–60
and Owen 322
portrait *27*
and Prince Regent 27, 28, 186
and Princess Amelia 48, 61, 62
Smith will 48–50, 179
Spring Gardens Terrace 164
and theatre 101–2, 202
Bicknell, Durand (brother) 55, 67
Bicknell, Eliza (sister) 169
Bicknell, Henry Edgeworth
 (cousin) 42, 94
Bicknell, Mrs Henry Edgeworth
 280
Bicknell, John (uncle) 38–42,
 93–4, 295–7
Bicknell, John Laurens (cousin)
 42, 94, 295, 297–8
Bicknell, Louisa (sister) 9, 133,
 169, 198, 204, 317, 319
Bicknell, Maria
 accepts Constable's proposal
 313–14
 at Spring Grove 67–8, 70, 72,
 99–100
 birthday wishes 136
 in Bognor 155–9, 167–8
 in Brighton 246, 250
 British Institution spring
 exhibition 216
 British Institution summer
 exhibition 224, 226
 children 325, 327, 328, 329, 330
 Christmas present to Constable
 256

352

Constable giving up ambition
255
Constable's declaration of love
37
Constable's visit to Spring
Grove 91–2, 94–5
Constable's visits to Spring
Gardens Terrace 153–5, 287,
291
Covent Garden 202, 210, 213
death 331
and Dr Rhudde 52, 294, 295
Dr Rhudde's will 326
in East Bergholt 4
family 26, 143
and father 323
first meeting with Constable 4,
7–9
French 21
and Golding Constable 138
in Greenwich 295, 298
Hampton Court 196–7
Harrow speech day 190
honeymoon 321
ill-health 54, 55–6, 329–30
and John Dunthorne 292–3
on journalism 164–5
letters from Bognor 168
letters from Putney 279–80, 283
letters from Richmond 198
letters from Spring Gardens
Terrace 98–9, 100, 101,
174–5, 209, 286–7, 299, 300
letters from Spring Grove 1, 2,
30–31, 75–6, 79, 81–2,
90–91, 116, 125–6, 128–9,
130, 132
London 134
looks and personality 8, 9

meets Constable at Royal
Academy exhibition 185
meets Constable at Somerset
House 223–4
meets Constable in London 202
meets Constable in St James's
Square 169–71
miscarriage 324
morning flies 188
and mother 161, 219, 245
mother's death 267–8
Mrs Rhudde's funeral 67
National School 207
overturns father's ban 259–60
painting 112
peace celebrations 229
planned Welsh excursion 242,
245
portraits 8, 306, 306, 309–310,
328
puppy 311, 312
in Putney 274–5, 307
quarrel with Constable 226–7
reading 49, 145–6, 197
Reynolds exhibition 190, 197
and Samuel Skey's death 146
and Sarah Skey 92, 189
sees Christ Rejected 216
wedding 316–20
in Wimbledon 236
Bicknell, Sabrina 40–43, 71–2,
146, 177, 295, 296, 297–8
Bicknell, Samuel (brother) 172,
173, 328
Bicknell, Sarah Laurens (half-
sister) see Skey, Sarah
Bigg, William Redmore 47, 85
Bleak House (Dickens) 50
Bloomfield, Robert 220

Blucher, Marshal 228, 275
Boat-building near Flatford Mill
 245–9, *248*
Bogdani, Maurice 143
Bognor 153, 155–9, 167–8
Bonaparte, Prince Jerome 276
Boswell, James 9
Boucher, François 57
Brantham 5
Brantham Mill 150
Bridgeman, Revd George 192
Brighton 154, 156, 161, 168,
 189–90, 245, 250–51, 329
Brightwell 279
British Institution *182*
 1814 spring exhibition 216,
 224
 Dutch and Flemish paintings
 272
 Haydon 105–6, 139–40
 Reynolds exhibition 181–5,
 190, 197
Brougham, Henry 232
Buchan, Dr William 30
Bunyan, John 54
Burdett, Sir Francis 46
Bures 172
Burke, Edmund 238–40
Burminster, Mrs 275
Burney, Dr Charles 43, 295
Burney, Charles (younger) 296–7
Burney, Fanny 297
Bury St Edmunds 304
Byron, Lord 243, 261, 267, 271
 at Reynolds exhibition 184
 Covent Garden 202–3
 Lady Heathcote's party 196
 private life 186, 188–9, 301–2
Byron, Lady Arabella 301, 302

Calcott, Augustus 120, 122, 124
Cambridge, Duke of 61
Caroline of Brunswick, Princess of
 Wales 28, 228, 229, 230, 232
Carpenter, Mr 216, 218
Cart with Two Horses, A 249,
 252–4, *253*
Castlereagh, Viscount 182, 262
Cézanne, Paul 13, 23, 36, 107
chandelier 268–9
Chantrey, Francis 277
Charles Bicknell (Murphy) 27–8, *27*
Charles X 329
Charlotte, Princess 46, 178, 179,
 229–30, 231–2, 302
Charlotte, Queen 250
Charlotte Street
 Constable and Maria's house
 328, 333
 Constable's lodgings 89, 96, 138
 fire 163–5, 191
Chesterfield, Earl of 284
chiaroscuro 59, 119
childhood 177
Christ Rejected (West) 222
Church of England 207, 292
Clarence, Duke of 250
Clarke, Reverend William
 Branwhite (son) 157
Clarke, William (father) 157
Claude 23, 85, 108, 110, 119, 145,
 205
 Cephalus and Procris 235
 *Landscape with Hagar and the
 Angel* 13–14, *14*, 44
 and nature 35–6, 57, 74
 and Turner 222, 271, 272
Claude Glass 57
Clermont, Mrs 302

Climate of London, The (Howard)
109
clouds 147, 149
Colchester 202
Coleridge, Samuel Taylor 127,
130
Collins, Wilkie 273
Collins, William 233, 273
Colt Hoare, Sir Richard 73
Compleat Angler, The (Walton)
114
Constable, Abram (brother)
coach travel 140
Constable's marriage 319
dances 7, 172, 271
and Dr Rhudde 161, 263, 323,
324
election 161
family business 15, 23, 262, 270
father's death 303
flute 118
local protests 304
mother's death 264, 265–6
and Napoleon 261
Royal Academy exhibition 269
visits Constable in London 63,
127
visits married couple 322
Constable, Abram (great-uncle) 15
Constable, Alfred Abram (son)
330
Constable, Ann (mother)
and Bicknells 161
birthday wishes 137
Charles Bicknell's ban 260
Constable giving up ambition
255
Constable's life-drawing 86–7
Constable's studio 21

death 263–6
and Dr Rhudde 51, 62–5, 77,
141, 143, 173, 262–3, 289
in East Bergholt 5–6, 9, 138–9,
140
encouragement of courtship 81,
101
encouragement of painting
32–3, 101
family 16
and James Gubbins 257
and John Dunthorne 209
and Mrs Everard 140
and Mrs Rhudde 67
nest of rogues 214–15
New Year parties 172
portrait *80*
rectory garden hearts 117
and Sarah Skey 92
and Sir George Beaumont 13,
14
visit to Charlotte Street 138
and Watts 85
worries about Constable 76,
178, 208, 256–7, 258
worries about husband 258
Constable, Ann (sister) 23, 264,
311, 321, 323
Constable, Charles Golding (son)
328, 332
Constable, Emily (daughter) 329
Constable, Golding (brother)
16–17, 23, 149
robbed 214
Royal Academy exhibition 269
Constable, Golding (father)
allowance to Constable 9
Ann's stroke 264
annuity 257

Constable, Golding (father) – *cont.*
career 9, 14–16
Christmas 172
Constable's career 7, 23, 97, 138
death 303–4
discouragement of courtship
 97–8, 138
and Dr Rhudde 63, 160–61
East Bergholt House 18
harvest 282
ill-health 257–8, 284, 289–90
on John Dunthorne 21, 58–9
local importance 18–20
London 109–110
offer of Dedham house 167
portrait *19*, 270
Royal Academy exhibition
 269–70
Stour 246–7
will 270
Constable, Isabel (daughter) 328
Constable, John 1, *6*
allowance from father 9–10
Ann Constable 80
at Stourhead 73–4
at Wivenhoe Park 314, 315
in Aveley 232
banned from Spring Gardens
 Terrace 174–5, 178–9
baptism 227
and Beaumont 13–14
Boat-building near Flatford Mill
 246–9, *248*
Brantham Mill 150
in Brighton 250
British Institution Reynolds
 exhibition 182, 183–4
British Institution spring
 exhibition 216

British Institution summer
 exhibition 224, 226
and brother Golding 16–17
and Byron 302
A Cart with Two Horses 249,
 252–4, *253*
and Charles Bicknell 38, 50,
 79–81, 161, 289, 311–12
Charlotte Street 89, 96, 138,
 163–5, 191, 328, 333
children 325–6, 327, 328,
 329–30, 332
in Colchester 202
A Cottage in a Cornfield 285–6,
 285, 325
Covent Garden 101, 102–3,
 210, 213
David Pike Watts 131, *131*
death 333
decides not to visit Putney
 276
decision to marry 305–6
Dedham Vale from Langham 200
dinner celebrating king's
 birthday 277
dogs 144, 161–2, 198
and Dr Rhudde 63–6, 143, 144,
 160, 270–71, 293–4, 311,
 324, 326
East Bergholt 4, 241, 286
East Bergholt Church 63–6, 64
East Bergholt Common, with the
 Windmill 22
East Bergholt House 18, 278–9,
 309
East Bergholt House and Garden
 17
education and artistic training
 20–24, 73

elected Academician 331
elected associate of Royal
Academy 327
fails to be elected associate of
Royal Academy 83, 84–5,
233, 254, 286, 322
fairs 198, 200
father's death 290, 303, 304–5
financial position 295
finish 233–6
first meeting with Maria 4, 7–9
and Fisher 129, 131, 133,
312–13
fishing 114–15
Flatford Lock 325
Flatford Mill 315–16, *315*
Flatford Mill from the Lock
112–14, 120, 124–5
food from home 256
and Gainsborough 224–5
geology 157
Golding Constable 19, 270
Golding Constable's Garden 263
and Gubbins family 251–2, 284
Hadleigh Castle 331–2, *332*
Hampstead 327
harvest 201, 281, 282, 285
A Hay Cart 281
and Haydon 31–2, 106, 139,
140
honeymoon 321
illness 76, 178
*James Gubbins in Church Street,
East Bergholt by Moonlight* 251,
252
and landscape 12–13, 33–8,
104–5, 111, 112, 145, 147–9
Landscape: Boys Fishing 176, *176*,
179, 216, 218

letters to Spring Grove 2, 74,
79, 89–90, 115–16, 126,
131–4
life-drawing 86–9
London 109–110, 202, 203–4,
207, 209–210
looks and personality 5–7, 9,
11–12, 60, 242–3, 258
Maria Bicknell 8, 306, *306*,
309–310
*Maria Constable and Four of her
Children* 327, *328*
Maria's birthday 290–91
Maria's death 331
Maria's letters 82, 85
Maria's puppy 311
marriage proposals 295, 299,
313–14
Mary Constable 120–21, *121*
meetings in St James Square
169–71
meets Maria at Royal Academy
exhibition 185
meets Maria at Somerset House
223–4
mentors 43–7
mother's death 264–6
music 118–20
and nature 39, 56–60
New Year balls 172
Newman Street 83
on other painters 273–4
Paris exhibition 329
Percy Street 32
and plants 244–5
and ploughing 201–2, 210
politics 159–60
portrait with Dawe 274
portrait of Mary Freer 191

Constable, John – *cont.*
portrait of Thomas Western
166–7, 172
portrait of William Godfrey
148, 167, 173
portraits commissioned by Lady
Heathcote 131, 163, 190–91
portraits commissioned by
Lewis 191–2
and Princess of Wales 231–2
proposed visit to Bognor 168
quarrel with Maria 226–7
reading 145–6, 157, 238–42
Rhubarb Leaves 244, *244*
Royal Academy 1810
exhibition 83
Royal Academy 1811
exhibition 107
Royal Academy 1812
exhibition 104, 107, 116–17,
122–3, 124–5
Royal Academy 1813
exhibition 181
Royal Academy 1814
exhibition 210, 218–20,
221–2
Royal Academy 1816
exhibition 299–300, 303
Royal Academy 1817
exhibition 325
Royal Academy 1819
exhibition 327
Royal Academy 1821
exhibition 327
Royal Academy dinner 192
in Salisbury 72–3
Scene on the River Stour 12
and sea coast 158–9
A Seated Woman from behind 102

shirts 256
and Skeys 156
in Southchurch 227–8
Spring: East Bergholt Common
151, *152*
Stoke-By-Nayland Church and
Village 58
and Stothard 134–5
Stour 12–13, 195
Study of Cows 199
Study of Female Nude 89
Summer Evening 90
A Summerland 210, 219–20, *219,*
221
thirty-sixth birthday 136
and Turner 187–8, 192, 194–5
Two Studies of East Bergholt
House 308
The Village Feast, East Bergholt
230–31, *230*
visit to Spring Grove 91–3,
94–6
visits to Spring Gardens Terrace
25, 32, 98–9, 153–5, 286,
291
A Water-wheel 15
and Watts 68–70, 131, *131,*
217–18, 309, 310–311
wedding 316–20
Wheatfield 305
The White Horse 327
and White's *Natural History*
243–4
Willie Lott's Cottage Seen over the
Stour by Moonlight 199
Wimbledon Park 277–8
Wivenhoe Park 314–15, 325
A Woman Writing at a Table 288
and women 189

in Worcester 95
and Wordsworth 127–8
Constable, John Charles (son) 325, 332
Constable, Lionel Bicknell (son) 330
Constable, Maria (wife) *see* Bicknell, Maria
Constable, Maria Luisa (Minna) (daughter) 327
Constable, Martha (sister) *see* Whalley, Martha
Constable, Mary (sister) 17, 23, 133, 264
 dances 7, 172
 and Dr Rhudde 321
 invitation to live with John 96–7, 98, 107
 and Mrs Everard 318
 portrait 120–21, *121*
consumption 47, 48, 54–6, 178, 328, 331, 332
Cookson, Canon 305
Cookson, Mary 305–6, 313, 321
Coombe Wood 134–5
Cooper, Josepha 186
Corn Law 262
Cornard Wood (Gainsborough) 225
Cottage in a Cornfield, A 285–6, *285*, 325
Courier 232
Covent Garden 202–3, 210–214, *211*
Cowper, William 11, 49, 126, 146, 158, 310, 333
Coyle, Mrs 270
Crane Hall Hill 214
Creation (Haydn) 213
Croker, John Wilson 330–31

Cromer 51, 143, 154
Crosier, John 18
Crossing the Brook (Turner) 272
Crotch, William 118, 119, 120
Cruden, Alexander 68

Daguerre, Louis 160
Dally, Mr 157, 158
Danby, Evelina 188
Danby, Sarah 188
Dash (dog) 311, 312, 321
David Pike Watts 131, *131*
Dawe, George 274
Day, Thomas 39, 40–42, 71, 72, 145–6, 206, 296, 298
Dedham 12, 15, 20, 167
Dedham Vale from Langham 200
Delacroix, Eugène 236, 329
Dibdin, Thomas 101–2
Dickens, Charles 50
Dido and Aeneas (Turner) 222, 235
Dido Building Carthage (Turner) 271–2, *272*
Diorama 160
Discourses on Art (Reynolds) 33
Domenichino 119
Domestic Medicine (Buchan) 30
Driffield, Revd George 227–8, 286–7, 318, 332
Dubourg, Matthew *27*
Dunthorne, John (father) 144, 147, 208–9, 235, 246, 292–3
 Constable's ambition 34–5
 inscription on *East Bergholt Church* 64–5
 sketching trips 21, 58–9
Dunthorne, Johnny (son) 144–5, 147, 208–9, 235

'Dying Negro, The' (Bicknell and Day) 39
Dysart, Countess of 154
Dysart, Earl of 16, 83

Eartham 158
East Bergholt 4–5, 147, 241
 Christmas 172
 crime 214–15
 general election 159
 girls' school 140
 harvest 281–2
 outdoor sketching 21, 36, 37, 58, 60
 postman 78
 rectory garden 117
 social events 7, 287–8
 victory feast 230–31, *230*
East Bergholt Church 63–6, *64*
East Bergholt Common 15, 22–3, *22*, 149, 151, *152*, 304–5
East Bergholt Common with the Windmill 22
East Bergholt House 17–18, *17*, *263*, 278–9, 308, *308*, 326
East Bergholt House and Garden 17
Eastlake, Charles 212
Edgeworth, Dick 39–40, 177
Edgeworth, Maria 295, 297–8
Edgeworth, Richard Lovell 39–40, 42, 297–8
education
 Constable 20–21
 National Schools 207
 Rousseau 39–40, 41, 177, 298
 women 10–11
Eldon, Lord 262

Elgin, Lord 106, 300–301
Elgin marbles 106, 300–301
'Eloisa to Abelard' (Pope) 287
Elsheimer, Adam 119
Elton, Charles Abraham 177
Emile, ou l'education (Rousseau) 39–40, 41
Emmeline (Smith) 49
Essays on the Nature and Principles of Taste (Alison) 238–9, 240–42
Everard, Mrs 5, 117, 140, 143, 173, 318, 326
Examiner, The 106, 125, 138, 233
Eyre, Mr 141, 161

Fagiani, Maria 267
fairs 198, 200–201, 205
'Fare thee well!' (Byron) 302
Farington, Joseph 44–6, *45*, 115, 127, 185
 and Barry 84
 British Institution exhibition 182, 190, 196
 British Institution summer exhibition 224
 and Burneys 297
 and Byron 186, 301, 302
 and Canon Cookson 305
 Constable's courtship and marriage 99, 306, 307
 Constable's Royal Academy associateship 83, 85, 233, 234, 286
 Cromer 154
 death 328
 dinner parties 139, 323
 Elgin marbles 301
 fire 163

illness 177–8
and Napoleon 166, 216, 271
Northcote's life of Reynolds
 197
peace celebrations 238
and Princess Charlotte 230
Regent's Park 206
Royal Academy 1812
 exhibition 117, 124
Royal Academy chandelier 268,
 269
Royal Academy dinner 192
and Turner 187, 188
and Wilson 226
and Wordsworth and Coleridge
 127
Farmer's Boy, The (Bloomfield)
 220
Farnham, Mrs 93, 143–4, 292,
 317, 322, 325
Feering 227, 228
Ferry, The 233
finish 232–6, 246, 301
Firebrace, Mary 93–4
Fisher, John, Bishop of Salisbury
 44, 77, 79, 178, 179, 306
British Institution exhibition
 182, 184, 190
Christmas invitation 97
Constables' honeymoon 321
dinner party 46
invitation to Salisbury 72–3
portrait 131, 137
and Princess Charlotte 229–30,
 231, 232
Fisher, John (younger) 73, 129,
 133, 145, 177
A Frosty Morning 180–81, 222
Brighton 250

Constable's marriage 312–14,
 316, 319, 320, 321
death 332
fishing 114–15
London 108–9, 178
marriage 305–6
purchases *The White Horse* 327
Fisher, Mary 305–6, 313, 321
fishing 113–15
Fitzhugh, Thomas 249, 252
Fitzroy, General Charles 48, 61–2
Fitzwilliam, Lord 196
Flatford Lock 325
Flatford Mill 8, 13, 15, 112–13,
 176–7
Flatford Mill 315–16, *315*
Flatford Mill from the Lock 112–14,
 119, 120, 124–5, 138
Flaxman, John 182, 183
Fletcher, Revd Joseph 258
Fordstreet 20
form 223–4, 232
Forster, Thomas 101, 109, 136–7,
 147, 149, 158
France 329
Francis, Mary 173
Frederick, Prince 229, 231
Freeman, Samuel *27*
Freer, Mary 191–2
Freud, Lucian 236
Frisk (dog) 283, 290
Frost Fair 205
Frosty Morning, A (Turner)
 179–81, *180*, 188, 222, 240
Fuseli, J. H. 84, 108, 187, 235

Gainsborough, John 20
Gainsborough, Thomas 20, 224–5
Gauguin, Paul 236

General View of the Agriculture of the County of Suffolk (Young) 201

Gentleman's Magazine 93–4, 283–4

geology 157

George III 47, 60–61, 67, 83–4, 266–7

George, Prince Regent 47, 67, 268
 and Bicknell 27, 28
 British Institution exhibition 182–4
 and Leigh 186
 peace celebrations 228–9, 230
 and Princess Amelia 48, 61, 62
 and Princess Charlotte 229, 231

Georgics, The (Virgil) 220–21

Germany 202

Gillray, James 31

Godfrey, Mrs 167, 273, 310

Godfrey, Peter 18, 78, 141, 160, 172, 214–15, 238, 249

Godfrey, Philadelphia 249, 270

Godfrey, Lieutenant William 148, 167, 173

Goethe, Johann Wolfgang von 55

Golding Constable 19

Golding Constable's Garden 263

Goodrich, John 215

Gosbeck 282

grain 261–2

Green Park 237, *237*

Greenwich 295, 298

Grimwood, Revd Dr Thomas 21

Gubbins, Mr 132, 251

Gubbins, Captain James 251–2, *251*, 252, 256–7, 276, 283–4

Gubbins, Mary 132, 251, 277, 321

Gubbins, Richard 252

Hadleigh Castle 227–8, 331–2

Hadleigh Castle 331–2, *332*

Hamlet 118

Hampstead 327

Hampton Court 196

Hannibal Crossing the Alps (Turner) 123–5, *123*, 179–80, 194, 222, 240

Harley Street 187, 191

Harris, Thomas 102, 202

Hartford, Lady 157

harvest 281–3, *281*, 284, 300

Hay Cart, A 281

Haydn, Joseph 213, 221

Haydon, Benjamin Robert *32*, 87–8, 108, 300
 British Institution and Royal Academy 105–7, 139–40, 189
 and Constable 31–2
 Covent Garden 212

Hayley, William 11

Haywain, The 329

Heathcote, Lady 131, 137, 163, 190–91, 196

Henderson, Mr 165

Hertford, Lady 267

Hess, Captain 231

Hogarth, William 84, 224

Holbrook 282

holidays 154

Hope, Thomas 75, 182

Hoppner, John *43*, 131, 163, 190

Horwood, Robert 25

Hotham, Richard 155, 157

Howard, Luke 109, 149

Hulse, Sir Samuel 280
Hunt, General 288
Hunt, Leigh 212
Hunt, Robert 125, 233
hunting 16
Hurlock, William 290–91
Hygeia 75

Ilam Hall 86
Ipswich Journal 19, 200–201, 214,
 308

J. M. W. Turner (Leslie) *194*
Jackson, John 43, 83, 224, 233
*James Gubbins in Church Street,
 East Bergholt by Moonlight* 251,
 252
Jeffery, Robert 28–9
Jew and the Doctor, The (Dibdin)
 101
John Constable (Reinagle) 6, *6*
Johnson, Dr 2–3, 10, 25, 143, 155,
 192–3
Jones, George 193
Joseph Farington RA (Lawrence) 45

Kean, Edmund 213, 232–3
Keats, John 54, 55
Kebell, Revd Henry 9, 66, 76–7,
 143
Keir, James 71–2
Kemble, John Philip 213
Kent, Duke of 206
Kenton, Benjamin 69
Keppel Street 325
Koch, Robert 55

La Roche, Sophie von 3
La Rochefoucauld, Duc de 3

Laënnec, René 54–5, 71
Lake, Warwick 29
Lamb, Lady Caroline 184, 186,
 196
landscape
 Beaumont 44
 Burke and Alison 238–9
 Constable 13, 33, 35–7, 56–60,
 84–5, 105
 and music 119
 picturesque 110–112
 sea 158
 temperature 145
 and weather 147–8, 151–2
 Wilson 225–6
 Wordsworth 128
*Landscape: Ploughing Scene in
 Suffolk* 210, 219–20, *219*,
 221
Landscape with Hagar and the Angel
 (Claude) 13–14, *14*, 44
Langham 12
Laudable Order of Anti-Gallicans
 77
Laurens, John 26, 39, 93
Lavenham 20
Lawrence, Thomas 139, 177, 182,
 192, 196, 297
 and Byron 301–2
 Elgin marbles 301
 and Kemble 212
 Napoleon and Wellington 276
 portraits 33–4, *45*, 124, 229
 and Princess Charlotte 178
 and Reynolds 197
Leigh, Augusta 186, 301
Leigh, Colonel George 186, 250,
 301
Leipzig 202

Leopold, Prince of Saxe-Coburg-
 Gotha 228
Leslie, Charles Robert 241, 333
 Constable's education 21
 Constable's personality 12, 103,
 242–3
 Constable's visit to Turner's
 gallery 187–8
 excursion with Stothard 135
 Maria's illness 330, 331
 post mill 23, 149
 Turner 194, *194*
 West 59
Lewis, Henry Greswold 191–2
Liechtenstein, Prince of 228
life-drawing 86–9
light 108, 112
Linnaeus, Carl 56
Little Wenham 5
Liverpool, Lord 161, 182, 196, 224
Lock, The 235
London 25–6, *25*, 107, 108–9
 fire service 164
 growth 234–5
 public health 178
 remodelling 205–6
 Thames 204–5
Lorraine, Claude *see* Claude
Lott, John 231, 247
Lott, Joseph 77
Lott, William 77, *199*, 231
Louis XVIII 228
Loyal Association 28
Lucas, David *12, 17*, 59, 128, 176,
 176, 219
Lucretia 40
Lunar Men 41, 71–2
Lycidas (Milton) 132–3
Lysons, Daniel 185–6

Macbeth (Haydon) 105–6, 139
McMahon, Colonel 186
Maidstone 101
Malta Fever 177
Manners, Lady Louisa 131, 137,
 190
Manning, Mr and Mrs 319
Mansfield Park (Austen) 11, 22, 30,
 53, 77–8, 110–111, 145, 206,
 213, 242
Maria Bicknell 8, 306, 306,
 309–310
Maria Constable and Four of her
 Children 327, *328*
marriage 2–4, 10, 30–31, 185–6,
 189
Martin, John 125–6
Mary Constable 120–21, 121
Mary, Princess 250
Mason, Mr 270
Massacre at Chios, The (Delacroix)
 329
Melbourne, Lady 184, 189
Methodism 283
Metternich, Prince 228
Milton, John 56, 132–3
Monet, Claude 329
Mont Ste Victoire 13
moon 158
'*moral auctioneer, The*' (John
 Rhudde) 142
mules 71
Mulgrave, Earl of 106, 184
Murphy, Denis Brownell 27–8,
 27
music 112, 118–20, 125
Musical Travels through England
 (John Bicknell) 296
Mycobacterium tuberculosis 55

Napoleon 123, 181, 196, 202, 216, 261, 271, 275–6
Napoleonic Wars 123, 273, 275–7
 Leipzig 202
 peace celebrations 228–30, 237–8
 Russia 165–6
 Vittoria 196
Nash, John 205, 207, 222, 237, 251, 267
National Schools 207
Natural History and Antiquities of Selborne, The (White) 243–4
nature 71, 74
 Coombe Wood 134–5
 Golding Constable 16
 landscape 110–112
 open-air sketches 56–60, 104
 Sabrina Bicknell 38–43
 Turner 123
 Wilson 225
Nayland 12
Needham Market 304
Newman Street 83
Nollekens, Joseph 182, 297
Northcote, James 187, 192, 197
Nott, Revd Dr 46

O'Neill, Eliza 274
open-air sketches 57–60, 104
Opie, Mrs 299
Orange, Prince of 229
Osmington 313, 316, 319, 321
Owen, William 87, 124, 322

Paine, Thomas 113
painting *see* art
Palestine (Crotch) 118, 119, 120
Palmer, John 77

Paris 329
Payne Knight, Richard 106, 110, 300–301
Pearce, Dr 154
Perceval, Spencer 130
Philosophical Inquiry into the Origin of Our Ideas of the Sublime and Beautiful (Burke) 238–40
Phipps, Hon. Augustus 184
picturesque 110–111
Pitt, William 51
Plaisirs de Mariage, Les (Gillray) 31
ploughing 201–2, 210, 219, 221
poaching 214–15
Pollock, Jackson 236
Pomfret, Lady 157
Pope, Alexander 287
portraits 33–4
postal service 78–9
Poussin, Nicolas 35, 59, 105
Price, Sir Uvedale 110, 190, 196
Proust, Marcel 114
Prussia 275
Pugin, Augustus *29, 87, 122, 182, 211, 320*
Putney 275, 279–80, 307

Queensbury, Marquess of 267

'Rasselas' (Johnson) 2–3
Rebow, General 155, 160–61
Redgrave, Richard 274, 333
Regent's Park 205–6, 222
Reinagle, Ramsay Richard *6*, 233, 273, 277
Rembrandt 113, 119, 234, 236
'Retrospection' (Elton) 177

Revans, Mr 172
Reynolds, Sir Joshua 20, 33, 57,
 95, 148
 British Institution exhibition
 181–5, 190, 197
 Discourses 121–2
 Northcote's life of 197
 portrait of Louisa Manners 190
 Royal Academy 84
Rhubarb Leaves 244, *244*
Rhudde, Anthony 51, 142–3
Rhudde, Deborah 142–3
Rhudde, Dr Durand 5, 18, 51–3,
 141, 142–3, 278
 at Cromer 154
 birthday 262–3
 Catharine's education 293–4
 and Constables 20, 62–6, 76–7,
 141
 Constable's marriage 318,
 321–5, 326
 death 326
 fair 200–201
 female admirers 140, 172–3
 and John Constable 143, 144,
 173–4
 and Kebell 66
 and Methodism 283
 Mrs Bicknell's death 270–71
 opposition to courtship 260,
 289, 291, 292, 295, 299
 as preacher 77–8
 rectory garden hearts 117
 return from Cromer 160–61
 and Watts 310
 will 279, 326–7
Rhudde, John 141–2
Rhudde, Mary 67
Richard III 213

Richmond 190, 227
Richmond Park 135
Roberson, Mr 264, 287, 310
Roberts, Miss 47, 48
Roberts, Mrs 19, 133–4, 141
Roberts, David 193
Robinson, Mr 262
Rock Buildings, Bognor 156
Rogers, Samuel 190
Rousseau, Jean-Jacques 39–40, 41,
 55, 111–12, 177, 206, 298
Rowlandson, Thomas 29, *87*, *122*,
 182, *211*, *320*
Rowley, Sir William 262
Royal Academy 83–4, 121, *122*,
 197
 1802 exhibition 34
 1810 exhibition 83
 1811 exhibition 107, 117
 1812 exhibition 104, 112, 113,
 115, 116–17, 120, 122–5
 1813 exhibition 176, *176*,
 179–81, 185
 1814 exhibition 209–210,
 218–20
 1815 exhibition 265, 266,
 269–70, 271–2, 273
 1816 exhibition 299–300, 303
 1817 exhibition 325
 1819 exhibition 327
 1821 exhibition 327
 chandelier 268–9
 Constable elected Academician
 331, 332–3
 Constable elected associate
 327
 Constable fails to be elected
 associate 83, 84–5, 233, 254,
 286, 322

Council Room dinner 192, 193
Farington 45–6
Haydon 105, 106, 189
Life Room 86–9, *87*, 333
Turner 189, 193
Royal Academy Schools 45
Royal Marriages Act 1772 48
Rubens, Peter Paul 57, 85, 153
Rudd, Sayer 142
Ruisdael, Jacob van 23, 35, 57,
113, 114, 150–51, 225, 227
Russell, Jesse 86
Russia 165–6, 202, 275

Sadak in Search of the Waters of
Oblivion (Martin) 125–6
St Dionis Backchurch, Fenchurch
Street 77
St James's Park 99, 100, 101, 238
St James's Square 170, 174
St Martin-in-the-Fields 319–20,
320, 330–31
Salamanca, Battle of 166
Salisbury 72–3, 321
Sandford and Merton (Day) 145–6
Scene on the River Stour 12
Scott, Walter 268
sea 156, 158
Seasons, The (Haydn) 221
Seasons, The (Thomson) 220–21
Seated Woman from behind, A 102
Sense and Sensibility (Austen) 11
Seward, Anna 38, 42
Shelley, Percy Bysshe 243
Sheridan, Richard Brinsley 182
Shoberl, Frederick 18
Siddons, Sarah 183–4, 213, 224
Sidney, Sabrina *see* Bicknell,
Sabrina

Simond, Louis 108, 212
Sir George Beaumont (Hoppner) *43*
Six Mile Bottom 186
'Sketches from Private Life'
(Byron) 302
sketching box 57–8
Skey, Arthur 93, 103, 146, 153,
156, 157, 169
Skey, Samuel (father) 71–2
Skey, Samuel (grandfather) 71,
72
Skey, Samuel (son) 71, 93, 146
Skey, Sarah 93–4, 137
in Bognor 156
in Brighton 161, 189–90
and Constable 92–3, 94, 96,
103, 168, 174
in London 98, 153, 169
and Louisa Bicknell 198
marriage to Fletcher 258
marriage to Samuel Skey 70–71,
72
Samuel's death 146
in Spring Grove 1–2, 68, 72,
116
Smirke, Robert 210–211, 271
Smith, Mrs (Nayland) 295, 305
Smith, Benjamin 48–9, 50
Smith, Charlotte 48–50, 55, 179
Smith, Charlotte Mary (daughter)
179
Smith, J. T. 253
Smith, Lionel 179
Smith, Richard 48–9, 179
Snow Storm: Hannibal and his Army
Crossing the Alps (Turner)
123–5, *123*, 179–80, 194, 222,
240
Soane, John 84, 191

Somerset House 86, 121, 122, *122*, 222–3, 268–9, 277
Sophia, Princess 250
Southampton 321
Southchurch 227–8
Southey, Robert 127
Spedding, Anthony 29, 179, 186
spinsterhood 10–11
Spring: East Bergholt Common 151, *152*
'Spring' (Thomson) 157
Spring Gardens Terrace 25–6, *25*, 99, 130, 153–4, 164, 174–5, 203–4, 205
Spring Grove 1–2, 70–71
 Constable's visit 91–3, 94–5
 Maria's visits 1, 67–8, 72, 99–100, 116, 125–6
Staël, Madame de 196
Stafford, Marquess of 182, 183
Statford St Mary 12
Steventon 7
Stoke-by-Nayland 68–9
Stoke-By-Nayland Church and Village 58
Stollery, John 214–15
Stollery, Thomas 215
Stothard, Thomas 85, 97, 134–5, 226
Stour 12–13, 19, 44, 60, 113, 114, 115
 Boat-building near Flatford Mill 245–9, *248*
 Landscape: Boys Fishing 176, *176*
 Scene on the River Stour 12
 Willie Lott's Cottage Seen over the Stour by Moonlight 199
Stourhead 73–4, 75, 205
Stratton Street 51

Strowger, Sam 86, 88, 193, 201, 218–19, 300
Study of Cows 199
Study of Female Nude 89
sublimity 239–40
Sudbury 20
Summer Evening 90
Summerland, A 210, 219–20, *219*, 221
Swanevelt 147
Sweden 202

Task, The (Cowper) 126
Tattingstone 18, 214
Taylor, Miss 140, 271, 293–4
Taylor, Ann 5–7
Taylor, Dr John 143
Taylor, Revd T. G. 140
Telegraph, The 15, 19, 109–110
Telford, Thomas 70
temperature 145
Temple of Concord, Green Park, The 237
Thackeray, William Makepeace 267
Thames 135, 204–5
theatre 101–3, 202–3, 210–213
Theatre Royal, Brighton 250
Theatre Royal, Drury Lane 212
Thinks I to Myself 145
Thomson, Henry 124, 233, 234
Thomson, James 109, 157, 220–21
Thrale, Mr 155
Thrale, Mrs 155
Tierney, Mr 267
Times, The 213, 288
'Tintern Abbey' (Wordsworth) 128

Townshend, 'Turnip' 221
Tragic Muse, The (Reynolds) 183
Travis, Mr 263, 284, 289, 321–2,
 323–4, 325
Trimmer, Revd 241
Trinitarianism 141, 142
tuberculosis 47, 48, 54–6, 178,
 328, 331, 332
Tull, Jethro 221
Turner, J. M. W. 34, 84, 166,
 193–5, 243
 1812 Royal Academy
 exhibition 123–5
 1814 Royal Academy
 exhibition 221–2
 and Beaumont 44
 British Institution exhibition
 182
 Crossing the Brook 272
 Dido and Aeneas 222, 235
 Dido Building Carthage 271–2,
 272
 Frosty Morning 179–81, *180*, 188,
 222, 240
 Hannibal Crossing the Alps
 123–5, *123*, 179–80, 194, 222,
 240
 Malta Fever 177
 pamphlet defending 272–3
 portrait *194*
 private gallery 187–8, 191
 Royal Academy dinner 192
 and women 188–9, 198
Turner, Mary 189
Turner, William Gay 187–8, 189
Two Studies of East Bergholt House
 308

Unitarianism 142

Valentine's Eve (Opie) 299
Van Eyck, Jan 35
Van Gogh, Vincent 23, 107, 236
Vanity Fair (Thackeray) 267
Velazquez, Diego 236
Venus and Adonis (Turner) 189
Victoria, Queen 206
Village Feast, East Bergholt, The
 230–31, *230*
Virgil 220–21

Wainwright, Mr 172, 310, 326
Walton, Isaac 114
Ward, Mrs 227
Ward, James 182
Warwick House 231, *231*
Water-wheel, A 15
Waterloo 276–7
Watteau, Antoine 135
Watts, David Pike 16, 43, 98, 138,
 206
 advice 68–70, 81, 217–18
 and Ann Constable 85
 British Institution exhibition
 182
 daughter's marriage 85–6
 death 309
 funds Lake District visit 37, 127
 and Gainsborough 225
 offer of lodging 165
 party invitation 208
 Portland Place 205
 portrait 131, *131*
 will 310–311
Watts, Mary 85–6
Watts, William 16
weather 147–8, 149, 158, 204–5
Weight, Mrs 163, 164
Weight, Richard 163, 164

Wellington, Lord 166, 196, 275, 276
West, Benjamin
 British Institution exhibition 182
 chiaroscuro 59
 Christ and the Little Child 83
 Christ Rejected 222
 encouragement of Constable 59, 85, 120
 fiftieth anniversary dinner 197
 and Haydon 139–40
 life models 87
 and Napoleon 271
 Northcote's life of Reynolds 197
 private gallery 187
 Royal Academy dinners 192, 269
Western, Captain Thomas 167, 172
Weymouth 319
Weymouth Bay 321
Whalley, Martha 23, 133, 227, 264, 319
Whalley, Mrs 289–90
Wheatfield 305
Whitbread, Mr 267
White, Revd Gilbert 243–4

White Horse, The 327
Whitmore, James 189
Wilberforce, William 196, 206
Wilhelm III of Prussia 228
Wilkie, David *32*, 43–4, 192, 273
Willie Lott's Cottage Seen over the Stour by Moonlight 199
Willis's Rooms 183
Wilson, Richard 34, 56, 70, 224, 225–6
Wimbledon Park 278
Wivenhoe Park 314–15
Wivenhoe Park 314–15, 325
Wollstonecraft, Mary 10, 43, 49
Woman Writing at a Table, A 288
women
 marriage and spinsterhood 10–11
 Turner 189
Worcester 95
Wordsworth, William 127–8, 159, 177, 182, 273
Wyatt, Jeffrey 192

Yarmouth, Lord 267
Yorick (dog) 144, 162
York, Duke of 250
Young, Arthur 201
Young, Charles Mayne 213